VOICES
OF THE AMERICAN WEST

Corinne Platt & Meredith Ogilby

FULCRUM
GOLDEN, COLORADO

Library of Congress Cataloging-in-Publication Data

Voices of the American West / [compiled and edited by] Corinne Platt ; [photographs] by Meredith Ogilby.
 p. cm.
 Includes bibliographical references.
 ISBN 978-1-55591-715-9 (hardcover)
 1. West (U.S.)--Biography--Anecdotes. 2. West (U.S.)--Civilization. I. Platt, Corinne. II. Ogilby, Meredith.
 F590.5.V65 2009
 303.48'4092278--dc22
 [B]
 2009014272

Printed in China by P. Chan & Edward, Inc.
0 9 8 7 6 5 4 3 2 1

Design by Jack Lenzo
Cover image © Shutterstock

Fulcrum Publishing
4690 Table Mountain Drive, Suite 100
Golden, Colorado 80403
800-992-2908 • 303-277-1623
www.fulcrumbooks.com

For Dick Pownall and Bob Parker, whose pioneering spirits were the original incentive for this project.

And for Mark and Chuck, two very understanding and supportive husbands. Thank you for your love and encouragement in all stages of this project.

CONTENTS

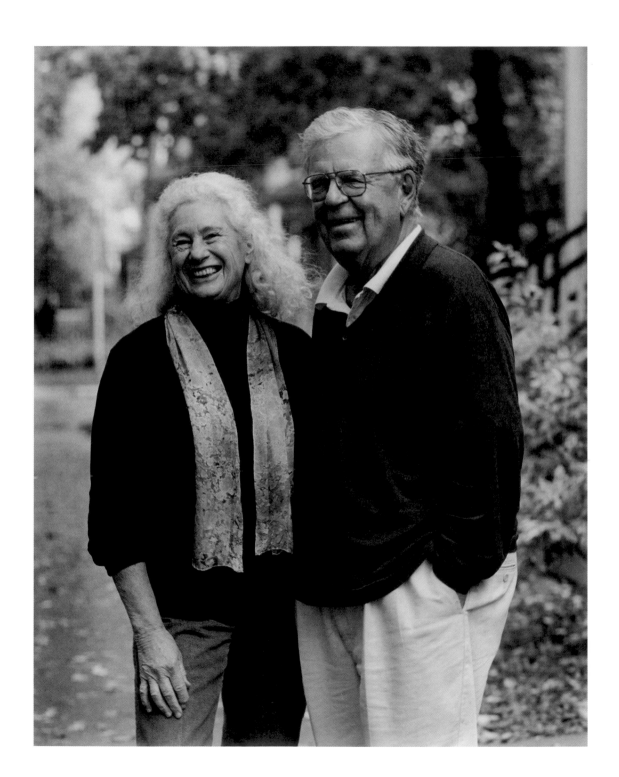

FOREWORD
REEDUCATING ONE WESTERNER

At the 2005 get-together in the Great Basin country of Oregon where I grew up, an acquaintance asked if anything had changed since we sold our ranch in 1967. "Sure," I said, waving my hand toward the heights of Steens Mountain, where before 1900 a hundred thousand sheep grazed and today only wild creatures graze. No one lives on the sage plains of Catlow Valley, just west of the mountain, but in 1915 Catlow had eleven post offices. The West continually evolves.

People are continually forced to rethink the ways they use the country. We used to believe that the territory was ours to do with as we pleased. Graze it down to bare dirt and let your cattle tromp the riparian areas. Dig holes and spray chemicals anywhere. Bulldoze the creeks.

Westerners are surrounded by millions of vacant acres. Why would anybody care if a few acres are trashed? That was how I thought, the way I'd been brought up to think—we indeed bulldozed a few creeks. And we thought we were doing God's work as we transmogrified our surroundings. Locals are coming to regret that heedlessness.

Changing the ways we think drives changes in the ways we act. Most people want to have a positive effect. But what would that positive effect be? In the Great Basin sage country of southeastern Oregon, people are thinking it through again, along with millions of people in the West, in America, and all over the world. We see that the place where we live can be as completely ruined as anywhere else, and we're eager to put a lid on the destructions.

My reeducation began in 1947, at age fifteen and reading *The Big Sky* on a screened-in veranda overlooking Warner Valley after a day in the hay fields. In Guthrie's novel, one man laments to another, saying something like, "You're too late, it's all ruint." This, in 1835? How could the vast West be ruined? The notion nagged at me over the years.

Then in the winter of 1962, managing the farming on the MC, I read *Silent Spring*, in which Rachael Carson details the degree to which the use of farm chemicals in the Tule Lake Basin (about a hundred air miles west of Warner) was decimating bird populations.

American farmers and ranchers were inadvertently poisoning their homelands. That was the news. In Warner, worse news. We were making the same mistakes.

I'd supervised spraying parathion nerve gas for clover mite in the barley crop and killed off the songbirds in the valley. *Silent Spring* threw me into a double bind—I was used to thinking that we were doing God's work, feeding people. But it turned out that my work was destructive to the good place where we lived, the land and watershed. I was glad to escape that quandary when we sold out in 1967. I went away to reinvent myself.

Ed Abbey was way past boys like me and at that same time writing *Desert Solitaire*. Over the next decade, James Welch published *Winter in the Blood*

and Richard Hugo was busy with emotionally charged poems triggered by his travels across the rural West and Norman Maclean published *A River Runs through It*. That was just among the people I came to know. All over the West people were reinventing themselves, thinking through their obligations to the places where they lived. Again.

Paradigm-changing histories like William Goetzmann's *Exploration and Empire* and Alvin Josephy's *The Nez Perce Indians and the Opening of the Northwest* and *The Legacy of Conquest* by Patricia Limerick opened doors onto unexpected western history. The West had thousands of stories most of us didn't know about: scientific histories and women's histories and Native American histories and Hispanic histories and religious histories and terrible stories of endless social violence and environmental wreckage and mercenary exploitation, but also stories of utopian colonies like the Hutterites and of unsung daily-life heroes and heroines. We had a more humanly complex and richer history than we'd suspected. Those stories counted for more than the utter mythological nonsense we saw in Buffalo Bill and John Wayne shoot-out "Westerns." It was a time of discovery for many westerners, an exciting time for me.

But I'm getting ahead of myself. In the summer of 1976, Jim Crumley and Steve Krauzer and I, basically in search of a good time, drove down to Sun Valley for a western conference. We had a swell time, but an unexpected thing happened. During four days of listening to the old-time moviemakers and to scholars, I came to understand that the West was living out the end of one story, our racist, sexist, imperialist shoot-out story, a justification of brutal conquests that is much like the conquest stories repeated over and over throughout world history. And that a few westerners were trying to figure out how to begin another story: forward looking, transcending, and useful.

It was my good fortune to continue those conferences at Sun Valley, staged by Richard Hart, where I encountered people taking part in the invention of a new western story: Alvin Josephy and William Goetzmann and Charles Wilkinson and Vine Deloria Jr. and Patty Limerick and Ross Toole and Stephen Pyne, Molly Ivins and Hal Cannon and Teresa Jordan and anthropologists and folklorists and literary and film theorists and many others. I took it as a conjunction of many of the best minds in the West. Maybe it was. In any event, those people instructed me. They taught me to try thinking for myself—not what did other people think, but what did I, personally, really think, and why?

A seriously innovating and useful tradition had been established when those Sun Valley conferences shut down in the middle 1980s. It continues. This book is evidence. The citizens represented here are exploring further contours and implications of our story in the West, honoring their own obligations. I found my own reeducation continuing and evolving as I read *Voices of the American West*. May it work that way all up and down the road.

—William Kittredge

INTRODUCTION

We keep each other alive with our stories. We need to share them, as much as we need to share food. We also require for our health the presence of good companions. One of the most extraordinary things about the land is that it knows this—and it compels language from some of us so that as a community we may converse about this or that place.

—Barry Lopez, A Literature of Place

This book began with a fortuitous reunion of two friends. Photographer Meredith Ogilby and I bumped into each other at the fourteenth annual Headwaters conference in Gunnison, Colorado. Meredith had recently visited Dick Pownall after his commemorative ascent—at age seventy-five—up the 13,770-foot Grand Teton in Wyoming, on the Pownall-Gilkey route named after his 1948 first ascent. Dick's quiet self-assurance and disregard for fanfare led Meredith to question what qualities define this extraordinary westerner. And who are others in the West living in defiance of limits? In a similar vein, I was considering who the people with enough passion and vision to make a difference in today's West are. We had no idea that the conference, with such a powerful combination of what George Sibley coined the West's "heavy lifters," and our chance encounter would be the catalyst for a four-year journey to articulate the Rocky Mountain West through its people. We committed to travel the West in search of men and women who could answer our questions: How has the West

defined you? Where do you think the West is heading, and what is your role? Are you hopeful about the future of the West?

Two weeks later we found ourselves in Stewart Udall's living room on the outskirts of Santa Fe, New Mexico. Stewart exemplified the character we sought, someone who helped shape the West and its future. He was born and raised in Arizona, grew up knowing and working the land, and dedicated his life to safeguarding the region's environmental integrity—though not all of his efforts are without controversy. He is generous of spirit but is also a widower who struggles with the loss of his eyesight and sometimes despairs for his grandchildren's future. He calls himself "a troubled optimist."

We drove thousands of miles looking for others shaped by the geography of the West and discovered pockets of the country we never knew existed. I remember dropping into Big Hole, Montana, on a sunny, bluebird afternoon and finally understanding the term *Big Sky Country.*

In far south New Mexico, we visited the Gray Ranch and Warner Glenn's family on the Malpai borderlands. The southwestern landscape at first seems harsh and desolate, but at sunset a softness comes over the land: the mountains glow purple and the horizon seems endless. Along the border framed by the Peloncillo and Chiricahua mountains, where Geronimo hid from the US Cavalry in the 1880s, our journey grew heavy when

we saw a lone Hispanic man handcuffed to a fence along a barren stretch of dirt road.

We encountered a blinding sandstorm on the Navajo Reservation, so powerful that sand filled our camper-truck even with the windows and doors closed. We had just spent an afternoon with James and Mae Peshlakai at their home in Cameron, Arizona, where we listened to Navajo tales of cultural dislocation. The next morning we drove through the sandstone sculptures of Monument Valley, and the world seemed clean and hopeful again as we reflected on the value of preserving the oral tradition. It reinforced our decision to combine our conversations and Meredith's black-and-white portraits into a book that honors that tradition.

Early in the project we sought out iconic westerners known for their unique visions: Charles Wilkinson, Patricia Nelson Limerick, Daniel Kemmis, Terry Tempest Williams, and William Kittredge. As the road grew longer, we discovered men and women such as Donald Warne, Jennifer Speers, and Lani Malmberg, whose faces are not as familiar but whose inspiration and commitment also come directly from the land.

We dropped in on Charris and Dulcie Ford at Mimbres Hot Springs in a canyon at the foothills of New Mexico's Gila Mountains. It was the first time either of us had been to a commune, and they left this message on our phone: "We're right after the sawhorse on the left. You can't see our house from the road, but look for a black 1951 Plymouth with weeds growing out of it. And if you wouldn't mind, please bring eggs, bread, milk, goat cheese, and organic bananas."

We traveled in Meredith's camper-truck or stayed in cheap motels. We called on old friends and asked to sleep on their floors and couches. To gain perspective on the severity and history of some of the issues facing today's West, we attended conferences: Quivira Coalition, Headwaters, Colorado College State of the Rockies, and the Wallace Stegner Center Symposium. During our drives we read out loud Charles Wilkinson's *Fire on the Plateau*, Daniel Kemmis's *This Sovereign Land*, Bill deBuys's *River of Traps*, Patty Limerick's *The Legacy of Conquest*, Gary Paul Nabhan's *Coming Home to Eat*, and books by Wallace Stegner, Aldo Leopold, and William Kittredge.

We were among the old guard huddled in our sleeping bags in the wee hours at the Ed Abbey Speaks gathering, a reunion of Ed Abbey's closest friends who gathered to commemorate the fifteenth anniversary of his death and also the fortieth anniversary of the Wilderness Act. It was held at Pack Creek Ranch, outside Moab, Utah, and there we listened to Abbey's giant friends Dave Foreman, Katie Lee, and John Nichols roar against the forces that have degraded the West. Later, in Bozeman, Montana, we heard Doug Peacock, the model for Ed Abbey's George Hayduke in *The Monkey Wrench Gang*, lament, "I thought by now there would be a hundred Ed Abbeys."

We spent an afternoon with Terry Tempest Williams in the desert canyon where she said she would take the people she loved if the world were about to end. We hiked with Terry up to a petroglyph of a great horned owl whose eyes look upcanyon toward a rock that holds an ancient pictograph of a woman giving birth. Over Mexican food and margaritas, Terry lived up to her reputation as a storyteller and convinced us that the fate of humanity and the land are inseparable.

These are conversations. They are not written essays, but moments of honest, thoughtful dialogue. We met people in coffee shops, noisy bars, and restaurants, and were invited into their homes. We shared stories, laughter, tears, and too many cups of coffee. The power of each story motivated us to leave our families again and again. As we traveled the West attempting to capture these individual personalities, what we found is that they captured us.

What Meredith and I discovered on our journey is a large community of visionary men and women who are highlighting solutions for a region that has been struggling with political agendas, bureaucrats, developers, climate change, pollution, habitat destruction, ecological degradation, and loss of culture. Each of these individuals has influenced the West. While their approaches to land use, public policy, or border issues may incite controversy, each remains determined to seek solutions. They share the common thread of a commitment to place as well as a profound appreciation for the complexity of the problems the West faces. And though many may share Stewart Udall's troubled optimism, most maintain hope for the West's future.

These timeless stories and photographs show a cross section of the West as it is today, however incomplete. Many of the West's most pressing issues are discussed in these pages. As you read about the struggles and motivations of these individuals, we hope you feel, as we do, a sense of stewardship for this, Our Beloved West.

THE SPIRIT OF THE WEST

The visionaries presented here are, in our opinion, the West's heavy lifters. They are people who know the land not just intellectually, but intimately. They are passionate thinkers and some of the West's most effective spokespeople. Stewart Udall offers a historical perspective from a time when political bipartisanship was possible. The American West would not know itself without Ed and Betsy Marston and *High Country News*. In their nineteen years as publisher and editor of the paper, they created an institution that educated thousands of people about the issues critical to the survival of the West. Bill Hedden's vast credentials include saving fifteen million people in southern Utah from radiation poisoning. The written and well-documented observations of Patricia Nelson Limerick and Charles Wilkinson embrace years of both the history and the struggle for resources in the West. When Terry Tempest Williams speaks of her family's roots in Utah, there is an arousing and eloquent spiritual force that embraces both people and the land. One of the region's great writers and environmental historians, Bill deBuys, says, "If spiritualism and the divinity existing in the world resides in place—and is specific to place—then you can't carry that God from place to place…If you remove the spirit from the land, if you eliminate its divinity, then you license yourself to be able to do anything with it you please." We think all the people interviewed for this section share both Bill's passion and his sentiment.

STEWART UDALL
TROUBLED OPTIMIST

Stewart served in the House of Representatives for three terms and as the secretary of the interior under presidents John F. Kennedy and Lyndon B. Johnson. During eight years as secretary, he worked tirelessly for environmental causes and land conservation. With Wallace Stegner as his assistant, he expanded our National Park System. When he returned to Arizona from Washington, he worked for more than twenty years to ultimately bring justice to the widows of Navajo uranium miners killed by radiation exposure. He says that one of his biggest regrets as secretary was that he didn't do enough for native people.

We shared a morning with Stewart at his adobe home in New Mexico. He walked us down a long hallway lined with photographs from his life: the inauguration of President Kennedy with Stewart at his side; Stewart strolling next to the poet Robert Frost; Stewart on Mt. Kilimanjaro. "Kennedy wanted to show that Americans had vigor, so I climbed Fuji and Kilimanjaro," he told us, imitating Kennedy's Boston accent on the word vigor. *Afterward we sat in his living room overlooking the Santa Fe valley. He showed us a play he was writing and talked about his love for cities and culture and his late wife, Lee.*

———

Being a westerner has special meaning to me. I grew up on the tail end of the frontier in a small town, St. John, Arizona, surrounded by national forests and Bureau of Land Management lands. When I was eight years old, I took care of the garden. I milked the cow. It was important that everyone in the family contribute. I think that growing up in a small town was part of what shaped my interest in character and convictions. You had to irrigate; kids had to work, tend the gardens, and take care of the pigs and chickens. I grew up in a dry part of the West understanding the importance of water.

I've always said, even when I was secretary of the interior, that I'm a troubled optimist. I'm a little more troubled about the West now than I was back then, but I'm not despairing. I hope that some of the problems we're seeing help us revert to looking at the West and the environment as a whole in a more sensible, conservative way.

I had the great fortune to come into office at a time when people wanted new policies. The reason that I and so many others were able to pass the wilderness bill was because in the 1900s Theodore Roosevelt started the conservation movement. The conservation movement was very powerful, and most of the people in this country thought that preserving land and creating parks were good for their communities. We felt we had a moral responsibility, a legacy, to leave the Earth, or that part of it where we lived, better. Recently, I went back and found the *Congressional Record*: the wilderness bill passed by a vote of seventy-eight to twelve. Of the twelve, six were Democrats and six were Republicans. I use some of my time now trying to remind people of the wonderful, broad bipartisan support that we had then.

I traveled the West with Kennedy two months before his death. We started in Pennsylvania and we moved across Wyoming, Utah, and other western states. We went out into the West and dedicated a park or a wildlife refuge, which gave people the sense that conservation mattered. If President [George W.] Bush or any of his department made this trip, I missed it.

We need presidential leadership. We need it desperately.

As westerners we are rich. We may be poor in many ways, but we have the richest environment there is. We have public lands, mountains, rivers, wildlife, and wilderness. I know that as a leader you can build a legacy and leave a legacy by creating open space, but you can also lose a legacy. I've been reading the stories that it's the hottest it has been in history. We are seeing a synergy with drought and global warming that will cause us to lose part of what we have.

I think the real test of the West in the coming decades will be whether we take action against global warming and whether we adapt to the end of the petroleum age. We've created a society based on cheap energy. Our automobile culture is unique in the world. I voted on the damn interstate highway program in 1956. We didn't know what we were doing. We didn't discuss it. We thought we had hundreds of years of oil. It was a mistake. And now we have to face up to the problem.

I supported the Central Arizona Project. We told Congress that the water was for agriculture. But the water was so expensive, most of the farmers couldn't use it. Now it's supporting this explosive growth of Phoenix and Tucson, and draining the Colorado River.

If we continue treating the land as something to be exploited, we will see the case made by the anti-conservationists that we have to shrink the wilderness, the national parks, and the national forests, that we can't afford them any longer.

The statement that is on my mind now is from Aldo Leopold. It puts what is happening today into focus: "We abuse land because we regard it as a commodity belonging to us. When we see land as a community to which we belong, we may begin to use it with love and respect" (*A Sand County Almanac*, 1949). The approach of the Bush administration and the approach that a lot of westerners favor is that land is a commodity. In Montana or Idaho they say we're holding back progress by having too much wilderness or by restricting the mining industry's access to federal land. It was unthinkable to sell off parts of the national forest when I was in Washington. And now that's what they're talking about.

There is so much that is disturbing. I saw a poll that says 46 percent of the American people think a conservationist is a bad person. What is conservation? It is preserving the best things we have.

I think the way for things that I value in the West to be protected and to be funded is to have a return to a bipartisan approach. Maybe that's a dream of mine, but I saw it. I helped orchestrate it in a way, and it was wonderful to see the overwhelming support for these changes. I think we need to strike a positive note, have epigraphs up of Wallace Stegner: "We need a society to match our scenery."

I have the old-fashioned view that it's important to have ties with the land. I feed my wife's birds every morning. I'm losing a lot of my piñon trees, but I'm trying to water and save what I can. I think there's hope. Maybe this big burst of growth will subside and people

in the West will again see how rich they are in terms of the environment that surrounds them and how important it is to preserve it.

———•••••———

During Stewart Udall's tenure as secretary of the interior, the Wilderness Act, the Wild and Scenic Rivers Act, and the National Trails System Act became law. He led the effort to create four national parks, fifty-six national wildlife refuges, eight national seashores and lakeshores, six national monuments, nine national recreation areas, and twenty-nine national historic sites. He is the author of The Quiet Crisis, *a best seller published in 1963 concerning the human relationship with the environment, and* The Myths of August: A Personal Exploration of Our Tragic Cold War with the Atom.

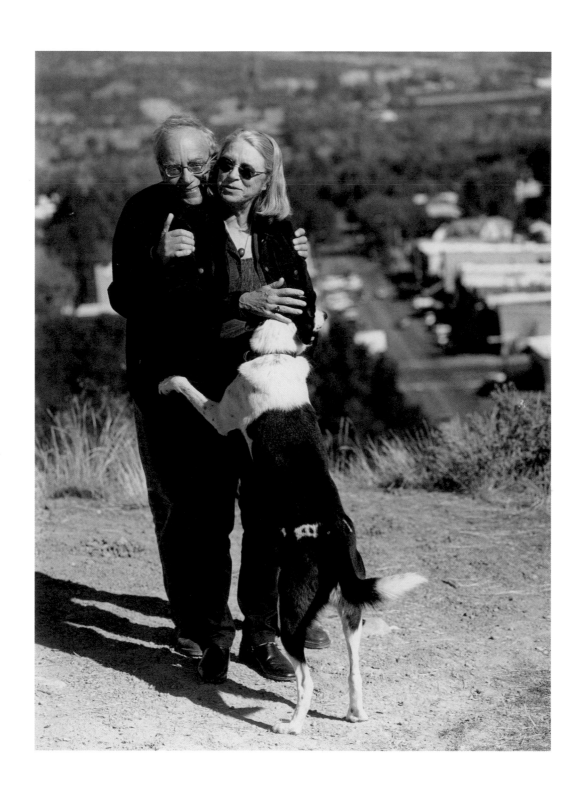

ED AND BETSY MARSTON
THE PAPER WE DID WAS A FUNCTION OF ITS TIME

Our formal interview with Ed and Betsy took place around a picnic table at The Flying Fork Cafe & Bakery in Paonia, Colorado. But our relationship with the Marstons extends far beyond one lunch.

Ed has been an integral part of this project since its inception. His knowledge of the West and its key players, along with his willingness to share contacts and suggestions with us, was invaluable. Ed and Betsy live one mountain pass away from Meredith, and we found ourselves heading to Paonia often during the project. Ed met with us for coffee, answered phone calls and e-mails, and offered suggestions and encouragement. He was definitely our best critic, as Betsy was for Meredith when she wrote her first book, A Life Well Rooted.

During their thirty-four years in Paonia, Ed and Betsy have published three newspapers, including High Country News, *and several books; revived four worn-out commercial buildings; been elected to various public bodies; and taken two journalism sabbaticals, one at Stanford and one at Berkeley. After growing up in Paonia, their two children migrated back to New York City, even though they were two and four years old when they left.*

As we've come to know the West more closely, we can only agree with what George Sibley said at the fourteenth annual Headwaters conference: "The West could simply not know itself without the truth-telling of High Country News."

Ed: *High Country News* was what I had been searching for. When I was a New Yorker and an academic, I didn't feel part of the larger America or part of what I called "real life." In the West I saw my first lump of coal, I learned what a culvert was, and I got to know men who spent their working lives underground and other men who spent their lives tending to cattle or sheep. It turned out that I had an instinct for describing a society made up of ranchers, loggers, hippies, dam builders, miners, and hard-bitten old-timers. And that is how I made my living in the West.

Betsy: The best thing about running *High Country News* and learning about the West was that we were covering what was, for that first decade anyway, as close to a classless society as you can get in the United States. When you're in New York, there's the stratifications of money and jobs. Here there were so few people, we were all mixed together.

Ed: In 1974 we decided to take a year off from our lives in New Jersey and spend it in Colorado. We drove West in a 1968 Valiant pulling a small red trailer. I was a physics professor and Betsy was in journalism. Unbeknownst to us, we shed those old lives somewhere in western Nebraska. It was a classic American road trip. We had fled west.

Betsy: I had been the producer of a television talk show called *New Jersey Speaks* that addressed issues like the women's rights movement, the Vietnam War, and the Mafia. I did a show on Paul Robeson, a black singer and

actor who was accused of being a Communist. It won me an Emmy.

For all we knew about Paonia, we might as well have moved to the moon. I made candles for fun. Ed tried to contract out as a technical writer. The locals called us newcomers "hippies." They didn't understand why young urban people would want to move here.

Within four months we got bored and decided to start a newspaper. Why a newspaper? Because we'd go to meetings and the accounts in the local paper bore no relationship to what had happened. All the local paper, *The Paonian*, cared about was fighting gun control and slandering hippies. So we borrowed $4,000 from the local bank and started the weekly *North Fork Times*. Twenty-four years later it continues as part of a larger weekly under different ownership. We put out that paper for six years—512 issues—and it taught us a lot about the West from the ground up.

Ed: We sold the newspaper in 1980 and took a year off. But before the year was out, we had started another paper, *Western Colorado Report*, to cover the West's oil shale boom. We began to exchange ideas with *High Country News*, which was being published up in Lander, Wyoming. They invited us to apply for the positions of publisher and editor, and when they offered us the jobs in 1983 we moved the whole paper to Paonia in the back of a pickup truck and merged *High Country News* with *Western Colorado Report*. By this time oil shale had gone bust and a new cultural and economic struggle for the West had begun.

Betsy: Our intent at the paper was to look at the West as if city and state boundaries did not exist. What mattered was the public's land. Towns and cities were just where people lived. We didn't think of ourselves as card-carrying environmentalists, but I guess we were.

Ed: Although oil shale had been confined to western Colorado, the entire West collapsed economically in the early to mid-1980s. Suddenly Btu's just weren't worth anything. Paonia's big industry was coal, and the number of mining jobs dropped from eight hundred to one hundred. Across the West, coal, conventional oil and natural gas, copper, timber, cattle, tourism, and electric power plants all went into the tank. It was *HCN*'s job to report on the ongoing demise of energy development and guess at the society that would emerge from the wreckage.

HCN's beat was ten states and a million square miles of public and private land, although we concentrated on the five hundred thousand square miles of public lands. We thought of each issue as a new chapter in a book that had started with founder Tom Bell in 1970 and is still going today.

The staff that produced our 456 chapters over nineteen years consisted initially of Betsy and myself. By the time we handed over the paper to the next generation, there were twenty-four people in the office and seven times the circulation. But we were still only putting out sixteen pages twenty-four times a year. I'd wonder how the damned thing had grown the way it did. And I wondered if it had been smart to let it grow.

Freelance writers and photographers across the West have always been vital to *High Country News*. The freelancers were in the field, testing my hypotheses about what made the West tick. Unless you had unifying theories about the West, how else could you cover states that averaged a hundred thousand square miles each, a herd of federal agencies and the five hundred thousand square

miles of land they managed, numerous industries, and thousands of small towns and medium-sized cities?

The working theory in the 1980s was that the Old West and its laws and ways were dying. We did a four-part series in 1986, published later as a book called *Reopening the Western Frontier*, about the West's many busts and what we thought would follow. Little did I guess then that what would eventually follow them would be them again, with gas development dominating and doing more damage than cattle and dams and hard-rock mining ever dreamt of doing.

Betsy: The ideas and stories were important. But to publish that paper year after year requires an institution and people. And building up that institution, and making it sustainable, was tough. Our office for years was a narrow set of rooms that doubled as corridors. When we addressed and mailed the paper every other week, we had to turn the newsroom into a mail room. Since the news staff became the mail staff, we weren't inconvenienced.

We did everything ourselves. It was Ed, the intern, and me. I remember not getting paid regularly that first year. Then we hired the first intern and began a tradition of hiring our interns. They had already worked with us—for free back then—and knew what they were getting into. And of course we were desperate for help. We needed them, and they were always fresh and insightful and added such life to the paper.

Over the years we worked with close to two hundred interns. It was never a family, but it was the closest thing to it and still is a remarkable part of the paper. Without generations of interns, *High Country News* would not be what it is. They are its heart.

The other heart—who says an institution has to have only one heart?—was the freelance writers and photographers. They would feed us stories and images from around the West. Finally, of course, there were the subscribers. They read us, critiqued us, supported us.

My role was different than Ed's. I'm an enabler, a talent scout; I like to help people emerge and have a voice. My niche is to get people listening and talking to each other and revealing truths from the grass roots as opposed to imposing those truths from above. If I can make essays better or sharper as editor of "Writers on the Range," I'm happy, I've done my job.

Ed came out of physics, so he was completely curious. He wasn't knee-jerk environmental, ever. That was a very useful thing in terms of building the paper's constituency. *HCN* was never an Earth First! journal or a Sierra Club journal. It was never a house organ. It was inquiring minds who passionately care about public lands but didn't have answers to what they needed.

Ed: One of the things that really bothered me when I moved here was the parochialism of the West—the ranching, logging, mining—and the narrow-mindedness of it all. I saw environmentalism as a way to open that up, open the discussion up to have new ideas. What's been disappointing is to see a new narrow-mindedness take over from the old narrow-mindedness. I think the environmental movement has become ideological, just like the people they took over from.

Betsy: Yes, drive a Prius or else.

Ed: I remember at the Sopris Foundation conference a few years ago I suggested that we need to look at nuclear power. I don't think it is a desirable choice, but compared perhaps to global climate change…but people came running up to lynch me and gave me all the reasons

why this was crazy. I know the negatives as well as they do, but there are other reasons why we might look at it.

It's as if we can sort of wish a world into being without any downside and all upside. As environmentalists we focused on the destruction that industry was doing to forests and streams and other resources, but we didn't see what we might be doing.

And it hasn't shifted. I think the environmental movement, formally defined, is still sort of looking for problems and is bureaucratic for the most part. But there have been spin-offs. At least we have the land conservancy movement. We have the Nature Conservancy. We have the watershed movement. And we have the ranchers, God bless them, who have been converted in significant numbers to being both food producers and environmentalists. Not so with logging, mining, or dam building.

The great thing about running *High Country News* was the surprises. The people you'd meet who sum up, in their lives, hopeful directions for the region. You can't dream these people up. You can't create them out of a movement or an idea. They have to bring themselves to life.

My most wonderful journalistic moment—my discovery moment—came in March 1992, when I wrote a twenty-eight-page special issue of *High Country News*. I believed it would be my last as publisher because it was so positive about ranching, and back then ranchers were villains to the environmental movement. The issue described ranchers in eastern Oregon who were attempting to improve their standard of living by marketing beef to high-end consumers. Their sales pitch was that they were producing good food while improving the health of the land.

The ranchers were led by a couple named Doc and Connie Hatfield. They had to overcome a sluggish land management bureaucracy and dedicated and hardworking environmentalists, some of whom opposed all cattle grazing and some of whom opposed the consensus and collaboration that was at the heart of the Hatfields' effort.

In the end Doc and Connie managed to fuse an environmental and an economic approach. They cared about the land, and they cared about making a living. I had wondered for years why ranchers never sold the fact that some of them really are environmentalists to the public. They would proclaim it, but always in a belligerent, screw-you kind of way. And then I discovered the Hatfields. And the Hatfields were selling the green sizzle and the red steak to consumers in a skilled way.

Betsy: What a great thing they started.

Ed: To my surprise, *HCN* readers and the board of directors took the March 23, 1992, *HCN* in stride. After the issue on Doc and Connie Hatfield, the paper's growth accelerated, and I think it diversified.

That was the evolution of the paper. You find the story. You're an experimentalist. You can have your ideas, but if you can't find them on the ground, then they're worthless.

Environmental issues do not exist in isolation. And disenfranchising ranchers, who are the leadership class in many western communities, is potentially very hazardous. They are critical to the social structure of the West. If they're gone, who replaces them as community leaders? We need to think about that carefully. Doc and Connie Hatfield were some of the first ranchers that I recognized as people, not just as symbols of the destruction of the West.

Betsy: Before we got to the Hatfields, we'd written a zillion stories about the damage cows had done to the land. But how long could we go on blaming ranchers without trying to find a workable solution?

We did stories on suburbanization, coal-bed methane. We wrote lots of stories on dams: the destructiveness of dams, the idea of draining Lake Powell. I remember calling David Brower and saying, "What do you think of the idea of draining Lake Powell?" He said, "It's a great idea."

Ed: The Hatfield story was our second big story. Our first was writer Tom Wolf's story of how Glen Canyon Dam was almost washed away in spring 1983. It was a journalistic scoop even though it came months after the event. Had the dam given way and let loose a full Lake Powell, the resulting flood would have toppled Hoover Dam also. It would have been this nation's biggest disaster ever.

Betsy: That story is where I learned what *cavitation* means, where water was going through the spillway tunnels and destroying the concrete of the dam. The whole dam shook. They could hear it. They could feel it. It came very, very close to destruction. So that was thrilling. A bad story is a good story.

Ed: The distressing thing was that for ten years after that people would say, "Do you remember that story you did on Glen Canyon Dam?" like it was last week. It was the one story people remembered. And it wasn't ideological at all. It could have gone into *The New York Times* or onto Fox News without changing a word.

I don't know if we played a large role in making environmentalism and thoughtful thinking about the West dinner table conversation. We were so tiny.

Betsy: But we talked to each other, and the choir got bigger.

Ed: I guess for part of the time we ran *HCN* we tried—I think succeeded—in helping people to look less emotionally and less ideologically at what the West was going through. We helped with the idea that people could talk to each other, and collaborate. You might have common interest where you think you don't. I used to meet environmentalists who thought I wanted to be a cowboy. I never wanted to be a cowboy or have a ranch or even admired them particularly. I admired parts of what they were, but they were them and I'm me. I believe in recognizing people and their strengths and their weaknesses. What I loved about the Hatfields and still do is that they could look at people straight without loading it up with all the bullshit.

The paper we did was a function of its time.

It wasn't Sherman's March through Georgia, and there was no Nobel Prize or even Pulitzer at the end of my career, but it was rewarding, and it saved my life. I would be dead now, literally, if I had continued to grind away at something I wasn't good at and wasn't drawn to intellectually. I needed satisfying work the way an alcoholic needs alcohol. Journalism in the West was my drink.

Ed and Betsy Marston live in Paonia, Colorado. Ed is a redeveloper of buildings in downtown Paonia. He has been an elected member of the board of Delta-Montrose Electric Association and is on the board of the Paonia Chamber of Commerce. He was a candidate for the Delta County Board of County Commissioners in the 2008 election. He is the author or editor of several

books and has a memoir in John Fielder's Colorado: 1870–2000.

Betsy is an elected school board member, on the board of the Paonia Chamber of Commerce, and works for High Country News as the editor of its "Writers on the Range" syndicate. In that position, she sends out three essays a week to sixty-plus western newspapers. She also writes a regular column, "Heard Around the West."

BILL HEDDEN
LASTING CONSERVATION

Bill is the executive director of the Grand Canyon Trust in Moab, Utah, and Flagstaff, Arizona. He has spearheaded numerous land conservation efforts across the western United States. One prominent westerner called him "the Forrest Gump of the West" for the many roles he has played in its preservation. He has worked on mineral issues, river conservation, industrial projects, recreation plans, grazing rights, and he is a woodworker on top of that. One of his pieces of furniture is in the Museum of Modern Art in New York City.

Bill lives in Castle Valley, Utah, in a once funky and now renovated and elegant home filled with his daughter Chloe's paintings and his hand-built furniture. Surrounded by red rock cliffs, the apple and plum orchards he and his wife, Eleanor, have nurtured for many years were just coming into bloom when we came to photograph Bill and visit with him for a second time. After our first visit in his office in Flagstaff, we enjoyed a long, relaxed afternoon at home with him and Eleanor.

I was finishing up my doctorate in neurobiology when I first came to Moab. I knew I didn't want to continue working in science because I didn't like killing animals every day. Eleanor is a Utah girl, and she wanted to move home and buy some land. She's a gardener and a farmer. We came to Castle Valley before really anybody else had moved here, and lived outside for two years while we got our well in and put in our gardens and orchards and built our house. I worked a variety of jobs, but all along I built furniture to support our family.

I was working construction on the Atlas Mill just as the Department of Energy [DOE] came forward with a proposal to put the nation's high-level nuclear waste dump at the entrance to Canyonlands National Park. The DOE was convincing people that the level of radiation was the same exposure as X-ray film and doctors' gloves and things like that. I knew that wasn't true, and within a month I was on the governor's task force. We were the official liaison with the DOE. One of the benefits of living in a state like Utah is that you can be involved in a hurry. That was my beginning in environmental work.

When I was a commissioner in Grand County, I started work on the Atlas tailings situation. Just as I came into office, the Nuclear Regulatory Commission came out with a finding that there was no significant impact from Atlas's plan to just cover the tailings pile on the riverbank. The tailings pile is 130 acres and contains the remains from cold war uranium production left behind when Atlas Minerals corporation filed bankruptcy in 1998 and walked away. It is the biggest uranium pile that has ever been built on the bank of a river in the United States. It is far more polluting than all the other piles built on the banks of rivers combined. The DOE has cleaned up all the other piles in its portfolio, and this was the last one.

If the tailings pile were just to be capped, it would be left there, leeching uranium into the river that supplies

drinking water for some twenty-five million people in Arizona, California, and Nevada and is spread on food crops throughout the Southwest. Downstream of the pile is Canyonlands National Park and Lake Powell, and further down, the Grand Canyon. It's unbelievable.

Finally, in 2005, the DOE announced that it would begin moving the sixteen million tons of radioactive waste on trains and carry them to a new disposal cell thirty miles away in a safe site. The cleanup will take about twenty years and cost approximately $900 million.

This is a classic story of how we chronically fail to account for the full costs of these mining and fuel cycles, and how the taxpayers end up footing the bill. I was commissioner during most of that time. The Grand Canyon Trust worked on this for nearly a decade. We never could have achieved it without literally thousands of private and institutional partners who commented on the DOE's plans and, in doing so, changed the agency's mind. The passion and creativity of citizens made our democracy work the way it is supposed to, protecting the water supply for the Southwest at the same time. I like telling this story because in the past decade the rights of Americans to participate in the decisions of their government have been under such broad assault.

The whole National Landscape Conservation System has been shortchanged. There are now some very hopeful potential answers to grazing conflicts, and yet the Bush administration did everything it could to torpedo them. The enmity of those people is beyond comprehension. They declared that there would be no Land and Water Conservation Fund money for any of the Clinton national monuments. It's very hard to overstate how bad they were with regard to the western public

lands. You might have to go back to Ulysses Grant to find somebody who was comparably bad about protecting our national heritage, and even Grant designated Yellowstone a national park.

The Grand Canyon Trust works on projects that we feel achieve lasting conservation. Basically, our mission is to protect and restore the Colorado Plateau. No hubris involved in that. We work very intensively in the adaptive management plan for the Colorado River through the Grand Canyon. We're trying to change the way Glen Canyon Dam is managed so that we restore the fish and the beaches and protect the archaeological resources. We think that if a bunch of very drastic management actions are taken, you could perhaps do those things and still leave Glen Canyon Dam in place. We have never pushed to take the dam down, but let me make it very clear that our position is that those resources have to be recovered and if we try these things and it's still not happening, then we might change that position and say, "Look, we've shown ourselves the only way to recover the ecology of the Grand Canyon is to take the dam down."

In 2000 we purchased fifty thousand acres of oil and gas leases on the Kaiparowits Plateau. We permanently retired the leases, and now those lands are protected from development. In 2004 we purchased a thirty-four-acre private inholding in the Grand Staircase–Escalante National Monument near Calf Creek.

Calf Creek is an interesting story. It wasn't grazing land, but it relates to the grazing work we are doing. Calf Creek is this surrealistically beautiful spring creek in a deep sandstone gorge. There are prehistoric ruins all along the edge and trout in the middle of the wild desert. The creek flows into the Escalante River right at the place

where Highway 12—which is a good candidate for the most scenic road in the country—crosses the Escalante River. It is the only place in the entire two-million-acre Grand Staircase–Escalante National Monument that you can actually access the river without going on a huge hiking expedition.

We purchased fifteen parcels of commercially zoned land right in the scenic heart of what is now the Grand Staircase–Escalante National Monument. It took a year and a half of negotiating and close to a million dollars, but the owners sold it to us in the end. They became convinced that this was a better deal. They loved the land; that's why they bought there in the first place.

Since then, we have been working to add a whole system of beautiful canyons to Arches National Park. All the water in the eastern half of the park is there, and all these incredibly beautiful riparian canyons. We bought the grazing permits from an old rancher who wanted out, and from that experience we developed a model of working with ranchers who want to sell their grazing permits. The park was expanded and grazing in those canyons closed.

We did the same thing in Capitol Reef National Park and Glen Canyon National Recreation Area, and we did it all along the Escalante River. Some more ranchers in the Grand Staircase came to us and wanted to sell their permits. We were working in a very good collaboration with the same people at Bureau of Land Management [BLM] who did Calf Creek with us. It was one of the most exciting things going on in the country. The ranchers were taking the money that we were giving them and they were getting out of debt and saving their ranches. Those backcountry allotments were

usually problematic to manage, but that is what made it so appealing to us. They were rugged backcountry canyons filled with biodiversity.

We're not the only ones doing this. It's being done by the Conservation Fund and the Nature Conservancy. The National Wildlife Federation has bought and retired permits in grizzly and wolf habitat.

In 2005 we partnered with the Conservation Fund and purchased Kane and Two Mile ranches, north of Grand Canyon National Park. Both ranches have tremendous ecological importance. They hold grazing permits on more than eight hundred and fifty thousand acres of public land. They will still be working ranches. We have to run cows out there, but the focus of the management will be to use it as an example of how low-level grazing that is well managed can still allow for habitat restoration projects and species diversity. This is considered the top site in the Southwest for wolf reintroduction. There are a lot of really exciting possibilities.

With the growth pressures across the West, we have an opportunity now that may never recur, to try to do some big things to rearrange land tenure in the West. In Arizona we have a literal checkerboard; every other section is state land across much of Arizona, and there's a scattering of state lands in all the western states except Nevada. That's madness for anybody trying to manage those lands. It simply doesn't work. We think the big land exchanges like we've done in Utah are a great way to protect big tracts of land. But they should be land exchanges to rearrange land tenure on a large scale before it becomes impossibly expensive to do that.

I wish we could somehow have the whole National Landscape Conservation System turn into something

positive. I'd like to get back to the idea that the BLM could really have a conservation mission. We're talking about pulling together a meeting of every living former director of the National Park Service with the hope of coming out with a ringing declaration of what the National Park System should be in the twenty-first century for America. We would follow that up and work with the Greater Yellowstone Coalition and the National Parks Conservation Association on this kind of big, inclusive vision, and work with them to achieve that vision.

Clearly human beings have got their hands all over everything, and we need to acknowledge that. The wilderness areas are tiny, and even the big ones like the Bob Marshall and the Greater Yellowstone have shown us that they don't enclose complete ecosystems. Everything is cut up into separate islands. We don't have much left that can really stand on its own, so it's going to take a lot of human involvement. I don't know that I agree with the idea that we have to be somehow using or screwing around with everything in order for it to be healthy.

In some places clearly we're dealing with almost everything having been degraded. If we can become wise enough to know how to intervene, to restore things without doing a whole lot of unintended damage, that will be valuable. But we're in a situation where we really need to protect the best of what's left and do that in an absolutely no-holds-barred way, and then start figuring out how we're going to restore functionality to the things that still can be restored.

Do I feel hopeful? It depends which day you ask me.

⸺

Since joining the staff of the Grand Canyon Trust in 1996, Bill Hedden has coordinated its activities in the canyon country of southern Utah, where he has worked on the cleanup of the radioactive uranium mill wastes near Moab, the retirement of grazing from ecologically critical areas, the creation of a directory of all conservation groups working on the Colorado Plateau, the expansion of Arches National Park in 1998, and a reform in the way Utah's state lands are managed. He was appointed executive director of the trust in April 2003. Bill is a longtime resident of Moab and member of the Nature Conservancy's Utah board and the board of the Southern Utah Wilderness Alliance. He is a nationally known furniture builder with a BA and a PhD in biology from Harvard University.

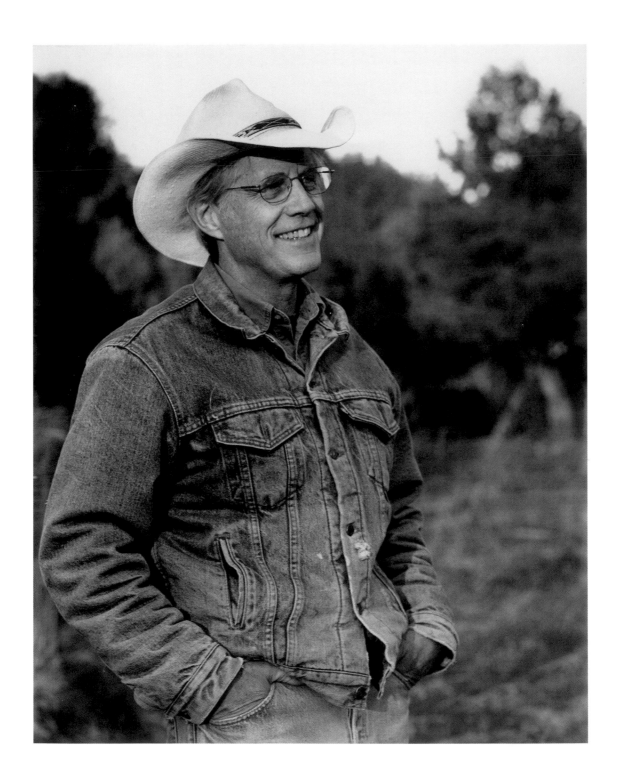

BILL DEBUYS
WRITING THE LAND AS CHARACTER

Bill deBuys is a writer and conservationist based in New Mexico. His first book, Enchantment and Exploitation: The Life and Hard Times of a New Mexico Mountain Range, *combines the cultural and natural history of northern New Mexico. His second book,* River of Traps, *was one of three finalists for the 1991 Pulitzer Prize. His third book,* Salt Dreams: Land and Water in Low-Down California, *is an environmental and social history of the land at the terminus of the Colorado River.*

We spent an afternoon and evening with Bill at his home in El Valle, sharing steaks, salad, and wine from Santa Fe. Standing by the edge of the river, Bill spoke of his adult children's newfound appreciation of the quiet spaces of El Valle. We walked the trail that frames his new book, The Walk, *a personal account of his connection with the land. His small cabin takes in the view and is free of electricity, indoor plumbing, and other modern comforts. His writing desk sits unadorned in a small corner of his bedroom. We felt lucky to experience the beauty of El Valle and what shapes this conservationist's awareness, writing, and passion for place.*

I've always been drawn to the land. As a writer I've wanted to write pieces that employ the land as a character, so that a story would have not just male and female characters, but it would also have the land as an operating force.

I came to New Mexico in 1972 as a research assistant for Dr. Robert Coles, a writer and psychiatrist looking at the lives of minority children in the region. I was freshly graduated from the University of North Carolina. A few years later I moved to the village of El Valle, where Alex Harris, the photographer with whom I wrote *River of Traps*, had already settled. In El Valle I was able to sink some roots and begin learning in earnest about the Hispanic culture of northern New Mexico. I was fortunate to find a mentor in Jacobo Romero, the eventual subject of *River of Traps*. He was my next-door neighbor and became a kind of grandfather to me, and during the time that I spent with him I was deeply immersed in his culture. One of the most important things I learned from him was the value of *place*. I'm not of northern New Mexico, but I've been here a long time now and my experience living and working with my neighbors in El Valle really changed the way I saw the world.

The farm in El Valle is my home. For years I spent my summers irrigating the pastures and helping my neighbors with their cattle and other farm chores. The casita my ex-wife and I built on our farm is not much to look at, but it is the home of my heart. More recently I built a larger house (with indoor plumbing!), which is now my primary residence.

When we bought the farm in El Valle, my neighbor Tomás came to me one day and said, "Now that you have a rancho, you have to have a horse. I want you to buy my horse." In fact, I bought his horse (for $200), and riding that horse over these hills became my introduction to forestry and land management. Because I was looking at

the land close up, I began asking questions about it.

I moved to Santa Fe in the eighties to earn my keep working in land and water conservation. Through the late eighties, the battle over who should control the use and future of public lands was getting more and more heated. Finally, on November 22, 1995, because of controversy over the La Manga timber sale on the Carson National Forest, a crowd of northern New Mexico loggers and ranchers hanged two environmentalists in effigy. It seemed like worse violence was sure to come. The environmentalists were saying the people living on the land didn't understand it and didn't know how to use it, that they were cutting too much timber and grazing too much forage. The people who were on the land, mainly Hispanos in northern New Mexico, were saying that the environmentalists had just gotten off the bus and they didn't know anything about the land, let alone the culture, and that they had no right to be speaking about it this way and interfering with people's livelihoods.

Meanwhile, as an environmental historian, I was aware of big changes in the landscape—the land as a character in the story again. It wasn't just a frozen stage on which the guys in black hats and white hats fought each other over what was going on. The land itself was changing. There was one datum of particular significance. A good friend and colleague, Craig Allen, with the US Geological Survey, had done his PhD dissertation on landscape changes in the Jemez Mountains. He found that between the mid-1930s and the mid-1980s, those mountains lost 55 percent of the grassy element in their landscape. The same was probably true for the rest of the region.

The ranchers and the environmentalists were fighting each other as though they were the only entities that mattered, and they were deaf to what the land was saying. What people ought to be doing, in my view, was get together and talk about how to work with the dynamics of the land. Why was the land changing? One of the biggest factors was the elimination of fire. Without fire, the density of woody plants on the landscape—shrubs like sagebrush, big trees like ponderosa, and little trees like piñon and juniper—was increasing and the grass was dying. Grass loves fire, and most of the landscapes of northern New Mexico are renewed by fire. If they don't burn regularly, they'll blow up into the destructive crown fires we've seen more and more frequently in recent years.

That is where the grass bank came in. I thought, "What if we could have a ranch where we could put cattle and take care of them while the places where the cattle normally graze are rehabilitated?" By rehabilitation, I mean get fire back into those landscapes and renew the vegetation, leaving it less woody and more grassy. At the same time, people like Warner Glenn, Bill McDonald, and Drum Hadley down at the Gray Ranch and in the Malpai Borderlands Group were starting grass banking. It was Drum Hadley who coined the term. It is a wonderful way to keep people ranching while bartering grazing land for restoration.

Some colleagues and I decided to organize what became the Valle Grande Grass Bank in northern New Mexico. We specifically wanted to help Hispanic ranchers because we recognized that this area is the home of the longest and deepest ranching tradition in America north of Mexico. Ours was a public-lands grass bank, which makes a lot of sense hereabouts because most of the small Hispanic ranchers don't have significant private

land. They might have anywhere from five to fifty acres of private land, but most of their range is public land, so what we tried to do was to rest and rehabilitate the Forest Service land that they put their cows on. Sometimes we would relocate a road or build a stock watering tank or put in a new fence, but mainly we used thinning and fire.

A lot of knowledge is stored up in indigenous cultures throughout the world. One of Western Anglo culture's biggest problems is the presumption that its views are consistently correct and that those of indigenous cultures are commensurately wrong. Such arrogance is dangerous. For example, if you look at the history of fire suppression, the first generations of mainstream American forest managers were absolutely sure that it was the right thing to get fire out of forests. But ecologically, that is blatantly wrong. If white Western culture had been humble enough to look at native practices, be they in New Zealand, Hawaii, the jungles of the Amazon, or [practices of] the Ute, Paiute, and Apache of the Americas, and at least give them due consideration, and if we had opened our eyes and ears enough to appreciate the land more fully, we might have avoided some of the mess we're in now.

The West, in many ways, is the most diverse part of the United States. It is a laboratory of diversity, and nowhere more than in New Mexico, where you have Mexicanos—folks recently arrived from the south—plus the longtime Hispanos of the region whose ancestors were here centuries ago, plus many Indian tribes, plus the great potpourri that we call Anglo. I think of this area as a kiln where the soul of the New West is being baked, and we have to hope that the ingredients will blend harmoniously.

Are we going to have an indigenous, place-informed culture, a West that embraces its inherent diversity? Or is the West going to be just another expression of the generic, land-consuming, television-defined mass-culture society? If you go to Phoenix and drive those miles and miles of monotone junked-up avenues, is that the West? Well, yes, it is. That's part of the West, but that's the part of the West that isn't place-based and is, to my way of thinking, pretty bleak.

I don't think we can have a West that really works unless it is a West that reveres the beauty and the strength of the land. Here we are in arguably one of the most beautiful regions on the planet, and if society doesn't rally to that beauty, doesn't ground itself in a sense of loyalty to that beauty and to that strength of place, then we are destined to a dreary kind of soulessness.

———

One of the country's premier nature writers, Bill deBuys is revered for his compassionate, clarifying prose. Bill teaches documentary studies at the College of Santa Fe. He helped found the Valle Grande Grass Bank and for many years worked for the Conservation Fund, the Nature Conservancy, and other land conservation groups. From 2001 to 2005 he chaired the Valles Caldera Trust. He is the author of six books, Enchantment and Exploitation, River of Traps, Salt Dreams, Seeing Things Whole, Valles Caldera, *and* The Walk, *and received a Guggenheim fellowship in 2008. On the threat of human-induced climate change, Bill suggests these four points as the start of an arid lands credo: love the desert, pray for rain, learn to be happy with less, and save the rivers.*

PATRICIA NELSON LIMERICK
GOING TOE-TO-TOE WITH WESTERN MYTHS

Patricia Nelson Limerick is head of the Center of the American West (CAW) at the University of Colorado. She is a western historian best known for her 1987 book The Legacy of Conquest *and her myth-busting persona. Nowadays, however, she prefers to listen to—rather than challenge—her adversaries and together search for common ground to solutions for today's West.*

We met with Patty at the University of Colorado campus in Boulder. She is quirky and witty and thrives on the interactions she has with students, who reciprocate with jokes and admiration. Her husband, architect Jeff Limerick, had recently passed away, and her grieving initiated long walks. This led her to intentional weight loss, or what she calls the Patty Limerick Pedestrian Diet and Exercise Plan. She enjoyed showing off her slender new body and western wardrobe to go with it. On November 4, 2008, she married longtime friend Houston Kempton.

I graduated from Yale with a PhD in history in 1980. I was twenty-nine. During an interview for a teaching position at Harvard, somebody asked me how I would teach western American history in a fresh way. I told them—as if this were going to be easy—that I would just reverse the accent and the emphasis. Instead of giving all the attention to white men going West, I would look at what numerically is probably more significant: the Indian people, the Mexican people—the people who were already there. I think I probably also said, "I will focus on the impacts settlers had on land, nature, and wildlife."

When I started teaching American history at Harvard I realized, "Oh, this is harder than I thought."

In 1981 I was invited to the Sun Valley conference on the American West. I think it was my very first speaking engagement. The day before I was to speak I was listening to people from the Bureau of Land Management [BLM], the oil and gas industry, and a guy from Arco talk about boomtowns and a new surge of men drinking and fighting and engaging in domestic violence. They were talking about these things like they came out of the energy boom—remember the energy boom was still kind of cooking along at this point. I'm thinking, "Guys, guys, these problems came from the mining towns of the nineteenth century, and the gold rush. This is the oldest story around."

My first thought was that they should read some western history. Then I started thinking that if they read western history, they would still be very misinformed. Western history at that time said that the frontier ended in 1890 and all the nineteenth-century problems were over, that now we were a different kind of region, in fact we weren't a region at all, we were just a part of the United States—interchangeable.

I gave my talk the next morning, and it was something along the order of, "Someone should write a book connecting the patterns between nineteenth-century and twentieth-century events." And all of a sudden, I was set

with the task of writing this book. Which of course followed soon after my declaration at Harvard that I was going to reverse the emphasis.

I wrote *Legacy of Conquest* after I moved to Boulder, Colorado, between 1984 and '86. I had not realized how important it was that I was not living in Cambridge, Massachusetts, when I wrote the book. To have this book come out of Colorado was so much better than a Harvard woman telling westerners about their history.

It was a different kind of history book because it talked about Indians and Mexicans and Asian and African American people and it was put together in a distinctive and humorous writing voice, which is quite unusual for an academic. After a while the book caught on, and with the work of many others behind this, western history began to take off.

Before the book was published, the Western History Association had shrunk to a couple of hundred people, many of them quite elderly. Then with all the new attention to the West and western history, the attendance grew to between twelve hundred and thirteen hundred members. Still, the book was very controversial and hotly debated. One poor soul told a reporter that I needed to be sent back to Russia.

I can't deny that I enjoyed all the debates about the book. I loved the adrenaline. Somehow the fun of public dispute overtook me. I used to use the word *idiocy* all the time, making fun of other historians. But, with the rarest of exceptions, I made some sort of peace with my critics over the next decade. I became president of the Western History Association much sooner than I ever expected. I had won. Of course, not everybody conceded that.

I began receiving invitations to speak to unusual groups that I would never have expected to want to hear from me: the BLM, ranchers, cowboys, environmental activists; it was very humbling. It was scary because they thought I could help them. I had an amazing set of experiences outside of the University. People responded with warmth and openness to me.

I must say, given the behavior of academics, that it's a weird world when I'm proposing that academics might be able to be part of the solution to the difficulties facing the West. It is wonderful to see how receptive people outside the University are to the academic perspective when it happens. Unfortunately, though, I think the future of academic history may be going off a little bit of a cliff. The regular academic history thing, where you just do your independent, individualistic research project and write it up in jargonized, theoretical language and have a review by other historians (and sometimes literally there are somewhere short of one hundred people who actually read a professor's stuff), is really sad. That is a melancholy situation, and most graduate training programs are replicating that. I'd like to see a lot more involvement with the public and a lot more clarity of language. A willingness to pay attention to what is happening outside the University. I love the profession of history, and I hope that our work at the center shows some of the promise and possibility of the future practice of history.

I believe that it is our competitive advantage at Center of the American West to have history as a principal card we play. We published *The Atlas of the New West* in 1997 as a way to celebrate the West as a region and also to explore the changes it had been undergoing. Now

we're working on the *Handbook for New Westerners*, sort of an owner's manual or operator's manual to the West. Maybe a little bit like the *Preppy Handbook*: something that will invite westerners to be better citizens.

We did a report, *What Every Westerner Should Know about Energy Efficiency and Conservation: A Guide to a New Relationship*. After doing that report, we decided to make a documentary film. It is called *Living with Energy*. It looks at different forms of energy use, but with a different tone than other films. What came out of an energy conversation at CAW was that energy efficiency and conservation are just not sexy topics. After several lamentations we decided we'd just go ahead and make it sexy.

The film starts out with me playing a marriage counselor. My opening line is "I may not know your name, but I already know one pretty private thing about you. I know that you've been involved in a tempestuous relationship pursuing a mad romance with fossil fuel, and it is time to move on to a better relationship."

The film develops this curious erotic metaphor, which of course is not our creation—thousands of people have referred to Americans' love affair with fossil fuels and our romance with petroleum. We just take that a little more literally than most people. I play a turn-of-the century (1900s) industrial worker. I play a pioneer woman, and with the wonders of digital manipulation, I can be plunked down in historic photographs so that I am standing right next to the pioneers.

In the film we're continually trying to say, "This is where we came from." Nobody can insist that life was uninterruptedly great before fossil fuel. Anybody who says that is suffering from serious memory deficit.

We use the Old West to remind people what life before fossil fuels was like. We don't cast modernization as a calamitous fall out of Eden. There is no point in pointing fingers or blaming each other for the circumstances of our fossil fuel use.

It is a very desperate symptom when a person can't remember who he is or where he came from or how he got where he is. I always say that amnesia is not good in an individual human being. You get rushed to the emergency room for that. And when society has the same problem, it is really dire. Historians are here to counter a very widespread case of amnesia.

One of the most exciting things at CAW in the past years is the visit to campus by nearly all of the living secretaries of the interior. We wanted to take a presence that is huge in shaping the West, past and present, which can seem like a massive bureaucracy if you don't humanize it, and bring these officials to campus and ask them questions about all kinds of things. There is absolutely no better way to see the changing attitudes toward nature in the United States than to watch what happened in both the practices of and the pressures on the Department of the Interior. We are now putting our thoughts about Interior together in a book that will draw from these interviews.

I have an extensive track record when it comes to attacking western myths and pleading with westerners to dump the myths and face up to reality. For the better part of a decade, I could not imagine anything more fun than going toe-to-toe with piously received, widely believed, and deferentially accepted western myths. When we decided to do the secretaries of the interior program, I started talking with James Watt. I remember

thinking, "Okay, I have strong opinions about him and his record." The old me would have gone head-to-head with him. But then I thought, "I have an unbelievable chance to talk to a person whose name is legendary and to ask him questions." That sobered me up in an instant. I don't think that most historians have had the chance to realize as I have what this means in practice. Many historians, as I was myself, are knee-jerk liberal, 1960s flashback, now-middle-aged kids. But it's not the 1960s anymore. I'm sad about that, but historians are supposed to change over time.

———◆———

Patty Limerick is the faculty director and chair of the board of the Center of the American West at the University of Colorado, where she is also a professor of history. Patty has dedicated her career to bridging the gap between academics and the general public and to demonstrating the benefits of applying historical perspective to contemporary dilemmas and conflicts. Under her leadership, the Center of the American West serves as a forum committed to the civil, respectful, problem-solving exploration of important, often contentious public issues. In an era of political polarization and contention, the center strives to bring out "the better angels of our nature" by appealing to our common loyalties and hopes as westerners.

Patty has received a number of awards and honors, including the MacArthur Fellowship (1995 to 2000) and the Hazel Barnes Prize, the University of Colorado's highest award for teaching and research (2001). She has served as president of several professional organizations, advised documentary and film projects, and done two tours as a Pulitzer nonfiction jurist. She regularly engages the public on the op-ed pages of local and national newspapers, and in the summer of 2005 she served as a guest columnist for The New York Times.

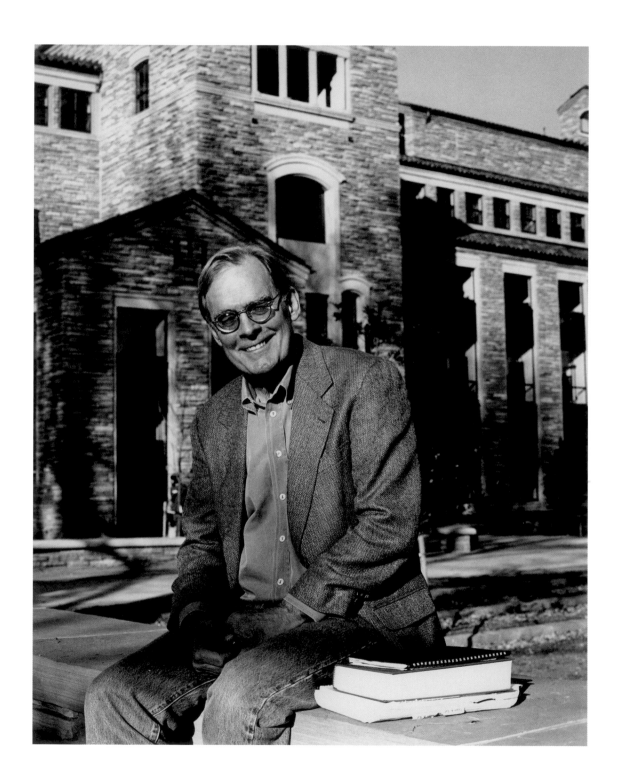

CHARLES WILKINSON
THE NEW WEST NEVER HAPPENED

Charles Wilkinson seems to know more about the West than anyone. We first heard him speak at the Headwaters conference in Gunnison, Colorado, and eventually spent an afternoon with him at the Wolf Law Building on the University of Colorado at Boulder campus. He works in a light-filled room that contains a large desk with no computer—an unusual sight these days. Charles spoke eloquently about so many important issues in the West today: Indian affairs; the state of the US Forest Service; population growth, urbanization, and development; watersheds, dams, and rivers; energy and sustainability; and more. We could fill the entire book with his words, but since that isn't our aim, we chose to include his thoughts on growth and development in the West.

One thing that grows on a person over time is wildness. Each year wildness has meant more to me. There is a canyon in southern Utah that drapes off Cedar Mesa. I have been an activist, but I have never particularly engaged in demonstrations or resistance. I don't know exactly why that is, but I just never have. But this canyon made me realize that I am capable of action. This canyon has sheer red rock sides. It's full of piñon and juniper trees. They've taken the cattle out, and now the sedges and willows are starting to come back in the canyon bottom. It has ancient pictographs, and hardly anybody goes there.

I've been there with all three of my sons, and their voices are every bit as much a part of those walls as the pictographs. If someone tried to dam that canyon, I could imagine chaining myself to a rock or a tree or standing in front of a bulldozer and fighting back. I've never had that emotion before. Having been down there a number of times, I realize that specific place has helped me understand myself better, and how I feel about wildness, and right and wrong.

One of the greatest gifts that anybody has ever given the West is Ed Abbey's gift of teaching us how to love the desert. *Desert* has always been a pejorative term. The desert is vacant country. It's sterile country. It's useless country. It's throwaway country. And Abbey, through all his craziness—which has plenty of worth in itself, just take a look at his prose—is really why we have a California Desert Protection Act. Abbey caused people from Denver to Los Angeles and from Japan to France to love the desert. It is almost humorous that there are still people who don't understand that in time almost all of southern Utah is going to be wilderness. It's not coming on real fast, but it's going to happen. It's just a matter of time. It's Ed Abbey who made that inevitable and, God, I thank him for that.

I was in Moab in the spring and I noticed that almost every car in the parking lot was a Colorado car. Later I was in town talking with somebody on the street who casually asked me where I was from. I told him Boulder,

Colorado. "Yeah," he smiled and said, "this is the time of year when the license plates turn green."

I can't talk about recreation and our impacts without talking about population growth. We're really afraid to address population growth. It's not a polite subject. We can't talk about it civilly, so we don't talk about it, and yet everybody in the West knows it's our biggest problem. When I give talks to ranchers, university students, farmers, it doesn't matter who, almost everybody raises his hand when I ask who believes that population growth is a serious problem. We need to dare to talk about it, and we need to talk about it in a loving way. My concern about growth is borne out of compassion, not out of anger and selfishness and wanting to close the gate behind me.

We fear for the West and the impact that population growth is having on our open space. The West has grown four times over since World War II. We've gone from seventeen million to nearly seventy million. We see megalopolises building up on the Front Range of Colorado; the Wasatch Front in Utah; Sun Valley, Idaho; Las Vegas; and on from San Diego to Santa Barbara. We are not just overrunning those areas individually, we're overrunning the entire intermountain West. The trails are more crowded; all our favorite places are more crowded. We're tearing up the ground more. I believe in being able to use off-road vehicles and trail bikes in the right places, but it should be limited to the right places. Right now we're not showing restraint. We're squeezing the westernness out of our way of life.

We've become too fast and too impersonal and too crowded and too jammed up and too stressed. Not that I know what to do about it, but we ought to talk about it. Have visioning sessions in communities that end up in land-use plans that limit population growth. I believe in having building moratoriums under the right circumstances so we can step back and implement those plans. I think people in the communities want it to be that way. It's not that we're trying to shut people out; we're trying to do what the land can take. We're trying to find true sustainability, with sustainability having a real human meaning. We want to sustain a society where it doesn't take forty minutes to drive six miles across town or where the schools are overcrowded and underfunded because there is no tax base, which is happening all over the rural West.

Where do you want to smell the sagebrush? It's okay to recognize that the smell of sagebrush is not an amenity, it's not quality of life, it's part of what helps us fulfill our humanity. You go out to Craig, Colorado, on the Western Slope, and in most of town you can smell sagebrush. But along the Front Range you can't. You used to be able to. We shouldn't shy away from recognizing that kind of loss or the loss of the long vistas. Those are part of what we need to be fully human.

⸺ ⸺

The term *the New West* was a little easier to understand when it started being used, around the 1980s. The New West was about a lighter consciousness, a more environmental, more preservation-oriented approach toward the West. It partly came out of Wallace Stegner's maxim "We need a society to match our scenery." People were noticing that the mining companies had gone too far, the big irrigators were overusing the water supply, we'd built too many reservoirs and were taking much too

much timber out of the national forest. There was a sense that traditional western towns had a hard edge and that those communities tended to be bristly toward outsiders. I think there was a hope that we could save the community but that new people could move in without it becoming contentious.

What has happened since then is that we've been overrun. The new population has not respected the land or the communities and has not searched for a slower way of life. Instead, they've searched for a place to get rich. Though we've always had that in the West, the new people didn't bring a love for the land, they brought a love for subdivisions and making money off subdivisions. Every drop of water we develop goes to subdivisions or to golf courses. The subdivision plans are drawn up all the way from Fort Collins to south of Colorado Springs. So what has happened in the West since the 1980s is not what people had in mind by the phrase *the New West*. Something different happened. We got overrun by developers.

And not just builders. Look at the raucousness and speed with which the Bush administration gave out oil and gas leases. They could hardly approve them fast enough. The West isn't a place where you just put in oil and gas wells everywhere there's an oil and gas pool. At least the New West would have said that isn't what you do. It isn't that you don't ever drill wells, it's just that you don't punch them in wherever the hell Union Oil, or whatever oil company, wants to. So in a sense *the New West* is a term that was very idealistic in the late 1970s and 1980s. It was really a hope for a new and better West that didn't happen. The West isn't dead, but the New West, that isn't what happened.

Fortunately, there really is a large number of people now who see themselves as citizens of the West, who care about it, and are idealistic about it, and are willing to sacrifice for it, although right now—at least in the short term—the developers are winning. But that citizenry is there, and they see more than making money in the West. This is a tough period right now. It's not just what the Bush administration did. It's also heavy development in the cities and many parts of the inland West.

There has to be corporate leadership. I think that's realistic, because corporations are more progressive today than ever before. I suppose the building community is more progressive, but to be progressive they've got to scale back. I'll give an example. There's a building code called LEED: Leadership in Energy and Environmental Design. The LEED rating system addresses energy and water use, indoor air quality, materials, siting, innovation, and design.

If you build according to LEED standards, you can either get platinum, silver, or gold LEED certified. The University of Colorado at Boulder built a new law school. [It is] one of the first university buildings to be LEED certified, and [the process] is rigorous. You get points for recycling all of your building waste instead of sending it to the dump. That includes reusing the soil. It includes how many bicycle rack stalls and how many showers we build, so people who bike in will be able to shower. You get points for using products from within a hundred and fifty mile radius. Our new law school has more natural interior light and is very efficient. I think that a lot of corporations, businesses, and schools are doing this.

Parallel to that is a citizenry that is much more educated about the region and about the wonders of the region. We know much more about the West than we

ever have. We know much more about its history. We know much more about its weaknesses and its strengths. We know what we have to lose and what we have to gain. This is a place to love, and we love it more than ever and we feel for it more than ever. But we've got to have a certain level of anger and resentment and determination to not quit on it.

———•·•·•———

Charles Wilkinson is the Moses Lasky Professor of Law and Distinguished University Professor at the University of Colorado. He is a former staff attorney with the Native American Rights Fund and is considered one of the West's leading authorities on natural resource law. He has written fourteen books, including The Eagle Bird: Mapping a New West *and* Fire on the Plateau: Conflict and Endurance in the American Southwest. *He won the Colorado Book Award for* Messages from Frank's Landing, *a profile of Billy Frank Jr. of the Nisqually tribe of western Washington. In his latest book,* Blood Struggle: The Rise of Modern Indian Nations, *he poses what he calls "the most fundamental question of all: Can the Indian voice endure?" He continues to write extensively on the American West.*

TERRY TEMPEST WILLIAMS
LEADING LIVES OF GREATER INTENTION

Author Terry Tempest Williams is a voice of empathy and protest in the American West. She is known for her opposition to drilling in the Arctic National Wildlife Refuge and stripping Utah's red rock wilderness of its protections. While steadfast in her resistance, her compassion for human beings and the natural world has made her one of the most eloquent voices in today's West. In a PBS documentary she stated, "I think the real story of the West is the story of spirit and of challenge. The challenge is to live and love with a broken heart."

We spent a day with Terry at her home in Castle Valley, Utah. Late in the afternoon we hiked into a favorite desert canyon to look at ancient petroglyphs. She showed us the only owl she has ever seen depicted by the Anasazi. To her, the owl symbolizes the feminine and enduring wisdom of the wilderness.

The balance between the writing, the activism, and the private life? They're all part of a piece. I look at my life as concentric circles, and it's breathing. I think that's the metaphor for me. You breathe in. You breathe out. You go in. You go out. It's public. It's private. It's action. It's stillness. What could seem to be oppositional to me is actually conversational. One informs the other. It's as much about engagement as it is about balance, and different times demand or ask for a different form of engagement. But it's all centered around a love of place, a commitment to community and beauty. Finding beauty

in a broken world is creating beauty in the world we find.

For me, a sense of place starts with family. Growing up in Utah, my family's business was laying pipe: natural-gas lines, water lines, sewage lines, and telephone cables. My great-grandfather John Henry Tempest started the business, and then it went to my grandfather John Henry Tempest Jr., and then my father, John Henry Tempest III. He passed it on to my brother Steve. The family business was always about working the land. Although it may not be ranching or farming, ours is another part of the tradition of the American West: growth and expansion, the creation of infrastructure, underground. Our business was predicated on weather and rock and what kind of substrate we were going to be digging in. My father is very proud of the scars along the mountains where natural gas lines have gone in so people can heat their homes.

One of the paradoxes is that I don't know anyone who loves the West more than our family does. It makes for interesting dynamics when your family is part of what could be construed as the exploitation of the West. But my father doesn't see it that way, and neither did my brother. Nor did my grandfather or great-grandfather. They see themselves as part of the progress of the West.

There is no question the lens that I see the world through is Mormon. Five generations. My husband Brooke's family has even stronger ties: Brigham Young is his great-great-grandfather. We were raised on Mormon stories. It is a patriarchal religion, and a woman's voice is a voice that is honored in the home with children. It's not

necessarily a voice that speaks to power and certainly not a disruptive voice. To go against that mind-set is not easy, especially for women. But it's changing. I am changing. The women in the church are changing. My nieces are not afraid to speak out if they see injustices. And their actions are much braver than mine. Callie is an attorney. Sara just returned from India, having worked in an orphanage, and Diane is interested in medicine.

Writing the essay "The Clan of One-Breasted Women" was a turning point for me. I remember the sentence "Blind obedience in the name of religion or patriotism ultimately takes our lives." That was a terrifying sentence to write. But I had just become aware of the full extent of the radioactive fallout that had rained down on Utah and its consequences. The United States government conducted aboveground atomic testing in Nevada between 1951 and 1962. My mother had recently died of breast cancer, and seven other women in my family were dead from cancer. I was forever changed by that sentence because not only did I cross a line metaphorically, I crossed a line physically, committing civil disobedience at the Nevada Test Site.

I never imagined that I would cross the line at a nuclear test site. I had no intention of being arrested, but I know that when we look at different movements around this country, whether it's the civil rights movement or issues of Indian sovereignty, social change at times requires disrupting the status quo. That's what activism is, creating a disruption of thinking through action.

I may be viewed by some in the American West and certainly in this country as a strident environmentalist, and I suppose I am. My activism stems from the heartbreak that I've seen in my family. With my brother Steve's death from lymphoma in January 2005, I see the next generation of downwinders who are carrying this nuclear legacy in their body. He was among five young men diagnosed with cancer in his neighborhood in Salt Lake City. Here again is the paradox of Utah. Former congressman Chris Cannon advocated that we initiate nuclear testing again. He said nuclear fallout is not a problem. That is beyond my comprehension when his family is carrying the same legacy as mine.

When you lose a parent, there's a part of you that is orphaned. Losing a sibling—Steve and I were so close, we were less than two years apart—I feel that half of me was buried. I think the gift of Steve's passing has been an awareness of the importance of being fully present, of telling the truth, of spending time with those we love and focusing on what matters, not what doesn't, and deciding what you say yes to, what you say no to. In a word, priorities.

One of the things Steve said to me in those last days was, "Ter, I'm so grateful we've had this time." I just thought, "What else is there? What else is there but time and space?"

And in the American West we have so much space, and we're squandering it. This red rock landscape in Castle Valley is an easy reminder of that. This is what I love about the West. You can't take yourself very seriously in the midst of a vast erosional landscape. On some level, we realize we're so insignificant because the country is so big. There is both humor and humility in this awareness. They're tightly connected. How pompous can you be when the wind is railing against you or the Colorado River is rising or a flash flood is threatening your home? This is big, dynamic country that yields powerful

perspectives. I think it makes us feel very, very small and very, very grateful to be here.

I think about activism in terms of the land. The extraction of oil and gas on fragile desert lands is inappropriate and astonishing. There are larger values here that have to do with majesty and awe and beauty and reverence, which those of us living in the American West recognize as fuel for our spirits. I can't believe what we're seeing in our lifetime. How the West is filling up and what is happening now in terms of the extraction industry. It's not that I am against oil and gas development. I am not. Our family has benefited from this industry. What I am against is the scale, the scope, and the rapidity of its development at the expense of community, both human and wild.

We are in a time of great transition. How are we going to respond? With collaborative thinking and creativity? Or fear and withdrawal?

I don't think we can take on the world. I don't think we can even take on this country, but I think we can work within our own communities. I find strength in this. The American West is made up of small communities, and we do talk to each other across the state boundaries and across county lines, and I think we inspire one another. That is the tack that I trust when the winds of change are blowing. We also have to ask the questions. I'm not sure we have the answers, but I think we can ask the questions.

How do we live lives of greater intention, and how do we do that together?

When you ask, "What do I fear?" It's the abstract I fear. I don't fear the specific, because we see it, we face it, we know it. A community is not abstract. Land is not abstract. But these big concepts like Freedom, Patriotism,

Capitalism, and the War on Terror, these are abstractions. I think abstractions create mob mentality, and that's really frightening. You know, when you read about the root causes of genocide in Rwanda, it was in so many ways about land and prejudice predicated by decades of colonial rule. The history of Indian people in this country is not dissimilar: it is based on abstractions and being fearful of Other. We are fearful of Other. Land, greed, and cruelty intersect. People become expendable. I think when we embrace community, Other is us. We're forced sometimes, forced is the right word, into relationship. When you're in relationship, there's engagement, and I believe engagement ultimately opens our hearts.

I think that if we're interested in the evolution of our spirit, a revolution of the spirit, it requires both love and criticism. I think we can have both, if we stand our ground in the places we love together, creating unusual partnerships, forge new terrain and new territory that hasn't been tried before. When I sink into despair, I become aware of the limitation of my own imagination. When imaginations are shared, collaboration is created. When collaboration is formed, community arises, and in community I think there is tremendous hope.

I'll never forget when Ed Abbey came to the University of Utah and we passed around somebody's hiking boot and raised money for the Utah Wilderness Association. That was in 1979, ten-plus years after *Desert Solitaire* was published, which was a watershed book, in the same way Rachel Carson's *Silent Spring* opened a new way of thinking in 1962. It is interesting when you talk to different students in different colleges, the history they have is so short. Suddenly, we as writers find ourselves as amateur historians sharing stories of individuals with

them, like César Chávez and the migrant farmworkers, or stories of Rachel Carson or Ed Abbey.

There is a tremendous history in this country of courage and bravery and dissent. I am inspired by people like John Lewis. He was one of the first individuals to cross the bridge at Selma, Alabama, in what he calls "an immoveable line." He walked across that bridge to secure the voting rights of African American people in 1965. He was beaten and as he felt his skull crack open he thought, "I will not die if I can just establish eye contact with this fellow human being." He wiped the blood covering his eyes just long enough to make contact with his attacker, and the man stopped beating him.

I believe that storytelling holds great power. It's not in the politics. I have tried to write political pieces. After September 11 I did nothing but write for newspapers and write diatribes, political treatises, op-ed pieces, trying to engage in the conversation, trying to be part of the resistance. I don't think I made any difference, but I think stories do.

I think we can be compassionate in our listening and we can also be fierce in what we ask for. For me, it's always about conversations.

I have this recurrent dream. It is such a revelation and it's so obvious and so simple. I am standing on the edge of our porch looking out over Castle Rock and Adobe Mesa, this amazing expanse. The scene is absolutely apocalyptic: thumper trucks, George Bush and Dick Cheney themselves out there with chain saws in their hands. Laura Bush said that if her husband had his way he'd cut down everything. I think that was the impetus of the dream. So there is George Bush with his chain saw. Black helicopters are buzzing around. The background is a rock, it is the interior West, it is the Arctic National Wildlife Refuge, it is everything right outside my door. And I think, "There's nothing to be done. There is a horrendous nightmare right in our backyard, and nothing can stop it."

Then I feel a person tap my shoulder. I turn around and my dear friend Laura Simms, a storyteller from New York City, says, "Terry, I've been in your house. I've looked everywhere and there's no sign of the storyteller. You've hidden her. Where have you hidden her? Is she in your closet? Is she in the basement? I think you need to go retrieve and revive the storyteller."

For me personally right now, I want to go back to the stories. I want to go back to the really deep stories that bypass rhetoric and pierce the heart and remind us what makes us human rather than what allows us to be in the shadow dance with one another. I think that's how we've always communicated as human beings, through conversations, through listening, through stories. I think we have to search for what is essential and strip away what isn't. It's easy to forget when you feel like everything is under siege, but I think we have to take a step back, breathe, and listen.

⸱⸱⸱⸱⸱

Terry Tempest Williams has been called "a citizen writer," a writer who speaks out eloquently on behalf of an ethical stance toward life. A naturalist and fierce advocate for freedom of speech, she has consistently shown us how environmental issues are social issues that ultimately become matters of justice. "So here is my question," she asks. "What might a different kind of power look like, feel like, and can power be redistributed equitably even beyond our own species?"

Terry, like her writing, cannot be categorized. She has served time in jail for acts of civil disobedience, testified before Congress on women's health issues, been a guest at the White House, camped in remote Utah and Alaskan wildernesses, and worked as "a barefoot artist" in Rwanda, practicing the arts to bring healing, self-empowerment, and social change to poor communities.

Terry is the author of the environmental literature classics Refuge: An Unnatural History of Family and Place; Leap; Red: Passion and Patience in the Desert; *and* The Open Space of Democracy. *Her new book,* Finding Beauty in a Broken World, *was published in 2008.*

In 2006 Terry received the Robert Marshall Award from The Wilderness Society, their highest honor given to an American citizen. She also received the Distinguished Achievement Award from the Western American Literature Association and the Wallace Stegner Award, given by the Center of the American West. She is the recipient of a Lannan Literary Fellowship and a John Simon Guggenheim Fellowship in creative nonfiction.

She is currently the Annie Clark Tanner Scholar in Environmental Humanities at the University of Utah and divides her time between Castle Valley, Utah, and Moose, Wyoming.

ROUSING THE PEOPLE

These people use a particular medium to arouse and inform others of the causes that fuel their passions. John McBride runs the Sopris Foundation, and in 2007 produced a movie, *Nobody's Home*, as a warning call to small communities to put zoning in place in order to halt resort-style development and towns filled with second homes. Bruce Gordon is a pilot who uses aerial photography to help publicize the environmental destruction he sees from the air. He allows flight to persuade teenagers to become activists. Charris Ford also reaches out to teens; with his knack for rapping, he crafts lyrics that extol the virtues of sustainability. Jon Marvel is an audacious rebel who enlightens people about the degradation of our public lands by livestock. John Fielder takes a different tack. He photographs the landscape to remind people how pristine Colorado is, hoping his viewers will gain a sense of stewardship from his art.

JOHN MCBRIDE
WAKE UP IN THE ROCKY MOUNTAIN WEST

As the photograph of John McBride and his wife, Laurie, on Utah's White Rim Trail suggests, John gives as much of himself to playing as he does to community service. Because of his exhaustive scope of intellectual curiosity and passion for positive change, we held three interviews with John to keep abreast of his latest ventures. He and Laurie, along with their three children and five grand-children, run the ABC Foundation, a family charity that gives to myriad causes, from wildlife and land preservation to women's rights and family planning. He also runs the Sopris Foundation, a small think tank outside Aspen, Colorado, that brainstorms solutions for towns and communities in the intermountain West.

My vision of the West is that all people here would one day wake up to really see the magnificence of their home. I wish they would feel more passionate about it and be less committed to the American frontier mentality and the attitude that we can all do whatever we want, when we want.

When people have a deep love for place, it's a magnificent thing.

I moved to Colorado almost fifty years ago; the landscape was beyond comparison. The mountains, spectacular valleys, and compact little rural towns at the end of winding two-lane roads surpassed even postcard Switzerland. There were more cows than people. Many of the people came from longtime ranching families, some descendants of early homesteaders. All were deeply committed and rooted to their place. I became one of the ranching families. Granted, I wasn't a homesteader, but I put down roots here. We now have three generations of McBrides living on our ranch.

Today, on the surface, some places look the same. But they are not. Those wonderful faces and strong hands are going, and they are not being replaced. Some ranches may look the same, but the families that made them what they are, generation after generation, are leaving.

Unfortunately, state and federal governments are catalysts for this change. In Colorado, State Senate Bill 35 effectively zones the whole state "rural subdivision" by allowing one house per every thirty-five acres. With this as the state's default zoning, large, intact agricultural zones are threatened, and the road is paved (and plumbed and serviced) for exurbia.

Thirty-five-acre zoning initiates a domino effect: rural subdivision zoning escalates legitimate ranches' value since land appraisals are issued for "highest and best use." There are unintended, detrimental consequences: ranch land (especially near resorts) is valued way higher than simply as a ranch. Rather than being valued at $1,000 an acre for a ranch, the land will be valued at $15,000 an acre for a *possible* subdivision. Finally, once the owner dies, his gift and estate taxes shoot the moon, given a federal tax rate of 45 percent. Today it isn't hard to find a ranch worth well over $10 million, let alone $2 million.

Families can't afford to keep those lands anymore.

Effectively, through public policy, we are slowly destroying the historic state of Colorado.

Through the Sopris Foundation, we have proposed to the Colorado Cattlemen's Association a resolution to support valuing farm- and ranch land at the higher value only at the time of actual conversion of the property's use. Call it a conversion tax as opposed to the current system of taxing land in anticipation of a future change. This would enable ranch families to continue to ranch through the generations if they so choose. This will in the long run help people who know and love the land remain on the land and perpetuate the historic landscape the West symbolizes.

I've been looking at land-use models in Europe. They are light-years ahead of us. Switzerland, for example, has four types of zoning: agricultural, forestry, residential, and urban. All land is zoned what it is, not what it might be. When you want to change the zoning, it takes a vote of all the people in the canton. The Swiss have no gift or death taxes, and the consequence of those few things is that they are maintaining their landscape. Even when you have a little farm: say some investor wants to come down to Switzerland and tear down a farm and build a great big home like we see in all our ski towns here. No way! All you can do is remodel the existing farmhouse, and you can't add more houses on the property. Somehow, they seem to understand consequences a lot better than we do.

Some years ago, when I was on the board of the Worldwatch Institute, I was impressed by their State of the World conference. I told Lester Brown [the organization's founder] that people in the West ought to hear his ideas. So we brought eight of their speakers out, and two

hundred and fifty people gathered at the Aspen Institute to listen. With the help of Tim Wirth, we decided to run similar conferences focused on the West. The past three years, the Sopris Foundation has held a conference called Innovative Ideas for the New West. The idea is to bring innovative ideas to county commissioners, mayors, planners, and other officials. We look at the fields of land-use planning, energy, and transportation. We've hosted representatives of the Swiss Rail, organic farmers, experts on biomass, biodiesel, and cellulosic ethanol, and a marvelous land-use planner from London named Ben Hamilton-Baillie. Sopris Foundation disseminates information to a lot of the people who might be interested from small towns throughout the West.

The Sopris Foundation is also doing work on energy and energy use. We brought together utility companies from across the state to discuss tiered-rate electricity pricing. We designed a carbon footprint reference card with cutting-edge research. We've analyzed how much energy vacant second homes in our valley consume. And we're writing a manual for decision makers that identifies best practices in sustainability from Europe.

Last year Sopris Foundation produced a film called *Nobody's Home* about absentee homeowners in Aspen. It was a way of warning smaller communities that they need to think seriously about their zoning before their towns change forever. Sixty percent of all homes in Aspen are owned by second homeowners. They spend very little time here. They build monster houses that sit empty but still crank out the heat. The average second home here uses four times as much energy as a smaller, occupied house. Aspen is a ghost town. The film's message: Wake up. You are going to lose your town if you don't zone it like you

mean it. Define *residence*, for example. *Residence* should mean "for a resident," somebody who lives and works in the town. I don't believe that a residence should be a private hotel or corporate retreat. As a result of speculation, many people who work in Aspen and used to live here can't afford it and have to commute thirty, forty, fifty miles each way to work. That shouldn't happen. I think this is an important message for a lot of communities.

The West is under serious attack right now, not just because of its population explosion or the oil and gas industry or the infestation of pine beetles, but by public policy.

We are very lame at dealing with the oil and gas industry. Right now in the West there are roughly thirty million acres under lease and one hundred thousand wells, which will increase to two hundred thousand. This is mostly on public lands, lands that the public owns that are supposedly dedicated to multiple use. However, the oil and gas industry—with the encouragement of the federal government—has walked all over the public in regards to that land. I've gone to hearings where 95 percent of the public comments are against what the oil and gas industry is doing, but it doesn't seem to matter.

It's not just the oil and gas well pads that are degrading the land, it's the miles and miles of roads they are building with river rock and gravel. These roads will not go away, and what nobody is paying attention to is that in order to get the gravel for the roads, companies like Lafarge are devastating places along the Colorado River. Lafarge is building huge pits and lakes and tearing down trees in order to build conveyer belts across the river to get to a crusher on one side. And these are magnificent riparian areas full of wildlife and waterfowl.

I always come back to Europe. I would like to see us do things more like Europe. There is such a passion in the Alps! We live in just as unique and beautiful a place, but somehow we don't revere it as much as our peers in the Alps. If we did, we wouldn't be developing the West as we are.

In 1998 I developed a community called the North Forty project at the Aspen Business Center, just outside of Aspen. It is based on a European model. To buy there you have to be a resident of Pitkin County. The lots are small, but there is a great communal feeling among the people who live there. It's for the middle class, the group that is getting the squeeze.

The people who have bought and built there have put down roots in this town. They've brought back a lot of what the feeling was in the old Aspen. I think that's just super. When the lots became available and people started building, the whole barter thing came back into existence. "If you help me design my house, I'll help you plumb yours." Those residents don't need a car to get into town; they can take public transportation, and they can shop right there. It's like a small village. It's how we should be designing our living situations. The old land-use notions are all wrong in the West. We're still designing for automobiles, and we've got to get away from that.

I think good things are starting to happen. But still there are a lot of developers and businesspeople who feel that the essence of business is growth and the essence of America is the freedom to do whatever you come up with to make a buck. We're starting to hit the wall between capitalism and environmentalism. We cannot be committed to endless growth with the environmental limits we have now. We've got to learn to think differently.

John McBride *51*

John McBride always loved the West and moved permanently to Colorado in 1962. He was involved in the initial development of both Vail and Snowmass. Later, as an entrepreneur, he created the Aspen Business Center and the North Forty employee housing project. He cares deeply about preserving community and open space, and commits his time to agencies that promote this vision. He lives on a working cattle ranch and is a longtime pilot. Such activities give him an unusual perspective to ponder the future of the West. As a developer he knows how easy it is to screw it up, as a rancher how hard it is to protect, and as a pilot how easy it is to see the difference.

BRUCE GORDON
CONSERVATION TAKES OFF

We joined Bruce on the Aspen airport tarmac just as he was about to fly a group of high school students over the Roan Plateau. After eighteen years of doing what he terms "conservation flying," Bruce started EcoFlight in 2002, using small planes to advocate and educate for the environment.

Bruce cut his teeth in environmental advocacy after years of climbing in the Himalayas and teaching outdoor education to kids. He and the late John Denver dreamed about a flight across America that would bring attention to the country's biggest environmental travesties. He is now making that dream come true.

⟶

Conservation flying gives the land a voice.

I've been flying politicians for a lot of years, but flying students is very dear to me. I have created an educational program for young adults called Kestrel. A kestrel is a bird noted for its hovering as it hunts. We take students up and let them "hover" over issues of environmental concern. EcoFlight's inaugural Flight across America allowed students to view the land in each of their states and compare the pristine wilderness areas to the proposed oil and gas development sites.

I gathered young adults from small communities affected by oil and gas development: Choteau, Montana; Pinedale, Wyoming; Otero Mesa, New Mexico; and New Castle, Colorado, outside the Roan Plateau. The sight of the landscapes, fragmented and scarred by oil and gas rigs, gave students the impetus to write and meet with the press about the horrors of what has been done to their land.

We are into our fourth Flight across America this year, and our students have produced videos, met with senators, founded environmental groups, and are an asset to their communities and to the USA.

I became interested in environmental issues through other activities. I was a climber. I came out west from the East Coast, and all of a sudden the world was different. I used to love to get lost in the mountains. I acquired skills, and the mountains identified me. From those years I developed a sense of awareness that I think is my way of trying to understand the world.

I took up flying with the idea of becoming a mountain rescue pilot up in Alaska. As I got into flying, I started learning more about local environmental issues, and I could really see those issues from the air. As a volunteer pilot said to me many years ago, "I have been flying all these years, and I finally started looking at the ground." Well, I started looking at the ground from up in the air as well. I looked at symmetry of the land, which I think gave me a more holistic view of environmental issues, and our world in general.

Oil and gas is a big cancer in the West right now. From month to month, the differences I see from the air are amazing. We've compared photographs from the Rocky Mountain Front in Montana and other places that are threatened but haven't been damaged, like the Otero Mesa in New Mexico and Adobe Town in Wyoming,

with areas where the landscape has been obliterated, such as the Roan Plateau in Colorado, the Pinedale Anticline in Wyoming, the Upper Green River Valley, and the Powder River Basin: places where there's nothing but oil wells. These photos tell a powerful story.

I make a concerted effort to fly representatives from the towns that are affected by the oil and gas development. In places like the Rocky Mountain Front and the Roan Plateau, we have probably flown every elected official. The impact is powerful. I think all but one of these passengers endorsed an initiative not to drill on the top of the plateau, a beautiful area that is home to four endangered species. Tomorrow I am flying three state representatives over the Roan Plateau, and yesterday I flew an international television station over the same area.

I have flown Aspen county commissioners over the neighboring counties to look at what could be coming their way. They are being proactive, and flight is an effective tool for them. Passengers are always shocked that the Roan Plateau looks as bad as it does. Nobody expects that level of industrialization and landscape fragmentation at the edge of wilderness lands.

Years ago I worked on the Colorado wilderness bill, championed by Senator Tim Wirth. Early on I called several of the people involved and said, "Look, the way to do this is by airplane. Colorado is a big state, but we can take a look at where the roads are, where they're not, where they're supposed to be, and really catalog and inventory the area." In the initial stages we worked with the conservation groups involved to identify the areas that should be wilderness; Senator Wirth flew with us. After we established the areas needed for protection, we flew *The Washington Post* and other national newspapers and magazines to get the word out to the public about the wilderness proposal. Eventually President Clinton came out and signed the Colorado wilderness bill. It was quite a success.

Another issue I've taken on is off-road vehicle use. Off-road vehicles [ORVs] are a big player in land fragmentation. I help the Southern Utah Wilderness Alliance [SUWA] in Utah. SUWA is focusing on protecting certain areas where we should use ORVs and areas where we shouldn't. When we look near the San Rafael Swell and the Factory Butte area from the air, all we see are tracks, tracks, and more tracks through the desert.

I am involved a lot with water issues. I've been flying over the Snake River looking at the health of the river and some of the planned developments that are going along the sides of that river. I work with the Jackson Hole Conservation Alliance and the Greater Yellowstone Coalition, as well as with the Wilderness Society, looking at the Upper Missouri River Breaks National Monument up in eastern Montana, which is a recreational area. We're looking at the impacts to the river that runs through the monument, as well as other lakes and streams that have been affected by oil and gas pollution.

Endangered species are at the heart of what I care about. During wolf reintroduction, I helped track wolves in the Flathead Wilderness in Montana. The terrain is very challenging and wild, and we had to land on little dirt strips for the night. We wanted to pick up signals from their radio collars so we could circle over individual wolves. We received a signal and circled and circled, and finally we saw a wolf peer out from the trees. I recall seeing the wolf's eyes and remembering Aldo Leopold writing about that fire, that green fire in a wolf's eyes, dying after he shot her.

To see that wolf looking up at me, I'll never forget

that. It pierced me. That was the spirit of wildness, which is the essence of what I do.

Bruce Gordon is the founder and president of EcoFlight. He has been actively involved in flying in defense of America's public lands for more than twenty years. His initiatives in the field have enabled him to meet and be honored by President Clinton and Vice President Al Gore. He has flown over ten countries around the world, mostly in bush and mountainous conditions. Passengers on his environmental flight missions have included ministers of foreign countries, senators and congressmen, and children of all ages.

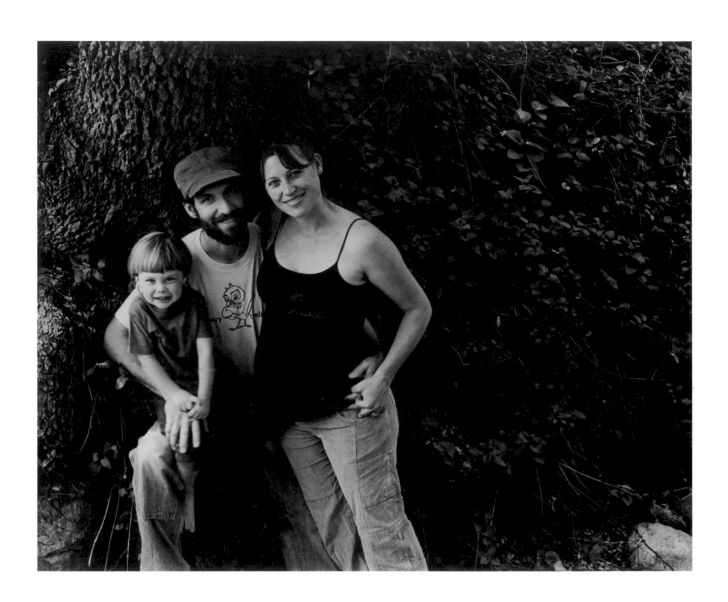

CHARRIS FORD
RUNNING ON FRENCH FRIES

Charris Ford spent his early years running his family's organic farm in Tennessee. He grew up in a solar-powered home, harvested rainwater, chopped wood, hauled drinking water, and cared for his wheelchair-bound mother. His Amish neighbors taught him the secrets of permaculture, as well as how to mow with a scythe and forage for wild food and alternative medicines. During long days toiling on the land, he spun rap songs in his head. Now he uses his rap songs to endorse recycled-fryer-grease biodiesel fuel.

The self-proclaimed Granola Ayatollah of Canola travels the country promoting conservation. Over time he has made good friends and devotees out of many movie stars and celebrities, including Dr. Andrew Weil. His tales allowed for a long breakfast and many cups of coffee out on the terrace at his mother-in law's small house at the Mimbres Hot Springs commune, in New Mexico.

When I got wind that I could run a vehicle on vegetable oil, I thought that was the coolest thing ever. I bought a beautiful old 1980 vintage International Harvester Scout—it was one of the first SUVs—and I run it on spent french-fry oil. It smells like french fries; it's great! Plus, [the fuel is] nontoxic, biodegradable, and renewable. We're in constant wars with oil-rich nations, and I just thought, "This is it. This is what I'm going to do. I'm going to help get this biodiesel thing going."

In 1999 I got together with some friends from Telluride and we started monkey-wrenching around on plans to build a biodiesel processor. We collected waste grease from restaurants; they paid us $2.50 a gallon to take it. We used it to make fuel for ourselves and a couple friends, and before long people from all around the region were interested.

I was thinking to myself, "Well, Telluride has air-quality problems. Why don't we start a project in town to try and get some of the public transportation on biodiesel?" A lot of the city buses were diesel, and I thought it would be a perfect fit for a progressive little town like this.

It was really not well received at first. It was like, "You want to do what? You want to put waste french-fry oil in my fuel tank? I don't think so, hippy." But I was serious, and I thought it was a good thing and we ought to do it; they've been doing it in Europe for years. I put together packets with some compelling information and distributed them in town. Finally, someone in the Public Works said, "You know, I think this is a good idea too, let's write a grant and get some money to do this." So I helped him write a DOE grant, we got the funds, and the bus project was approved. We even earned the distinction of being the first city bus in the nation to run on 100 percent biodiesel. Now everyone is like, "Oh my God, biodiesel, of course, totally!"

We first started making biodiesel in an eighty-gallon processor and then grew into a five-hundred-

gallon batch processor. We were the largest and first biodiesel production facility in the state of Colorado too, and one of the first in the country. We called it Grassolean because I wanted to distinguish our sustainable fuel–producing practices from the agribusiness-as-usual practices of biodiesel industry. And it rhymes with *gasoline*, so it's fun to say.

We didn't break the story, as it were, because Europe was already doing biodiesel. Germany burns canola oil— they call it rapeseed oil there. And Rudolph Diesel's first engine was running on vegetable oil when he unveiled it at the 1900 world exhibition in France. He had this vision that farmers could grow their own fuel, also benefiting nations without petroleum reserves. It was a brilliant idea. But it was an idea that was completely lost to us.

I think his idea disappeared because the oil interests were so powerful and oil was abundant. It turns out, though, as oil becomes more and more valuable by the barrel, biodiesel is becoming a very logical thing to turn to.

That being said, we have such an appetite for a liquid transportation fuel that any amount of recycled vegetable oil is barely a drop in the bucket. And so when you ask, "Is biodiesel going to save the world?" the answer to me is that of course it's not going to save the world. Biodiesel in conjunction with the most brilliant alternative fuel, which is conservation, added to solar, wind, and sustainably produced hydrogen and driving less—these things can save the world together. There's no magic bullet or get-out-of-jail-free card, and biodiesel is no exception to that fact; it's got its limitations too.

I have been invited to speak on biodiesel and sustainable living at events in Cuba, Canada, Spain, Italy, and the US. At first I thought that all this travel was neat, but lately I have slowed down because I don't feel good about flying so much. Dulcie, my wife, calls it "flying to save the environment," but we also agree it just doesn't make sense to fly around the world speaking about conservation.

For the longest time I have dreamed of running my own "Grassolean Station," a kind of last-chance-for-the-environment gas station. You know, a classic old eclectic roadside attraction meets a sustainable-living general store. I imagine a Route 66–style station built with salvaged and green building materials, with solar panels atop a living roof, [and I'd] offer biofuel, organic food, local goods, and the like. My dream location is a little farm out on some old country road where I could tinker around the shop and garden with my family in between customers. I don't suppose I'd get rich selling biodiesel and home-grown breakfast to the random passerby, but it sounds like heaven to me!

I got into biodiesel because I loved the idea of making fuel from recycled waste french-fry oil. Unfortunately, greed never sleeps, and most biodiesel you'll find at the pump today is made from genetically modified crops grown on clear-cut rain forest land and shipped halfway around the world. That hardly makes for an environmentally responsible fuel. Tragically, biodiesel has been co-opted by big agriculture, and food prices are rising around the world as biofuel crops compete with food crops for farmland. Global commodities like wheat and rice are becoming too expensive for many poor people to afford. So now, in addition to promoting sustainably produced biofuel, I am also an outspoken critic of the biofuel industry—which is too ironic for words.

Really I think protecting the planet is the coolest thing ever. Growing food is sexy. Reducing humanity's

carbon footprint is our civic duty. Simple living can provide an incredible quality of life and leaves more for others to enjoy. The power of conservation has got to be the most abundant untapped natural resource on Earth.

The youth of the world have so much power to affect positive change, and I love the challenge of presenting environmental messages in fresh ways they can relate to.

I think it's worthwhile if kids see me as this hip environmentalist who hangs out with Val Kilmer, Woody Harrelson, Daryl Hannah, and these kinds of neat, high-profile types, and they think, "Oh, that's cool. I want to be an environmentalist." That's my goal, to inspire young people to think that taking care of the planet is an awesome thing to do. Here's one of my eco-raps, which I perform for high school and college kids. It goes like this:

A lot of bing, a lot of bang, a lot of bing boom bang.
This rhyme is so fresh, it's green and still growing.
And like a rolling river, the beat keeps flowin'.

Ya know the Earth is fragile, and that's a fact.
We've been taking from nature, now it's time to give back.
We've done lots of harm just by spinning our wheels,
polluting planet Earth with all these automobiles.

So when I bought my last car, I said I wouldn't buy another
until they made an engine that ran on apple butter.
And to my apple butter dream car, I stayed loyal
until I found an engine that ran on veggie oil!

So let me tell you the latest about French-fried potatoes.
It's so great that everybody just loves the taste.
But there's a bunch of old fryer grease just going to waste.

The diesel engine was designed with peanut oil in mind,
but it could run on almost any oil you could find—
corn, soy, chicken fat, sunflower, flax, hempseed.
Farmers could grow their own fuel, not only their feed.

We need to stop burning toxic fuel to make power.
I'd rather get my fuel from a sunflower.

I've got that veggie fuel burning. Now I'm rolling with ease.
Is that the scent of french fries I'm smelling on the breeze?
A lot of bing, a lot of bang, a lot of bing boom bang.

Charris Ford is the founder of Grassolean Solutions LLC, an organization devoted to providing people with sustainable-energy information and products. He has been working for many years to raise awareness about alternative fuels and has lived in solar-powered homes for at least twelve of those years. Charris operates his own 100-percent biodiesel-powered truck and was the subject of the much-celebrated film about biodiesel called French Fries to Go.

The son of an award-winning Madison Avenue advertising man and a visionary mother who started one of the first holistic health centers in the United States, Charris is passionate about the power of media as a tool for important social and environmental change. He lives with his wife, Dulcie, and two young sons, Kashius Kahlil Huckleberry Holden Light Kentucky River Ben and Phoenix Fuller Thelonious True Heart Skookum River Blythe.

JON MARVEL
RANCHING IS AN IRRATIONAL IDEA

One of the first things Jon Marvel did when we walked into his office in Hailey, Idaho, was hand each of us a copy of the enormous coffee-table book Welfare Ranching: The Subsidized Destruction of the American West. *Inside, a sticker declares that the book is a gift from the Western Watersheds Project (WWP). Jon is the executive director of WWP, a group whose aim is to restore western watersheds, and the man who wants to see the end of public-lands grazing in the West.*

WWP works with other organizations, including Forest Guardians, and partners with Advocates for the West law firm on their many suits and battles. In 2005 WWP won an unprecedented federal court injunction ruling the removal of livestock from more than eight hundred thousand acres of Bureau of Land Management (BLM) lands in south-central Idaho because of federal law violations.

Jon took us on a daylong tour of the BLM lands surrounding his home in Hailey. Though we know it was his standard circuit, we did see the destruction to the land and watersheds that he cries foul about.

In parts of the West where the average rainfall is less than fifteen inches a year, ranching really doesn't make sense. It's an irrational idea that comes from our settlement history. It's wasteful, it's inappropriate, and there has never been an adequate analysis of its suitability. We've tried to sustain it, and the result has been an ecological disaster.

If you drive a car on a paved road through public lands in any western state, when a dirt road comes up, turn off on it. Right or left, it doesn't matter. Drive on that road as far as you want to. After two minutes or twenty minutes of driving, stop your car, get out, and you will be in a landscape degraded by livestock (presuming you didn't drive down somebody's driveway). It's that simple. It's everywhere. Every place in the arid West has experienced the negative impacts of livestock.

Domestic livestock have so many negative effects on the health of the watersheds: through riparian degradation, erosion, water quality and quantity degradation. The benefits of removal and the potential for what could be out on the western landscape are so great that we should choose to do it. For example, we don't need the seven hundred and fifty thousand miles of fencing that are now on our public BLM lands in the West (there are another three hundred thousand miles on Forest Service land). That amount of fencing is completely unnecessary for any kind of wildlife management except for livestock, and these lands are so unproductive for livestock. There's a litany of negative effects.

Livestock ranching has not only been very disruptive to the ecology of the West, it has informed the mythology of the West. The reason the US has this fascination with ranching and cowboys is because of the legacy of literature from Owen Wister to Tony Hillerman and film and TV from Tom Mix to Ben Cartwright. All of these writers and characters contributed to the idea

that the West is ranching. I would argue that the West is really the western landscape; it's not ranching. I think we are finally leaving the cowboy era, though; very few films or novels are about the cowboy West anymore.

The National Public Lands Grazing Campaign, along with WWP, proposed a very generous, federally funded buyout that would offer $175 per AUM [animal unit month] to ranchers who agreed to voluntarily relinquish their grazing permits. This is about three times the value of these permits when bought and sold by ranchers and would cost about $2.5 to $3 billion if all grazing permits are retired, or what we spend in Iraq in about three weeks. There hasn't been a hearing, and it will take time for such legislation to succeed, but it has been entered in Congress by Congressman Raúl Grijalva of the Seventh District of Arizona. It is good legislation because it enables generous compensation for ranchers to voluntarily relinquish their grazing permits. The Forest Service and BLM would then permanently retire them. It takes the contentiousness out of the issue.

That would give ranchers money to buy other private land or perhaps invest in education or training so they can have a job that would sustain their family.

An article in the *Journal of Range Management* shows that 54 percent of all ranchers who hold public-land grazing permits across the West do not rely on ranching for their main source of income. In almost all other ranch operations, one or more members of the family need to hold a job in town. They might be a schoolteacher, the night janitor at the high school, or perhaps they work for the county road crew. There are all kinds of jobs that ranchers and their family members hold in order to live on the ranch. The fact is that small western ranches depend on local towns for survival, not the other way around.

About 60 percent of ranching permits across the West are now owned by absentee owners who only ranch for aesthetic reasons. Those people buy ranches not for their productive capability to raise livestock, but because they're pretty, because they like the view, because they can invite their friends to come visit them, and because they still want the rancher lifestyle. In central Idaho Mary Hewlett Jaffe, the daughter of William Hewlett, cofounder of Hewlett-Packard, has cattle grazing on one hundred thousand acres of public lands, the largest BLM allotment in central Idaho. She lives in Portland, Oregon. Likewise, Paradise Valley, Montana, is full of rich actors and celebrities who buy a thousand acres and have a ranch. Should we be paying for their desire to be ranchers?

They also maintain agriculture status, which they see as their heritage, and owners of these trophy ranches keep cows because somebody informs them that they'll lose tax benefits if they don't. States should take this into mind and pass legislation that enables tax exemption for wildlife habitat protection.

Domestic sheep production has negative impacts on the ecology of the landscape as well. One of the most important negative impacts from domestic sheep production in the West is the elimination of bighorn sheep. Biologists with the Fish and Game departments in various states estimate as many as one million bighorn sheep were in the West at the time of Lewis and Clark. Now there are fewer than fifty thousand. Domestic sheep production transmits disease from domestic sheep to bighorn sheep. They have no resistance and they die. Unrestrained hunting in the nineteenth and twentieth century also reduced bighorn sheep, but their primary

destruction in the West was caused by domestic livestock, specifically domestic sheep.

So, the question is, why do we need domestic sheep on public lands when our clothing is not made of wool anymore and people don't eat mutton? I would say that it is lethargy related to historic inertia. We have sheep because they were there for a hundred years and the Forest Service and the BLM continue to have a pretense that it is an important part of their management needs. If you believe that western wildness has a high value, there's really no dollar amount you can place on bighorn sheep. So why don't we look at the end of public-lands ranching as an opportunity to restore bighorn sheep across the West?

It's the same with the displacement of native ungulates like deer and elk: they are in direct competition for forage with domestic cattle.

Bison are another example. The state of Montana and Wildlife Services killed three thousand bison in July 2008. The given reason was the transfer of brucellosis from the bison to the cattle, even though there has never been a confirmed case of brucellosis ever being transmitted to cattle from bison. It's really not about brucellosis in my judgment and the judgment of many others, it's about who controls the landscape: cattlemen.

I think we'll understand that the quality of our lives will be improved by not having livestock on the land. The result of that change and recognition will be vastly improved ecological health, which will be more resilient, more capable of withstanding the kind of climate change we're facing. It will also take into account the need for people to be in wild areas that are not dominated by human change.

There may be places in the West where ranching on public lands is environmentally sustainable, perhaps where it rains a little more, like parts of southwest Montana, but it is never economically viable if all costs are included.

The progressive ranchers (and there are some who want to bring fire back and improve the way they relate to a landscape) even if their intentions are absolutely the best (and often they have the best intentions) are still asking how many cows they can raise.

It's very clear that there are groups like the Nature Conservancy who are enablers of ranching on public lands. I believe they perceive ranching as desirable in the context of the American West. Those groups, by creating avenues for ecologically sustainable ranching, are economic enablers of a dependency that is not healthy. They receive money from government agencies or private individuals in order to reduce the cost to ranchers. That externalization of cost reinforces the dependency that ranchers who use public lands already have on the government. Ranching has a special place in the minds of many people so that they overlook the creation of the dependence. And there would not be public-lands ranching without the subsidies that already exist. The only way to maintain ranching on public lands is for the rest of us to pay for it.

How do we change that? By being honest about it. By saying, "Look, this isn't economically feasible anymore. We don't need to pay for it. It's created all these negative ecological impacts. We have provided a way out for ranchers that is reasonable and supportive and has a time frame." After that, if they want to continue to ranch on public lands they have to pay the fees, they

have to meet all the ecological considerations, including the fencing issues. We want clean water and we want wildlife out there.

I choose wildlife. And I think most Americans choose wildlife, given the opportunity and understanding.

Keeping ranchers in business is no way to guarantee that subdivision won't happen, but we're forced to confront the cow-versus-condo idea as if it is the governing basis for preventing subdivision in the West. People focus all the time on the issue of subdivision of private lands across the West, but it applies only to certain areas. It certainly doesn't apply in eastern Montana, large areas of eastern Wyoming, Colorado, New Mexico, or rural areas of Utah, Idaho, and Nevada—people are just not clamoring for summer homes outside Eureka, Nevada. Public-lands ranching plays little or no role in subdivisions in a lot of the western landscape.

Yet people like to make the argument that if the land isn't full of cows, it will be full of condos. People say to me, "Jon, you just want to get rid of the cows, and you're going to destroy the West because it will just be developed into summer homes. They will be abandoned nine months of the year, and you'll destroy the community because those people aren't part of the community. They just demand services, and everybody else just changes sheets and has to be subservient, and presumably wear maids' outfits."

To those people I say, let's actually do something to prevent subdivision.

Let's encourage and bring about county zoning across the West that reflects the landscape ideal that we want as citizens of the West. In Telluride, Colorado, for example, the town was finally able to buy a 560-acre parcel of valley floor to prevent it from being subdivided. That is a sign of the desire of people not to allow a landscape to be lost to development. That desire exists all over, and we need to make sure the opportunity exists and we have to fight against this very limited point of view of private property rights that has resulted in sprawl, inappropriate commercial development, and increased cost to taxpayers.

We need to understand that if we lose our ability to regulate subdivision we are going to lose the landscapes that we want to save. But we need public funding. That funding mechanism needs to come from many different sources, not just private enterprise. Why can't we have a real estate transfer tax everywhere in the West that enables local communities to buy land to prevent it from being subdivided or buy conservation easements, whichever they want? In many cases it's actually cheaper to buy the land outright. Without the funding to buy landscapes, we're not going to be able to prevent subdivision because private property owners subdivide land where there is demand for smaller lots. And they do it because they can make money. In order to counter that, we have to offer them money not to. Otherwise it is going to be difficult, especially in the face of counties that are unwilling to put in 80- or 160-acre zoning restrictions. There are areas in the West where you cannot have a lot smaller than 80 acres. There's no reason it couldn't be 160 acres. Is that undemocratic to put a restriction on subdivision? Maybe in some respects, but unless we try, how are we going to know what we can achieve?

If we are able to end public-lands ranching in the West and control the high demand for rural subdivision, we can re-create a West that we lost. That West will

include an ecologically healthy complex of wildlife and watershed, with all the species that are native to these landscapes, species, whether they are plants or animals, that will survive even the impacts of global warming in many locations. We need to re-create that kind of resilience which we've been losing [more and more] every decade for the last 120 years. We can do it. I'm optimistic about that.

This vision of the West includes people who understand wildness, wildlife, and watersheds, and appreciate clean water and the opportunity to experience landscapes without massive human intervention. If we can't think like that, we really are stuck in a past that is exploitive and based on dominion over the landscape, that has landed us where we are. So, with a positive view and the understanding that nature is resilient itself, we can bring back bighorn sheep, Colorado cutthroat trout, pygmy rabbits, and sage grouse.

With that vision, and a little time, we can restore the American West.

Jon Marvel is an architect in Hailey, Idaho, where he has lived for almost forty years. In 1993 he cofounded the Idaho Watersheds Project, now the Western Watersheds Project, to bid on expiring grazing leases on Idaho state school endowment land. The Western Watersheds Project now has offices in seven western states and seeks to protect and restore western watersheds and wildlife through education, public policy initiatives, and litigation.

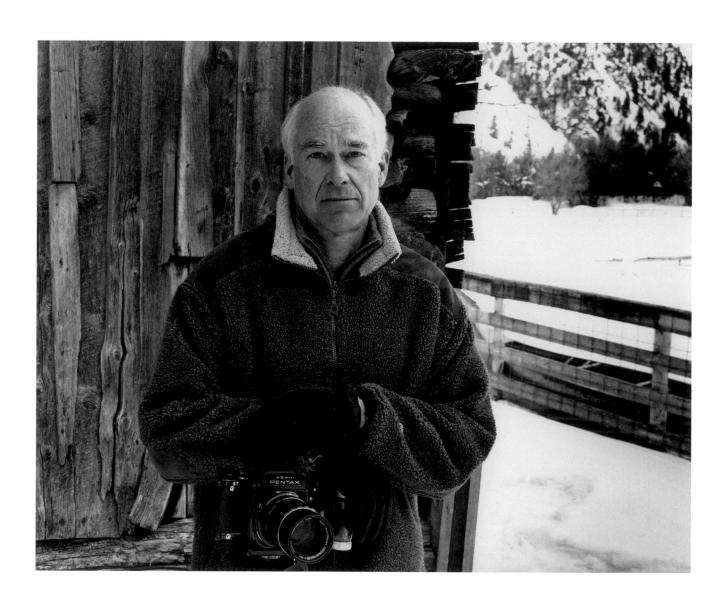

JOHN FIELDER
USING PHOTOGRAPHS AS A CATALYST

John Fielder spends three to four months a year in Colorado's backcountry photographing his favorite places. He spends another quarter of his life on the road giving slide shows and addressing regional environmental issues. His best-selling book Colorado 1870–2000 *presents William Henry Jackson's early photographs of Colorado. Standing in Jackson's footsteps, John rephotographed Jackson's images. The book highlights the changes that have occurred in Colorado in the last century.*

John joined us for lunch on a snowy day at Ogilby's Hell Roaring Ranch in Carbondale and for a photo shoot in front of the original ranch buildings. We originally met John at his gallery in Denver, but we all agreed his picture should be taken outside, where he is most at home.

———

My evolution over the past thirty years was getting to know the beauty of landscape, which I had to do for my photography. I had to understand colors and shapes, and how light interacted with the land. That forced me, in order to be a good photographer, to understand nature and ecology.

It's one thing to see a photograph in a book or on a slide screen. It's entirely another to be in that location and not only see it, but smell, taste, touch, and hear the sensuousness of the land. Personally I don't believe that you'll ever have a conservation advocate unless that person experiences the land firsthand. Hopefully the photograph, and maybe some well-chosen words, are the catalyst to get them out there. That's how I build advocacy, through the display of the photos somewhere: on a gallery wall, in a book, or on a slide screen. I would like to think that the notion that the planet is a special and beautiful place does not get bypassed, that something sinks in, if not subconsciously, subliminally. My approach over the years has been to make things look not better than they really are, but certainly the best that I possibly can.

In 1990 Colorado senator Tim Wirth knew about my budding career and invited me to photograph the three-quarters of a million acres that ultimately became wilderness in the 1993 Colorado wilderness bill. I spent a year and a half photographing fifteen prospective wilderness areas, the photographs of which he used both in a book and to convince his cohorts in Congress to pass the bill.

I'll never forget the first time he asked me to do a slide show. I'd never stood up in front of people and talked before. I did the show, and it seemed like people enjoyed it. That was the first time I used my photography to try to influence the public. Now I do that fifty times a year.

A lot of folks ask me to show environmental degradation, like clear-cuts, mining damage, or inappropriate real estate development. I leave that to other photographers. I believe that the natural world is so powerful and overwhelming that if that doesn't convince, nothing will.

Ultimately, when you ask, "Are you an environmentalist?," 90 percent of people in America say yes. But

when they go to the polls, they vote for their pocketbooks. I think about this a lot. How can we create a scenario that equates protecting the environment with, at the same time, padding your pocketbook? I'm convinced that only when that happens will there ever be true preservation of the West.

I think we can buy our way out of the problem. In 1992 a group of us got together at the behest of former Colorado governor Roy Romer to redirect lottery profits to protect open space, parks, and wildlife habitat. That is now GOCO, Great Outdoors Colorado. We got GOCO passed in 1992. Ken Salazar was our leader; Tom Strickland was involved. I was involved. It passed easily. Unfortunately, as good as GOCO is, it gives only $50 million a year, which is a drop in the bucket compared to what we need to preserve rural ranch and farmland that is being lost to development in Colorado. By my calculations, if we can do ten times GOCO, we can save the state. We're losing one hundred to two hundred thousand acres of farm- and ranch land every year in this state.

I'm currently working with a writer, and we are documenting ranches in Colorado. We are covering all of the ecologies of the different landscapes in the state: mountain, desert, and plains. I've long photographed Colorado's public lands. Now I'm pointing my camera at the other 60 percent of Colorado's land mass: its private lands and, in particular, what remains of its working ranches. We will use the book to raise awareness for the need to preserve ranch land across Colorado. We'll also use the book to raise money for land preservation in partnership with the Colorado Coalition of Land Trusts.

I have people come up to me all the time and say, "You publish all those books and calendars, and that brings people to Colorado." But they have it all wrong. First of all, we can't stop growth. What we try to do is plan for it best by deciding where development should occur and where it shouldn't, to protect as much of the landscape as we can. I meet thousands of people a year, and in twenty-three years I can only remember two people who ever said, "John, I moved here because of your photos."

Since my wife and son died, I think I've gained a greater appreciation for life and how fleeting it is. Clearly a new chapter is evolving in my life, and I'm not sure exactly what it is going to be. I sold Westcliffe Publishing and moved to Summit County. I look forward to living among aspen trees with a view of one of my favorite mountain ranges and focusing on what I have: my daughters and my grandchildren.

I've been to book signings where a sixth-generation Colorado family member comes up to me and says, "John, Granny was blown away by seeing what Colorado looked like when she was a little girl." When I see the passion people have in their eyes and in their voice for Colorado, how special a place it has been for them, it renews my belief that ultimately people will vote for the right issues and advocate for the right things. If I can continue to reach people with my images, then I am doing my job.

⸺

John Fielder spends half of his life living out of the back of his car. He has authored and/or photographed more than twenty books, including Photographing the Landscape: The Art of Seeing, *which won a Colorado Book Award in 1996, and* Mountain Ranges of Colorado. *He has won the Daniel L. Ritchie Award for Ethical Behavior*

and Social Responsibility, the Ansel Adams Award for Conservation Photography, and the University of Colorado Distinguished Service Award. In 1996 he founded Nature Photography Is Fun for Kids—free slide lectures for children—as a way to teach photography and appreciation for the natural environment.

FIGHTING FOR THE WILD LANDS

Each individual in this section has gone out on a limb to preserve land they feel is sacrosanct, beginning with the tireless Dave Foreman, who cofounded Earth First! under the maxim "No compromise in defense of Mother Earth." Dave has made a lasting impression on the environmental movement and now focuses on saving large corridors of wilderness for wolves, bears, and other carnivores. Gloria Flora, an employee with the US Forest Service, blew the whistle on fraudulent activity in Nevada. She told us that her secret desire when she joined the Forest Service was to singlehandedly stop clear-cutting. "You know, you have to have a vision." That she has, and today Gloria advocates for sustainability, both for public lands and human beings. Connie Harvey, Dottie Fox, and Joy Caudill have been called the Maroon Belles for their role in preserving land in the Colorado Rockies. They started protecting and defending federal lands fifty years ago from their kitchen tables, and Connie and Joy are still active today, though they warn that they won't be around forever to fight the battles and are happy to see young people carrying on the tradition. River poet and singer Katie Lee's singularly focused fight for Glen Canyon for more than forty years has made her an activist icon. The late author Ellen Meloy called Katie "outrageous, mischievous, and never shy about calling a shithead a shithead."

Though of a different temperament and background, Rich Ingebretsen too believes that Glen Canyon Dam is a political blunder and wants to see it decommissioned. Upstream, Jennifer Speers, an understated warrior in the battle to save open space, took a bold stance against inappropriate development along the Colorado River. We were fortunate to find her, as she likely represents scores of other activists quietly doing their part. And finally, Johanna Wald is one of the Natural Resource Defense Council's topflight environmental lawyers and is an advocate for western public lands. She possesses the rare combination of being an attorney who can litigate while also retaining an advocate's vision for the future.

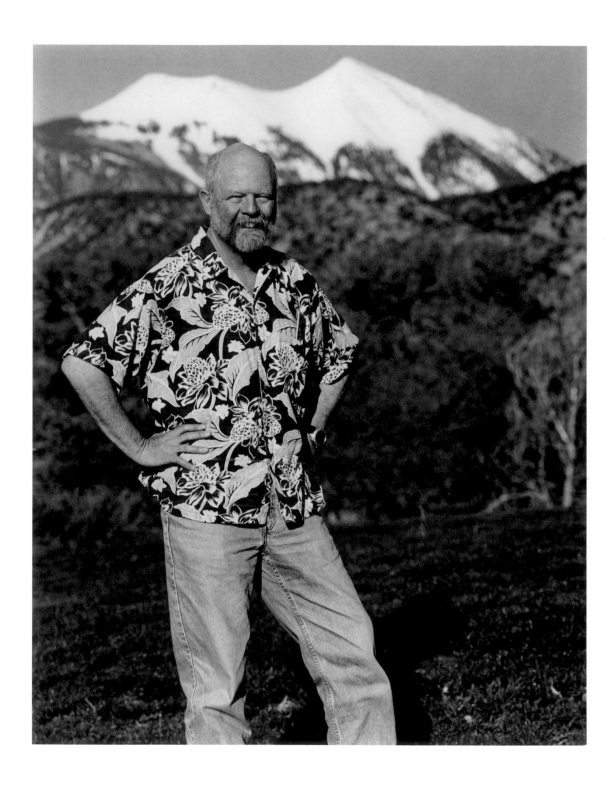

DAVE FOREMAN
PUTTING WILD BACK INTO WILDERNESS

Dave has worked the front lines of the conservation movement since the early 1970s. He is a cofounder of Earth First! and now works in large-scale conservation, wilderness protection, and conservation biology. He recently published Rewilding North America: A Vision for Conservation in the 21st Century, *which looks at the global extinction crisis. He continues to be one of the country's most outspoken and tireless advocates for wilderness protection.*

Commanding in voice, stature, and character, Dave ended the Ed Abbey Speaks gathering at Ken Sleight's Pack Creek Ranch in Moab with this tribute: "Like Abbey, we have to be volcanoes! We have to rise up and erupt against the forces that are destroying the last wild places on Earth." We had a much more tempered—but just as compelling—conversation with him at his home in Albuquerque a few months later.

* • • • *

Culturally, I never felt that comfortable in the environmental movement. In fact, I refuse to call myself an environmentalist. I'm a conservationist. To me environmentalism is about pollution's effect on people, an urban-quality-of-life kind of thing, where conservation is about wild land and wildlife. I think they're two fairly distinct movements. We used to be "citizen conservationists," which is a term that went out of style. Now we're "activists" or "environmental activists" or whatever, but I'm doing my best to restore "citizen conservationist" as a term for us, because I think it says a great deal.

The whole battle over conservation for me comes down to whether we are able to tolerate, celebrate, and love the land in a self-willed condition, where we don't have to impose our energy on it. I want to go somewhere where nature is working on its own. I want people to expand the concept of self to include the landscape around them. I want our desire to protect wilderness to come from passion and an emotional identification with wilderness.

Wild nature in North America is attacked on so many fronts. The last wild places are threatened by logging, livestock grazing, off-road vehicles, road building, mining, energy exploitation, and a host of other assaults by government and industry. It's insane.

Now, because we have wounded the land so badly, we have a seriously battered patient out there, and sometimes, even though you quit the abuse, the patient isn't going to heal. You have to go to the emergency room. I think now we recognize, forty-five years after the Wilderness Act, that some of the abuses aren't going to heal on their own. We have to go in very carefully, very humbly, and do some careful ecological restoration. To me, that means controlling, and in places eliminating, exotic species, restoring a natural fire regime, and putting large carnivores back into the system.

The Rewilding Institute is developing strategies for the survival of large carnivores. The rewilding argument posits that large predators actually help maintain the integrity of ecosystems. In turn, they require large cores of

protected landscape for foraging and seasonal movements. And they demand connectivity between those spaces.

Michael Soulé and the team at the Wildlands Project hypothesized that top carnivores like grizzly bears and wolves need to be present in an ecosystem in what they call ecologically effective densities. When these species fall below the densities needed to regulate their ecosystem, the ecological systems begin to break down. In my eyes, the accepted approach to endangered and threatened species recovery needs to be changed from preserving minimum viable populations that just barely stave off extinction of the species to restoring species at population densities where they can prevent or repair ecological wounds.

What we need is for large carnivores to fulfill their ecological function. We need a large enough population for them to do that. When the population drops below this break point, they don't fulfill their function. Yellowstone and the surrounding area are too small for gray wolves and grizzly bears. What we're trying to do at the Rewilding Institute is develop continental-scale conservation, preserving large corridors of land and the linkages between them.

We're trying to preserve corridors that link, for example, the Yellowstone National Park ecosystem with the Glacier/Bob Marshall ecosystem and the central Idaho ecosystem and the Canadian Rockies. In the East we're trying to connect a chain of wilderness areas from the Everglades to northern Maine and into Canada so the eastern cougar and the Florida panther will once again be connected. We need to restore wolves, cougars, lynx, wolverines, grizzly and black bears, jaguars, sea otters, and other top carnivores throughout North America to their natural ranges.

Obviously, there are large areas across North America where human populations and intensive agriculture do not make rewilding feasible. But without the goal of rewilding large areas with large carnivores, we are closing our eyes to what conservation really means, and what it demands.

As we look at conservation from a standpoint of evolution, it's important to protect the big branches as well as the little twigs. For example, there are only two or three species of elephants, a whole order of mammals, left on the Earth. We lose those, we lose a huge part of the evolutionary experiment. Let's keep all the pieces we have. Right now large carnivores are among the most endangered things on Earth. We've lost 90 percent of the sharks off the Atlantic coast in the last ten years. Lions have also crashed from two hundred thousand to twenty-three thousand in Africa in the last ten years.

The concept of reestablishing large carnivores is everywhere. We've talked to folks in southern Africa. There's even a group trying to rewild Scotland and bring back lynx, beavers, and wolves. Margo McKnight, formerly from the Brevard Zoo in Melbourne, Florida, and I are working to raise money to buy land for the Northern Jaguar Project in the northern Sonoran Desert in Arizona.

People have this belief that our civilization is going to endure. America will always be here. We're going to advance. We can work out all the problems. Everything is solvable. Well, it's not. If we don't have room for large predators, for wolves, bears, saltwater crocodiles, and harpy eagles, human beings have clearly exceeded local carrying capacity. In the book *Continental Conservation*, Dan Simberloff, a leading author on ecological restoration, makes it very clear that we can't restore an ecosystem

to an arbitrary point in the past. For one thing, we don't really know what it was like then, and second, even without our interference the ecosystem would have changed by now. So what we do is put all the species and processes we can back in there, and then they re-create themselves as a system. That requires more humility than we've had in other ecological restorations.

A lot of people say to me, "Oh, you've changed so much during your career." But I really haven't. What I've been doing from the beginning is trying to identify new ways of protecting wilderness, things that other people aren't doing, and it's all part of the same process. The Earth First! stuff worked for a while, but I'm beyond it. I'm trying to pull it all together.

You know, I'm a wilderness recreationist, for goodness sakes. I don't want to diminish that in any way, but that's only a piece of it. One of the points we're making to the traditional wilderness movement is if we can integrate these biological arguments, that only strengthens the aesthetic and recreational rationale for wilderness.

To me there are some very disturbing trends in outdoor recreation today, the whole extreme kind of approach, which makes the outdoors a gymnasium. You see this in human-powered sports, not just mountain biking, but in climbing, kayaking, and backcountry skiing. And the transformation of *Outside* magazine into the outdoor jock publication. I dropped my subscription to *Outside* several years ago. It's not just because I'm older and arthritic now, but there's a contemplation side of being outdoors that's being lost.

I'm trying to just keep the evolutionary dance going. We're in the middle of a horrendous extinction right now that we're causing, and I don't believe that human beings will necessarily work it all out. We people, though we are capable of doing awful things, can do extraordinary things, and we have to reach deep in our hearts and do more of them. We have to heal ecological wounds and put the landscape back together again. This goes to the heart of what kind of people we are. I can't imagine the legacy of destroying large mammals on this Earth, destroying coral reef ecosystems, songbirds, or amphibians. I'm all for compromise, it's just that our opportunity for compromise passed about a hundred years ago.

----·••·----

Dave Foreman has worked as a wilderness advocate since 1971. From 1973 to 1980 he worked for the Wilderness Society as Southwest regional representative in New Mexico and director of wilderness affairs in Washington, DC. Disillusioned by the inability of mainstream conservation organizations to halt the destructive forces within our culture, he cofounded Earth First! in 1979. Its goal was to help develop a biocentric worldview and to fight with uncompromising passion for the Earth. After splitting off from Earth First!, he became a cofounder, board member, and chairman of the Wildlands Project and served as publisher of the project's journal, Wild Earth. *He was awarded the Paul Petzholdt Award for Excellence in Wilderness Education. In 1998 he was named by* Audubon *magazine as one of the top one hundred conservationists of the twentieth century. He wrote* Confessions of an Eco-Warrior *and, most recently,* Rewilding North America.

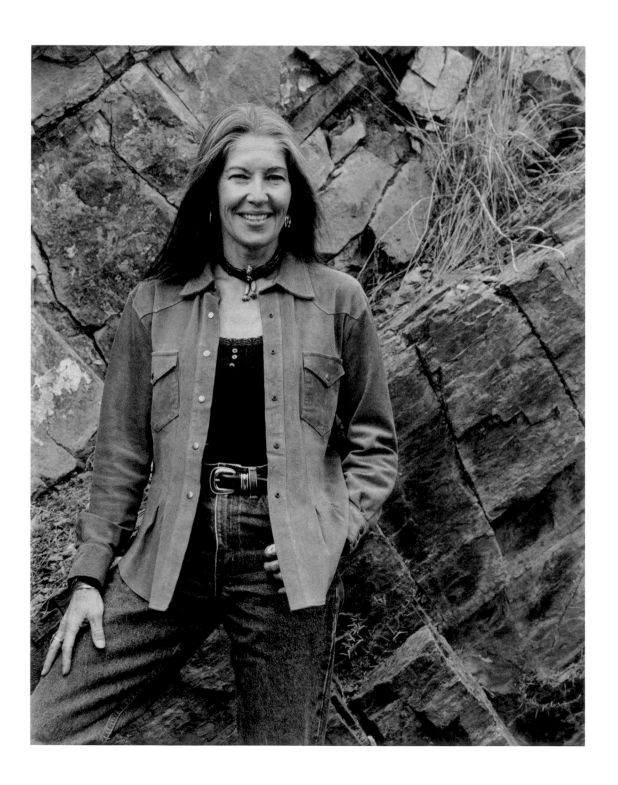

GLORIA FLORA
RECONNECTING PEOPLE TO THEIR LANDSCAPES

Gloria has been called an environmental hero by many and been criticized as a whistle-blower by some. After twenty-two years with the US Forest Service, she resigned as forest supervisor of the Humboldt-Toiyabe—the largest national forest in the lower forty-eight states—to bring notice to a group of antigovernment detractors who were threatening Forest Service employees and destroying natural resources. In the letter of resignation she wrote to her employees she said, "I learned that in Nevada as a federal employee you have no right to speak, no right to do your job, and certainly no right to be treated with respect. I could go on and on with examples of those of you who have been castigated in public, shunned in your communities, refused service in restaurants, kicked out of motels…just because of who you work for."

We talked with Gloria for hours over breakfast at a noisy diner in Helena, Montana, and continued our conversation in the funky log cabin that houses her office. On the wall hung the Olaus and Margaret Murie Award, given to Gloria by the Wilderness Society in 2000. She now runs Sustainable Obtainable Solutions, an environmental consulting firm in Helena. On the back of her business card is a quote from Aldo Leopold: "There are two things that interest me, the relationship between people to their land and the relationship of people to each other."

I left the Forest Service in 2000 after tangling with the anti–federal government factions in Nevada. That's a whole other story, but suffice it to say, political expediencies allowed bizarre antisocial behavior, which included serious harassment and intimidation of my employees as well as significant damage to national forest lands. After a string of bombings, bulldozing rivers, and threats of bodily harm and social intimidation of my employees with no support from the Department of Justice, I resigned in a very public way to call attention to the problems.

When I first arrived at Montana's Lewis and Clark National Forest as supervisor, a forestwide Environmental Impact Statement [EIS] assessing if these lands should continue to be leased for oil and gas had just begun. It became very obvious to me that the Rocky Mountain Front portion of the forest was a place of huge ecological and cultural significance. People's attachment to that landscape, their reverence for that landscape, and their passion for that landscape were really palpable.

The Rocky Mountain Front covers over three hundred and fifty thousand acres of public land adjacent to the Bob Marshall Wilderness, largely roadless wildlands. These huge limestone reefs jut thousands of feet in the air as they crash into the Great Plains. The front runs for a hundred and fifty miles from the Canadian border, almost to Helena. There are still remnants of the Old North Trail, traveled ten thousand years ago by peoples migrating up and down, all the way along the Rockies. Members of the Blackfeet Nation call the range Miistakis, "the backbone of the world."

With the exception of free-roaming bison, the front remains home to every species present at the time of the Lewis and Clark expedition, and they are thriving: wolves, bald and golden eagles, lynx, wolverine, cougar; the second largest elk herd and one of the largest bighorn sheep herds in the US; mountain goats, fish, owls—you name it. It is a fantastic, intact ecosystem. The grizzly bears on the Rocky Mountain Front are becoming plains animals again: they spend three seasons a year in the lowlands. My God, that is not happening anywhere else. The largest grizzly bear found in the US since the 1950s turned up on the Rocky Mountain Front a couple of years ago. And then we found another one! Those big boys are unique contributors to the gene pool, representing a size of bear that we almost annihilated. What a testimony to conservation.

There was tremendous pressure at the time to continue to allow oil and gas leasing because it was believed—despite evidence to the contrary—that there might be some marketable gas fields under the front. I talked to thousands of people over those two years, people from industry, organizations, government, agencies, and regular citizens. It became clear that the only responsible stewardship choice was to not allow new leasing on the Rocky Mountain Front.

I based my decision on two things: the remarkable ecological integrity of the area and people's attachment to the front, their sense of place.

This was really unusual because the Forest Service grew up believing that if industry asks for a resource, they had to give it to them. Even if it meant expensive studies and gnarly controversies. I mean, the Forest Service would stick their heads in a pencil sharpener for the sake of industry and expect taxpayers to foot the bill. The Forest Service ground through these analyses, and industry just sat back, counting their money, because the Forest Service always gave them something in the end. The typical Forest Service approach has been you take a landscape where industry wants something, you divide it in half, retain half for wildlife and other values, and develop the other half. Then you come back ten years later and divide the wild part in half again. Well, this is why we're running out of backcountry and why roadless areas are so critical, because we've done this over and over.

Where did the Forest Service's apparent lack of conservation ethic come from? I think it comes from the post–World War II fervor. We had just won the war, we had new technology and money, and the GI Bill promised a cheap mortgage to veterans. There were a lot of houses to be built, and we knew where there were trees and other materials to be had: public lands.

Obviously, industry worked very closely with politicians and the Forest Service at this time in what [historian] Paul Hirt has called "a conspiracy of optimism." If they played their cards right, they could get resources really cheaply and with little oversight. More was better, and a "can-do" organization like the Forest Service was happy to prove they could meet the challenge. And they got rewarded for producing more, which made industry happy. So there was real camaraderie there.

Industry justified its voracious appetite by claiming it was continually providing more jobs while actually, when timber harvest soared from four billion board feet to twelve [billion] in the 1970s, timber-related jobs dropped by over 30 percent in Oregon. The harvesting and milling technology was getting so good, a lot less

manual labor was needed. Timber jobs were drying up long before the Forest Service was forced back to more sustainable levels of harvest.

I see public lands as a treasure chest of national natural resources. There is not an endless supply that keeps bubbling up regardless of what we do. It operates much more like a checking account: we can't keep withdrawing from that natural capital without replenishing it. It's not a matter of policy; it's reality. The National Environmental Policy Act of 1969 [NEPA] and the National Forest Management Act of 1976 [NFMA] are beautiful acts. If we had actually followed them, the Forest Service would look very different. NEPA demands full disclosure of impacts and public involvement. NFMA is very evenhanded in dealing with resources; it supports visual quality, recreation, biodiversity, and wilderness on equal footing with commodity resources. These values are just as important to society as wood, cattle grazing, and minerals.

After leaving the Forest Service, I started Sustainable Obtainable Solutions, an organization dedicated to the sustainability of public lands. One thing I've been doing is working with the Champion Tree Project to clone the largest trees of every species. They've withstood tremendous change, natural disasters, and clear-cutting. We are trying to preserve the genetics of these trees. The US has less than 3 percent of the old growth that we had when white people first came into this country. We want to add these clones to urban forests and watershed restoration projects so that they spread their genetics back into the gene pool. In the face of climate change and shifting habitats, with the help of universities and arboreta, we're creating living libraries around the nation.

I also partner with the Center for Climate Strategies. We're helping states develop action plans to reduce greenhouse gas emissions, increase opportunities for natural carbon sequestration, and develop adaptation strategies. We use a multistakeholder process where folks can set reduction goals and come to consensus on the best actions for that state.

One of the coolest things that's happened to me is getting a species of toad named after me as an award for my forest conservation work. I love that toad and want to protect it. If each of us had a species named after us, we'd be much more thoughtful in how we treat the natural world.

* * *

Gloria Flora runs Sustainable Obtainable Solutions, a group that advocates sustainable practices and helps concerned communities and organizations understand and apply systems thinking and sustainability criteria to their deliberations on the conservation of public lands. She is currently focusing on climate change and energy issues, the keys to sustainability challenges. Gloria is featured in The 11th Hour, *Leonardo DiCaprio's heartfelt plea to wake up to the plethora of environmental issues facing us. The film offers solutions and hope in the midst of these emergencies.*

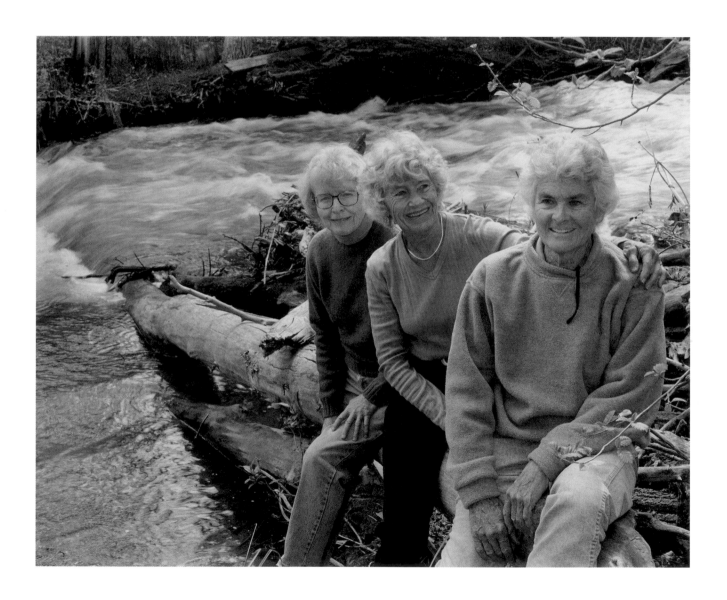

CONNIE HARVEY, JOY CAUDILL, AND DOTTIE FOX

LITTLE OLD LADIES IN TENNIS SHOES

Connie Harvey, Joy Caudill, and Dottie Fox are three Aspen mothers and outdoorswomen who first joined forces as environmental activists in the 1960s. Together they are largely responsible for initiating legislation that secured a half-million acres of wilderness in Colorado. They have since become legendary citizen conservationists and were featured in Wild for Good, *a documentary that sets their achievements against the backdrop of national preservation efforts, policy, and legislation over the past sixty years. Wilderness Workshop, a nonprofit organization they started, has become a model for grassroots environmental advocacy across the country.*

Connie and Joy continue to be very involved in defending the environment. Connie lends her voice to causes in the valley and outside the immediate area in her weekly column, "Taking Issue," in the Aspen Daily News. *Dottie, who passed away in 2006, was recognized as one of the "ten American land heroes," people who have gone above and beyond the call of duty to protect and defend federal lands, by the Wilderness Society in 1999.*

We held a memorable conversation with the three women at Joy's kitchen table, in her home overlooking Mt. Sopris. It reminded us of their legendary conversations around the same table, exchanges that changed the face of Colorado's wilderness. They were quick to note: "Our work never ends."

Connie: When our family moved here in 1959 from New Jersey, I brought along my love of animals and nature, but my life was mostly about family and skiing. I knew exactly nothing about environmental activism, and was similarly ignorant of local politics, public lands, and government legislation.

I remember my introduction to environmental activism very well. It was before the passage of the Wilderness Act of 1964, and I was standing at the Aspen Highlands ski school meeting place, getting ready to teach skiing. A couple approached me, and the man asked if I was Connie Harvey. I admitted I was, and the man then said, "You are a member of the Sierra Club," and introduced himself, Ed Wayburn, and his wife, Peggy.

At the time I didn't know it, but the Wayburns were among the greatest conservationists America has ever produced. The two of them are responsible for saving many of our greatest treasures.

Wasting no time, Ed told me that our Democratic congressman, Wayne Aspinall, then chairman of the House Interior Committee, was blocking a bill to create Redwood National Park. He said that only letters from his constituents were likely to persuade Aspinall to let the bill out of committee.

Ed had brought a film to show, so the next day I invited about ten people to come and watch it in our

living room. We concluded that as many people as possible should see it, and we managed to rent the Isis movie theater in Aspen for a free afternoon showing. Lots of people came to see the film, and collectively I think we sent over three hundred letters to Aspinall. A few months later we got a Redwood National Park, which is much smaller than it should have been, but at least it exists. That was my introduction to being an activist.

Joy was in it from the beginning. She was one of the people who came to the film.

Joy: I grew up in Denver and spent most summer weekends in the mountains. Some years we spent a month in Aspen on a friend's ranch, riding horseback and hiking the backcountry. I really loved the mountain life, and when in 1946 my parents decided we should move to Aspen, I was ecstatic.

I remember being at a high mountain lake and thinking, "Wouldn't it be wonderful it this place could stay the same forever?" Those were the days when the noisy scooters called tote goats were tearing up the backcountry. The Wilderness Act passed in 1964, and that opened a door.

Connie and I started writing letters at my kitchen table. One of our first projects was to add on to the Maroon Bells–Snowmass Wilderness. We learned where and how it was feasible to add wilderness. We needed to be political, which I found difficult. Sally Ranney, who had worked with the Wilderness Society, was helpful; in fact, I consider her my mentor as to how to go about grassroots work. Gradually we grew into a group that wrote hundreds of letters. Connie and I collaborated a lot. I would calm Connie down when she would get a little hotheaded, and she would jab me when I was a

little too conservative. We were a good pair. And we grew and grew.

Connie: We were just a bunch of people standing around a table with a lot of USGS maps spread around. We marked them up as to where we thought the wilderness boundaries should logically be.

Dottie: I came to Aspen in 1969. I had been involved in Boulder with the League of Women Voters. I learned a lot about politics in that group. I heard these two gals were up to a lot of mischief and that sounded good to me, and I began going to their meetings. I was also a member of Great Old Broads for Wilderness, a group of women dedicated to protecting America's roadless public lands.

Joy: At one point I remember Connie saying, "You know, we'd have a lot more clout if we called ourselves something." So we became the Aspen Wilderness Workshop.

Connie: We were very hands-on working. We did it all.

Joy: Our board members worked hard. When we were looking at wilderness expansion, we divided up the maps into sections and each group volunteered to take a section and look at it in detail to make sure it fit wilderness criteria and then recommend where boundaries were feasible.

Dottie: We had forty volunteers working in the wilderness. Some people went out for a day hike, and others would go for weeklong backpack trips. A few got lost. We drew on our maps what we found, and everybody came back with really accurate information. They walked the land. They slept on it, they ate on it, and they knew that territory. It was a very accurate study.

Joy: This had a lot of clout with the Forest Service. We knew what we were talking about, and we were very thorough. I think we earned the Forest Service's respect.

Dottie: Joy and I went down to the new forest supervisor's office in Glenwood Springs, and while we were waiting for him, Joy noticed a little slip of paper on his desk that said, "Do not underestimate the Wilderness Workshop."

Connie: We [also] learned that you have to get to know your congressmen and -women. You have to write them. You have to go to the Forest Service, and you have to stay on top of what they're doing. You go to one hearing, and it's sort of threatening, but the next one is not so bad. We all lobbied. We never went to Washington, but we went as far as Denver to lobby for wilderness.

Dottie: When the Hunter-Fryingpan, north of Aspen, wasn't taken in as wilderness, we became advocates for it. We had to let the public know about it. We had lectures, slide shows, and started a petition drive. We sat in front of the post office and market and asked people if they wanted wilderness up in the Hunter-Fryingpan. Of course everybody did. The Hunter-Fryingpan is so gorgeous. We had a real supportive community. We ended up with a huge stack of petitions, and we didn't know what to do with them all. So we bought a big roll of white butcher paper, and we pasted the petitions all along the roll. Then we went to the county commissioners and asked if we could hang it on the courthouse. We climbed way up to the third floor. We hung the thing down the window. It went all the way down the courthouse, way out across Main Street. It had twenty-five hundred names. All the press was there, and a representative from Congress who was in town to talk about the wilderness bill. Joy and I went out to meet

with Congressman Jim Johnson, and we rolled the thing up and tied it with a red ribbon and handed it to him and said, "You take this back to Congress and show them how the people feel about this." He just gasped. Eventually we got the Hunter-Fryingpan into wilderness.

Connie: We worked on the ski-area expansion. That was the first Environmental Impact Statement I ever saw. Then there was another on oil shale. We had to dig into those enormous manuals and write comments. And then there was Rare 1 and Rare 2 [roadless area review] and different water issues.

Joy: We wrote a set of guidelines for local planners that we called the Environmental Bill of Rights. Pitkin County officially adopted our bill.

Dottie: We saw it as a bill of rights for the land and its resources. The planning office still has it on their wall. And they say they look at it if there is a question.

Connie: I want to do a national environmental bill of rights. I think it's the time to do it. All the environmental groups are so frustrated right now because of the way they are being treated. The laws are no longer respected. If each environmental group put as much energy into supporting a national environmental bill of rights as they do into one lawsuit, it would be a constitutional amendment, mind you!

We worked on the forest revision plan, and we also supported wilderness that wasn't in our immediate area, for example, Alaska's Arctic National Wildlife Refuge. We made sure there were a lot of letters and showed a big film about it.

Over the years we've been called everything from little old ladies in tennis shoes to ecoterrorists, but the Sierra Club honored us as environmental heroes.

Joy: For a couple of years when the Colorado Wilderness Act was in process, I was working forty hours a week. It was very time-consuming. I've had people tell me I'm their inspiration.

Dottie: I still write letters and make phone calls. I've heard from environmentalists back in Washington that if you sit down and write a letter, it's much more powerful than sending an e-mail.

Joy: If there was something threatening our wild lands, we'd go to bat. The three of us had real staying power, but we weren't in it for glory. We're just interested in results.

Dottie: To know that one has made a difference in saving little bits and pieces of the planet is the reward that keeps me doing environmental work— and the great people you meet who are doing the same thing make it all worthwhile. I think if you love the land, that is a passion. We had that in common. And, we had fun.

———•··•———

Connie Harvey was born in Vienna, Austria, the only child of a divorced American mother who was there to study medicine. During the Hitler years, Connie's mother joined the anti-Nazi underground and helped many people escape, including an Austrian whom she later married. Connie attended McGill University in Montreal, where she was on the ski team. She and her husband and three children moved to Aspen in 1959. Connie taught skiing, had three more children, and became an advocate for wilderness. Today Connie remains active in ranching, writes a weekly column for the Aspen Daily News, *and continues to work with the Aspen Wilderness Workshop.*

Joy Caudill is a third-generation Coloradan. She grew up in Denver but moved with her parents to Aspen in 1946. She married Sam Caudill in 1952, and they raised five children. Now they have eleven grandchildren. She has spent more than thirty years working on wilderness and land conservation. "Wilderness," Joy says, "refuels my soul. I can go up in the mountains as tight as a bowstring, uptight and worried, and gradually it all falls off."

Joy Caudill and Connie Harvey founded the Aspen Wilderness Workshop, now called Wilderness Workshop, in 1967. The organization is still very active in wilderness and public-land conservation.

Dottie Fox, who died in September 2006 following a long battle with cancer, was a native Coloradan who raised four children. Dottie lived in the Roaring Fork Valley for more than thirty years. Her love for the land was always with her. She hiked the trails, climbed the mountains, painted the landscape, and worked hard to protect the incredible place she called home. She was chairwoman of the Aspen Wilderness Workshop and founder and board member of the Great Old Broads for Wilderness. She spent twelve years on the board of the Aspen Center for Environmental Studies, ten years on the board of the Southern Utah Wilderness Alliance, and nine years on the Pitkin County Board of Adjustment. She was president of the League of Women Voters of Aspen and president of the Roaring Fork group of the Sierra Club. Dottie was also a watercolor painter and teacher; in her words, "As my left brain deals with environmental issues, my right brain paints the lovely areas I try to save. It's been a good mix."

KATIE LEE
NOT GOING TO STOP SCREAMING

Shortly after we arrived at Katie Lee's house, perched on a hillside in Jerome, Arizona, a whole raft of men on motorcycles roared by. Katie commented, "They're all sixty-somethings. The only thing that is still hard between their legs is that damn motorcycle."

Now in her late eighties, Katie can still be found bicycling the steep roads of Jerome. She continues to travel the Southwest with her movie All My Rivers Are Gone: Glen Canyon Betrayed *and to sing her protest songs. She is the author of four books and countless ballads and love songs, all laments and protests against the bureaucracy behind Glen Canyon Dam.*

We first encountered Katie at the Ed Abbey Speaks gathering. The event was a fund-raiser for the Glen Canyon Institute, Rich Ingebretsen's nonprofit group whose aim is to restore Glen Canyon to the Eden it was before the dam. Abbey's aging clan is as audacious as ever, and Katie Lee is no exception. She was right at home surrounded by people who disdain the dam as much as she does.

On January 21, 1963, the canyon of my love was drowned and disfigured beneath the waters of Powell Reservoir, behind Glen Canyon Dam. For forty years I've been screaming my head off about this. I have put together books, films, slides, and lectures about Glen Canyon. I still tour the Four Corners to protest. I'm eighty-seven years old, and I'm not giving up.

That canyon became a part of me, and cutting it off felt like killing myself. It was like my appendage. You fall in love with a place like that and you know what it's done to change your whole life, well, then you don't let it go. I can't imagine what my life would have been if I had never seen the Glen. I was so lucky to find it at the absolutely perfect time: before it was discovered.

My friend the photographer Tad Nichols first took me down there. I went home to Tucson from Hollywood to give a concert—my first "back home" concert after five years in Hollywood. My mother gave a big party for me. Tad came, and he brought a movie of the first powerboat run that was taken down the Grand Canyon. I was knocked back silly. I thought, "I can't believe what I'm seeing. I have to see and feel that place. How am I going to get there?" A few months later, Tad called me at 10:00 at night and asked me if I wanted to go. I told him that was ridiculous—it cost $500 to run the upper Grand Canyon and $500 for the lower. I was making $10 a week. He told me I could go for the cost of my food.

[In addition to Grand Canyon,] I ended up running both Glen Canyon and the San Juan with Mexican Hat Expeditions. I brought my guitar and sang on the beach at night. That's how I paid my way. I was their entertainment. In the evenings around the fire, I pulled out my guitar and sang to the river because the river sang to me.

In between river trips I went back to Hollywood. I was there to be a movie star. I ended up doing a lot of

bit parts. And I always played guitar and sang, which confused the hell out of everyone. They never knew where to put me.

I began doing a lot of trips in Glen Canyon with Tad and our friend Frank Wright. We wanted to get away from people and go out and explore. The people who loved Glen Canyon were not joiners. We were all very individualistic. We were innocent. We were the most apolitical group in the world. We were just out there to enjoy nature and the wilderness and find out what it did for us. It took me a while to realize what was really going on with Glen Canyon Dam.

When I learned what they were going to destroy, I started writing to senators, Barry Goldwater, the white-water companies, the park service. I sent stacks of letters to government officials telling them the dam was ridiculous. That was my form of protest. They responded with their stupid form letters. Except for Barry Goldwater. We had a correspondence. He said he had to do this for Arizona. Years later he said that Glen Canyon Dam was one of his biggest mistakes. I wanted to say to him, "You bet your ass it was. I told you so in the first place. Why didn't you listen?"

It was hopeless. Poor David Brower went to his grave wishing he had stopped the dam. I told David time and again that nothing could have stopped it. It was a steamroller. Even Stewart Udall okayed it.

My protest over the years has been that I want the river to run free. At first I wanted to blow up the dam. It was fun to dream about how that might happen. I've worked with the Glen Canyon Institute and the group Living Rivers. I've sung my bitchy words "No river's safe until these apes find something else to do" to all who will listen to me. I'm angry. And I've learned that the best thing to do with anger is turn it into action.

I don't know if the dam will come down, but I do believe that Glen Canyon is going to come back faster than we think. Not in my lifetime or in your lifetime. But I know that it will happen, because the river knows the way around that dam. We are in a twenty-year drought, and nobody is paying attention. They think it is going to be over in a couple of years. Bullshit. I went through the drought in the 1930s down in Tucson. It ain't going to be over in a couple of years—it's going to get worse.

Glen Canyon Institute wants to make Glen Canyon a national park. My blood freezes to hear the words *Glen Canyon* and *national park* in tandem. National parks are for anyone at any time. Glen Canyon is not. Invite a herd of buffalo into your rose garden and you'll know why. The Glen's ecosystem was (and is) intricate, fecund, seminal, and above all, fragile. Protection, not annihilation by boot print and camp sprawl, is its due as the reservoir drops. Between the protective walls of Glen Canyon lie the cradle, the nursery, a quiet-river breeding ground for a diverse ecosystem that once fed the Grand Canyon, a canyon now sick and dying without it.

While humans are basically taking the planet apart, I bang the gong one more time for places to escape the madness. Mother Nature is pissed, and is doing her best to show us the *real* problem, which is *us*. And we still have not paid attention.

I learned from being in the Glen that time is not my enemy. I've had the best life. I wouldn't trade it for anybody's.

The Wreck-the Nation Bureau Song

Three jeers for the Wreck-the Nation Bureau
Freeloaders with souls so pure-o
Wiped out the good Lord's work in six short years.
They never saw the old Glen Canyon
Just dammed it up while they were standin'
At their drawing boards with cotton in their ears.

They've gone and dammed the Frying Pan
The Gunnison and more
For them all rivers of the world
Must be a reservoir!
So busy with inundation
They can't unsalt the sea,
'Cause that would mean an end
To their pork barrel revelry!

———

A native Arizonan, Katie Lee began her professional career in 1948 as a stage and screen actress. She performed in motion pictures in Hollywood, had running parts on four major NBC radio shows, and was a pioneer actress and folk music director on The Telephone Hour with Helen Parrish. *In the mid-fifties she left Hollywood to spend ten years singing folk songs in coffeehouses and cabarets throughout the United States, Canada, and Mexico, accompanied by her own guitar.*

Her first book, Ten Thousand Goddam Cattle, *documents cowboy songs and verse. Katie followed up the book with a double album and an award-winning documentary,* The Last Wagon, *which celebrates the lives of Gail Gardner and Billy Simon, Arizona's cowboy legends. The film won the 1972 Cine Golden Eagle Award.*

Katie published her second book, All My Rivers Are Gone, *in 1999. The book brings Glen Canyon back to life as she tells about her journeys down the Colorado River with a few close friends. It was republished in 2006 under the new title* Glen Canyon Betrayed: A Sensuous Elegy. *Two recordings were released in tandem with the book:* Colorado River Songs *and* Glen Canyon River Journeys.

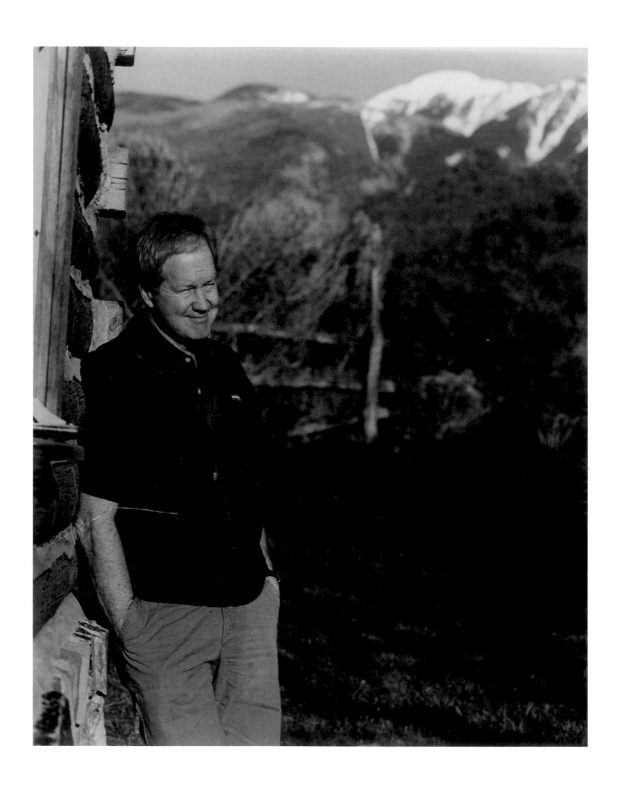

RICH INGEBRETSEN
RESTORING WHAT GOD CREATED AND MAN DESTROYED

Rich is an emergency-room doctor and a physics professor at the University of Utah in Salt Lake City. He is a devout Mormon. In 1995 he founded the Glen Canyon Institute with the intent to decommission Glen Canyon Dam and restore Glen Canyon to a national park.

We first met Rich at the Ed Abbey Speaks gathering with many of Abbey's boisterous friends, Katie Lee and Dave Foreman among them.

We caught up with Rich a second time at his office in Salt Lake after we attended the Wallace Stegner conference. His office is flooded with nostalgic pictures, maps, and books of Glen Canyon before the dam. He told us that after six years of drought, the hidden canyons, arches, and creeks of Glen Canyon are becoming visible again, a thought that lights his eyes with a palpable hope.

When I was a boy scout I hiked to Rainbow Bridge up Forbidding Creek to Bridge Canyon. It was absolutely spectacular. My scoutmaster kept pointing high up the canyon wall saying, "One day the water will be way up there and we won't have to walk all this way to get here."

I remember looking at the canyon and thinking, "Why are they doing this?" I kept thinking how sad it was going to be that all these beautiful canyons were going to be underwater.

We hiked to an alcove where the birds were playing. My scoutmaster said, "This will be underwater by this time next year." I went back ten years later to that same place and looked down deep into the water and remembered what it had looked like. It hurt my heart.

It wasn't until I was an adult that I began to investigate why they had put up the dam. I found that it was just a political structure. Floyd Dominy and the Bureau of Reclamation wanted to litter the West with dams in the name of water storage—they called it progress. In one year they built a thousand dams and hundreds of reservoirs. The result of Glen Canyon Dam, Lake Powell, is said to supply water to Phoenix, Las Vegas, and Los Angeles. In truth, those cities get their water from Lake Mead, downstream. Another truth is that the dam is destroying the ecology of the Colorado River.

The more I investigate, the more I see how useless the dam is. People think it is the power supply for Los Angeles, but the dam provides 1 percent of the power on a grid where there is a 25 percent surplus. There has never been a debate among power users. If all the dams and power-generating stations went away, we would not be without power. It's not even the cheapest power, nor is it in the bottom half of the cheapest power, and it comes at such a price.

I started the Glen Canyon Institute to look at the issues around the dam, and ultimately to try to decommission the dam, which means literally to drain it. A lot of people want the dam to come down, but we'll never get rid of it. It will be there forever.

It is our hope that we can restore Glen Canyon

with that dam still in place and save the Grand Canyon by getting free water and sediment flowing again. In our scenario, the river will bypass the dam. Glen Canyon Dam is destroying the Grand Canyon by holding back the sediment that is natural to the ecology of the river. When you don't allow the sediment down the river, the entire ecosystem is thrown off. The animals derive their nutrients from the sediment, the plants live on it, the fish live on it. We've killed the fish, and other species of the Grand Canyon are going extinct. We're getting ready to drive that canyon to extinction because of the dam. It's not right.

Lake Powell loses one million acre-feet of water a year to evaporation. That alone can provide Los Angeles for a whole year, or Salt Lake City for five years. In a system where Las Vegas and Los Angeles are out of water, to evaporate that much water to the sky is a horrible travesty. Both Lake Powell and Lake Mead are less than half full. We don't need two half-full reservoirs losing millions of gallons of water to the air. I think we can successful empty the water out of Powell and put it in Mead. Las Vegas is out of water. Phoenix, Los Angeles, every one of those Southwest cities wants water. Putting another million acre-feet of water back into the system will only help them.

This drought has been a wonderful thing for our mission because we take people down there to show them what is underneath Lake Powell. This summer or fall, we'll see the top part of Gregory Natural Bridge, the second largest natural bridge in the world. When that comes out, we'll see a big arch sticking out of water.

Where the Colorado River ends and Lake Powell starts is a very interesting place because the canyons are nowhere more beautiful than right there. Cataract [Canyon] is absolutely compelling. The rapids are enormously thundering, and there's a little island with the river going right and left, and then it trickles around the waterfalls. There are big towering sidewalls, golden in color. It is one of the most beautiful places I've ever seen. I go down into where the waterfall is, and there is all sorts of life there: little bugs and tadpoles and fish and birds. I sit there, and I'm just amazed at life. And then you turn around and there's Lake Powell, and you can see what God created, and what man has destroyed.

One year I took the president of the largest health conglomerate in Utah on a raft trip down Cataract Canyon. When he started the trip he said, "Now, Rich, you're not going to convert me." The river was high, just ballsy high, and we were on all these big rapids. We got to that point where Cataract Canyon meets Lake Powell, and there were powerboats right there at the mouth of Cataract, at the end of Powell. And the powerboat went around us and it was offensive, and he looked at me and said, "Rich, they don't deserve to be here." That's an exact quote. He knew the value of the loss.

Rich Ingebretsen became interested in Colorado River issues in the early 1990s. He founded the Glen Canyon Institute in 1995 to look at restoring the Colorado River through Glen and the Grand canyons. Later he joined the Southern Utah Wilderness Alliance (SUWA) and is now the vice chair of that organization. His passion for rivers led him to create River Bound Adventures, an educational backcountry river organization that teaches people about the importance of free-flowing rivers. His love of the outdoors and medicine came together when he

founded Wilderness Medicine of Utah in 1993.

Rich teaches at the University of Utah, where he is a professor in the Physics Department and an instructor at the School of Medicine. He is the winner of the 2005 University Distinguished Teaching Award and the Students Choice for Outstanding Teacher in 2002.

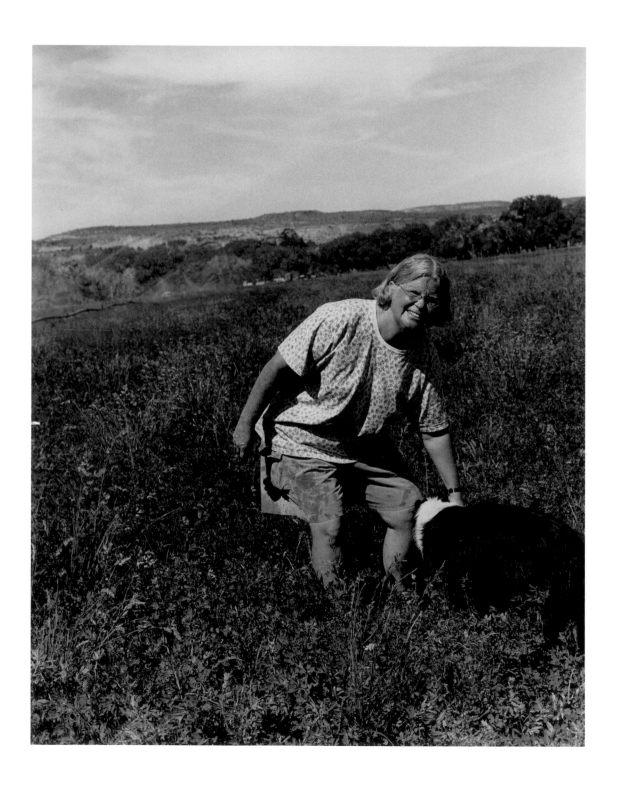

JENNIFER SPEERS
SAVING THE LAND PIECE BY PIECE

We visited with Jennifer at Cottonwood Bend Ranch, thirty miles outside of Moab, on the Colorado River. We found her irrigating the fields with her ranch manager, Scott. In work clothes and big rubber boots, she brought us back to her log home, where we sat on the porch in hickory chairs, sipping lemonade and watching the cliff swallows wheel along the river.

Raised on a farm in New York, Jennifer says she's always had the land in her blood. At her part-time home in Salt Lake City, she and her husband, Randy, work with HawkWatch International. They care for sick or injured birds until they can be released back into the wild or given a home.

When Jennifer bought the Cottonwood Bend Ranch in 2002, it was threatened by development. Adjacent to the ranch was a housing development ready to explode with growth. She bought that also, including its thirty-two-hundred-square-foot model home. In an unprecedented act, she disassembled the house, pulled the pavement out of the subdivision, and replanted the land with native seeds.

My ranch manager, Scott, and I pretty much did the tear-down ourselves. We salvaged everything we could. Scott took out the windows, the whole kitchen, and a beautiful granite countertop. We sold the windows and doors and the big propane tank. Not much went to waste other than the walls. At one point we thought about trying to save the lumber, but once you start pulling the walls apart it's hard to get decent pieces that can be reused. We did save the vegas, the big beams used for structure.

We pulled out the pavement. We pulled out the landscaping. A man from Moab came out with a tree digger and balled up all the nonnatives and took them into town. As far as I know they are living at somebody's house. But they don't belong out here.

Lots of people stopped by as we were cleaning up, wondering what was happening. One man said to me, "Wasn't there a house here? Where did it go?"

I said, "We tore it down."

To which the person said, "That was a good house."

"Yes, it was a good house," I said.

"No, it was a good house, wasn't it?" the person responded.

"Well, yes, it was structurally sound," I said.

Then he said, "Where did it go?"

People just couldn't wrap their heads around it.

I thought for sure that Scott must have thought I was crazier than a damn hoot owl. One day we were talking about it, and I asked him what he was hearing in town, if there was anything negative being said. And he replied, "People come up to me and ask, 'What is wrong with your boss, is she just crazy or what?' And I respond, 'Well, wasn't it crazy to put the house there in the first place?'"

And I think, "Goddamn, he gets it."

Looking at it now, you can hardly tell that there

was ever anything there. The road is gone. A lot of the noninvasive trees, the cottonwoods, are resprouting. We planted native grasses, but after that didn't do much restoration. We are allowing it to be its own experiment and do what it wants to do naturally.

The property is a piece of riverfront that should never have been developed. This is a desert on a steep riverbank. There is a twenty-foot drop off the bank to the river. It's not one of those properties where you can walk out to the waterfront. There had never been anything there but washed-out desert and scrub brush. Building megahomes was all wrong. I can't tell you how many people during and after the process said to me, "I'm so glad that's gone. It just didn't belong there."

I bought Cottonwood Bend Ranch to help the Nature Conservancy. I'm on their board, and I knew they wanted to preserve this land. I've bought several more old ranches since then. None of them have been worked since the 1970s. My intention is to save them from becoming developments or guest ranches right on the river. The riverbanks should be left alone.

There is nothing wrong with development, but I think we have enough now. Developing the ranches breaks up the land. I believe that as little development as possible is better, and if you're going to develop land, develop it sensibly.

I'm just sort of saving land. This is a great part of the world. It's so pretty, and I hate to see it overrun. So I guess you could say I'm trying to save it piece by piece.

If you don't live in the West and you drive through it, you might wonder what the beef is, there's so much space. Well, yes, there is so much space, but we've got to keep it that way.

Jennifer Speers was born in upstate New York and raised on a farm. When people ask how she became involved in conservation, she likes to say that conservation is in her genes. Her great-grandfather saved the Palisades along the Hudson River with the help of many other people and created the Palisades Interstate Park. She came west to go to the University of Utah and to ski and never looked back. While her legal address is Salt Lake City, she spends most of her time in Moab on her ranch on the Colorado River at the confluence with the Dolores, where she raises alfalfa to sell and cares for her horses.

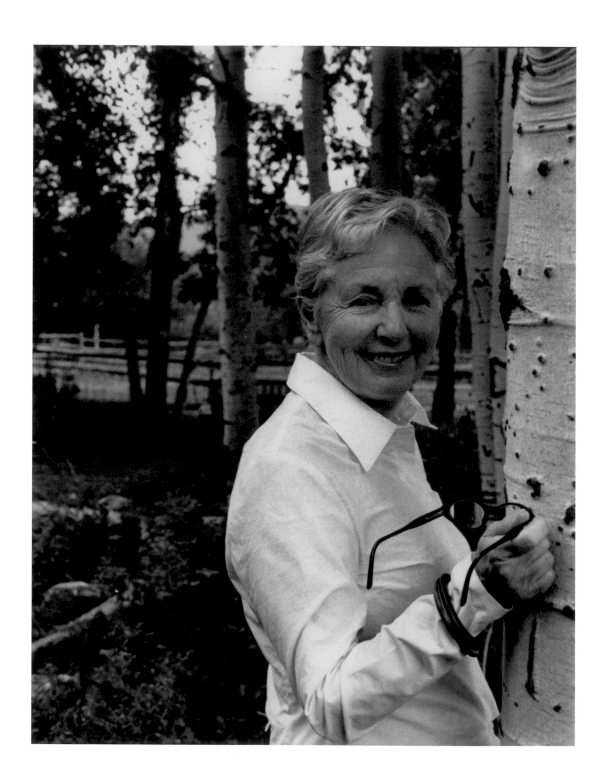

JOHANNA WALD
IN DEFENSE OF NATIONAL TREASURES

Johanna Wald is a senior attorney at the Natural Resources Defense Council (NRDC). She is a nationally recognized authority on issues relating to the management of federal lands and resources. In the spring of 2007 Meredith spent four days on an NRDC wolf and grizzly tour of Yellowstone National Park that included Johanna; NRDC's senior wildlife advocate, Louisa Wilcox; and NRDC founder John Adams. They took many presunrise drives into Yellowstone's Lamar Valley to view wolves and grizzlies in their natural habitat.

NRDC is an environmental action group working to safeguard the Earth. By fighting in court, lobbying in Congress and state legislatures, working through agencies, and mobilizing millions of people worldwide, NRDC has stopped megacorporate interests from destroying the last of our clean air and water, our public lands and wildlife habitats.

I never dreamed when I was growing up that I would spend my entire professional career protecting wildlife and open spaces. I had never been west until the summer of 1965. I fell in love with every place that I saw, but at that point I had no idea that I was going to make my life out West.

When I started working at NRDC in 1972, the public-interest law movement was very young. It was in its infancy, and to go to work for an organization like NRDC, if you were a man, was taking a very big risk, and nobody wanted to take it. But I was delighted to take it on a part-time basis. The first day that my son went to nursery school, I didn't even go with him. I was so excited to have a job that I went to work instead. NRDC had only been in existence for about four years then.

It was only in 1996 with the 104th Congress that NRDC started to become the large membership organization that it is now. The 104th Congress had a big run at public lands. They tried to tie the hands of federal-land managers so that they would still be responsible for managing our parks, forests, and other public lands, but they wouldn't be able to implement the laws. They tried to turn those lands over to the states. We launched a membership drive inviting the public—the owners of these lands—to join us in fighting the attack, and essentially we were successful. NRDC was able to mobilize lots of citizens who ultimately became NRDC members. As Frances Beinecke, the president of NRDC, says, most Americans believe that they have a right to clean air and a right to clean water. They value recreational open space, they care about special places, and they know that they do. I think it's the love of the land, the open space and wilderness, that brings people to this organization. And that's what we are committed to protect.

The BioGems Initiative is NRDC's effort to ensure that the most exceptional and imperiled wild places in the Western Hemisphere—our biogems—remain wild. It's really about citizen initiative; each year BioGems mobilizes hundreds of thousands of citizens to

take action, via Internet action alerts, postcards, faxes, and phone calls, in defense of these natural treasures and the wildlife that depends on them for survival.

The BioGems Initiative grew out of a campaign in which NRDC went up against Mitsubishi. They wanted to build a salt factory along Laguna San Ignacio, in Baja, California, which is actually the last untouched birthing area for the gray whale on the west coast of the country. We defeated Mitsubishi, and we realized that if we told people about an iconic landscape that was threatened, they would be willing to do something about it.

In 2001, when we launched the BioGems Initiative formally, is, I believe, exactly when George W. Bush became the president. We realized that oil and gas development was going to be the biggest threat to the wild lands and the wildlife of the West. We included the Greater Yellowstone Rockies as one of our original biogems because of that. And it is why we again and again ask our BioGems defenders to take action on behalf of threatened places like the Roan Plateau in Colorado, Utah's red rock canyon country, and Montana's Rocky Mountain Front. All of these places—which are beautiful and wild and are habitat for remarkable wildlife species—are reminders of the once vast wilderness that the West used to be. It is very gratifying when we tell people that they can help protect a certain place that they respond so positively.

Those messages make a difference in so many ways, especially telling the land managers that people all around the country care about specific places. That what happens to this area isn't of importance just to the people who live here, it is of importance to people in every state of this country, and many people who live beyond it. So it makes it more than just a local issue or a regional issue. I've had land managers tell me, "I didn't realize that this place mattered to so many people."

We have generated about fifty thousand messages so far to protect the Vermillion Basin in northwest Colorado. We've received hundreds of thousands of responses to our action alerts on Yellowstone. Typically we get forty- to fifty- or sixty thousand on a land-use issue, which shines a public spotlight on the issue. Frequently a project will be scaled back or revised to make it more environmentally responsible as the result of this outpouring of public support. In other cases, projects have been abandoned outright. For example, we had an action alert on a proposed oil and gas project near Glen Canyon National Recreation Area, and people responded. I think there were close to eighty thousand messages that time, and the project was rejected.

Then there was an oil and gas project proposed along the White River in southern Utah. It was the third time the Bureau of Land Management tried to get this project off the ground. And it was the third time that we asked BioGems defenders to help us speak out against this project. We had the word out for less than a week, it was summertime, and a lot of people were on vacation and away from their computers. We generated forty-nine thousand messages. It was extraordinary, really extraordinary.

I think the environmental and conservation organizations understand the huge threat we're facing today with the devastating plans for oil and gas drilling. We understand also not only that no single organization can stop that threat, can even build a credible defense for that threat, but in certain cases, like in the Powder River Basin in Wyoming, we have to go way beyond ourselves

and our members and build coalitions that are more characteristic of the environmental movement in the earlier days.

Some of my earliest clients were the Powder River Basin Resource Council, and Northern Plains Resource Council, and Western Organization of Resource Councils. I went to court with those farmers and ranchers as an environmentalist to try to stop the sacrifice of the Powder River Basin for its coal, but somehow, and I'm not even sure that I know yet the reason, those coalitions sort of fell apart and we went our separate ways. With the advent of the [George W.] Bush administration, what we as a community, and I as an individual, and the NRDC as an organization realized was that we had to reach out, not just to farmers and ranchers, but also to hunters and anglers, because we had somehow stopped talking to them.

We started talking to each other again and strategizing and prioritizing and deciding together what was the successful outcome of a specific campaign in a particular place that was faced with whatever particular specific threat— whether it was a land-use planning process or an oil and gas project.

I have ideas about a vision for the West, particularly given the huge challenge of climate change. We have to think about bigger protective areas, more wilderness, and we have to focus on the connections, the corridors, and the other means of connecting these larger protected ecosystems up and down the spine of the Rockies. We need other voices, we need other interests, we need the farmers and ranchers, we need the people of the small communities, we need the people of the bigger communities who are going to look to the open space of the West for their recreation. All of those people are important

and need to participate in the construction of their vision. It needs to be more than just the resources and the lands themselves.

When I think about the first time I went to Yellowstone and I saw a wolf, I couldn't decide whether or not I should fall down crying or jump up and down with glee at the realization that we as a society could undo an ecological wrong that we had done. If we can bring back the wolf, we can do almost anything. We can really rehabilitate strip mines, we can really rehabilitate oil and gas fields, we can restore our ecosystems, and I get emotional, as you can tell, when I even think about it. It's such a moving affirmation.

My work is incredibly gratifying. I think the coalitions we have built that I'm working with and am part of now are among the strongest coalitions that I've seen throughout my thirty-six-year career at NRDC. My hope, and actually my commitment, is to do everything that I can to keep those coalitions strong so that when we don't have to fight these huge defensive battles anymore, we can be proactive. We can sit down together and create a vision of the West we all share, and that we want to promote. And my hope is we can do it together, because if we don't do it together, first of all it won't be very good, and second of all it won't be enduring.

Johanna Wald grew up in the East but fell in love with the West on her first visit, while still in law school. She joined NDRC in 1972 and ever since has been working to protect publicly owned wild places, most recently from inappropriate energy development. When people ask how it is that she has done this work for so long, she says there

are two reasons: first, the lands themselves, and second, the westerners and other people she's had the privilege of working with along the way. Together they sustain her

commitment. She lives in San Francisco with her husband but spends as much time outdoors experiencing the public lands as she can.

ADVOCATING FOR WILD CREATURES

Wolves and bears are close to our hearts in the American West. We wanted to look at the controversies that face wild animals and address the often contentious Endangered Species Act, for the fate of the gray wolf and grizzly bear is still dependent on human decision making and public policy. We began with Doug Peacock, whose veneration for grizzly bears and the wild is legendary, a passion he writes about in his book *Grizzly Years*. Chris Servheen is the grizzly bear recovery coordinator for the US Fish and Wildlife Service and has a more pragmatic approach to their survival. Then there is the controversial wolf.

Stephen Gordon, whose Diamond G Ranch borders Yellowstone National Park, sued the federal government over the wolf's reintroduction in 1994. In reaching for compromise, Jon Robinette, Stephen's ranch manager, implemented a coexistence program for grizzly bears on the ranch and is working to do the same with wolves. We wanted the wolf to have a third voice, so we also spoke to Hank Fischer, a leader in the ten-year effort to restore wolves to Yellowstone and central Idaho. He has spent years watching them in the wild and offered yet another viewpoint on a complex situation.

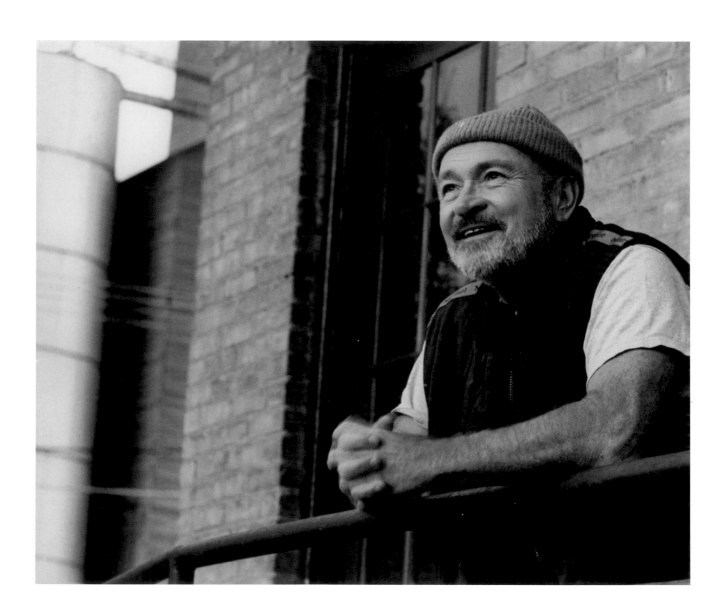

DOUG PEACOCK
TO A GRIZZLY BEAR, WE'RE JUST ANOTHER FLAVOR OF MEAT

We agreed to meet the infamous Doug Peacock at Montana Ale Works, a brewpub in Bozeman, Montana, near his hometown of Livingston. We miscommunicated on time, and when we found each other the drinks had already been flowing. We sat in the only quiet corner, in a back room of the pub, and enjoyed a soulful conversation with Doug and his wife, Andrea.

The author of many books, including Grizzly Years, *Doug is a proponent of wild spaces. He was the model for Edward Abbey's character George Hayduke in* The Monkey Wrench Gang, *and while he is no Hayduke, one commonality stands: he is an outspoken defender of wilderness and critic of man.*

Going into grizzly bear country is such an exercise in humility. It's not like in California, where you put on your Kelty pack and get to be the top dog. You're a second-rate citizen in grizzly country. You hear a little better. You see a little better. This one animal alters the psychic content of the land that much.

Of course, we're the dominant paradigm, the dominant species, the great white race that conquered and slaughtered animals on this continent like no other people ever did to any other continent of animals. No one matched what we did to the American bison, the wolf, or the grizzly bear. The biomass of death we dealt, it's unprecedented in the history of the world.

The grizzly bear is the one thing on this continent that rises above all of that domination and screams out a different message. The presence of this one animal can insist on humility in human beings because to them, on certain occasions, we're just another flavor of meat. It can kill and eat you anytime it wants to. It largely chooses not to, but it could and it can. The lessons are not warlike macho symbols at all. The lessons are awe, reverence, restraint, and humility. That's what the bear teaches.

I'm not at all happy about the way grizzly bears are treated today. What grizzly bears need is wild. Grizzly bear management is like military intelligence. It's a contradiction in terms. You can't manage this animal, you have to allow it to exist outside our control, and our culture is very bad at letting go of that kind of control.

The only way to have the bear out there is to give it habitat. The greatest habitat requirement for a grizzly bear is security from human beings. That's it. I mean, they can make a living anywhere. They are the great pioneers on this continent. They can live almost anywhere in the West that's not paved or plowed, but they need security from human beings, and in short that means roadless habitat. We had the Roadless Initiative that was all of a sudden turned around by the Bush administration.

Now the US Fish and Wildlife Service has taken grizzly bears off the endangered species list, leaving Yellowstone without any linkage to other grizzly bear populations. Without genetic exchange from areas like Glacier National Park in Canada or a much larger number of grizzlies, they're doomed to extinction, whether it's

in fifty years or five hundred years. [US Fish and Wildlife Service wildlife biologist] Chris Servheen and his friends would perhaps solve that by helicoptering in a few bears, but, quite frankly, that's not good enough for me. Delisting the grizzly is absolutely bad for the bear in every way I can think. In fact, it may represent one of the most destructive actions the Bush administration took against the natural world, largely because the Yellowstone grizzly delisting policy was developed hand-in-hand with the government's denial of the existence of global warming.

We are now facing the greatest climatic changes in history. In the Yellowstone ecosystem, [these changes] already threaten major bear foods. Whitebark pine and its nuts are the grizzly's most important fall food. They're full of the fat and protein bears need to survive the winter. These trees are vulnerable now to blister rust and beetle infestation. They could be gone from Yellowstone within a few decades. Without these nuts, grizzlies are going to look for food at lower elevations, which means their chance of running into people is higher. Translate that into more bears getting killed.

Man and bears have coexisted together for at least twenty thousand years, and only recently has that relationship altered. Bears can live with human beings. They tolerate us very well. It's we humans who are ignorant and intolerant. Right now there's a whole politic that's real and alive and deadly, especially in the Northern Rockies. The profile tends to be recent immigrants from California who are male. They buy the biggest trucks, and they have five Kill a Wolf bumper stickers, and they truly out-redneck the locals, the people who have lived here a long time. There are no laws. The endangered species laws have not been enforced. There's no prosecution.

A person killing a grizzly bear is going to get the maximum fine of $777, which is what my drywall cost today, incidentally. A successful grizzly hunt in Alaska or Canada costs about $17,000.

Before agriculture, we saw these animals as kin, as relatives, and we had elaborate residual contracts where when a hunter took a life, he gave something back. He always had a contract with the animal, and they were seen as extensions of ourselves. It was mixed up together. The way we should treat other species draws from the same well as the way we should treat other cultures, other races, other sexes and sexual preferences. It is a well of tolerance.

I don't know how human beings rationalize the way they treat wild animals. But, you know, it has everything to do with the way we treat prisoners in the foreign prisons. The great slaughter of the American bison—we killed seventy million bison in probably sixty years—I see the human carnage witnessed in Vietnam as having the same things in common.

Throughout the years, people have told me that *Grizzly Years* was valuable to them, to hear how I handled what was—well, I wouldn't have called it anything in those days. It was just war sickness, but it's got all kinds of psychological names now. I could not have survived after Vietnam without having wild country to go back into. So the salient issue for me is wilderness as primarily a place for wild animals. Without that, I don't think we'll have much of a world left. If we can save wilderness, we'll have a chance to save ourselves.

I just finished writing an introduction to a new book, *The Best of Edward Abbey*. I thought there would be all kinds of Ed Abbeys coming along in the last fifteen years. Hell, there should be a hundred Ed Abbeys.

And for whatever reason, there aren't. What else are we going to do? Roll over and play dead? No. We can fight. I'm gonna sharpen my knifes, clean my weapons, and keep fighting.

—————⚬•⚬•⚬—————

Doug Peacock served in the Vietnam War and, upon returning, felt so disillusioned with human society that he sought solace in the beauty of the wilderness. Although he had little scientific background, his passion for and firsthand experience with bears soon brought him recognition as an expert in grizzly behavior. He wrote Grizzly Years: In Search of the American Wilderness *after returning from Vietnam, where he served as a Green Beret medic. The book conveys man's need for wilderness and wild animals and advocates for the protection of the grizzly bear. Most recently he published* Walking It Off: A Veteran's Chronicle of War and Wilderness *and* The Essential Grizzly, *with his wife, Andrea Peacock. His newest book,* In the Presence of Grizzlies: The Ancient Bond Between Men and Bears, *was released in March 2009.*

CHRIS SERVHEEN
THE MOST IMPORTANT HABITAT FOR GRIZZLY BEARS IS THE HUMAN HEART

We met with Chris Servheen, the grizzly bear recovery coordinator for the US Fish and Wildlife Service, in his office at the University of Montana, where he surrounds himself with photographs of bears, habitat maps, and a casting of a grizzly footprint the size of a basketball. Meredith wanted to photograph Chris with a grizzly bear, so he took us to the Brown Bear Resources gift shop in downtown Missoula. The store has two full-size grizzlies, albeit stuffed ones. We chose the large, snarling bear, but Chris pointed us to the smaller, more realistic standing grizzly. He was a good sport, posing with the bear and not mentioning what he really thought of the idea.

Chris directs all the research and management on grizzly bears from Yellowstone through Glacier National Park, northern Idaho and Washington to the North Cascades. In 2005 the US Fish and Wildlife Service proposed removing the grizzly bear from the endangered species list in Yellowstone National Park, and in March 2007 the law went into effect. Only a challenge in federal court can stop the ruling.

People think that grizzly bears are huge, powerful, dominant animals, but the truth is that they are really, really vulnerable. Their survival on the land is up to us. Animals like starlings or house sparrows are the ones that are super powerful, because they're going to be here no matter what we do. Bears are not.

In Yellowstone we've achieved our recovery goals. We have about five hundred grizzlies that live in the area. We have a system in place to ensure the future of the bears, which is why we proposed the delisting of that population. That is the objective of the whole recovery program. There are several other ecosystems with bears that aren't up for delisting: the northern Continental Divide up in Montana, the Yaak [Valley] in northwest Montana, the Selkirks in northern Idaho, and the North Cascades in Washington. It will probably be a long time before we consider delisting in those populations. But we've been working on Yellowstone for twenty-five years.

If the bears run into too much trouble, they can be placed back on the endangered species list. Grizzly bears are a managed population. Delisting doesn't mean we walk away from them and say, "Good luck, hope you're here in a hundred years."

I don't think that whitebark pine nuts are essential to the survival of grizzlies like other people do. It is not an annually available food. The key issue is not the change in pine nut availability. The key issue is how they're going to respond to that change. We know that there is an increase in temperature. There's no doubt about that. But we don't feel the current situation is a long-term threat to the bears. We're talking about one of the ultimate generalist species. It eats everything.

Some people think there is never enough protection. They want more bears, and they want space for the bears. We wouldn't be proposing delisting if we didn't

feel we'd met all the needs of the bear and we can guarantee the long-term future of the bear. There are no plans that allow for hunting yet. Hunting will never threaten the future of Yellowstone grizzly bears.

The recovery of the grizzly bear is not a biological problem; it's a social problem. The biggest threat to grizzly bears right now is private land development. There may be oil and gas on the periphery of grizzly bear habitat here and there, but I don't think it's going to be a big deal. What happens on private land really is the dominant mortality factor. If ranchers in the Yellowstone area can't maintain viable ranches, their land is going to get sold and subdivided. That is much more of a threat to grizzly bears than a few cows. We have a lot of grizzly bears interacting with cows, and there's very little problem between them. But when you take those big blocks and you cut them into subdivisions and you get these big trophy houses all over the place, it changes the movement patterns of animals like elk and bear.

Big landowners like Ted Turner who buy and preserve large pieces of property are very important to the future of multiple wildlife species. The Flying D has a hundred and twenty-five thousand acres under conservation, and it adds to the Yellowstone ecosystem. That's an incredible piece of ground, and they've got grizzly bears. They're doing a lot of good.

We need to link grizzly populations with other grizzly populations so that they're not islands. The linkage issue involves three things: working with the highway departments to get roads that are friendly and permeable to bears and other species, working with private land owners, particularly in these mountain valleys where the bottom of the valleys are often in private ownership, and working with the manager adjacent to the private lands. And finally, we also need county commissioners to understand and communicate to citizens what it means to live in bear habitat, like not leaving food and garbage outside.

If we lived in a perfect world, we could leave bears alone. But we live in a world with lots of human activity on top of bears. Their survival is based on the people who live, work, and recreate in bear habitat, not environmentalists in Washington, DC. We want citizens to own the fact that there are other species that are worthwhile having around. And the question is, will we as humans who are now dominating the landscape allow some level of space and accommodation for these animals? If we can, then we will have these animals. And if we can't, if we say, "No, we don't have space for them," or "We don't want any roads closed," or "We don't want restrictions on ATVs," then we will make the decision not to have them. It's the guy with the gun when he's elk hunting deciding whether he is going to shoot that bear or not. Those types of decisions will determine the future for grizzly bears.

The most important habitat for grizzly bears is the human heart. That's where it is.

⁘

As grizzly bear recovery coordinator for the US Fish and Wildlife Service since 1981, Chris Servheen is responsible for coordinating all the research on and management of grizzly bears in the lower forty-eight states and working with biologists in Alberta and British Columbia. He was the Environmental Impact Statement team leader for the Bitterroot Grizzly Bear Reintroduction EIS. He has led

projects involving the application of Global Positioning System collars on grizzly bears and black bears to learn more about their movements in relationship to human activity, and he works with state and federal highway departments in developing ways to move animals safely across roadways.

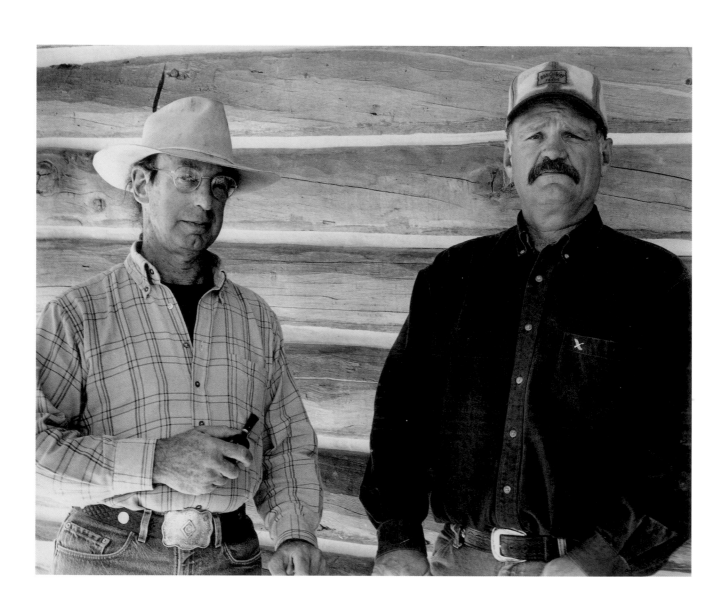

STEPHEN GORDON, JON ROBINETT, AND HANK FISCHER

THE VERY COMPLICATED WORLD OF WOLVES

By 1926 wolves were completely eradicated from Yellowstone National Park and almost entirely from the interior West. The story is grim. In less than fifty years humans intentionally killed every wolf we could. Wolves were poisoned, hunted, and trapped by a burgeoning civilization that saw them as an enemy. In Shadow Mountain, author Renee Askins, director of the Wolf Fund and one of the people responsible for the reintroduction of wolves to Yellowstone in the 1990s, says, "Our forefathers didn't just want to control wolves, they wanted to conquer them. They didn't just kill wolves, they tortured them. They lassoed animals and tore them apart by their limbs, they wired their jaws shut and left them to starve, they doused them with gasoline and ignited them."

The eradication of wolves was followed by a long political struggle to reintroduce wolves to Yellowstone National Park in the 1980s and 1990s. Thirty-one wolves were introduced between 1994 and 1995. Now they are thriving. The state of Wyoming estimates it has 309 wolves in 35 packs.

But there is no clear picture on where humans stand with wolves. Many love them and think no number is too many. Others hate them and continue to kill them. What is clear is that in order to coexist with human society, wolves need to be managed. The US Fish and Wildlife Service wants wolves removed from the endangered species list. However, Defenders of Wildlife and many other environmental groups disagree with this move. They believe wolves need more protection and if they don't have it, we will eradicate them again.

In March 2008 wolves in Idaho, Montana, Wyoming, eastern Washington, and Oregon were removed from the endangered species list. In the fall of the same year, conservation groups won a lawsuit and the wolves were relisted and protected once more. In the months leading up to that ruling, however, more than 110 wolves were killed in Idaho, Montana, and Wyoming—almost one per day. Before leaving office in 2009, President Bush once again removed federal protection for wolves in Idaho and Montana, leaving them at risk to man's hand. In his new post as secretary of the interior, Ken Salazar rubberstamped Bush's plan.

The future of wolves hangs in a delicate balance. Conservationists argue that wolves need large corridors of protection to survive as a species, and that protections in Wyoming won't matter if wolves aren't protected in the bordering states of Idaho and Montana. The wolf population in Yellowstone National Park shrank in 2008, which shows that even when protected, wolves are very vulnerable.

STEPHEN GORDON
WHAT ABOUT MY PRIVATE PROPERTY RIGHTS?

Stephen Gordon owns the six-thousand-acre Diamond G Ranch, formerly owned by the Disney family. The ranch sits at the north end of the Dunoir Valley, about twenty miles north of Dubois, Wyoming. It is surrounded by national forest on three sides and also borders Yellowstone National Park. Carved in half by the Dunoir Creek, the valley is an elk migration corridor between Yellowstone National Park and the east fork of the Wind River.

Wolves that have wandered out of the park are wreaking havoc on the ranch. Stephen was the first person to sue the federal government over the reintroduction of wolves, claiming they are making mincemeat of his cattle and his lifestyle. We journeyed to the Diamond G Ranch, a gorgeous valley that backs up to the Absaroka Range. He cooked us elk stew that we ate while we talked with him and his wife, Marilee. We noticed that he kept a gun next to him at all times.

The Nature Conservancy has indicated that this ranch is the most ecologically diverse of any property in private hands in the state of Wyoming. We have grizzly bear, moose, deer, antelope, bald eagles, hawks, great blue herons, beavers, otters, and badgers. But it has also been a cattle ranch for almost a hundred years.

When wolves were reintroduced, we had the first impact, since we're the closest to Yellowstone. Two wolves came down here and denned a couple hundred yards off our property on the national forest. They had five pups. Then they started killing my livestock.

Before the wolves came, we had a death loss in our livestock of 1 to 1½ percent a year. Since the wolves have come, we have lost 10 percent every year. Originally we ran a herd of eight hundred. The first year we lost forty calves. We lost sixty-two another year when we had six hundred calves up here. We cut the herd back to 334 this year. We had twelve confirmed kills, eleven by wolves, one by a bear. And we have twenty missing. They are unaccounted for, and we presume they were killed by wolves.

The US Fish and Wildlife Service [USFWS] has done its own study and found that for every calf the wolves kill, there are four others that were killed that they didn't find. The Defenders of Wildlife created a voluntary fund, as an inducement to the reintroduction of wolves, to compensate ranchers for their losses, but they only pay for kills that are confirmed by the USFWS. But the USFWS has been loath to confirm wolf kills, since their estimates were unrealistically low. As a result, the Defenders of Wildlife paid us for about 5 percent of what we lost.

We've had a terrible time for a lot of reasons. First of all, we've had to reduce our herd. Secondly, when the cattle are here, my ranch manager, Jon, stays up from midnight until five in the morning trying to run the wolves off. The one night that he didn't go out was the night we had a calf killed. We've lost nine dogs to wolves, all killed in the yard.

Not only does the presence of wolves create a lot

of anxiety and extra work for us, but if we find a dead calf—and we've had twelve confirmed this year—we have to call up the USFWS and wait until they come and look at it. We waste a whole day. Now they're willing to actually confirm kills, but for the first few years after they reintroduced wolves, they refused. They said to us after looking at one dead calf, "Well, maybe it was killed by Martians."

We went to the USFWS because we had worked with them before with grizzly bears. We asked to be part of the solution. We said, "Look, this is a problem for us. You need to figure out how to manage the wolves around livestock."

We went to Washington. We met with the head of the USFWS and the undersecretary of the Interior Department. We put forward our case, and we got nowhere.

They denied that there was a problem. They would come up and look at a dead calf and say, "Well, it looks like the wolf killed it, but we can't prove it, so we can't confirm it." Back then the policy was if you had two confirmed kills they'd come in and kill one wolf and see if that made a difference. That went on for a few years.

Because we were getting nowhere with Fish and Wildlife, I sued them in federal court. I perceived that the wolf reintroduction program provided for the elimination of predatory wolves and included language about protecting ranchers and that they weren't doing this.

The judge sat on our case for three and a half years. He then only looked at the official record, which did not show predation. He discounted the testimony that wolves were killing our livestock and dismissed our case as being premature. We never got a fair court hearing.

Now we have a permit to shoot them. The problem is they come in at night. Our cattle are spread over tens of thousands of acres. We can't really defend them. Since we've had this permit we've been able to shoot two wolves in four years. It's not so easy.

We can't use our dogs anymore for working livestock, which is a problem for us. Even when we take them out during the day, if we encounter wolves in the woods, they'll kill the dog.

The history of the West is a history of land use. The generations of people who came here, starting in the 1800s, came here to ranch. They came here to farm. They came here to log. A lot of the ties for the railroads were cut in these mountains and floated down the Wind River to the railhead in Riverton. Now the generation of people who come here have come to be in this environment but not use the land. They want to hike. They want to see wildlife. They're not taking into account the importance of the others who are here.

This ranch is productive. We are raising livestock. The livestock belong to me. If someone came into your house and stole your TV set, you'd probably scream bloody murder. Well, it's the same with us. We have a thief who's coming in and stealing part of our livestock. Wolves will probably put us and other ranchers out of business.

When you have to make a living on the land, it creates a very different mentality: self-sufficiency, a sense of pride, hard work, and integrity. A lot of that is an American culture, the culture of the cowboy, the culture of the people who settled the West. And to the extent that this disappears, you're going lose a lot of the culture of the West.

We're the victims of outsiders because not only are

a lot of the environmental interests outside interests—Defenders of Wildlife are in Washington, DC—but the environmentalists and the government have sold the people of this country a bill of goods with respect to wolves. They say, "Wolves have a bad reputation. You know we need to bring them back. They got a bum rap."

Well, that's not true. They were eliminated because they conflict with human civilization. What about my private property rights? Is the fact that we actually get to own property here lost in this whole debate? That's what makes us different than other places. We border on twenty-two million acres of public land. The government owns half of the land in the state of Wyoming.

In Teton County, where Jackson Hole is, 90 percent is public land. The public has plenty of territory.

—•◦•—

Stephen Gordon was born in Chicago in 1942, educated at the University of Chicago, New York University Law School, and Cambridge University. He practiced law in New York from 1968 to 1970, worked on Wall Street in investment banking for several years, and served as CEO of a group of industrial companies he acquired in 1975. In 1989, after spending twenty years working in an office in Manhattan, he sold these businesses, choosing to live in the West and raise cattle.

JON ROBINETT
WOLVES ARE PAYING THE PRICE FOR WHAT WE DID

Jon Robinett, Stephen's ranch manager, has proposed creative solutions to the state of Wyoming. He worked successfully with Wyoming Fish and Game to deal with grizzly bears on the Diamond G. Now they cohabitate peacefully with all beings on the ranch, including cattle. To mitigate the depredations from wolves, Jon studies their behavior. He keeps pictures of the different wolves and packs on the ranch, and of the many kills. He did not support wolf reintroduction, because he didn't believe the wolves would be well managed. Now that they are a real problem on the ranch, he has to kill the wolves that kill livestock or the ranch goes out of business.

—•◦•—

What we're finding out is that there is no predictable behavior for wolves. What you see is their behavior. They come up on the porch now to get a dog. Sometimes they act like feral dogs. Once wolves learn that behavior, they don't stop it.

Here they don't follow the prey base. They don't follow the elk migration because they don't have to. They have a built-in one with the cattle. We've been able to manage around the grizzlies, but it's impossible to manage around the wolves.

Our problem is chronic because we're so close to Yellowstone. This is highly valued habitat for wolf prey. Wolves don't need specific habitat like bears do to survive; they just need food. Hank Fischer says the reintroduction

of wolves completed the ecosystem. What the hell does that mean? It's helped the riparian areas and the cottonwood stands, it's reduced the number of ungulates, but are those reasons enough to bring them back? Wolves have changed the whole dynamic of this area.

In the cattle business here, the number of depredations we have by predators is insignificant [compared to] the number of cattle we work with. Unless it's happening to you. There are twenty-three thousand public-land users in the cattle and sheep industry in the USA. If they all went out of business tomorrow, it would only retard the red meat industry for a week. We can't say we need this meat, but what we do say is that we have the same constitutional rights that you do. We have the right to be here (so far). We have the ability, and it is our way of life.

Every dollar Stephen puts into the Fremont County treasury turns over six times before it leaves the area. That is something most people don't understand. The economy of this community is based on recreation and wildlife resources. The cattle industry is still a big player. If we lose our elk population or our cattle population, recreation won't compensate for those two losses. We have to work our way out.

We offered to get rid of the cattle and turn Stephen's land into open space. We went to the state legislature and asked if we could do away with their proposed commercial status of this property. We asked that instead of raising the tax base to commercial property, which increases the property taxes ten times, that we be able to keep it agricultural status. What better benefit to all? If we turned this all into open space, the surrounding allotments would become recreational. There wouldn't be any

cattle. There wouldn't be any conflict. To us, this was the perfect solution.

All the government sees is that the market value of this ranch is 5 percent of the development value of the ranch. There is no equitable trade-off with the wolf program. Stephen pays the price for what everybody else wants.

In Wyoming we need to look at population density of wolves and leave the rest of them alone. We only wanted to maintain wolves in certain areas. Where they are socially and economically unacceptable, we need to eliminate them. Now the federal government wants to take wolves off the endangered species list.

The two things I don't agree with are why would you bring a species back to hunt it? The goal of the state is to have a wolf- and bear-hunting season. If you want to have wolves in Yellowstone, that's fine. But why let the population increase so we can have a hunting season?

When the government gave us a shoot-on-sight permit, we received death threats. Anonymous people made threats against my grandkids. The environmental community helped get the wolves in. Now that it is time to start managing wolves, the environmentalists turn on us, the people who want to manage them. Since wolves were transplanted into Yellowstone under the experimental, nonessential provision of the Endangered Species Act, we can't legally kill one unless we see it in the act of depredation.

Wolves are paying the price for what we did. That is the part I don't like. We say, "We don't want them, we'll just kill them. Well, we didn't want them to begin with." It's not fair to the wolves. If you are going to give a piece of land to an animal, you shouldn't delist it. It's like what we did to the Indians. We gave them the worst

piece of land we could find, then we said, "There's oil on it; we want it back." We did the same with the wild horses and the buffalo. We don't manage things, we destroy them. We interfere. We reintroduce the wolf, list it to protect it, delist it to control it. Why did we even start this insanity?

Humans have a lot of arrogance. We're kind of up above looking down, and we don't feel like we are part of life. The further we get away from the land, the less stable we are. If I see a wolf out on this land, my choice would be not to shoot it. I want to know why he's here and what he needs. We can't coexist if we don't understand the animals' needs. That is the key to it. If ranchers and people around the state who want to stop wolves

were a little more flexible, if we all worked together, we could accomplish something.

---·••·---

Jon Robinett was born and raised in Casper, Wyoming. He is the great-grandson of Dan Speas, who came to the Casper area in the late 1800s to ranch. Jon has been involved with the cattle industry most of his life. He has managed yearling, cow, calf, and registered cattle operations. Jon was on the National Board of the Red Angus Association and was a brand inspector in the Laramie area. He is currently managing the Diamond G Ranch in Dubois, Wyoming, where he has worked since 1989. He is married to Deb and has two children and four grandchildren.

HANK FISCHER
SOME CALL THE WOLF A KILLER, BUT HE'S ALSO A GREAT PROVIDER

Hank Fisher is a special projects coordinator with the National Wildlife Federation. He helped in the fifteen-year-long effort, between 1980 and 1995, to reintroduce wolves to Yellowstone. He and his wife take people into the backcountry to observe wolf behavior. He has devised several programs that assist in the successful cohabitation of humans and wolves. We visited with him at his home outside of Missoula, Montana.

---·••·---

Wolves are a big issue for many ranchers, even if they don't graze livestock where wolves are present. For many, it's about control. Ranchers used to be the dominant users of public lands, but that has changed dramatically

over the last several decades. For some, wolf reintroduction is a symbol of that change, a signal that the ranching community no longer controls public-land management. Now don't get me wrong, ranching is still important, and hopefully will continue to be in the future. But significant polarization has developed between the livestock community and conservationists. Ranchers feel like wolf supporters don't value their way of life or respect the contributions stockmen make to wildlife conservation.

In the 1990s I established Defenders of Wildlife's Wolf Compensation Fund. Our goal was to assume at least partial economic responsibility for the problems caused by wolves. The fund pays ranchers at market value for livestock kills. I believe the program has helped promote

Stephen Gordon, Jon Robinett, and Hank Fischer *123*

tolerance of wolves, and certainly has sent a signal that conservationists are concerned about wolf impacts on ranchers. The fund has paid out more than $900,000 in claims since its inception.

While at Defenders, I also started a Proactive Carnivore Conservation Fund. This provided help to ranchers who took actions to prevent predation, such as having livestock-guarding dogs, building electric fencing, or providing additional range riders. Since the program started, Defenders has initiated nearly two hundred projects at a cost of almost $700,000.

When I moved to the National Wildlife Federation [NWF] in 2002, I wanted to take the wolf-livestock issue one step further. The problem was what could be done in situations where ranchers were doing all the right things and yet they were still experiencing chronic wolf problems. NWF started an allotment retirement program in 2003. We pay ranchers market value for voluntarily retiring their livestock allotments. In almost all cases they use our funds to secure new grazing in areas without predator conflicts. Since 2003 we have retired twenty-three allotments totaling nearly five hundred thousand acres. These include some of the most contentious grazing allotments in the Yellowstone ecosystem. Yet because we respected the ranchers' economic concerns, these retirements have generated little controversy.

The lesson here is that when you negotiate with ranchers on an economic basis instead of a philosophical basis, you enhance your chance of success. What I say to them is, "What you do has value, and we're going to pay you for that value." I think that's the difference.

Yellowstone needs its wolves and grizzly bears. It wouldn't be the same place without them. Back in the 1930s, Aldo Leopold recognized that something was missing in Yellowstone, that not having large predators was a major omission. We need large carnivores to have a complete system.

Leading scientists contend large predators play a defining role in healthy ecosystems. Wolves provide food for many wildlife species, including scavengers like coyotes, magpies, ravens, and eagles. Wolves also influence where grazing animals feed. Elk in Yellowstone used to graze more along the rivers, where they decimated the streamside vegetation. Aspen and willow have become uncommon in the park. But with wolves, that seems to be changing. We're now seeing more willow growth along the rivers, which translates to more songbirds and more beaver.

The trickle-down effect of wolves is tremendous. Without wolves, we have a food chain that's heavy on elk. You used to see geriatric elk in the park that were fifteen or twenty years old. Not anymore. With wolves, we see faster cycling of nutrients because elk don't live as long. Instead of getting the occasional pulse of carrion that would come from winter-killed elk, wolves now provide a steady supply of nutrients to the system all year round. That really enriches the entire system. One day I watched a bluebird picking fly larvae out of an elk carcass. Ravens cache pieces of meat in the trees that get eaten by martens and gray jays. Some call the wolf a killer, but he's also a great provider.

I've been immersed in wolf conservation for nearly thirty years, but I have to confess I have no greater affection for wolves than any other creature. I don't even own a wolf T-shirt. My romance is with Yellowstone's natural system as a whole. I'm captivated by the intricate and elaborate interplay of wolves with elk, aspen, fire, and

weather. I'm intrigued by how this animal grabs people's souls, how they either love them or hate them. There are feelings about wolves that simply can't be explained.

———— ❖·❖·❖ ————

Hank Fischer is special projects coordinator for the National Wildlife Federation. He holds a master's degree in environmental studies from the University of Montana. He has been intensively involved with large carnivore conservation for the thirty years he has worked in the Northern Rockies as a professional conservationist. He is the author of Wolf Wars: The Remarkable Inside Story of the Restoration of Wolves to Yellowstone, Montana Wildlife Viewing Guide, *and* Paddling Montana.

REACHING AND INSPIRING OTHERS

Educators are so often the unsung heroes of our society, but with their passion and commitment, these gifted people are creating lifelong learners out of their students. Mike Johnston is altering the face of public school education, both as a principal and a policy maker. He is so promising, President Barack Obama chose him as one of his education advisors. After hearing that Ted Major had been a life-changing teacher for so many young people, we wanted to meet him and include his contribution. Ted and his wife, Joan, founded the Teton Valley Science School. Gudy Gaskill is almost single-handedly responsible for building the 468-mile-long Colorado Trail, which, she says, "Builds character and changes people's lives." The same could be said for each of these inspirational leaders.

MICHAEL JOHNSTON
WE NEED A MIKE JOHNSTON IN EVERY SCHOOL

Mike squeezed in a visit with us at Vail Mountain School (VMS), his alma mater, between a television interview and a speech delivered to a packed house of parents, alumni, and teachers in the VMS auditorium. Later in the week we spent a morning at Mapleton Expeditionary School of the Arts (MESA), in Thorton, Colorado, where as principal Mike has created a unique and intimate environment. Much of our visit was in the school cafeteria, as Mike very deliberately puts himself in the trenches and was covering lunch hour duty and conversing with students. Earlier that morning he had gone door to door to wake up students who had missed the bus to an Outward Bound expedition.

MESA was created by disbanding a large traditional high school and replacing it with smaller schools, each with its own focus. When President Obama spoke at MESA during his campaign, he said that MESA exemplifies the kind of success that is possible in American education. He also stated, "We need a Mike Johnston in every school." The Obama campaign named Mike as one of its top three education advisors, and he continues to work as an informal advisor to the administration and the Department of Education.

It may appear that at age thirty-four, Mike is just beginning his career. However, he comes to his position with an impressive set of credentials, including two years in the Mississippi Delta with Teach For America. He also developed a program called New Leaders for New Schools, a nonprofit he cofounded while a graduate student at Harvard. New leaders recruit, train, and place principals in urban schools around the country. In May 2009 Mike was appointed to the Colorado State Senate.

I grew up believing that history was something that I could shape, something that I could change, and that I had a moral responsibility to do so. I was particularly troubled by the history of inequality. We haven't solved that problem in the US, and we continue to live with massive inequality. So long as that exists, we are called to do something about it.

As a college student, the more I studied the civil rights movement and became engaged in the works of Dr. Martin Luther King, the more I felt I had missed an opportunity to be a part of this aspect of American history; it had come and gone, and I was too late.

I became obsessed with what the civil rights movement did and didn't do. The more I researched, the more I found that there remained a profound inequality of access to opportunity, despite all the formal barriers that had been removed.

We still have a country where only 9 percent of poor kids ever go to college, and the average black or Latino kid entering the ninth grade is running four grade levels behind their white or Asian peers. Despite all the great work that has been done, it doesn't much matter where someone gets to sit on the bus if they can't read the street signs. And it doesn't matter what colleges one can

go to if he or she can't complete the personal statement to get into that college.

To me education is the civil rights question of our generation. Contrary to what I had originally thought, that my generation had missed our moment, my generation actually walked right into the moment. What we have to do is to create a public education system that finally delivers on the notion that all men are created equal, and that no matter where you grow up, what color you are, or how much money you have, this country will give you a fair shot at success.

I have tried to find the right level for myself of where I think I can have the most impact: as a teacher, a principal, or a policy maker. I have experimented with each of these roles and found that what works best for me is being able to do a little of each of them. I love being around kids and being in the school every day, where I can try and have an impact on their lives. I also like to step back and think about education as a broader movement and work toward moving it ahead.

Colorado has a tremendous amount of hope and opportunity, and a lot of talented teachers and principals. I feel a relentless sense of this being home. I feel like Colorado has an independent streak, that there is a belief that we can figure things out. History is not going to confine us to believe that we can only do what's already been done. At the same time, Colorado is either forty-ninth or fiftieth on the number of kids of color that we send to college. We are one of the worst states in the country. We don't serve our kids well.

After I spent some time in teaching and went to graduate school at Harvard, I gained a better sense of how the education-policy questions linked to the education-

practice questions I saw. That helped me see that we can't just fix the education questions, that ultimately they are tied to bigger problems that also need to be tackled.

What I've seen over the years is that there are a lot of kids who have no honest shot at making it into the middle class without a college education, no honest chance for them to get a job that would support a family without that education. I felt like I couldn't have enough of an impact as a teacher to be able to change those systems. That was what drove me to go to graduate school and then to law school.

As a principal I think now I have much more of the sense of what the levers are that matter for kids and what I would want to do. The great promise and challenge of MESA is it's our chance to try and build what we think the ideal school looks like. It's exciting to look at all the components that go into that. MESA is a model in progress. We still have a lot of improvements left to make, but I think about it as a working model and the embodiment of our best ideas. When we find a better idea, we add it in or we change it, and when an idea does not get results, we delete it. It's an ongoing draft.

First off, we're a small community that has intense bonds between students and adults, students and students, and adults and adults. We have very high expectations of our students, and we marshal all possible resources to support kids in meeting those expectations. Essentially, we take kids who don't believe they are going to college. We tell every single one of them that they are going to make it into college. We say to them, "We know that's a lot to ask of you, but we are going to provide all twenty-seven of these support systems to help make sure you get there. We're not going to ask you to ski a double

black diamond if you have never put skis on before. We are going to take very seriously that you meet our goal. And when you show us that you are not meeting it, we are going to add intervention twenty-eight and twenty-nine and thirty, because that's clearly not enough to get you where you need to be."

We hold student-run community meetings where all of our students sit together in a circle. One of the things we highlight in the circle is student talent, which could be anything from playing the violin to doing hacky sack to singing or writing poetry.

The structure of the community meeting revolves around there being an audience. There is an audience watching every time a kid does something great or something knuckleheaded. The circle is there to remind them that this is going to get hard, but when it gets hard, each student knows he never has to walk alone. At the same time, that audience is going to be there to celebrate each kid's talents and achievements and all the things they do well. We think the more kinds of positive feedback kids get about good behavior, the better they perform. School communities also ought to be able to support people so that they feel comfortable taking risks.

We do appreciations, which are a chance for every student to recognize and celebrate any one of their classmates or teachers who are helping them be successful, or a student, colleague, or teacher who is just being a great friend.

We celebrate a student of the week.

We do a system we call accountability. If any student has done anything to break trust with somebody in the group, they are accountable to the whole student body. And that means some hard conversations. The nature of this community is that people are accountable to each other. So it's not about being accountable to me, it's about the fact that we have 538 kids in this school who are busting their butts to get into college, and anything one kid is doing to distract from that goal is hurting those 537 other kids. They don't have to be sorry to me, they have to be sorry to the twenty-four students who lose ten minutes of instructional time because he or she wanted to be a clown.

One of the biggest challenges for our students is that they come from a culture that doesn't prioritize kids going to college. We have made getting into college the coolest thing a kid can do. For so many of our kids, the thing they looked forward to the most was their *quinceañera* or getting their driver's license. Those things are nothing compared to the power of graduating from high school and getting into college. So we began a ritual where every student in the senior class signs what we call a commitment board that says they will commit to graduating from high school and getting admitted to a four-year college during the course of the year. We hang that in the junior and senior wing as a reminder for them all year long.

When students start getting admitted to college, we hold a fairly elaborate ceremony. On a wall in the auditorium there is an acceptance board. An intentionally rickety ladder stands beneath it, and as each student is admitted to college he or she has to climb that ladder. The idea is that each of us is handed a rickety ladder somewhere along the way, and it's hard to climb it alone. The student picks four people who have had a profound impact on them, and they ask them to support the ladder as they climb it. The student stands on top of a chair

and we say, "Today we are here to celebrate Monique. Monique, tell us where you got into college." She tells us where she got into college. Monique gets to choose her own theme song, and we play the theme song, she walks down the aisle, everybody hugs her, claps, gives her a high five, she climbs the ladder and signs the board.

Our goal is every single senior who signs the commitment board will sign this canvas board. Last May we had our forty-fourth student in the class of forty-four climb the ladder, sign the board, and get into college. We're the first public high school in Colorado that we know of to do that. We felt like that was a sign to our young people who weren't really sure that anything was possible to say, "If you believe and you are willing to work harder than you've ever worked before, we can do all of this, but you've got to be willing to commit to do it."

Obviously there are models of teaching that are more direct instruction–based that really work for kids who are willing to sit down in a chair for a hundred minutes and look straight ahead and take notes and do their homework. But there's another section of kids who won't and can't engage in that type of learning, and our belief is that we can build a system that engages those kids and then support them to high levels of achievement. Our commitment first and foremost is to the student's success, so we'll modify and revise the ideas as we need to based on the results that we get. We believe that by deeply implementing the practices that we have in place we can get there, and we have some early signs that that's happening. The grade we've seen the most growth with right now is our ninth grade, which are the students who started with us in their sixth-grade year. They've been

with us for three years. So we believe that if we have students over time working within this model that we can really get there.

MESA's number one objective is to prepare kids to succeed in college or the workplace, depending on which they choose. The second is to prepare them to be engaged and productive citizens of the world, to be ready to go out and know that they are going to be a positive contributor to their family, their community, their state, and their country. That's why all the work we do on character development is so important. To train a lot of supersmart kids without any sense of moral compass is not going to be helpful. We very much commit to doing both.

All of the ideas we have only make a difference if they impact students who walk into the building every day. So, I think that is the real test of our success and failures.

Michael Johnston is the cofounder and principal of MESA and cofounder of New Leaders for New Schools, a national nonprofit that recruits, prepares, and places urban school leaders. Michael has served as education advisor to state and federal political campaigns around the country, including spending the last two years as education advisor to President Obama's presidential campaign and his transition team. Michael holds degrees from Yale College, the Harvard Graduate School of Education, and the Yale Law School. In 2002 he published In the Deep Heart's Core *about his two years with Teach For America working in the Mississippi Delta. He lives in Denver with his wife, Courtney, and his two sons, Emmet and Seamus.*

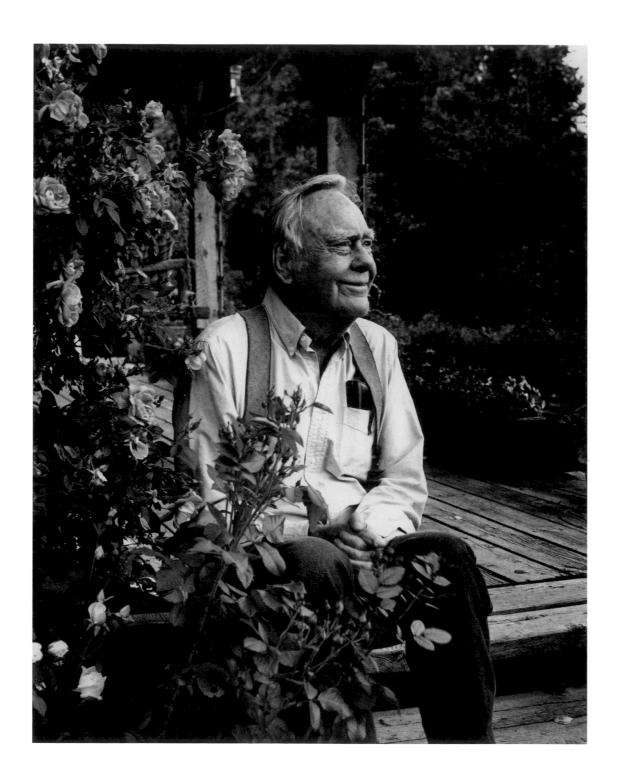

TED MAJOR
THE REAL THING

We drove over the pass from Jackson Hole to Victor, Idaho, to spend an afternoon with Ted Major and his wife, Joan. While we drank tea, Ted shared stories about growing up in Utah, fighting in World War II, and skiing at Alta and Sun Valley in the 1930s and 1940s. Later he took us on a tour of his ornate rose gardens.

In 1967 Ted and Joan founded the Teton Valley Science School, an experiential science program based in the outdoors. For many of his students he was a life-altering teacher, the person who introduced them to a community of people committed to the land and ecology of the American West. Students met with people such as Mardy and Olaus Murie, who helped create the Arctic National Wildlife Refuge; Frank Craighead, known for his grizzly bear research; and writers such as Peter Matthiessen, Wallace Stegner, and Barry Lopez.

One of many well-known alumni, Terry Tempest Williams says of the school, "Perhaps the one thing Ted didn't count on was the emotion he inspired. We fell in love with the land and the people who understood it."

My whole philosophy behind founding Teton Valley Science School [TSS] was to establish a new method for teaching high school students field ecology. I believed that teaching in the out-of-doors rather than in the traditional classroom has great advantages: get kids out in the field, have them do research, not just talk about it.

We worked out of Grand Teton National Park between 1969 and 1974. We used an old house for our main lodge. We took the oldest cabins we could find from a girls' summer camp that was on Cottonwood Creek and we moved them—some of them were hand hewn, they were beautiful. We had five cabins on cinder blocks with woodstoves and pump-up lanterns in them. I taught all the kids how to light the lanterns outside every night. That would be a no-no now. There were bears all over. And we went out every day in a yellow bus.

The TSS schedule included orientation, project selection, use of scientific equipment, and becoming familiar with the park. Students attended weekly seminars at the University of Wyoming field station, and each student chose a research project and contributed to plant and animal collections. We taught them the scientific method and how to write a scientific paper that they presented to their peer group, scientists, and parents during the last week of their program.

One of the great strengths of the school was the involvement of outstanding scientists who joined us each week and helped students with their research projects, led field trips, and gave lectures.

My brother Jack Major, who was a great geologist, came. Dave Love, the bedrock geologist and the man who knew more about the Tetons than anybody in the world, he participated. We had the Craigheads, who invented biotelemetry and used it in Yellowstone to track animals. We worked with Ade Murie, the greatest ecologist the Yellowstone Park has ever had.

Our teaching approach led to many scientific discoveries. Terry Tempest Williams sighted a red-headed woodpecker just outside the park boundary—a new sighting. One of Jack's graduate students observed a red-winged crossbill—a new addition to the park checklist. A student collecting dragonflies found a species that was later verified to be new to Wyoming.

Another student, while mapping vegetation on a stream floodplain, was able to identify all but one plant. I knew it was in the bean family, but little else. I told her to grab a bike and check the herbarium at park headquarters. She phoned that it wasn't there; however, a taxonomist knew the plant—*Onobrychis viciaefolia*. A call to the University of Wyoming herbarium informed her that it had not been found in Wyoming and believed it had been introduced to the US by horses imported from Ireland. Jack sent her name to an obscure journal so she would be credited with the discovery. They also put her name in a publication in Grand Teton National Park. It almost makes me weep when I think about it.

There were many other exciting discoveries brought about by our students and staff during our twelve-year tenure at the school, including recording several new plant species. Upon reflection, another interesting discovery comes to mind: a student studying pikas read in some literature that pikas were not nocturnal. He took his sleeping bag and found that pikas were very active at night, some even dashed across him. I suggested he write the author.

Another student studied biotic and abiotic factors where *Letharis vulpina*, chartreuse lichen, was growing. She found a duplicate site, but sadly not *Letharis*, and felt her research was useless. I told her that there were probably other factors involved; there are innumerable plants that botanists do not know why they are grown where they are found. Today Penny is a professor of fire ecology at the University of Idaho and wrote that TSS had a significant influence on her doctoral studies.

Daily activities at the school included the identification of "flower of the day." Flower books were removed and students were stuck with a key to the flora of the park. We did not care if they cheated, only that they became proficient with keys. The identification of various skulls, pinecones, scats, etcetera, were some of our other activities.

We had an old box that you'd put your hand in through a sleeve. I would let them feel different rock and plant textures and try to identify them. I'd slip some peanut butter in the box, and the kids would think they were feeling something really horrible. I must admit that I copied the idea of the Feely Box from an Audubon program, but the kids loved it.

After our summer field ecology program closed, local fifth-grade classes visited TSS for three days. We took them to a specially known area in the park where the elk like to congregate. One evening while sitting on a large log in a dense forest, we heard shrill bugling all around us. Suddenly a young bull came crashing through the woods, followed by a magnificent six-point herd bull chasing this youngster away from his harem. The kids were transfixed. You can't beat that!

We are proud to have started TSS. Proud that TSS is still teaching field studies and proud that many students are still fierce defenders of wilderness and the natural world. TSS has expanded its reach and affiliated programs, but the general purpose of connecting people to nature through education continues.

If people would live by the adage "Man is a part of nature, not apart, and through understanding comes respect," there is still hope that our world will remain ecologically sustainable for those who will succeed us.

———◆———

Ted Major is founder and director emeritus of Teton Valley Science School. Ted spent three years training at Camp Hale in Colorado with the Tenth Mountain Division. He was transferred to the 83rd Division as a platoon leader during World War II and fought throughout Europe. In 1950 Ted married Joan Cornelius, with whom he spent many years ranching before the couple embarked on the venture of wilderness education. After the war Ted attended Utah State Agricultural College, now Utah State University, and received a bachelor's degree in animal husbandry. Later he received a master's degree in science education from the University of Utah and also did postgraduate work at Cornell University. Ted and Joan founded Teton Valley Science School in 1967, and Ted served as director until 1979. In 1982 he coauthored a book, The Secret Language of Snow, *with Terry Tempest Williams. As the founders of TSS, Ted and Joan demonstrated that with commitment and drive it is possible to turn a dream into a reality. Both Ted and Joan dedicated their lives to ensuring that any student who came to Teton Valley Science School would leave a different person, more committed to conservation and more determined to give something back. Their love for nature, science, and hands-on learning changed many lives.*

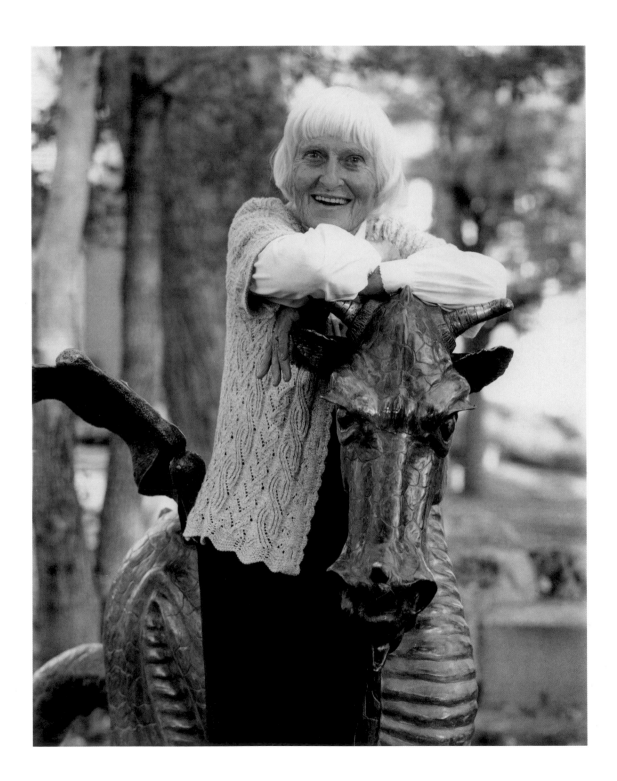

GUDY GASKILL
MOTHER OF THE COLORADO TRAIL

Now in her mid-eighties, Gudy Gaskill still has the energy of her younger years. A longtime member of the Colorado Mountain Club, Gudy has hiked all over the world, climbed all fifty-four of Colorado's fourteen-thousand-foot peaks, and summited several other peaks up to twenty-three thousand feet in elevation.

Gudy is known for her almost single-handed effort in building the Colorado Trail, a 468-mile-long trek between Denver and Durango, one of the longest continuous trails in the United States. For her it is much more than just a trail; it's a lifestyle. She and her husband, David, live in the foothills west of Golden, Colorado, where they have easy access to the mountains and two of their eight grandchildren, who live next door.

Gudy is a potter and often uses dragons as a symbol on bowls, teapots, cups, and plates. "He is such a force, so fierce and forbidding," she says, "but also kind and compassionate, kind of like Puff the Magic Dragon." She entertained us for an afternoon at the Colorado Mountain Club offices in Golden and found it thrilling to sit with this unobtrusive dragon for her photograph.

My husband, David, and I joined the Colorado Mountain Club in the 1950s, after we moved to Denver. In the early seventies I got wind of plans for a trail between Denver and Durango and was so excited. According to Merrill Hastings, the former publisher of *Colorado Magazine*, the trail was conceived in a conversation between him and Bill Lucas, our Rocky Mountain regional forester at the time. Both were horse riders and were impressed with the extensive trails in Europe. One of them said to the other, "Wouldn't it be nice if we could ride our horses without having to drag the pack-horses behind us?" So, they conceived of a European-style trail in America.

Bill and Merrill asked many different environmental organizations to participate in the planning of the trail. Those groups helped, but I was the only one who actually stayed with it. I was president of the Colorado Mountain Club. I was also chairman of the Huts and Trails Committee, which was an environmental group that went out and cleaned, picking up after the sixties' children. Between the war and the sixties, they all lived in tents and shared communities. We did a lot of cleaning up after them. Anyway, I was the only woman on the Colorado Mountain Trail Foundation board of directors, and Bill told me they had hired me—for $10 a day—to get the trail started. I never saw any money, but in 1974 I was asked to chair the committee that would develop and manage the building of the trail.

We had to draw the route through thirteen different Forest Service districts and try to link existing mining and logging roads. Then we sent the plan to the different districts. If a forester didn't want the trail, I would go down there and try to persuade the district ranger of its value. Most districts were in agreement after a year.

At the same time, I was recruiting and training

volunteers, leading trail crews, and purchasing supplies. Over the course of the next thirteen years of building the trail, I oversaw over ten thousand volunteers from all fifty states and many foreign countries.

As we were starting the trail, Ed Quillen wrote an article called "Trail to Nowhere" in *Empire* magazine. Fortunately, it caught the attention of Dick and Dottie Lamm; Dick was the governor of Colorado at the time. They came out on the trail and helped put in a new section of trail along Twin Lakes. Dick was so thrilled by the end of the day, he said he wanted to hang out with us all summer. After his experience he hosted a fund-raiser. He actually managed to add a rider to a bill and earmarked $14,000 for the trail. It was a real turning point for us.

Our volunteers were the heart and soul of the trail. I discovered that with volunteer help, the trail could be built for about $500 per mile, compared to the Forest Service's estimated $25,000 per mile. We could build one mile in one week if we had a full crew. And that was a lot of hard work.

We finished the trail in 1987. It was voted by *Backpacker* and *Outside* magazines as the best trail in the West and by *Backpacker* as one of the thirty best trails in the world.

Michael Martin Murphey wrote the words to "Along, Along the Colorado Trail" about his time on the trail. He sang with the trail riders every night around the campfire and gave a percentage of the money he raised doing that to the Colorado Trail Foundation. It was just mind-boggling to sit around the campfire and listen to him sing songs. Judy Collins dedicated a song to me and sang it, and it was just beautiful.

I can't believe how many people still hike the trail in the summer. When I hike the whole trail, it takes me six weeks or more, but people have done it in twenty-eight days. For me it's just leisurely hiking, and I tell anyone who wants to do it to plan on six weeks so they don't miss any of it. A lot of people will walk it for a week one summer, then maybe two weeks the following summer. And there are two couples I know of who hike a section every weekend. They start in different places and cross paths and end up taking each other's cars home. It will take them three summers to complete the trail.

Now I spend about twelve weeks every summer at the Colorado Trail Foundation facility in the mountains above Lake City, managing the foundation's education and art programs. The cabin is on the Alpine Loop Scenic Byway, right at the foot of Redcloud and Sunshine peaks. We offer classes in wildflowers, painting, geology, storytelling, photography, and wilderness first aid. I buy the food and cook for the students. On Saturday afternoons, when the last guest leaves at the end of one session, I make the two-hour drive to Gunnison to stock up on provisions for the next group and check in on the home we still own there. Then I drive back and get ready for the next group first thing Sunday morning. I love it.

David was always very supportive. I was footloose and fancy free before we were married. I was afraid my freedom was going to be squelched, so he and I signed a contract saying that we could each do our own thing and the other one could not complain about it unless we really thought that it was destroying the family. He worked on the trail approximately one day.

I didn't build the trail to leave any kind of a legacy. I just did it because I thought it was the most gorgeous

scenery I'd ever seen. I wanted other people to be able to see it too. Just to think that other people could share that was incredible. I still get letters all the time, from people around the world, saying that it changed their lives. It's neat for me to share in those little moments.

David is also in his late eighties. He hasn't been doing much hiking lately. I asked him one day if there was someplace in the world he'd like to go that he hasn't gone to. He said he'd like to go hiking in Canada. So, as a Christmas gift I gave him another hike. We're going up to Banff and Mt. Assiniboine. He is helicoptering out when we're done, and I will backpack out the other side. He'll drive around and pick me up, then we'll hike for a few more days. The northern light is wonderful. It changes my attitude about being too old for backpacking anymore.

It's just that I love hiking. I can't stay inside.

Gudy Gaskill fell in love with the Rocky Mountains in the 1930s. In the early 1940s she and her twin sister, Ingeborg, enrolled at Western State College (WSC). After Gudy earned her bachelor's degree, she married David, also a WSC graduate, and moved to Kansas, where they ran up to ten thousand sheep before their herd was wiped out in a blizzard in the early 1950s. David and Gudy joined the Colorado Mountain Club after moving back to Denver in 1952. By the 1970s she was leading trips throughout the world. She was named the first woman president of the CMC in 1977. She has won numerous awards, appeared on the Today *show, been honored by two US presidents, and in 2002 was inducted into the Colorado Women's Hall of Fame. Merle McDonald of the Colorado Trail Foundation said of Gudy, "No person, man or woman, has ever single-handedly had a greater impact on the successful completion of a national treasure as Gudy has with the completion of the Colorado Trail."*

PRESERVING THE CULTURES OF THE WEST

As Charles Wilkinson told us, "It has been so beautiful what the tribes have done in modern times." It is heartening to learn that Native American tribes across the West are bringing themselves back from the subjugation of the US government and the Bureau of Indian Affairs. Though the issues on the reservations have hardly been solved, Native American culture is experiencing a rebirth. James and Mae Peshlakai run the Peshlakai Cultural Foundation as a way to help the Navajo, or Diné, people relearn their cultural traditions, dances, and rituals. Roxanne Swentzell allows glimpses into the Pueblo culture through her sculpture, acting as a storyteller for her people. And Donald Warne has launched a crusade to revamp Native American healthcare.

Gary Nabhan is preserving a different type of culture, that of lost food traditions. He is also helping native cultures procure and safeguard their time-honored seeds in seed banks.

The Latin American population is burgeoning across the country, and we are all becoming more acquainted with our Spanish-speaking neighbors. Immigration is one of the driving forces of contention and policy in today's West. Sylvia Martinez and Luis Polar each have a foot in both Hispanic and American culture, and they are both committed to helping Latinos find their way in America, Luis through his newspaper, *La Tribuna*, and Sylvia through her advocacy group, Latinos Unidos. We feel sure that their voices will continue to be heard in the future.

JAMES AND MAE PESHLAKAI
OUR TRADITIONS ARE GOING TO BE GONE SOON

James and Mae Peshlakai are educators and artists attempting to bring an understanding of Navajo culture and the complexity of issues their people face to a broader public as well as to their own people. They have done this through lectures but also through teaching weaving and silversmithing, arts that are rich in cultural tradition. James's great-great-grandfather, Beshligaii Adsitdii, was a well-known Navajo headman, silversmith, and medicine man. He dedicated his life to the preservation of his people. Traveling to Washington, DC, to seek peace between the cowboy settlers and Navajos, he influenced President Theodore Roosevelt to annex what is today the western side of the Navajo Reservation.

James and Mae have raised five children, two of whom served in the armed services. When their youngest son was killed in an auto accident, they started the Peshlakai Cultural Foundation in his memory. Author Tony Hillerman borrowed the name James Peshlakai to use as a character in The Wailing Wind *and* The First Eagle. *Though he made him a bad guy, he said of the real Peshlakai, "The Navajos need a hundred people like him."*

We visited with the Peshlakais, their daughter Tina, and their granddaughter Shelby at their home in Cameron, Arizona, on the Navajo Reservation. James and Mae offered a rich account of the history of the Navajo, or Diné, people. After a long conversation we helped feed the lambs they raise in a trailer behind their house.

JAMES PESHLAKAI

It takes a lot of research to publicly write about Native Americans, because some things we talk about will not hold true for the next tribe. Some of the things that we talk about on the western side of the reservation will not jibe with the eastern side of the reservation. Right now in the United States there are different jurisdictions when you talk about Native Americans. There are constitutional tribes and nonconstitutional tribes, and there are treaty tribes and nontreaty tribes.

In 1921 Indians were made citizens of the United States, but we didn't have the right to vote. You had to know how to read and write English to be able to vote. That was the requirement until the 1960s. Then the hippies came in and said, "Look, you have a right to vote." The liberal politicians came in and said, "You guys have a right to your religion, a right to vote, and a right to have your own language." So that's when the Indians started to vote and they started putting Native Americans in state offices.

But the hippies did a lot of damage to our cultural preservation too. Every young Indian said, "It's my right to do this, my right to do that," which was the beginning of the end of our cultural tradition. Before that, nobody talked about "my right."

This is when I began to try to help my people. I'm trying to educate the people about our culture, how we're connected to everything—to nature, to the land, to the

earth, to the sky, to the water, to the sun—that we are all one people—the insects, the animals, and the birds.

I worked with the Navajo police department and saw all the violations. I worked with the State welfare and saw how much we needed and didn't have. Then I worked with the State, and that's when I really helped. I worked in the hills, organizing arts and crafts cooperatives and trying to get the adult education programs going. We started the Navajo Vista program; the domestic Peace Corps, Volunteers in Service to America; college extension classes; and home demonstration programs.

I started an underground newspaper called *Western Navajo Voice*. We ran it for a while until we were shut down by one of our own people. But we were able to open some ears and eyes to different issues. We looked at the ways Indians were being discriminated against. For example, the streets on the Indian side of the reservation were full of potholes and were unkempt, whereas the streets on the side where the Bureau of Indian Affairs people lived, even the driveways, were being paved. FBI people followed me around. It was not a happy thing. We were right there in the middle of the discrimination period. But we really opened some eyes and some ears.

There are so many things that we try to do and the government just stops us. Then they say, "Why are these Indians just twiddling their thumbs?" Congress passed public laws that place freezes on development on the Indian land. They call it "Navajo-Hopi land disputes." We cannot make plans. We cannot relocate our outhouses or our sheep corrals. We have windmills that were built back in the fifties that cannot be repaired.

So we started programs that were mobile, where we don't need buildings or running water. One of them

is a day camp for the little kids. The other is the arts and crafts cooperative. We opt off the reservation for that. We take the art to big cities to sell. I started working at the public schools. The students have an Indian club, and they have bake sales and get together once a week.

My people voted me into a political office at the Cameron Chapter, and I became the Cameron Chapter president, like the town mayor. You look at your town; you look at your people. Where are they going to get their water? What are they going to eat? What are they going to do with the sewer? What is going to happen with their trash? Where are their kids going to go to school?

There is so much to tell the American public. People like to say, "Why aren't the Indians doing something about this place?" Well, when you want your people to eat, you don't make noise.

When I started teaching at the schools, I taught about Navajos. I would leave a blank space in the lesson and then have the kids have their parents or grandparents fill that in. Then these elderly started to come to Tuba City wondering, "Who is this man who is teaching about the Navajo?" Whereas it [speaking Navajo] used to be forbidden at the Indian boarding schools where I went. I got whipped once and never talked Navajo again.

When I taught at the Navajo Community College, I did the same thing. I left spaces for their elders to fill in. I told them, "What your grandparents or your parents tell you, it's yours. It's yours."

One day there was a bear cub that came to Tuba City. He was outside the school, wandering around. The Navajos took him down with ropes. They wanted a medicine man, and I happened to be walking by. Someone pointed at me and said, "There's one!" They ran up to me

and dragged me over to the bear and I was thinking, "If this bear gets loose…" I told them to bring white cornmeal, so people ran and somebody brought a bowl of white cornmeal. Hundreds and hundreds of little faces peeked through the windows of the school. I went up to the bear and sprinkled some cornmeal on him and some in his mouth. I started singing a song and offered the bear to calm down. All these little kids watched as the people there made offerings to the bear. Then the vet came and tranquilized the bear and the animal guys took him off the reservation. The Navajo people said, "No, that's our bear. We want him on the reservation." When I walked down the streets in Tuba City, all these kids and all these people would say, "That's the man who sang to the bear." The medicine men even asked me what I sang to the bear. So I'm not a great man, I'm just in these places when the situations happen.

When my daughter was going to Colorado Rocky Mountain School in Carbondale, Colorado, I was invited to speak there. I tried to talk to the students about our culture. So I brought some students from Arizona up to dance, both Navajo and Hopi. The Hopi kids knew their dance, but the Navajo kids didn't. I realized that the Navajo kids didn't know their culture. I found out when I was trying to teach that I had forgotten my culture too because I was too busy trying to be a white guy. I forgot the songs. It was terrible.

I relearned my singing and dancing. To remember the songs, I had to start in the middle of the songs. We started from scratch. We put on a premiere performance for our community. We charged $0.50, and a lot of people came and saw their kids singing and dancing. Afterwards some of the parents told me how much they had forgotten

and how happy they were that their kids were learning because our ceremonial dances were almost gone. Very few people were dancing anymore, and now it is regenerated.

There are huge companies in the Black Mesa of Navajo Country; Peabody Coal is one. A lot of Navajos work there, and a lot of them started having dance groups. Now the ceremonial dances are huge occasions and competitions. The costumes and the glitter are amazing. There are traditional outfits, and so beautiful. The boys used to try to dance in tennis shoes. Not now. People now travel and dance on tour.

We hold dances and art shows to raise money. There are more than twenty tribes within two hundred to three hundred miles in our region—Utah, Colorado, New Mexico, and Nevada—and they all want to come to the dances. Navajo teach by show, not tell. Laughter and culture and dances are the way we teach our people. It is fun and hands-on.

People in the tribe who think I know so much said that we had to start a foundation for our son, Jameson, who was killed in a car accident in 2000. They said our son was a little teacher. He traveled with the office of tourism promoting Arizona and was the spokesperson for the Navajo and other Indian tribes in Arizona. He was doing really well, and when he left, we kind of gave up and thought, "Oh what's the use?" But friends told us that instead of dwelling on our loss, we should start a foundation in his honor. The Peshlakai Cultural Foundation for the Advancement of Native Americans is a way for Indians to teach Indians the real thing. For example, someone from the Hopi tribe can write a grant to teach how to make Hopi baskets, or Navajo how to weave a rug or do pottery or learn stories. It stays within the tribe.

We're not teaching whites, we're teaching our own people. The thing is, all of this Western education [is what] our children are taught in your education system. Our traditions are going to be gone here soon.

James Peshlakai (Navajo/Hopi/Chiricahua Apache) is the resident elder at the Native American Student Services office at Northern Arizona University (NAU). Since 1969 James has been instrumental in starting adult education on the Navajo Reservation with NAU, and is a Navajo cultural consultant. Between 1971 and 1995, James was elected and reelected five times to serve as president and then secretary for the Cameron Chapter of the Navajo Nation in Cameron, Arizona. Between 1971 and 1990, James was a member of the Navajo Nation Bar Association, practicing law in the Navajo Nation Court of Appeals and in the Hopi Tribal Courts. In 2000, 2005, and 2006, James was honored in Who's Who among America's Teachers.

James founded the Peshlakai Cultural Foundation and manages Peshlakai Trading Company and Gallery for his children in Tusayan, Arizona. He is presently a part-time professor teaching with the Applied Indigenous Studies Department at NAU and taking care of his sheep ranch east of Cameron, Arizona, on the Navajo Reservation.

MAE PESHLAKAI

All the tribes in the United States have different beliefs. We believe that we can't gamble, which is good. But in this day and age, money takes over. We can't live without money anymore, and now there are younger people who are desperate for jobs. We're going to have to resort to some sort of work.

People come from far away and they look at the reservation and say, "It's so pitiful that you guys live in a barren place and there are no jobs. What do you do?" Of course we don't have jobs. It's hard to create jobs when the government doesn't want us to create jobs for ourselves. There is so much red tape—state government, BIA [Bureau of Indian Affairs], local government, federal government—and you feel that there's no hope on the reservation. Some people just give up and move off the reservation where there are more opportunities.

People are born having big dreams, and then other people bring you down where you feel there's no hope. It's just that way. It seems our own people, they can't think for themselves anymore, they've been taught not to. But James and I, we can think. We never had help from any kind of welfare. James and I were two of the very few fortunate people. We've traveled all over the United States with our lectures. We've been to Brandeis University, Brown University, University of Hawaii, Wheaton, Gettysburg, and Australia. We did get involved with education, the laws, arts and crafts, food co-op, all these things that both help keep our culture and allow us to continue to exist.

One of the things I do with the Peshlakai Cultural Foundation is talk to young people about our clan system. We are a matrilineal society. We have this clan system that is very important to us. I am of the Tangle People Clan and Jim is Red House Clan. This goes back to our teaching. It is the first thing that we learn when we are young girls—not so much the boys—but we tell

them what clan they are. You can't marry anybody that is in your clan group. My father is of the Deer Water Clan. My paternal grandfather, Rotgat People; my maternal grandfather, the Salt Clan. I am from four clans. Jim is the same way. He is of the Red House Clan, born for the Cliff-dweller Clan. His paternal grandfather is the Wandering People Clan, which originated from the conquistadors, and his maternal grandmother is the Red Streak into the Water Clan.

When people came with different beliefs they said, "You have a right to marry whoever you want." And some kids believe it. They fall in love without asking. I go into the schools, and some Navajo women don't know their four clans. I tell them we don't have such thing as a first, second, or third cousin. But you can meet someone on the other side of the world who is from the Tangle Clan. And if she is older than you, she is your mom or your grandmother. If she is in your age group, she is your sister. If she is of the Tangle People Clan born of the Salt Clan, then she is your aunt. It is hard to understand if you aren't a Navajo. It is important that we know our clans because this tradition goes back to our foundation.

This is the goal of the [Peshlakai Cultural] Foundation: to preserve Native American cultures and traditions. We want our children to know their native languages, songs, dances, foods, and oral history. We hold a series of art shows and dances at Tusayan on the South Rim of the Grand Canyon to raise money. This year our season begins with a Hand Drumming Contest and ends with a Hoop Dance Contest and Ceremonial Pow Wow.

⎯⎯•⎯⎯

Mae Peshlakai was the first of seven siblings born in a hogan with her Navajo (Diné) relatives attending her birth. At eight years of age, she and her sister Angie were taken by force to a series of BIA boarding schools where any hint of Diné culture was condemned, even punished. During the summers Mae was educated within Diné culture. Encouraged by elder female relatives, Mae worked with wool, carding it, spinning it into yarns, dying it, and then weaving it.

Her silver work has taken her all over the United States, Australia, and Mexico. She has had art galleries in Flagstaff, Tuba City, Cameron, and Tusayan, on the western end of the South Rim of the Grand Canyon. She has also taught summer workshops in Colorado. Her clients have included President Ford and his family.

ROXANNE SWENTZELL
WE ARE ALL BORN OF THE EARTH

Roxanne Swentzell's hands create stories in clay. Her sculptures—many of people with wonderfully recognizable expressions—offer a glimpse into the Pueblo culture. The power and recognition of her work have allowed Roxanne to become an iconic storyteller for her people and an active promoter of the traditions of Pueblo life. Her sculptures often parody the confusion of the traditional native world meeting the modern nonnative world. Her work is exhibited in her own gallery as part of the Pueblo of Pojoaque Poeh Center just outside Santa Fe, New Mexico.

Roxanne grew up on the Santa Clara Pueblo, embraced by a family of artists. Her aunt Nora Naranjo-Morse is a potter, sculptor, writer, and filmmaker. Her uncle Michael Naranjo is an acclaimed sculptor, and he is also blind. Several other sculptors and artists make up the family. Her mother, Rina Swentzell, is a well-known architect, writer, and sculptor.

Roxanne walked us through the retrospective exhibit of her sculpture. We loved seeing the evolution of her work and listening to the heartfelt stories of her people and culture.

I believe that my art comes from way inside me, and who I am happens to be from this place. You can't detach the two. I am part of the Santa Clara Pueblo, and we have been in this area for hundreds and hundreds of years.

From a Pueblo perspective, our aim is to have balance: balance between night and day, summer and winter, male and female. Everything has to be balanced by the opposite or it becomes misaligned. If that happens, bad things follow.

My father was German. He taught philosophy and had a very European mentality. My mother grew up as a Pueblo Indian girl. Somehow they got together. Talk about extremes! My father saw me as an artist. My mother sees me as a struggling person, I think, trying to make sense of it all. In the world my mother comes from, calling yourself an artist doesn't make sense because you just do what you do. If you made art, you didn't call it art. We didn't sign our names to artwork. It just was. In my dad's world, there is Michelangelo and all the great artists of the world. I grew up more with my mother's side of the world because that's where we lived.

I started sculpting as a very small child. My mother was a potter, and clay was part of our life. She calls us mud people. I had an intense speech impediment, and no one could understand me. I found that sculpting little figures about how I felt was how I could communicate. I made little people, beginning when I was four or five years old, and I never stopped. The figurines were all about emotions, how I felt. I remember making a little girl crying on a desk because I hated school. I'd sculpt the things I saw, like my father reading a book, just scenes from my life.

Pueblos believe in rings of centeredness. We understand the need for having a center place, a heart,

a soul, or being centered in oneself. Even the way the buildings themselves—the pueblos—are built, and the ceremonial houses, all focus to the center, toward what we call the Gaia, the mother. The theory is that it brings us back home. We are the people of this place. We didn't come from somewhere else. We'll point to the ground and say we're from this spot. There's something about knowing this that makes me feel grounded.

Pueblos are amazing tribes. Unlike the rest of the tribes in the United States, they were not moved from their original place. We are still in our homeland. We've continued our dances and our language up till now. Most other tribes have broken away from that. So to me, the Pueblos have a really strong sense of core, though it's been shaken a lot from the outside. I sometimes think that what I'm doing with my pieces is trying to find the core of my being.

Here is a sculpture of a woman in her traditional clothes drinking a soda. She shows the conflict of two cultures coming together. A very real conflict. Sometimes it boggles my brain to see two worlds in the same place. When I watch our traditional dances, I feel like I've gone back in time. Especially when the men wear animal skins and branches and mud. But then a car drives by. These two worlds don't go together, this very old tradition next to modern society. These feelings come out in my work.

I always think of my artwork somewhat as my babies. My pieces are like children who are born through me. This woman has her babies emerging out of the pot on her head. The pot we are all born of is the earth. And she is Mother Earth.

My mother is an architect who grew up building mud houses. When HUD [the Department of Housing and Urban Development] housing came in to help the Pueblos set up tract housing, it destroyed the structure of the pueblo architecturally. She was distraught. One more way of destroying our culture is to give people free housing. We don't know how to fix those kinds of houses. We know how to fix mud. HUD housing killed a lot of tradition for the Pueblos in the name of help. Mom went to architecture school so she could fight it and learn how to approach those kinds of people.

My mother talks about growing up on the pueblo where you had all your aunts, uncles, and family all around you. The kids are raised by the community. When my kids were growing up, I had my aunt next door, my brother next to her. His kids and my kids roamed around. The doors were all open. The traditional buildings of the pueblo were built around a central outside area. You can think of it as rings around the place. It's a lot harder when you break it all up into separate neighborhoods and separate yards. There were no yards back then. The outside was everyone's outside. Today my son lives next door. My daughter actually has a piece of land right next to his. And that's a tradition too: your family stays within the pueblo.

When George Rivera offered to let me make this building into a gallery, it was just an old pigeon coop, full of pigeons. When it came time to fix it up, my entire family, grandmas, aunts, babies, uncles, and all the teenage kids, came to help. We don't hire outside contractors with hard hats to come in. Instead, we do it together. My sisters and aunties plastered the walls. All the kids mixed up the mud. That is a very cultural thing for Pueblos. If someone's house needs fixing, the family comes. I guess it is similar to a barn raising in other cultures.

There is a big sculpture out front of the Poeh. The

girl is holding a little bead. I call it *Window to the Past*. Throughout these hills are old ruins of our ancestors. Often I'll find little beads from old jewelry. We get so excited when we find an arrowhead or a bead because it is a very real connection to the past. The beads have a little hole, and in my sculpture, the girl is looking through into the past. That's us.

This is a Pueblo clown. They're striped figures. They're slightly different depending on what pueblo you are at, but basically, all the pueblos have them. They are sacred. They fool around, they play tricks, but for a specific purpose. They love to make fun of the tribal officials, for instance, because they're important. They act as reflections for people.

I remember as a little girl watching five or six clowns at a pueblo. They were holding something. I could tell that it was important to them. They started fighting over it, and I thought whatever it was must be very precious. Finally one clown ended up with it and the rest of them left. The clown who had it sat down on the ground. I waited to see what it was. Eventually he dropped his hand and got up and walked away. There was never anything in his hand. It was so profound to me because we make all kinds of fluff about nothing, and the clowns were teasing us for that.

I don't believe I can make art detached from my culture. I'm a woman, so my work has a female influence. I'm a mother, so it has a mother aspect. Because I'm from Santa Clara, my work reflects that, because that's who I am.

Roxanne Swentzell's sculptures and bronzes are in the National Museum of the American Indian in Washington, DC, the Heard Museum in Phoenix, the Museum of New Zealand, and the Denver Art Museum, as well as other galleries throughout the country. Her 1997 sculpture Emergence of the Clowns *was part of* Twentieth Century American Sculpture at the White House: Honoring Native America. *She founded the Flowering Tree Permaculture Institute, a nonprofit organization to help her people live sustainably on the pueblo. She maintains a seed bank of native seeds and continues to harvest crops from them, lest they disappear forever, acknowledging that native seeds are just one more thing that her people are losing.*

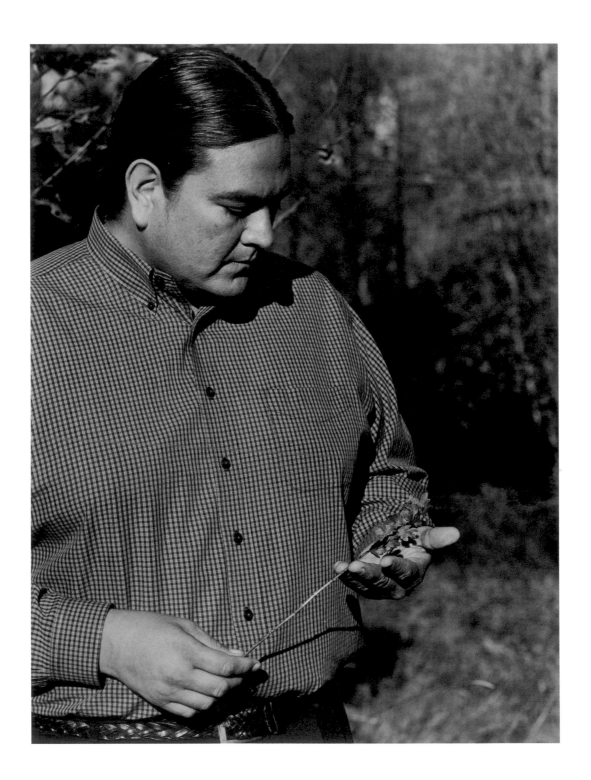

DONALD WARNE
HEALTH IS A BALANCE BETWEEN SPIRITUAL, MENTAL, PHYSICAL, AND EMOTIONAL

As a young boy Donald Warne learned the traditional ways of Lakota healing from his uncles. He is an enrolled member of the Oglala Lakota (Sioux) tribe from Pine Ridge, South Dakota. There, he partook in ancient ceremonies and healing rituals, and was recognized as a medicine man. In high school he decided he wanted to become a physician, and was encouraged to do so by his uncles. Now Donald Warne, MD, MPH, is working at the highest levels of policy making to ensure better healthcare for Indian people.

We heard Donald give a lecture about the Lakota Medicine Wheel in Telluride, Colorado, and were able to squeeze in a memorable breakfast with this extraordinary man before he flew back home to be with his infant son, Shonto. Named after his mother's hometown on the Navajo Reservation, Shonto means "sunlight reflecting off water." In the face of so much disparity, Donald strives to maintain a balance between the demands of modern life and traditional customs of his native community.

———

In this country American Indians are the only citizens born with a legal right to healthcare. The federal government is responsible for providing American Indians with certain social programs, including housing, education, and healthcare. The problem has been that the Indian Health Service [IHS] is tremendously underfunded. If you look at the per capita expenditures for healthcare in this country, it's about $4,000 per person per year. Medicaid is about $3,500 per person per year. The Veteran's Administration is over $5,000, and IHS is $1,800.

The only population with a legal right to healthcare is getting the worst service. It is an issue of social justice, and it should be illegal. If not illegal, at least recognized as immoral and unethical.

In the traditional Lakota way, health is seen as balance among the spiritual, mental, physical, and emotional realms. It is much more than just physical. I learned that at a very young age. At this point in my life, it feels like I'm saying, "One plus one equals two," but every once in a while people say, "Wow. I didn't think of that before."

In modern medicine we don't address mental or emotional health very well, and we ignore spiritual health. We focus primarily on physical health. But if we're not integrating all facets of human existence, it's an incomplete healing system. It seems reasonable to me that a system of healing should reflect human experience, but that's outside the realm of what modern medicine can absorb. That is why we have such a huge movement toward alternative medicine.

The decline of American Indian health is a long story. When the state of Arizona decided to push for growth, our health was put in jeopardy. Deserts in central Arizona were not designed by nature to support three million people. The only reason that Phoenix can support that many people is because the Pima and other

rivers were dammed. The result for local tribes was that they lost their traditional lifestyle: they lost farming, healthy food, and physical activity.

Our traditional sources of healthy food were replaced with the government commodity food program. These foods, when looked at from an environmental health perspective, are toxic, and all native people have been exposed to them for the last seventy years. The foods are very unnatural; they're not part of a traditional diet. We used to eat lard, now it's vegetable shortening, which of course is artificially enhanced to preserve its consistency. White sugar was never part of the diet; neither were white bread, bleached flour, canned meat, peanut butter, or commodity cheese.

I see a lot of emotional and spiritual turmoil that I base on our loss of self-sufficiency. Being unable to provide for your people has a huge impact on self-esteem, which has increased the rates of depression and self-medication through alcohol and other substances. In some communities about half the adults over age thirty now have Type 2 diabetes, and we're diagnosing it in kids as young as six years old.

— —

I'm not sure what triggered the idea of going to medical school for me. I was on more of a traditional healing path. But when I went to Indian service facilities, I hardly ever saw any native providers. It seemed like the role for the Indians was to be patients, and the role for the white people was to be doctors. That didn't feel right.

I'm just starting to develop the Medicine Wheel Foundation, whose purpose is to optimize the health of native people. The Medicine Wheel is an ancient symbol depicting holism and balance as a model for health. Health is defined as balance among four realms: spiritual, mental, physical, and emotional. These concepts are best understood from a traditional cultural perspective that teaches us that to live in a healthy way is to live at the center of the wheel, in balance among the four directions.

This is true for health professions and educational programs as well. Unfortunately, medical school training is typically not geared to meet the cultural, social, and environmental needs of American Indians, and the result is a significant disparity in the number of our physicians. Although we represent nearly 2 percent of the population, we represent only 0.1 percent of the physicians. The disparities are similar for nursing, dentistry, and other health professions. One of the best ways to ensure the promotion of cultural competency in the healthcare system is to develop a health education system that targets the American Indian population.

Something else I am trying to get off the ground right now is an American Indian School of Health Sciences. The idea is to partner with the community to develop the school and to establish a solid pre–health professions curriculum at the college level. We would actually work to nurture and cultivate the potential students who will be going into medical school and other health professions.

Another program at the foundation is the PATH program [Preservation and Advancement of Traditional Healing]. PATH develops apprenticeship programs that integrate local healing traditions. We are establishing a fund with which we can pay traditional healers to be mentors to younger community members, to pass along their knowledge. Currently there are a lot of traditional

healers who work as laborers or janitors or whatever they can do just to make money. They're caught in a quandary because they're not supposed to charge money for their services typically, so they wind up living in extreme poverty. Some of our best traditional healers struggle to even find housing, and it shouldn't be that way.

As a physician and a healer, Donald Warne, MD, MPH, synthesizes his medical training with his cultural knowledge as a member of the Oglala Lakota tribe to deepen both the intelligence and effectiveness of his work in health policy development.

Donald is an adjunct clinical professor at the Arizona State University Sandra Day O'Connor College of Law, where he teaches American Indian Health Policy and is helping to create an American Indian Policy Center. He received his MD from Stanford University and his master's of public health from Harvard University, with a focus on health policy. He is a certified diabetes educator (CDE) and a diplomat of both the American Board of Family Practice and the American Board of Medical Acupuncture. He has completed fellowships in alternative medicine from the Arizona Center for Health and Medicine and in minority health policy from Harvard Medical School.

GARY NABHAN
KNOW WHERE YOUR FOOD COMES FROM

We ventured to Gary Nabhan's farm outside Flagstaff, Arizona, to capture the early evening light and photograph him with one of his Black Spanish turkeys. The turkey protested wildly during capture, but eventually stopped struggling long enough for a photograph. After touring the farm we settled in on his deck with a glass of wine while he told us about his life's work.

Gary helped recover the lost food traditions of numerous Native American tribes in the Southwest. Now he is doing the same across America. He is an essayist, poet, and author who believes in celebrating and honoring his elders and acquires more than half of all his foods from local sources.

While helping an ethnobiologist named Amadeo Rea with his fieldwork in the Gila River Indian community, I was included at a Thanksgiving dinner with one family who had prepared all native foods for the feast. Amadeo told an elderly Pima woman that I was Lebanese. She had worked for a Lebanese lawyer in Phoenix as a cook and loved cooking Lebanese food, but she remembered that some of the spices and ingredients were really hard to get. She felt that the same was true of her native foods and wondered if it was true of all ethnic food traditions.

Suddenly I was not just a white guy and an immigrant, and she wasn't just a Native American. I realized that ethnic food traditions, immigrant or native, are imperiled by the globalization and the commodification of foods. So that was the starting point of helping solve some of the issues related to an agriculture adapted to the West. Such an interest didn't pit me against the needs of native peoples, but recognized that in ways we were all in the same struggle to keep each of our traditions alive.

I helped to found Native Seeds/SEARCH [Southwestern Endangered Aridland Resource Clearing House], and we began to work with other cultures. Native Seeds/SEARCH helped found the Traditional Native American Farmers Association, which expanded the network of people helping one another solve problems of food sovereignty. We determined what seeds had historically or prehistorically been distributed throughout the Southwest and went back to the reservations, villages, and *rancheras* to find out whether people were still growing them. We helped them safeguard those seeds in seed banks so they would never lose them. In a number of cases we literally were gifted the last handful of seeds left in an old jar. We grow them out and return them to the communities where the original stewards have lived. We want the seeds out in the landscape making a difference, not just frozen in seed banks and museums.

We've helped repatriate all Hopi seeds that were in museums and government seed banks back to the Hopi tribe, who now have their own seed bank. There are Hopi people who still farm sustainably. The drought of the last seven years has diminished the number of people planting each year, but several still had successful crops last year. Their people have done their farming in an unbroken

chain for four thousand years. That project was very much about helping to restore a cultural landscape.

I decided about the time I was writing *Coming Home to Eat* that I could no longer be a researcher doing autopsies on declining food traditions. I had to take this issue on in my own life. Now, twelve miles east of Flagstaff, my wife, Laurie, and I graze Navajo-Churro sheep, turkeys, and grow up to an acre of crops that are adapted to semiarid climates. We have implemented a number of permaculture designs on our land: we capture almost all the water that falls and funnel it into the fields and into watering troughs for the livestock. The countryside that my family comes from in Lebanon and Syria looks almost identical to the country between my farm and the Hopi Reservation. And the climate is the same. There is good adaptability for Lebanese and Syrian seeds to this climate, so I can help maintain my own clan's traditions. I lived for a year getting 80 percent of my food within 250 miles of my Arizona home, 90 percent of it from species that are native to the region. The question I ask myself is how do I move from doing this as an individual to doing it as a family, a community, and a food shed?

We know that what we eat shapes our landscape, more so than any other human activity in history. A diet of corn-fed beef is a vote for a world dominated by genetically engineered grain, factory feedlots, and toxic, nitrate-laden streams. If we all ate grass-fed buffalo, on the other hand, we would be supporting unfenced, open pastures. Prairie grasses and herbs would become abundant again, and in a lot of places land health would return.

As a way to encourage people to eat close to their food shed, Laurie and I helped start the Flagstaff Community Farmers' Market. In 2001 we published the first directory of sustainable food producers who were willing to direct-market their produce. Now we've seen a twenty-fold increase in local food consumption, directly benefiting producers within a 130-mile range. Connected to the market is a community-supported agriculture project [CSA] with over 170 families. I helped jump-start a wild foraging initiative, a community kitchen, and a regional branding campaign called Canyon Country Fresh Project under which farmers and ranchers can market their products. We helped sponsor other directories and marketing initiatives for Hopi, Navajo, Hispanic, and Anglo farmers and ranchers in this area. What we're realizing is that we're reinventing a lot of the networks that used to exist fifty years ago in the West.

These markets have incredible social and economic benefits to the community. We call the money "sticky money" because it stays within the community rather than going off to Walmart headquarters or to Safeway. Likewise, there are spin-off benefits from each project. The value of the farms and ranches in western communities is not just the value of the beef or mutton that comes off them. There are wild foods, wildlife benefits, recreational benefits, watershed working benefits, and what scientists now call ecosystem services: having intact landscapes around cities and towns is critical to maintaining ecological integrity, which we don't get if they are fragmented and subdivided.

Within a hundred miles of here we have some of the oldest continuously inhabited villages in North America. Each of them is a blend of nature and culture rather than being one or the other. Our foods, for example, are both natural beings and cultural legacies.

Laurie and I continue to work in cross-border

projects in the Sonoran Desert of Mexico. We're assisting the Seri in marketing their wild oregano and mesquite basketry as fair-trade products. We help them develop habitat conservation plans, largely put together by their own trained young people.

Native knowledge and scientific knowledge are oftentimes more complementary than contradictory. And I think good observers tend to appreciate the insights of other good observers, so we found it's easy to blend and complement Western science with native knowledge, rather than treating native knowledge as superstitious or obsolete. And that kind of traditional knowledge is not just found among Native Americans; it's found in any community that has been on the land for some time.

The ultimate goal of my work is to save and revitalize the remaining unique riches of each region. To honor the cultural and biological assets of each particular landscape rather than assuming that the best answer to local problems always comes from the outside. To begin to save what's unique, and build on it.

The greatest obstacle to this goal is the community equivalent of low self-esteem. Very few communities are convinced that their own strengths and knowledge and talents and resources are enough to get them through difficult times, so they give in, they throw in the towel too early.

What I'm trying to do is take an eco-regional approach to eating. The RAFT [Renewing America's Food Traditions] Coalition is the first nationwide eco-gastronomic campaign. We came up with a map of North America based on food traditions. RAFT carves the continent into food nations distinguished by their keystone foodstuffs.

For example, in Flagstaff, I live on the border between Chile Pepper Nation and Piñon Nut Nation. The Pacific Northwest is Salmon Nation, while the Upper Midwest is Wild Rice Nation. The idea of RAFT is to catalog America's indigenous and authentic foods and their cultural significance. We look at which foods have fallen out of use and are at risk of extinction and which are capable of being restored and revitalized in ways that benefit communities and regions.

One of RAFT's founding partners is Chefs Collaborative, a national network of chefs who promote sustainable cuisine. Chefs Alice Waters and Rick Bayless have prepared entire menus from the plants and animals of their specific regions, and contract with farmers to grow some of the plants themselves. Now there is a market for many of the farms and farmers whose livelihoods were threatened. The goal is to get these foods back on our farms and ranches, in our rivers and forests, and, most importantly, on our tables. "You gotta eat it to save it," as my friend Poppy Tooker says. Try to imagine what it would be like if each of us would get 80 percent of our food from local sources. Imagine all the food miles and fossil fuel consumption saved.

When we know where our food comes from, we can give something back to our land and water, to the rural culture, the migrant harvester, curer, smoker, poacher, roaster, or vintner. We can give something back to the soil, something as fleeting as compost or something lasting and legal, like protection. We, as humans, have not been given roots as obvious as those of plants. The surest way we have to lodge ourselves within this blessed earth is by knowing where our food comes from.

———

Gary Nabhan *161*

Gary Paul Nabhan, PhD, is a writer, plant explorer, farmer, lecturer, and world-renowned conservation scientist. He is former director of the Center for Sustainable Environments, where he catalyzed the Canyon Country Fresh network on the Colorado Plateau. He is moving back to southern Arizona to work with the Southwest Center on Borderland Foodways, and to farm. After earning degrees in agriculture and arid lands resources from the University of Arizona, he cofounded Native Seeds/SEARCH and became a leading voice for conserving and renovating native plant agriculture in the Americas. Gary was awarded a MacArthur "genius fellowship" and a Lifetime Achievement Award from the Society for Conservation Biology. He is the author of many books, including Coming Home to Eat, Why Some Like It Hot, Cultures of Habitat, and Renewing Salmon Nation's Food Traditions. He has published more than two hundred magazine articles and won the John Burroughs Medal for Nature Writing, the Southwest Book Award, and the Lannan Literary Award.

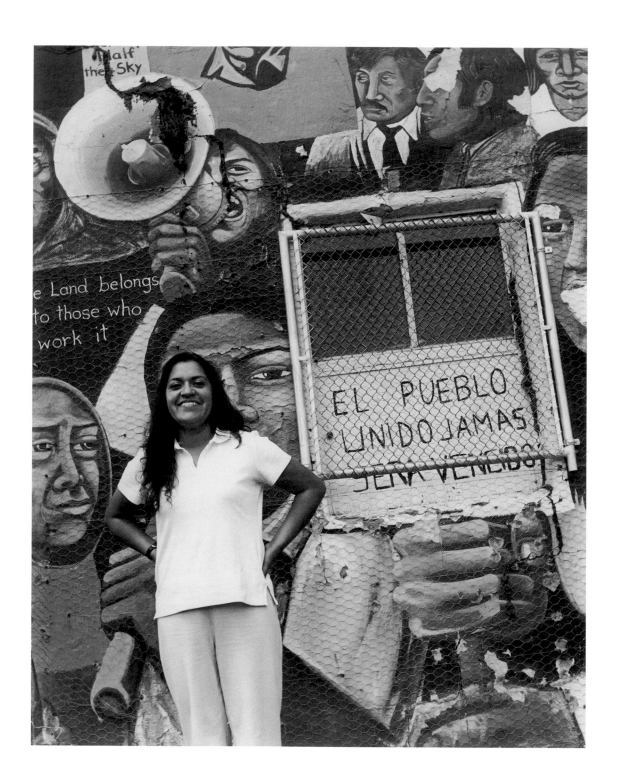

SYLVIA MARTINEZ
PEOPLE BELIEVE THE LIES

The Rio Grande restaurant in Greeley, Colorado, was our meeting spot with Sylvia. We held the interview over the local lunch noise and many interruptions from friends and colleagues—some in English, some in Spanish. Sylvia is highly respected for her work at Latinos Unidos, a local advocacy group that fights for immigrants' rights and addresses issues in the community affecting Latinos. She also works full time as an investigator for the Colorado State public defender's office and is in school working toward her bachelor's degree so she can attend law school. In eight years she hopes to be an attorney.

Sylvia speaks passionately about her two children and wants to see them go to college so they will be able to excel in the world. At age thirty-three, she is just getting started. She reminded us of a young César Chávez, fighting for the economic and social justice for her people, and we won't be at all surprised to one day read her biography.

I grew up working in the fields, harvesting onions, potatoes, and sugar beets. I was born in Montana, raised in Texas, and we migrated to Colorado to work. I am one of seven, and we all worked in the fields. My parents are out working right now in LaSalle, about six miles from here. I go out and help them all the time, just to be with them and the other pickers. I sent my son out to work in the fields last summer, not because we need the money, but to instill in him why it is important to stand up for the people who are out there working, so when some-

body says to him that they don't deserve to be here, he knows how hard they work and how difficult that work is and how little money they make. It's very hot out there. People don't have tents or umbrellas, and he gets it.

My dad was born in Mexico. He came to Texas when he was sixteen. My mom was born in Idaho, but both her parents are Mexican and came to America as illegals. Eventually they became citizens. All my grandparents died quite young; they lived a hard life. I envy the people who have their grandparents. That is why I am out there in the summer.

The label *illegal aliens* bothers me. As a lot of people know, trying to dehumanize a certain group makes it easier for people to criticize and hate. I hear stories all the time of how horribly Hispanics are treated when they go to apply for a job or a service or any kind of assistance, especially when they don't speak the language. Former congressman Tom Tancredo talks about illegals and what a drain they are on society and how they should all be deported. And the illegals he's talking about are Mexican. They happen to be brown, I happen to be brown, my son happens to be brown. I worry that someday my son will be seen around town, brown skin, short hair, and maybe baggy pants, and be labeled as a criminal.

A lot of misinformation has been fed through what I call racist groups, such as the Minutemen and the local CAIR group [Colorado Alliance for Immigration Reform]. They spread myths about how illegals shouldn't be here, how they don't want to learn English, and how

they don't deserve any help and deserve to work in the fields because they came here illegally. They lie and say that illegals are on public assistance. So many people believe what the media feeds them. It's so frustrating. Most of the people who work in the fields who are undocumented don't go to the doctor. They are afraid of being deported. So the people who say they are taking our services away are ridiculous.

I was in class and we were talking about race and immigration, and a girl in class—she is young—said that most of the people who are on Medicaid are illegals, that they are the ones taking advantage of the system. I told her to call the local Social Security office and ask if you need a Social Security card to get on Medicaid, because you do. She didn't realize that. This is what I mean.

We created Latinos Unidos to help people figure out where to go where they feel comfortable and can trust somebody. When I met with the county commissioners, they said, "We have all these services, we have Social Security," and I told them that people don't feel comfortable because they aren't treated as they ought to be when they go to obtain services. I am treated poorly all the time even though I am a professional and I speak both languages fluently. I can't imagine how poorly other people are treated.

We educate people about things like what is probable cause to be questioned and how they can be deported. Right now there is a huge panic in the undocumented community about how the immigration issues are going to affect them. Are they going to keep doing raids at work sites? Are they going to be deported immediately upon being stopped by a police officer? There is so much uncertainty.

I can't say that I have always been active or outspoken politically. I think things were escalating and when it was proposed to bring the Immigration and Customs Enforcement [ICE] office to Greeley, that pushed me over the edge. I heard about the proposal for the ICE office, and I went to a meeting to get some answers: what it meant, who was proposing it, etcetera… I met some wonderful people who are active in this community, and they inspired me to get involved.

We went to the city council meeting to get specific information and data about the ICE proposal. At the meeting, they were saying that 10 percent of people involved in gangs in Weld County were illegals. I said, "Ten percent of what number?" Eventually they said there were five hundred suspected gang members, and illegals made up 8 percent. I told them I wanted names. At that point the number dwindled down to less than 1 percent. This had already been signed by the county commissioners and was being used as evidence for the need of the ICE office. How do people just sign things without asking questions? I am appalled that a local government entity would propose this, that the county would sign off on it, and that city council would sign off on it without any questions.

Only eight individuals out of five hundred known gang members are illegal immigrants. Latinos make up only 17 percent of the people in jail. Those are both legals and illegals.

What I told the people who proposed the ICE office is this: if there were a need for ICE, I would support it. I don't like crime. I believe that criminals should be punished, no matter their skin color or whether they are here legally or illegally. But again, when I started asking the questions, the answers didn't match up.

You know what sickens me? The ICE office proposal was made in September, after harvesting season. That sickens me.

On December 12, 2006, ICE agents raided the Swift meatpacking plant. Three buses rolled in at 6:00 in the morning. Nobody knew they were coming. They took away 261 people, and many were deported that night. They took sets of parents with no regard for the children and left one telephone number that people could call to find out if their family members were there. I mean, these are people. They are already at rock bottom in this country doing work other people don't want, and then to get a kick in the rear like that is just horrible. It was one of the worst days of my life. I'll never forget the looks on people's faces, the horror I saw in their eyes, wives crying for their husbands, husbands crying for their wives.

We're organizing to let people know what's going on. But it's so hard when you open your eyes. You see all these inconsistencies, and it's overwhelming!

Our local school district has been put on watch by the state regarding CSAP [Colorado Student Assessment Program] scores. They proposed an overhaul of our bilingual education. They call it English language acquisition, which means that all kids have one year to learn English and take the CSAP in English. They don't have the staff to deal with the monolingual kids as it is. How are they going to get all the kids to test in English in one year? Our school district is 50 percent Latino, and of that 20 percent are monolingual kids. They just hired a communications director at over $100,000 a year, and he doesn't even speak Spanish.

At one school board meeting I stood up and spoke nothing but Spanish. Afterwards I said, "Now tell me how you feel about what I just said." After that meeting I was informed that they will have an interpreter at all school board meetings from now on. It baffles me that it takes something like that to make a change, to ask them how it feels. It is not their responsibility that so many parents don't speak English, but if their primary goal is to reach the kids, then they have to be able to reach the parents.

Do I think all people should learn to speak English? Absolutely. Do I think that all people should try to obtain citizenship? Definitely. How else do you get ahead? But it is easier said than done. My focus is to inform the larger community of the truth and get rid of the myths. I think the myths are used by people in power to hold power

I am proud to be an American. I was taught by my parents to be proud of where I come from, but a lot of kids are made to feel ashamed. What do we learn in our history books in this country that should make us feel proud of our Mexican heritage? I think it really makes our kids feel substandard. My son has been called a wetback twice this year, once by a basketball teammate and once by a girl at school. But it doesn't even affect him because he is so sure of who he is and he is so secure in himself. He says, "My grandfather is Mexican, and I am a Mexican American, and I am proud of it."

⋆⋆⋆

Sylvia Martinez was born into an immigrant family of agricultural workers. One of seven children, she was raised by her Mexican father and Mexican American mother. As a child she learned to speak English in the dual-language curriculum of Eagle Pass, Texas. Now she is fluent in both English and Spanish.

In 2006 Sylvia received the Community Leadership Award from Hispanic Women of Weld County. In 2007 she received the Panorama Unsung Hero Award from the Greeley Tribune *and the Archbishop José Gomez Award in Social Justice from the Denver Archdiocese. She would like to see Latinos Unidos become a social justice group that defends anyone—regardless of their ethnicity or gender—who has suffered discrimination or injustice. "I was like many other Latinos in the community," she once said. "I read what was going on in the community and the comments that were made, and even though it bothered me, I never thought I could make a difference."*

She is married to LeRoy Martinez and has two children, José and Quiana.

LUIS POLAR
BRIDGING THE GAP

We met with Luis at the Glenwood Springs Post Independent office, which at the time housed La Tribuna, and later joined him and his wife, Sanya, and two children, Nicolás and Ana, in the Glenwood town park for a photo session and some time on the playground.

Luis is a compelling voice for the growing Hispanic community in Colorado. Although he appears urban and entirely plugged in to the United States, he has experienced what it feels like to be an immigrant in a foreign country. He shared his story of arriving at Stapleton Airport in Denver with no idea of how or where to catch a bus and having to spend the night in the airport.

Unfortunately, early in 2009 La Tribuna was shut down by its parent company, Colorado Mountain News Media, because of the recession and the increasing popularity of Internet news. When we last spoke with him, Luis had just started his own bilingual newspaper, La Union, in downtown Glenwood Springs.

Growing up in Latin America, especially in Quito and Panama, we would drive to certain areas that were very poor. People lived on the side of hills with tin and cardboard walls, no running water, and mud floors. I remember asking my dad why some people had to live like that when others lived in regular homes. My dad said, "Well, Son, the life is tough sometimes, and this is the way people end up. That's why you have to go to college and educate yourself." That always stuck in my mind.

In 1989, when I first came to Colorado, there were not that many Hispanics. At least they were not as evident as they are now. I fell in love with the beautiful little town of Glenwood Springs. I felt very grateful to be here and knew I would stay for a long time. As the years went by, I saw the immigrant community start to grow. I saw that there was a little bit of resemblance in certain parts of the valley that reminded me of growing up in Ecuador. It seemed like people here were living at the standard of Latin America in certain ways. I wanted to do something about that.

I graduated from Colorado Mountain College in 1992 with a degree in photography. After years of working many different jobs, about the summer of 2000 my girlfriend and soon-to-be wife, Sanya, discovered that a group of people in the Basalt area were trying to start a Spanish-language newspaper. They had decided that was the most important thing that they could do to integrate the Hispanic community into the general population of the valley.

I told them that I knew art and photography and was fluent in both languages. They deliberated a bit about my credentials and finally said, "Well, Luis, fantastic news, we think you are going to be the one who is going to lead us to the next stage of this newspaper." We decided to call it *La Mision*, meaning "the mission," which in this case was to help the whole community.

I was the executive director/publisher/editor/photographer. I distributed the paper too. It was a great

thing because somebody would say, "Hey, Luis, we are having an exhibition of pottery, how can we get in the newspaper?" Often I would tell them that if they took photos and wrote me a little story, I would translate it into Spanish. Most of our content was in Spanish and English, and that's what brought the two communities together, because the Anglos could read what was happening in the Hispanic community and the Hispanic folks could read in English and get their English level a little higher, but also read in Spanish. It was a little more work because we had to translate everything into both languages, but I think it showed that we were a community newspaper because we were trying to bridge that gap—that was the whole idea behind it.

I began connecting with people who wanted to share something with the Hispanic community, for instance, about the importance of voter registration or the importance of giving kids a good education. I also connected with nonprofits throughout the valley. They gave me material—photography, text, statistics—anything I received I would put in the newspaper, so I collaborated with the YouthZone, the Buddy Program, the Roaring Fork Conservancy, and hundreds of non-profits in the valley.

Soon the paper grew enough that I sold ads. I would talk to Valley View Hospital or car dealerships or lawyers or real estate agents and tell them, "We have this great newspaper, the rates are very inexpensive, we take care of translation. We can take care of distribution. Would you like papers in your office? Great, you want twenty? Fantastic. Give me your address, and we'll make sure that every month we have the paper at your doorstep." It was a monthly paper, so it gave me a lot of time to work

with collaborators, photographers, circulation folks, and sales people. We did all this on a volunteer basis. I call it a labor of love, and it was just amazing to see how everybody came together to put each paper together.

La Mision was a nonprofit organization, and the goal was to educate and inform—period. We were not there to tell people if there was an accident, if somebody got killed; it was not a news type of organization.

In May 2006 our first weekly issue under the new banner, *La Tribuna*, came out. Colorado Mountain News Media, the organization that allowed us to print the paper for so many years for free, decided that it was time to bring us into their family of newspapers. Now we are a weekly publication.

In publishing *La Mision* and now *La Tribuna*, I try to include information that allows people to know what the possibilities are in the States. We talk about the services available to immigrants and the importance of parents getting involved in their kids' education, going to school and to the meetings—even though they have language barriers.

We often run a feature on somebody in the region—we cover six counties—so it could be somebody from Grand Junction to Aspen to Vail to Breckenridge. Usually that person is from Latin America and maybe volunteers his time in the community, or is a dishwasher who works really hard to put his kids through school.

Growing up in Latin America, *recycling* was a Chinese word—nobody knew what it was. When I came to the States, I realized that wow, people really care about the environment here, and I got involved too. As a family, Sanya and I do our best to conserve, recycle, and things of that sort, so I figured I needed to let our readers

know how to take care of the environment by recycling, conserving energy, how they can get their homes insulated in the wintertime, how to plant trees to protect from the sun in the summertime, and just give folks little tidbits of information so that they can become part of a greener society.

We did a story on the importance of breast-feeding, and that it is a woman's right to breast-feed anywhere. You don't have to have a special booth to do that. The idea behind running that story was to empower the population to know that if you have a baby, you need to take care of a baby's feeding. If it is a problem with your employer, they need to give you a space to do that. A lot of people, including myself, weren't aware of that.

For me, one of the goals of the newspaper is to try to educate and inform people how they can be aware of the resources this country has, but also how they can give back. A lot of folks receive, but they don't necessarily know that you need to give back too, through volunteering, through some sort of fund-raising, being part of the schools, parent/teacher associations, and things of that sort. So that's how the newspaper really comes into play.

In Latin America, papers are very big. They are institutions, like the government. You can't just walk in and say, "I want to speak to the editor of the paper." At *La Tribuna*, our doors are always open. We are here to receive anybody who has a thought, anybody who has an idea to share with us. They are more than welcome to sit down and talk.

Whenever I talk with folks in the streets, I see an invisible barrier. It is not a physical barrier, but it is an invisible barrier. I go to the park, let's say, I see a group of Hispanic families having a good time over here, and

a group of Anglo folks having a good time over there. Very seldom do I see a collaboration or a unity between the two. When people see me in the streets, they think I'm Anglo, they don't really perceive me as a Puerto Rican, just because of my skin and my freckles, but I say, "*¿Cómo estás?*" and they are like, "White boy, damn, pretty good." They ask, "Where are you from?" and I say Puerto Rico, and so that brings that barrier down. The Hispanic community really needs friendly individuals. We are a very gregarious and friendly community. We like to have fun and laugh and get together.

The newspaper is a great tool for bringing some of those barriers down. If you don't speak the same language, it is tough for you to know what the other person is thinking. At the same time there are cultural differences in food and music and other things that make Latinos a beautiful society, but there are a lot of things that bring us together with Anglos: our kids going to school, work, transportation issues, all sorts of things that no matter what language you speak, everybody has to deal with. So it would be best if all of us pushed the cart one way, because right now folks are pushing their own ways, in different directions. We have to find out a way to join forces, because all of us want the same things: to live happily, to be healthy, and we want the best for our kids.

My dad was very instrumental in forming my personality. He grew up in a small city south of Peru. It was a poor place. He didn't have a bathroom, he had to go and use the latrine outside, sort of a basic way of living, but very happy. They had chickens. They got the eggs in the morning. When I was growing up I was shy, always in the back of the classroom, never volunteered, never raised my hand unless the teacher made me. My father called me

Luchito, my nickname in Spanish. He'd say, "Luchito, you need to go out there and raise your voice, you have great thoughts." That always stuck in my mind.

I'm sort of teetering between two cultures. When I'm at the park and I see a group of Hispanics, I go Latino all the way. I have my shirt that says Puerto Rico, and I go hang out with the guys, have a couple of beers. I can ask them, "Hey, what's going on in the community? What are your issues? Are you having a great time?" Most people really love living in this country, so the beauty is that I can go and immerse myself in the Hispanic community. The next day I can go to a board of directors meeting in Aspen and talk to a bunch of Anglo folks, find out what they are thinking about transportation or medical issues, and then I can throw in a little bit about what's going on in the Hispanic community.

At some point I'd like to go into politics so I can bring those two worlds together. What are the issues affecting both communities? I have a perspective of the whole picture. Right now we are focusing on either the one side or the other, and we need to focus on both. I think my goal, as I keep growing as a professional individual, as a family member, as a community member, would be to figure out how I can empower myself to step forward and join some sort of a campaign to give my knowledge and my expertise to creating a better way of living in our valley and beyond.

⸺

Luis Polar was managing editor of La Tribuna, *a weekly Spanish-language newspaper covering the Western Slope of Colorado. He arrived in the Roaring Fork Valley in 1989 from his native Puerto Rico, pursuing his passion for photography. He has been involved with a variety of nonprofits for the last eight years, most recently as executive director of Mision Comunidad, an organization that published a Spanish-language monthly newspaper aimed at informing and educating the Hispanic population of the region.*

CREATIVE WAYS OF WORKING THE LAND

When we first began this book, we were fairly green in our knowledge of the new practices of land management. It was eye-opening to learn that land can be more ecologically healthy when it is being worked than when it is left alone. A good example of that can be found in Lani Malmberg's work. We spent a lighthearted day moving fences with Lani and her herd of weed-eating goats, in Cheyenne, Wyoming. Lani's goats create quite a stir in cities where she rents them out to eat nonnative plants, but ultimately, she says, seeing live animals makes people really happy.

We met Quivera cofounder Courtney White, who, in the spirit of Aldo Leopold, is becoming a well-known land philosopher. The Quivera Coalition is a nonprofit organization that fosters ecological, economic, and social health on western landscapes by building bridges between ranchers, conservationists, public-land managers, scientists, and others.

At the Quivira conference in January of 2004, we discovered that one can be both a rancher and an environmentalist. We needed to see for ourselves what this new breed of ranchers was doing. We toured the Gray Ranch in southern New Mexico, a place supporting one of the first successful partnerships of land activists and ranchers working together. We wanted to document lifelong rancher and hunter Warner Glenn's dramatic encounter with a jaguar and learn about his and wife Wendy's collaborative efforts with the Malpai Borderlands Group, which promotes sustainable land practices. Fire then led us to Sid Goodloe, who showed us how he restored his ranch to ecological health through chaining and prescribed burns.

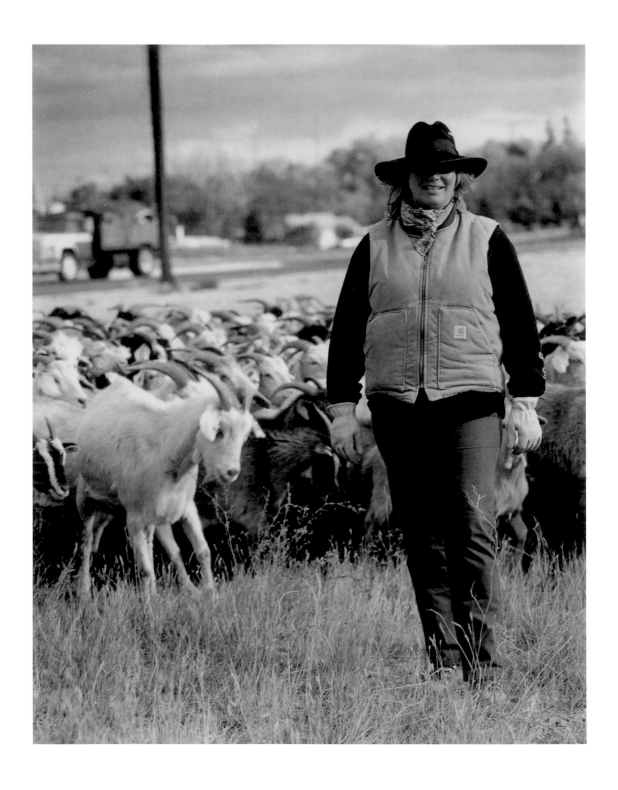

LANI MALMBERG
GOATS ARE AS EFFECTIVE AS POISONOUS CHEMICALS

Lani Malmberg grew up in the sand hills of Nebraska. Her family moved to Wyoming when she was seventeen; there she became a cowgirl and spent most of her time on the back of a horse, learning how to rope. She discovered weed science in graduate school and now travels throughout the West with twelve hundred cashmere goats that eat noxious weeds. She lives in a camper shell on the back of her pickup, which sports hand-sewn curtains, several kinds of tea, and most other comforts of home. Her outfit is aptly called Ewe4ic Ecological.

> *We saw the goats at work in downtown Cheyenne, Wyoming, eating weeds along the greenbelt between the river and the highway. She is so popular that the police came out to hold traffic while the goats crossed a main intersection. As she often does, Lani had befriended a homeless man she found living under a bridge and hired him to assist with goat patrol.*

Goats are a lot easier than other animals, but also I manage my herd to keep their instincts. I don't make pets, I don't spoil them; they've got to get through the winter. If a predator comes, they had better know how to take care of themselves, because I may or may not be around and may or may not be able to do anything. I've worked hard to train them. This business is based on respect: for the land, for the goats, and for the dogs—I have three working border collies. There is no such thing as controlling eight hundred goats in the middle of the city unless you have respect. That's what protects me, it's not technology, and it's not anything else. And I believe it's because I have that respect for the land and the animals that grizzly bears, wolves, mountain lions, and coyotes never bother me, never.

I have a master's in weed science, which most people have never heard of. I hadn't either, but it had a stipend, so I took it. I was a single mother raising two boys while I was in college. I had to figure things out.

My sons and I were running a sheep-grazing project, and that's where I got the idea that somebody—not me—ought to run a grazing service. Soon after, I met a woman that said she had just bought two cashmere goats, and I said, "Really, what do they look like?"

As soon as I saw those animals, I knew it would work. Goats are the exact opposite of cattle, and grass is their last food choice. Goats are browsers, not grazers. They don't like grass; rather, they choose the banes of the western range: Canada thistle, Russian and spotted knapweed, leafy spurge, white top. They'll also eat cactus, sagebrush, juniper, and salt cedar. One of the amazing things about goats is they don't like water. Cattle will trample a streambed to death to get to the water. When goats get near a stream, they jump over it; they don't even like to get their feet wet.

My sons took all their college money and I mortgaged my pickup and we bought a hundred head of goats. You should have heard the banker when I said, "I want to buy some goats." I still to this day doubt if I could get a

loan for goats. They'll throw new vehicles at you, but not a goat, not anything that would make money. We built up, and in three years I had twenty-two hundred goats. They come from Kashmir, in India. They're not milk goats. You can milk them if you want to, but it would be like trying to make a Chihuahua run a race. These goats are made for hair; they're good for cashmere sweaters.

The goats don't just eat the weeds, they actually kill them. They are as effective as poisonous chemicals, and in some cases, much more successful. They can go where spraying isn't allowed: beside waterways, in environmentally sensitive areas like national parks, in cities like Cheyenne, where they are trying not to use chemicals, and in towns like Taos, which hired the goats after the town banned the spraying of chemicals to control noxious weeds.

This is my fourth year in Cheyenne. I come twice a year. I graze it in late spring–early summer and fall. My boss, Bob Lee, has been the director of environmental management for the Cheyenne Weed and Pest Department since 1973. He's got a degree in chemistry and English and he's retired military and he's brilliant. He runs this whole city with damn few chemicals.

I take good care of the soil. We get the goats to poop in it, and while they're eating they stomp it down and recycle it to fertilizer. What they don't eat they knock down as mulch. Then I'll use the goats to trample. I have grass seed in the back of my pickup that I'll use to seed this afternoon and let the goats trample it in. There are three thousand hooves, and they are light animals, so the soil doesn't get compacted. It's almost like tilling.

The word *weed* is really a man-made word. To farmers, weeds are plants that they don't want in their fields because they're causing them economic damage. As far as plants go, they are not bad plants. It's just that we decided they are. We Americans decide lots of things—like that we hate dandelions.

Noxious weed—don't confuse noxious with toxic—is a legal term. Noxious weeds all share common traits, and one of those is they are nonnative. They are also very aggressive and they're invasive. Federal and state laws mandate that if you have them on your land, you have to control them because they are a threat to the ecosystem. Furthermore, the chemical companies were instrumental in getting the laws passed so people would have to spray more.

Because they're nonnative, they get in and take over where there are no competitors, no predators. Nothing eats them. There are no insects that will eat them because they are out of their home place, which is why they threaten the ecosystem.

Leafy spurge is a serious problem. It came in as a contaminant in alfalfa seed with the immigrants into North Dakota. Russian olive trees are a problem in the West; the government paid you to plant them in the fifties, and now they pay you to kill them. And they are beautiful.

Tamarisk is a serious problem in the West. My goats will eat it twelve months out of the year, but it is impossible to get anybody in Colorado to listen to any kind of sense. Instead they want to fight over chemicals and biocontrol insects and not listen to any reason at all. New Mexico is worse. The chemical people always get us pushed out.

In Sharon, Nebraska, my son Reggie and I took a hundred head and we went to the elementary school

and put them on the football field. I brought fifty pounds of baby carrots and let them feed Sarge, my lead goat, and then whoever else came up. Those kids learn about their plants, their city, and their management; it's something real.

Sometimes I carry a gun with me. I got in trouble in Boulder for shooting on campus. I was attacked by three malamutes in the middle of the night. I hit one dog twice. I was trying to kill two of them and, oh man, I was in big, big trouble for that. The police were there at daylight telling me, "Put that gun away and don't use it again." They were really upset that I was shooting in town and told me I could take my goats and leave.

It's hard work, and I love it. I used to have a house. With that you just do everything over and over and over and over. You get done dusting and it's time to dust again, and you eat and then you've got to wash the dishes and put them away. Everything is so repetitive. I mean, what's the difference? You pick your repetition. We move the goats all the time in this job in the city. I get a huge muscle in my arm from moving the fence that contains the goats. I could arm wrestle for a dollar and probably be a millionaire. Of course, [having] Swedish blood doesn't hurt—being big and strong, you know.

I never get lonely. I don't miss electricity. My camper is set up on solar. I get free showers at the truck stop. The only thing I ever miss is a hot bubble bath. But it is fun, you know, everything is a trade-off. I don't have a house payment, I don't have an electric bill, I don't have trash, I don't have sewer, I don't have a mortgage, I don't have to fix the roof. I don't have any of that. I do drive a $45,000 pickup, but I have to because I cannot be stranded. So I've got a $45,000 pickup and a $200 house on the back of it. I haul my water and use a refrigerator that runs on propane. Somebody asked me once, "What kind of food do you put in the cooler?" And I said, "The ever-so-thinnest sliced deli meat I can get, because that's the only thing that fits on top of the beer."

Lani Malmberg's background is in cattle ranching. She has a degree in environmental restoration and biology/botany from Mesa State College and a master's in weed science from Colorado State University. She has been a gypsy goatherder since 1996. Her goats have done land restoration in twelve western states, most recently at several Xcel generating stations in Colorado. Each season she hires two or three homeless people to help with the goats, and she is happy to say that every one she has hired has gotten on their feet and moved on.

COURTNEY WHITE
WE'RE ALL NEW TO THE WEST

We arrived at Courtney White's adobe home on the outskirts of Santa Fe at 6:00 AM on a Sunday to catch the morning light. We accidentally woke his young son, Sterling, who rose and shared coffee and donuts with us in his pajamas. Courtney is a self-described land health activist. Rooted in traditional environmentalism, he now subscribes to the radical center, a place where environmentalists, ranchers, and scientists come together to create alternative solutions for land health. In 1997 he and Jim Winder formed the Quivira Coalition, a group that fosters ecological, economic, and social health on western landscapes. We attended the 2004 Quivira conference just as we were beginning this book.

I grew up a card-carrying environmentalist with the Sierra Club. I became very concerned about the assault on environmental laws in 1994, and in the process I met a rancher. In fact, one day I walked into a statewide Sierra Club meeting in Kingston, New Mexico, and there was a cowboy hat on the table, and I thought, "This doesn't make any sense." There was a rancher there named Jim Winder, and I was shocked when I found out that Jim was on the statewide board of the Sierra Club. I hadn't invested a lot of energy in the grazing wars, but I had a lot of prejudicial feelings about cows, the usual stuff: the only good cow is a dead cow. Jim said, "Don't judge me. Why don't you come to the ranch?" So we took the tour of his ranch, which is near Deming, New Mexico, and I saw on it all the things I valued as a conservationist: open space, water, and wildlife. Jim knew the grasses, he knew how ecosystems functioned, and he had a great sense of humor.

Jim and I started talking. You have to understand, at the time this was crazy. There were only overgrazing ranchers and hardheaded environmentalists, and we were always butting heads. But Jim and I started talking, and we decided there must be a middle ground. When you get down to it, we have more in common than in difference. From that, we decided to form a little nonprofit called the Quivira Coalition. *Quivira* is an old Spanish colonial term used to describe unknown territory beyond the frontier.

We decided to create a neutral place where ranchers and people concerned about the environment could meet and talk. We began taking tours of well-managed ranches, and we called ourselves the ultimate grassroots organization because we focus on grass and roots: we wonder what's going on below our feet. A lot of ranchers came to the workshops.

It is my personal opinion that the livestock grazing question is one of the most complex in the environmental pantheon. That is in direct contrast to what the anticow people are trying to accomplish. Their whole philosophy is to try to push people off the land, which conforms to the ecological model that says that nature knows best. Well, maybe, but under global climate change, what's natural anymore?

Aldo Leopold wrote years ago that "healthy land is the only permanently profitable land." Now we're asking

deeper questions about whether the land is functioning or not. My point is we spend a lot of time looking up. We don't spend enough time looking down. Land health is the language that describes the common ground below our feet, and I feel very strongly that this is the emerging paradigm in the conservation movement. The old paradigm was to protect it, to create wilderness, to create a park. You know, you go back historically, John Muir and those guys, it's all about parks and drawing lines on maps. I think all of that has faded away as a paradigm now. For one thing, global climate change doesn't know boundaries. Noxious weeds don't respect boundaries. So, we're finding that folks are thinking a lot more about land health, land function, and how to fix it.

We call ourselves a land health organization. It's larger than just ranchers and environmentalists working it out. I call it a land health movement because our thoughts are based on a lot of science. When we got started, there was a lot of skepticism, and there was some pretty deep bovine bigotry. I think over the last eight years, there's been enough progress on a lot of different fronts and folks understand that cattle can be managed sustainably on the land.

Before our Quivira conference in 2003, we decided to organize a retreat of twenty ranchers, environmentalists, public-lands managers, and scientists, with the express intent of calling an end to the grazing wars so that it was no longer necessary for one side to fight the other. We had plenty of models to use and felt there was too much in common to continue to strangle each other. So we wrote an invitation to join the radical center. I think on a lot of levels, people think that ranching isn't working well, environmentalism isn't working well, public-lands

management's not working very well, scientist are not hugely engaged. We've got a lot of threat from subdivisions. The West is changing dramatically.

To me, it's about a West that works, about trying to fix real problems. Trying to break gridlock. This is what the radical center is about. It's increasing participatory democracy, which we all feel is not working very well. And it's got to be about paychecks. If we don't find a way for rural folks to make a paycheck, then we're pretty much wasting our time. As one of my board members likes to remind me, profit is not a dirty word. Part of my struggle with the environmental movement is that they don't like profit on public land, except I don't know what that means. It's okay to profit from river rafting on public land. It's okay to profit from nature photography on public land, but you can't graze a cow. Aldo Leopold said, "Look, if the land is healthy, it really doesn't matter what you're doing, right? If it's recreation or ranching or photography, if the land is functioning properly, it shouldn't matter what's going on." Which is a pretty radical paradigm shift.

Roger Bowe ranches out near the Texas state line, on thousands of acres of private land. Prior to 1985, he and his father were running eighteen head to the acre, and the land health was in slow decline. They know that because they were monitoring, they were measuring it. Roger decided to change the way he manages his ranch. He divided the ranch into sixty-two paddocks, which gave the land lots of rest. You graze it and then you get off the land and let the plants recover. And that's what he did. Essentially he mimics the migratory behavior of herbivores like bison, which graze and then go away. They don't come back for a long time.

As a result, he decreased his bare ground by 33 percent. Bare ground is often an indicator of poor land health. You don't want bare ground—weeds come in. When he rested the land, snakeweed, which nobody likes, declined, grasses came back, springs came back. Water flowed. The cost of his production per pound dropped more than 50 percent. He set land health objectives and has been very successful.

This is where I really part ways with the anticow people. Who is going to do this type of restoration work? For starters, it's the folks who live here. We have the labor pool in place, the ranchers and other rural people. You're not going to outsource this work. What I like about restoration work is that it is a form of giving. You feel like you're giving back to nature. You get in the creek, you get muddy, you build things with your hands. It's a satisfying, soul-enriching experience, and everybody who does it comes away a different person. We have a serious problem, I feel, particularly in the generation coming up, that there is an increasing disconnect between folks who live in cities and the natural environment. I feel very strongly that eventually we can get more folks out doing restoration work rather than merely recreating, as a way of reconnecting urban people to wild country.

Wes Jackson likes to ask the question "How do we become native to these landscapes?" Most of us are strangers here. Many of us have arrived relatively recently, and frankly, we're still trying to figure out how to live in this landscape sustainably. That's why I get excited about what some of these ranchers are up to. They have figured out a way to live sustainably in these landscapes. They could teach those of us who live in cities a lot. We're still living pretty unsustainably, and that's why when folks try to run people off the land, I get upset, because you're running off folks who have figured out some of this and you're trying to replace them with what? A mall? So how do we become native to this land? We started with cows, and started with the conflict between ranchers and environmentalists, and I think we've ended up asking these larger questions about how do we live in this landscape, for the long run.

———

A former archaeologist and Sierra Club activist, Courtney White voluntarily dropped out of the "conflict industry" in 1997 to cofound the Quivira Coalition, a nonprofit organization dedicated to building bridges between ranchers, conservationists, public-land managers, scientists, and others around the idea of land health. Since then, his work has expanded to include restoration, resilience, and local food production.

His writing has appeared in numerous publications, including Farming, Rangelands, *and* Natural Resources Journal. *His essay "The Working Wilderness: A Call for a Land Health Movement" was recently published in Wendell Berry's collection of essays titled* The Way of Ignorance. *In 2008 Courtney's book* Revolution on the Range: The Rise of a New Ranch in the American West *was published.*

Courtney lives in Santa Fe, New Mexico, with his family and a backyard full of chickens.

SID GOODLOE
YOU DON'T FIND MORALS IN CITIES

Sid Goodloe ranches in the sparsely populated region near Capitan, New Mexico. In ranching circles Sid is lauded for restoring his ranch to ecological balance, a journey that obsessed him for more than forty years.

To find Sid and his wife, Cheryl, we followed the smoke in the air down a long, winding dirt road—changing a flat tire along the way (our second that day)—to their ranch, where we met Sid, armed with a pitchfork, Cheryl, and Katie, their border collie, working the fire lines. The Forest Service had finally acquiesced to months of pleading and allowed Sid a prescribed burn. Sid spent from sunup to nightfall tending the fire lines. We enjoyed a family dinner at their house and a lengthy chat with Sid and Cheryl. Sid explained to us why fire is as important to the land as rain and sunlight.

It's gratifying to me to see people beginning to think about conservation. For some reason, a lot of ranchers, if you mention the word *conservation*, it's almost as bad as using the *E* word. I don't know why. I love every inch of the land. I've always tried to do right by the land.

I read *Sand County Almanac* by Aldo Leopold, and my gosh, I don't know why people haven't accused me of copying him. The things I read in there are the exact same things I've been saying about conservation and erosion control for thirty years, and he said them in the 1920s. That guy was fifty years ahead of his time. Everything he said is coming true. When I started trying

to revive my ranch, people liked to look at the pictures and liked to look at what I had done in the way of juniper control, but they didn't pay any attention to this forest business at all. They thought I was a nut. Boy, now everybody wants me to come talk to them.

It's a proven fact that this country burned every seven to ten years. The whole Southwest, from Colorado to California, burned at a regular interval. Either the Indians set it or the lightning set it, and it kept the tree population down to a reasonable number. There's supposed to be about five to ten trees to the acre. Now we have a thousand, and it is a tremendous, tremendous fire danger.

Crown fires are what we've been seeing this century. That's where the fire gets in the tops of the trees. The wind carries the fire from tree to tree, and preheats the needles in these trees, which are full of turpentine. Once they get preheated, they just explode. You can't stop a crown fire. What we're trying to do is prevent those kinds of fires by burning the ladder fuels.

The human mind-set is afraid of fire, and until you get over that basic fear, and until you can get rid of Smokey Bear and his fifty years of brainwashing, everybody under forty-five years of age is of the opinion that all fires are bad and all trees are good. That's Smokey. Well, the Forest Service has realized that their Smokey Bear campaign did too much good. Now they're changing from fire suppression to fire management, and that's what I'm doing here, fire management.

I'll come back after this fire. I can't reseed under these ponderosa trees because the pine needles kill the grass. I'll find the open areas and seed them with native grasses. Up here at 7,200 feet, I can plant brome and timothy grasses. They grow well up here and require only .01 percent of the water these trees do, and unlike the trees, the grass holds the soil. Trees suck up all the water and dry out the soil around them, leading to erosion. The bottom line to conservation is to hold the soil. It doesn't matter what else happens. You can't improve land if the soil has been washed away. But no matter what you do, if you have a drought, there's just no water. We've been in a drought since about 2000.

The drought at least makes people conscious. Out of a hundred and twenty or so bills introduced in the New Mexico legislature this last session, ninety of them were water bills because of this drought. People think that passing laws is going to get rid of the drought. We don't know whether global warming is going to cause wetter or drier times, and El Niño this, La Niña that. I don't know what La Mama does, but she'll come out someday.

Watershed rehabilitation is basically the bottom line of what I try to do. That includes brush control, forest thinning, erosion dams, planned grazing, and other kinds of holistic approaches to management. When I first came here, the lower part of the ranch was covered with juniper. I took out most of those trees and returned it to the way it was a hundred and fifty years ago. The stream came back, and now there is water on the ranch again.

The biggest threat to ranching now is subdivision. The environmentalists are still concentrating on overgrazing, and they're on the wrong trail. They ought to get back on the main road: exurban development. Once you break up an expanse, you've ruined the aesthetics. And you've got all these dogs, cats, and off-road vehicles that go with subdivisions. That destroys more land. It's like a spreading fire: you can't stop it.

There are a lot of people who have made a lot of money and need a tax break and they buy a ranch. They'll put a conservation easement on it. That's good for the land. It may not be good for the community or the social structure in the area, but it's good for the land. I'm donating an easement here that's worth $100,000. I'm doing that because I don't want this land to be subdivided. It's just my feeling, and my kids are going along with me on that. I'm not worried about them subdividing it, but my great-grandkids might.

The reason we formed the Southern Rockies Agriculture Land Trust is to protect family ranching, to keep families on the land. Raising a child in the country is so much better than raising him running up and down the mall with a pair of shorts on that come past his knees. And these kids out here, like my grandkid, they've got jobs to do. They have responsibility. They have a work ethic. They have morals. The things that you don't find much in the cities anymore.

⚬⚬⚬⚬

For fifty-one years, Sid Goodloe has been owner-operator of the Carrizo Valley Ranch, sixteen miles north of Capitan, New Mexico. Sid's interests range far beyond his own ranch. He is board member of the Quivira Coalition, founding member of the New Mexico Riparian Council, a member of the National Commission on Wildfire Disasters, and travels the world as a livestock consultant. He has been the recipient of many awards,

including the National Cattlemen's Association's Environmental Stewardship Award in 1995, the New Mexico Watershed Coalition's Watershed Steward Award, and the Lifetime Achievement Award from the New Mexico Riparian Council in 2003. Sid has a master's degree in range science and a bachelor's degree in animal science, both from Texas A&M University. In 1999 he helped form the Southern Rockies Agricultural Land Trust (SRALT) to assist private landowners in New Mexico in acquiring conservation easements. SRALT is an all-volunteer land trust dedicated to providing future generations a way to enrich and fortify their lives with connections to land unencumbered with condos, malls, and paved streets.

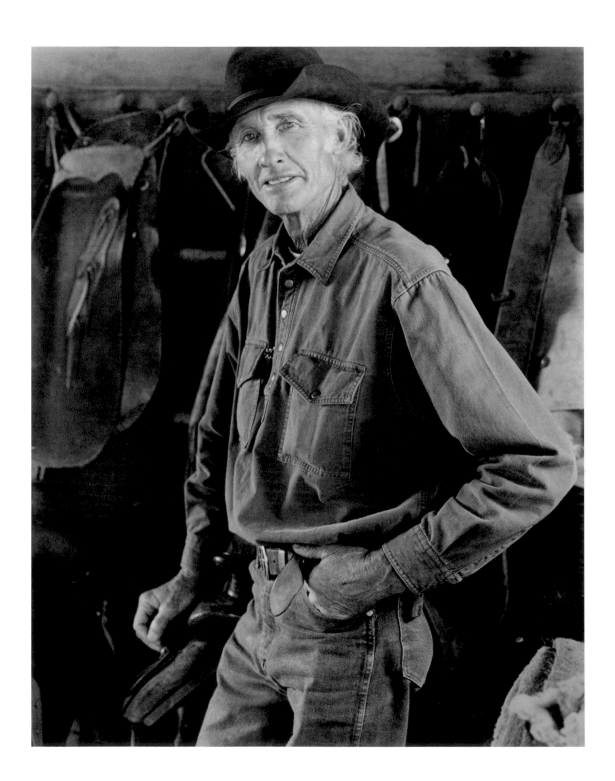

WARNER GLENN
NOT GOING TO LOSE THE COWBOY WAY OF LIFE

Warner Glenn has been described as many things: "the real deal," "the most manly man I've ever met," and "the best hunter and cowboy in Cochise County." Though a fourth-generation Arizona rancher and second-generation mountain lion tracker and hunter, Warner, now in his seventies, represents a new breed of rancher, born from the desire to preserve the land and culture that defines him. In 1994 he and his wife, Wendy, helped found the Malpai Borderlands Group, a coalition of ranchers, scientists, and government agencies who work with the Nature Conservancy to promote sustainable ranching and other livelihoods that support open space and the ecological health of the land.

We had an eye-opening visit to the Malpai borderlands. Surrounding the town of Douglas, in the southeast corner of Arizona along the Mexican border, is a dry, brittle landscape full of cinder and lava rock, and covered in mesquite, prickly pear cactus, and tobosa grass. It is a land of empty and rugged vistas.

Warner and Wendy built their ranch by hand. In the main house is a museum containing artifacts they collected off the land, along with the pictures Warner took of a jaguar and many photographs of the Masai who came to the ranch to learn about the Malpai Borderlands Group.

Beneath his Stetson and chaps is a gentle man, quick to tell a joke, play a tune on his guitar, or tell you about the birds in his yard. When he speaks, he speaks about the value of open space and open country and the importance of preserving the lifestyle that has kept him alive his whole life.

There was never a time when I wondered what I was going to do when I grew up. I always wanted to be a hunter and a rancher. I sure did. I mean, I knew I was going to have to take some school. I went through high school, and I went through a year and a half of the University of Arizona. I could have gone through four years if I had wanted to, but that was all I needed.

I started hunting with my dad. He started hunting to protect his livestock from [mountain] lions. From when I was eight years old, I was hunting—when I wasn't in school. I hunt because I love hunting. People from all over the country come to hunt with us, and surprisingly, with the controversy and pressures there are today, we're booked.

We hunt about any adult lion. If we know a lion is pregnant, like when we get her treed and we look at her, I tell our hunter, "It's legal to kill that lion, but if it's all right with you, we'll let it go and we'll just keep hunting." I've never had one hunter say no. They all say, "Well, heck, I don't want to kill a mama." So far, but that's just kind of an unwritten rule we go by. You don't want to kill off your population.

I don't want this to sound corny, but the cowboy way of life has kind of been shoved in the background, and out here we're not losing that. We depend on our horses or

our mules to go out and work the cattle. We don't depend on pickups like they do in some areas. We haul stuff, but we still do a lot of work on horseback because of the ruggedness of the country—it's hard to get around. I'm not saying that some of these ranchers don't have four-wheelers; we're probably the only ones around that don't.

Cattle ranching and guiding hunting clients have been my life work. I have had moderate success at both, and I don't think I would want to change a thing if given the chance. I've had the constant pleasure of riding a good horse or mule through beautiful country, been able to breathe clean mountain air, and been blessed with a wonderful family. Besides all that, I have owned some dogs that were a pleasure to hunt with and call my friends.

[Our daughter,] Kelly, she's loved the ranch all her life. She went away to Cal Poly to college, and she came back. She just likes this way of life, and she's a wonderful hand. When you're good at something you tend to like it. And she's good at it.

—

On March 7, 1996, Warner, Kelly, a cowboy named Aaron Prudler, and a hunting client tracked what they thought was a tom lion. The animal led them on a long chase through the rugged Peloncillo Mountains. In the end it wasn't a mountain lion they had tracked, but a jaguar. Kelly, on an alternate route, didn't see the jaguar, but Warner became the first person to photograph a wild jaguar in the United States. For Warner, it was a lifelong dream.

A conservationist at heart, Warner did what many ranchers may not have done. He let the jaguar live, photographed it, and then wrote a book announcing its presence. In the minds of many ranchers, this was a sure way to have more restrictions placed on land already in jeopardy of being shut down to ranching. Once an endangered species is known to live on public land, cattle grazing can be restricted. For Warner, revealing the truth was the only option.

FROM THE HUNT:

Warner: When I hit that road probably another good mile and came around the bend, those dogs were just coming off some bluffy peaks to my right and they were really running hard. I could tell they were smelling the body scent of that animal in the air—and I could not believe that that thing was still moving that fast. I just couldn't believe that any lion could run that far that fast. I never even dreamed of it being anything but a lion.

By this time the dogs had gone over a big old red peak, we call it Red Mountain, and I couldn't hear them anymore. By the time I got to the top—it took me probably thirty minutes to climb over that peak—I could hear them barking bayed in a big basin ahead of me and I could tell they had it stopped. At that point, I'm looking about a half a mile across this basin and I could see this object, this animal on a big bluff, atop a big pinnacle of rock. Of course I'm still thinking tom lion. When I walked around the big piñon tree where I tied my mule, Snowy River, I could see this animal sitting on the rock about a hundred yards [away], and that's the first time I realized it was a jaguar. Here's this big old spotted cat crouched on the rock with this big black stripe down his back. At that point he was looking over the edge at the dogs. I said to myself, "God Almighty, that's a jaguar!" I ran back around the bush to my mule and grabbed my

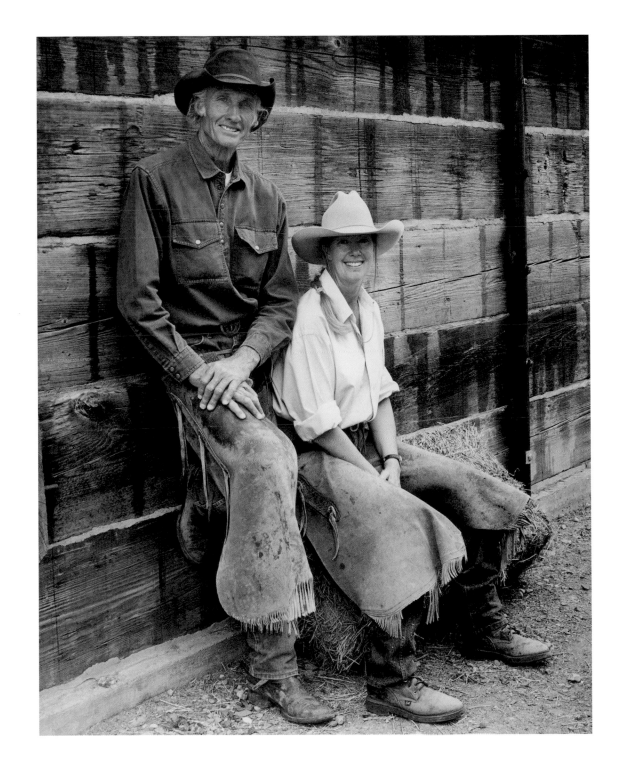

Warner Glenn *193*

camera and I came around that bush like it might be the only picture I'd get of the jaguar. I took the picture from a hundred yards."

Kelly: Then Dad gets on the radio and says, "Kelly, this is a jaguar," and I immediately started crying, because for sixty years Dad and his dad had wanted to find a jaguar and had gone to Mexico to look for one and had never seen one.

Warner: I walked down to get within thirty feet of where he's sittin', and he's crouched there looking at the dogs. I took a picture of him there, looking at the dogs, and he looked back at me and then, no change of expression, he just looked back and forth between me and those dogs. Then he looked at me again. Then he raised up on that front end on the rock and went to looking around, and I knew that rascal was going to move out of there. I got a picture of him coming back over that rock, and then he came right over heading towards me, and then he went right down over the slope of the rock and made the jump. He jumped right in the middle of the dogs and all of them took off and *kay yay yay yay yay yay*, and they ran away over the mountain. I had to go up and get my mule, which was a hundred yards up the mountain. So I ran up there, and I got on old Snowy River, and boy, we smoked it off that mountain. When we got around the edge where the ridge went off the mountain, I could hear them barking again, and this time I knew they were barking right in this thing's face—it was just a frantic bark—and I was frantic to get down there. Boy, I was rolling off that mountain fast.

When I got within about thirty or forty feet, I could hear that jaguar roaring. I mean, he was roaring like a bull. It wasn't a growl like a tom lion, he was letting off this big ol' *rheu rheu!* like a mad bull, and at

first I thought, "What in the world is that noise?" Then I thought, "My gosh, that damn jaguar is making that noise." And boy, he was mad. That sucker was mad. They're the only roaring cat we have in North America.

I have a blue tic dog named Blue, and she was laying in there below him in a hole out of my sight. I didn't realize that, and the rest of the dogs were on top of the thing just barking right off at it, so I snapped these pictures and that thing looked around and saw me, and from that point on, when he turned around and made eye contact with me, he never took his eyes off of my face. He locked on and boy!, here he came. I was just too dang close and he was coming, and he made a big leap out of there and hit right where the dogs were. Those dogs met him, and he'd a-been right on my lap that next jump. I mean, he was dang sure—that look, you've seen it; I've seen it in stud horses that were mad. I've seen it in bulls that were mad too. They lock on and everything is out of their sight, except you.

I was running backwards and at that point, when he hit right there, those dogs met him head-on. Maple and Cheyenne and Pearl and Map all just met him head-on, but boy, they just went head over heels back into that hole, and he didn't know quite what to do then. It took his mind off of me. And then he had old Maple by the leg. I run in there and kicked a bunch of stuff on him that hit him on the rear end, and he turned Maple loose and whipped around. I took my hat off and beat those dogs that were up there with me back and was hollering at 'em, "Get back, get back!" As soon as the pressure kind of got off of him just a little bit, he looked around and I saw the top of his back and [he] turned and went 'round the edge of the ledge right there and went around out of

sight. There was a little canyon there just about ten or fifteen yards, and he went across, and I saw him coming out the other side of that canyon—he was pulling out, and boy, was I glad. I necked those dogs, and we got out of there. And that's when I told Kelly on the radio, I said, "Boy, Kelly, that thing's gone; I'm gettin' out of here."

———•————

Warner Glenn was born in 1936 in Douglas, Arizona. He was taken to the J-A Ranch in Hunt Canyon, Chiricahua Mountains, when he was two weeks old and was raised there. He attended his first five years of school at a small country school at the mouth of Rucker Canyon, thirteen miles from his home. He finished school in Douglas and attended the University of Arizona at Tucson for a year and a half before going to work on his parents' ranch and in the family hunting business. Now he and his wife, Wendy, with their daughter, Kelly, operate both his parents' ranch and their own ranch, as well as the hunting guide business.

WENDY GLENN
KEEPING RANCHERS ON THE LAND

Wendy and Warner Glenn scratched their ranch into existence with the help of lion hunting, subdividing, and a small number of cattle. When land management conflicts began to threaten their ranch, they helped form the Malpai Borderlands Group (MBG). MBG is one of many groups around the West dedicated to keeping ranchers on the land. Each is different, but each shares humble, on-the-ground origins with a group of neighbors dedicated to preserving a way of life. After being enraptured by Warner's jaguar encounter, we sat with Wendy outside the mule barn and learned about the Malpai Borderlands Group.

———•————

When we bought this ranch in 1960, it was undeveloped. There were almost no pastures; fencing was down. There were no pipelines to distribute water to the cattle.

Warner and I lived in a mobile home until we could build a house. And even then, as we built, we lived for awhile without windows and doors.

It was almost as hard to name the ranch as it was to build the house. It had been called the Slaughter Ranch, after the man who had originally owned it. But instead of naming it the Glenn Ranch, we decided to name it after the land. The word *malapais* means badland, but it also means lava rock, which is all the rock you see around here. The mountains you see around us in the valley are cinder craters. We thought the word sounded neat. But there was a ranch north of us years ago already called Malapais, so we changed the spelling and named our ranch Malpai and thought that sounded good.

In 1991 we started having meetings with the neighbors, getting together here. We fed them and we sat down together to try to solve some of the problems we

faced and share our concerns for the health and future of our land.

The incident that inspired some of our first meetings was the suppression of a small brush fire in our valley by a land management agency. All of us felt strongly that this fire was beneficial and should not have been put out. We believed, and still believe, that fire suppression is a major factor in brush taking over grasslands. We wanted fire to regain some of its natural role in the ecosystem and be allowed to burn whenever possible.

To do this, we had to expand beyond just the local neighbors. So we held a big meeting: thirty ranch families met at the Malpai Ranch. Out of that meeting came a request for the land management agencies to work with ranchers on a comprehensive fire plan for the area.

After that, in 1994, we decided to officially organize. Bill McDonald, John Cook, and a whole group of us sat in our living room there and came up with a board of directors. And then we tried to come up with a name. We kept coming back to the word *borderlands* because we're on the border next to two Mexican states and two American states.

Someone asked, "Well, most of our meetings are here. We're in malapais country. Do you mind if we use the name you have on your ranch?"

So we became the Malpai Borderlands Group.

The land here is mountains, canyons, valleys, and riparian corridors from 3,500 to 8,500 feet of elevation. The area includes the San Bernardino Valley, the Peloncillo Mountains, the Animas Valley, and Animas Mountain. Several rare, threatened, and endangered species are found here. It is the only place in the US where Gould's turkey and white-sided jackrabbits occur naturally. It is also home

to popular big game species such as Coues deer, mule deer, pronghorn antelope, lion, bear, and desert bighorn sheep.

The most remarkable feature of this landscape is that fewer than one hundred families reside on it. Many of these families have been here for generations. Except for a small wildlife refuge, this is cattle ranching country.

We formed Malpai Borderlands Group [MBG] to bring not just ranchers together, but also scientists and key agencies so we could solve problems. Warner is on the board of directors, and I am the office manager. We hold meetings and workshops and host a lot of the group's guests at our home, which is also the MBG office.

Ultimately we're working to keep the habitat healthy and keep ranchers on the land. Perhaps as important as any single thing we have accomplished is the fact that this small group in a remote corner of Arizona and New Mexico has had a very significant influence on the way that ranchers, the environmental community, the government, and the public perceive conservation and ranching today. The focus is moving away from confrontation, regulation, and litigation, and moving toward finding common ground and working together using the best available science, working at the grassroots level, and exhibiting real stewardship.

What does MBG actually do? We have projects like turning gullies back into streams. We purchase ranchers' conservation easements in exchange for grass or cash so they can protect open space and stay in ranching. We put fire back on the land to force out the brush and bring back the grass. We work to ensure that wildlife and cattle have water.

There are still many challenges. Pressure from subdivisions will increase, as [will] the impacts of

undocumented aliens and the Border Patrol on the land. Drought has taken a huge toll on the land and on the livelihood of many people here.

Despite everyone's best efforts, it is a struggle to keep ranching here on the borderlands, as it is almost everywhere. But we are all in it for the same thing: to keep open country and to keep ranchers on the land.

———

Wendy Glenn was born in Douglas, Arizona, in 1940. She attended the Douglas schools as a girl and the University of Colorado at Boulder. She married Warner Glenn in 1960 and lived on the J-A Ranch with his parents until 1963. In 1979 they built their house by hand on the Malpai Ranch. She and Warner have two children, Kelly Glenn Kimbro and Cody Ira Glenn. She works for the Malpai Borderlands Group.

NEW TYPES OF ECONOMIES

The people in this category bring new meaning to the corporate boardroom. Yvon Chouinard's story of turning Patagonia into an experiment in sustainability is an ingenious tale of what one man is doing to make a difference. Peter Metcalf saw wilderness as having economic value and leveraged the Outdoor Retailer Trade Show—a huge moneymaker for the state of Utah— against officials who continually stonewalled wilderness protection. Doc and Connie Hatfield turned a dying ranch and ranch community into a thriving cooperative business and are mentors for ranchers all over the West. We see their efforts as a new way of asking the land to produce a profit while simultaneously improving its health.

YVON CHOUINARD
I RUN MY BUSINESS AS A WAY TO CHANGE THE WORLD

Fortunately, it was raining in Moose, Wyoming, the day we were to meet Yvon. He had forgotten about our interview and set off to go climbing with friends early that morning. He returned just as we arrived. We drank tea and talked in front of a picture window that perfectly frames the Teton Mountain Range. Meredith and I felt right at home. After our interview he treated us to lunch at nearby Dornan's Pub.

Yvon recounts his climbing-bum years, scraping by and living out of the back of a car, with fondness. When he's not climbing, surfing, or fishing, Yvon runs Patagonia, an outdoor gear and clothing company. Patagonia, he says, exists as an experiment in long-term sustainability and good citizenship. His book, Let My People Go Surfing, *is his story of turning Patagonia into an ecologically sound business model and living an examined life himself.*

If you really want to change the world, you have to change business. That's what's destroying America. Business and this economy based on endlessly consuming and discarding.

I wrote the book *Let My People Go Surfing* as a textbook for young people. Patagonia employs a thousand people around the world, and we probably have only four or five employees with any kind of business degree. They're all people who studied anthropology and biology. Suddenly they're working in business with no preparation whatsoever. It is a positive thing because we break all the rules. If I get somebody with an MBA, they want do it by the book, which doesn't work in our company.

I never wanted to be a businessman. I was a blacksmith, and I enjoyed working with my hands. I happened to make things that people wanted to buy. I always thought businessmen were real greaseballs, and still do. But one day I woke up and said, "Well, I guess I am a businessman and probably will be for the rest of my life." I decided that if business was going to be my life's work that I had to put it on my own terms.

In the beginning Patagonia was just a way to make money to support ourselves. But in the last twenty years I have run the business strictly as a way to try to change the world. In fact, every time we have made decisions because it's the *right* thing to do, the company has ended up making more profit.

Take our Capilene underwear. We used to package it in paper and plastic. One day I decided the packaging was ridiculous and we had to get rid of it. The person who was in charge of the Capilene underwear business said that we needed to be ready to take a 30 percent cut in revenue because we were competing with companies with very sophisticated packaging. I said, "I don't care. We're not in business to sell underwear; we're in business to change the world." So we got rid of our underwear packaging and we ended up putting a rubber band around it. Guess what? Our sales went *up* 30 percent.

We examined every process in the company. We

found out that industrially grown cotton is the worst fabric environmentally to be making clothing out of—much worse than synthetic. So we started using organic cotton. We recently found out that there is antimony, a toxic element, in polyester. So what do we do? We began working with a Japanese mill that just spent a hundred million dollars on a factory that recycles polyester and takes the antimony out. They take soda pop bottles, rugs, anything that's polyester, and they make fiber for us. We'll not only make our long underwear out of the fiber, but what we used to make out of nylon—shell jackets, for instance—will now be polyester. When the consumer is done with the garment, they can give it back to Patagonia and we'll send it to the mill. They'll recycle it back into the original polymer—because polyester can be recycled indefinitely.

Patagonia also started the 1% for the Planet alliance, which now has about 750 company members. Each company gives 1 percent of their sales to environmental causes of their choosing. I look at it as an Earth tax. It's a tax for me being a polluter. You can never be perfect; you're always going to be a sinner. There is no way we could ever manufacturer a piece of clothing that doesn't cause any harm. All we can do is work toward minimizing that, and the 1 percent Earth tax is our penance.

Personally I believe that social activists are going to change the world. Who do I trust to protect the last of the old-growth forest? I don't trust the federal government. They want to cut it. Do I trust state governments? No, they want to cut it too. Do I trust local governments? No, they want to cut it too. The only entities I trust are the little local activists. Every year we fund 350 activist organizations that are out there nipping at the heels of government and forcing corporations to be accountable.

I believe that we don't understand the damage that we're doing unless we really, really lead an examined life. If you want to feed your family healthy food, for instance, you have to ask a lot of questions. You can't just go to the supermarket and buy some tomatoes from Mexico, because they may have been sprayed with DDT, which is still legal in Mexico. You've got to find out which tomatoes are sprayed and which aren't, and even if you ask the grocer, he won't know.

The turning point for me was in the early seventies, in Ventura. I went to a surf movie at a local theater, and some young guy got up and talked about how the city council was going to vote to channelize the Ventura River. We all went to the city council meeting to oppose it. Scientists were saying the river was dead, there was nothing alive in it. This kid got up who was a biology major in college. He gave a slide presentation that showed all the animals and birds that are dependent on that river, from water snakes to eels to muskrats, even though the river was polluted. We could see that it wasn't a dead river, and he ended the show with a photo of a steelhead smolt. He said that there was still fifty steelhead that came up that river, but that there used to be a run of four thousand. That brought the house down, and we totally defeated the plan to channelize the river. That proved to me what one person can do, and it showed the power of activism. That changed my life.

Patagonia for me is an experiment to see how far we can go towards sustainability and be a profitable, viable business. It exists to put into practice all of these things that William McDonough and some of the great thinkers say we have to do in order to turn things around. Somebody's got to do that. Since I'm a privately

held company, I do can do whatever I want. I don't mind taking risks because I never wanted to be a businessman in the first place. So we try everything, and fortunately most things we try work out.

I'm a total pessimist about the fate of the planet. But I'm a Buddhist about it all. I've accepted the fact that there is a beginning and end to everything, and I just live for the day. I'm a very happy person. I mean, it bothers me, but I'm not depressed, because the cure for depression is action. I feel like I'm doing what I can. That's why I hang on to Patagonia. Every week some huge multinational corporation wants to buy us because they look at us as an undervalued little company. People always tell me to ramp up sales like crazy and then go public and make a killing. That's the American system. I just say, "Forget it. We're not for sale at any price." It drives them crazy. I don't need the constant growth, which as far as I'm concerned is what is killing the world.

They say if you want to be a samurai you can't be afraid of dying because the second you flinch you'll get your head lopped off. For me, I can try anything, even though I could lose the whole company—and it doesn't bother me.

Yvon Chouinard is the founder and owner of Patagonia Inc., based in Ventura, California. He began in business by designing, manufacturing, and distributing rock-climbing equipment in the late 1950s. His tinkering led to an improved ice ax that is the basis for modern ice ax design. In 1964 he produced his first mail-order catalog, a one-page mimeographed sheet containing advice not to expect fast delivery during climbing season. In 2001, along with Craig Mathews, owner of West Yellowstone's Blue Ribbon Flies, he started 1% for the Planet, an alliance of businesses that contribute at least 1 percent of their net annual sales to groups on a list of researched and approved environmental organizations.

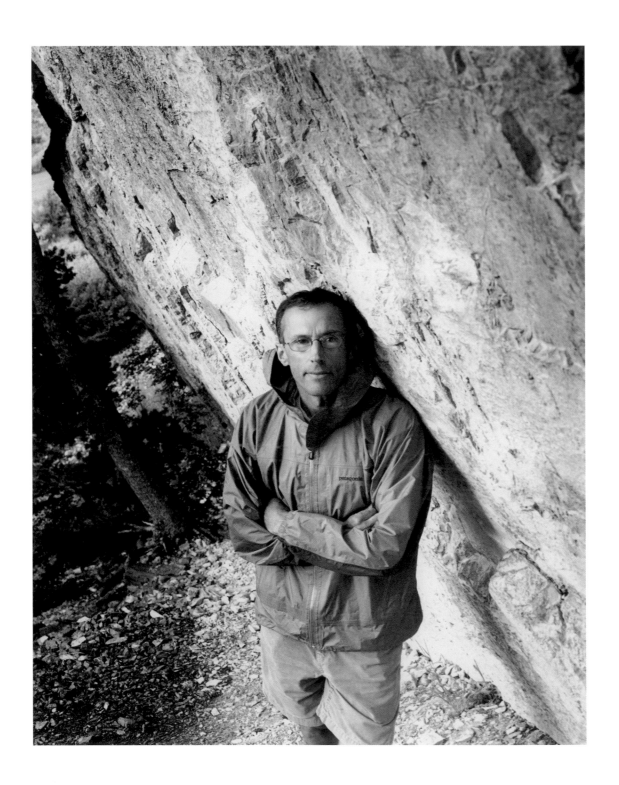

PETER METCALF
OUTDOOR ADVENTURE WITH A CONSCIENCE

As a young climber in the 1970s, Peter Metcalf was intrigued with Yvon Chouinard's first company, Chouinard Equipment. A self-professed climbing bum, he relied on the steel pitons and rock-climbing protection the company sold and eventually started working there. In 1989 he and several employees bought the company's assets for $1 and started a new company, Black Diamond Equipment, Ltd. Black Diamond manufactures climbing, skiing, and mountaineering gear, and Peter has become an active advocate for the lands that allow his company, and the sports it fosters, to thrive. In 1996 Peter took a bold stand against Utah governor Mike Leavitt's plan to open nearly six million acres of previously protected Wilderness Inventory areas in Utah to oil and gas drilling and coal mining.

We visited with Peter in Salt Lake City at Black Diamond's headquarters. We were captivated by the old-style climbing gear hanging on the walls next to photographs of legendary climbers and skiers. We reconnected with him at Yvon's house in Wyoming and hiked up to one of Peter's favorite bouldering areas to take a picture.

I think a lot of life is being at the right place at the right time, and knowing it, and doing something about it. To understand the situation with the Outdoor Retailer show I have to backtrack some, so bear with me.

When we decided to move Black Diamond to Salt Lake City in 1990, we made a commitment as an employee group that we were passionate about the activities that define Black Diamond: climbing, mountaineering, and backcountry skiing. The vision was to be one with the sports. Our mission statement was "To design, manufacture, and produce products of exemplary quality and durability."

We made ten pledges as an employee-owned company. One was to share the company's success with its employees. A second was to be a fierce, but very ethical, competitor, and a global company. But one of the most important commitments we made was to champion the preservation of and access to mountain, crag, and canyon environments.

After we moved to Salt Lake, I served on the board of the Economic Development Corporation of Utah. Unemployment here at the time was unbelievable. Salt Lake City was on its knees economically in 1990 and 1991. I was on the advisory board of the Outdoor Retailer trade show, an expo dedicated to promoting the outdoor industry and its products. I was instrumental in bringing the show to Salt Lake City in 1996, and it's now the biggest trade show at the Salt Palace. It brings thirty-seven thousand people and millions of dollars to the city every year.

Meanwhile, also in 1996, Utah's governor, Mike Leavitt, signed a behind-the-scenes deal with Secretary of the Interior Gale Norton. They cut almost six million acres of wilderness study land that had been placed under the protection of the government by Clinton's secretary

of the interior, Bruce Babbitt. When they cut that deal, pulling out the protection, I was furious. I felt like Leavitt was attacking one of the most vibrant parts of the state's economy: all the wilderness in southern Utah. These lands are where people go canyoneering, climbing, backpacking, and river running. Yes, I'm an environmentalist, and do what I can from that perspective; however, I am also a businessman, and this is something I looked at as a bad economic move on the part of the Leavitt administration.

I was mulling over what to do, and I thought to myself, "The issue here is the trade show. I don't have a real say in it, but nobody will know that I don't have the power if I threaten to pull the show." What I liked about the threat was two things. One, the central business district of Salt Lake is economically pretty tenuous, and I knew if the trade show went, it would be devastating to the city. The governor's mansion looks right down on it. I would be transforming this southern-Utah-seemingly-academic environmental debate into a tangible economic issue in his front yard. It's like being an eighteen-year-old and taking your old Camaro and doing a wheelie across your neighbor's front yard, spinning up the grass and peeling out to make a statement. I thought the threat of pulling the show created the in-your-face drama required to get action. I remember reading a Navajo medicine man's quote: "We are the people we've been waiting for." It hit me that as an outdoor industry organization, the show is the power, and it's been in front of us the whole time.

I wrote a letter to *The Salt Lake Tribune* that said: "I have serious concerns about the recent behind-the-scenes agreements that Governor Mike Leavitt cut with Interior Secretary Gale Norton…Our governor has gone from a general indifference toward wilderness to a recently enacted negative attitude about protecting public lands…There are many, myself included, who believe it is time to consider pulling these shows out of Utah in protest of the message the state has sent the outdoor industry and community."

Once the hotel owners, restaurateurs, and city officials heard we were threatening to pull the show, they pleaded with Leavitt to work with us. The governor's office immediately established the Utah Wilderness Task Force, which I am on with the governor, lieutenant governor, and county commissioners. Instead of saying, "Wilderness over my dead body," they now say, "Maybe wilderness does provide economic value here. How many jobs can we get out of this thing?"

When you really start debating wilderness with people, in the end, it is a philosophical issue. You need wilderness: it's beautiful, it's important, it makes people feel wonderful. However, this is a philosophical debate, and just like the potential of a radical Muslim not to be able to communicate with a born-again Christian, pro- and antiwilderness advocates seem to lack a common language. But there really is a universal Esperanto: the dollar sign. If you can talk dollars, you can talk to anybody. Whether it's global warming or wind power, money is a universal language.

This experience has been filled with a mixture of conflicting emotions: intoxication, gratification, frustration, and at times exhaustion. I say this on behalf of Black Diamond, the outdoor industry, and myself: everybody has taken great pride in our role in doing this. The idea of giving back, of having a conscience, of shouldering success, of being something bigger than just

making a buck, all those values very much come from the people I learned business from when I was general manager of a Patagonia subsidiary in the 1980s: Yvon and Melinda Chouinard and Kris McDivitt. This company is a result of everything I learned about business from them. Finally, it feels like the whole outdoor industry is coming of age.

————

At age eleven, in 1966, Peter was taken on his first backpacking trip in the Catskills of New York. Three years later he was introduced to technical rock climbing. Rarely has someone's life been so forged by the combination of climbing and love for all places wild. In 1989 Peter founded Black Diamond Equipment, an employee-owned company committed to making a difference for the sports and environments of climbing and backcountry skiing.

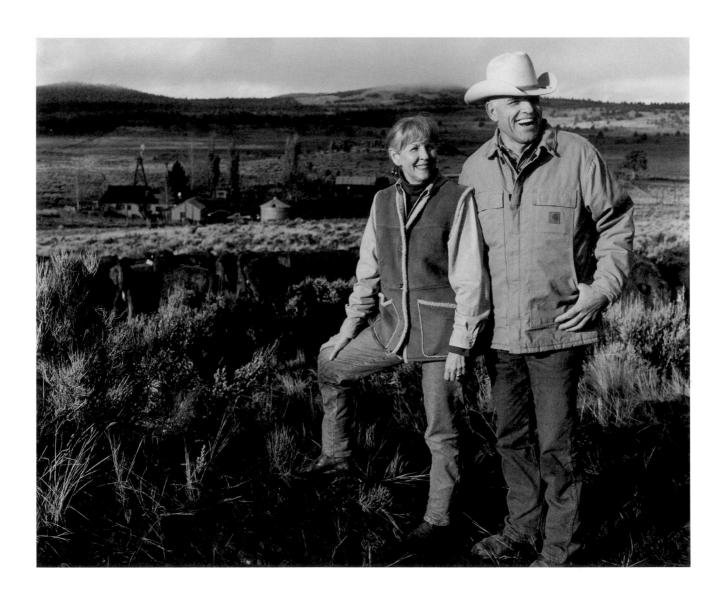

DOC AND CONNIE HATFIELD
STETSONS AND BOOTS ARE IMPORTANT

In 1976 Doc and Connie Hatfield bought a twenty-five-thousand-acre ranch in the juniper-clad hills of Brothers, Oregon. Their phone was an eleven-party radio-phone with spotty reception. Today they help run Country Natural Beef (CNB), a thriving cooperative, and raise cattle with their son and daughter-in-law. They also travel the West speaking to other ranchers about how to run successful and sustainable cattle operations.

Meredith and her husband, Chuck, were welcomed to the "board room" of Country Natural Beef, which consisted of ninety-plus families—including wives and children—sitting in a large circle in an even larger room. The group was establishing its operating policy for 2005. Inspired by this model, Chuck and Meredith, with their daughter and son-in-law, started a modest grass-fed beef operation at their Hell Roaring Ranch in Colorado.

Connie: All we heard in 1986 was, "Don't eat red meat; it is bad for you." At that point, ranchers were going broke. People thought that ranchers weren't caring for the land. This was in Oregon, where 60 percent of the land is either Forest Service or Bureau of Land Management, public land. We didn't know what to do, and cows were our lifeline.

I went into this little fitness center in Bend one day. Out came a twenty-five-year-old Jack LaLanne–type guy with big muscles. His name was Ace. I told him I

was a rancher and I wanted his opinion of red meat for people who are worried about their health and fitness. He recommended eating it at least three times a week but said that he was having the hardest time getting Argentinean beef in Bend.

Argentinean beef has no hormones and no antibiotics and it is short-fed, which means it doesn't have a lot of excess fat.

As I drove home I thought to myself, "You call yourself a rancher? You live fifty-five miles from where a man is saying he needs what you raise." We didn't put hormones or antibiotics in our cattle either, but we sold them as little calves. We didn't hold them over until they were grown, and we never marketed them. We just whined and complained when the market was down. The market had been down for six years, and we were not doing well financially.

When I got home I was excited, and I talked to Doc and he thought I had a good idea.

I decided to gather a group of ranchers together because Ace had just given us a market. The oldest were in their seventies, and the youngest were in their twenties. Ace came also, and we talked about what we were going to do to survive. Right then and there, Oregon Country Beef (now Country Natural Beef) was born.

Doc: This meeting came at a crucial time. The years 1981 to 1986 were some of the worst years in agriculture. Iowa farmers were shooting themselves because for the first time, land values went down and interest

rates went up. Prior to that, it was the other way around. Land values went up a lot faster than interest, so no matter what you did, you could bail out and come out ahead as a rancher. All of a sudden ranchers were going out of business, and nobody wanted beef. We were serious about needing to do something different.

At that first meeting, we figured that we had ten thousand mother cows represented. We sent Connie to Portland as our representative to find out how ten thousand cows could fill a need that wasn't being met. She talked to several meat purveyors. They had never had anybody come to them and say, "What need do you have that we might be able to fill?" They felt a smaller cut of a leaner product grown in Oregon, from real ranchers that you could trace back to, who didn't use hormones and antibiotics, that tasted good all the time would work.

The meeting at our house was in February. We formed a goal in March, and we had meat in the retail case in August. And then a year later, we put some bylaws together and became a cooperative.

Our original goal was to market quality beef products and retain our independence as a community cooperative. The important factors are that it is consumer-driven, profitable, sustainable, and long-lasting. A large part of what we wanted was grassroots rancher control. That is what has made it function and allowed us to grow.

Connie: A wonderful woman came to our first meeting. She was about seventy, though we never did know her age—it was very important that nobody knew her age. She was a real ranch woman. When she came in, I was sitting at the table writing out name tags, and I said, "Grace, are you a rancher?" I thought I had insulted

her. I should have asked if she ranched with her husband, that type of thing. But she said, "You're darn tootin' I'm a rancher. You know, I've been a rancher all of my life, but I've never thought of it that way. You put 'rancher' down there."

Doc and I both grew up with ranching, and that was the first time either of us ever referred to a woman as a rancher. Usually the men were the cattlemen and the ladies would ring the cowbells for dinner. What this said to us was, we all have a problem, let's work on it together. We think that the key to our success is that all of our husband-and-wife teams work together, because what CNB has become is a community of shared values. Also, during our meetings, we get babysitters. We honor the young couples and the young mothers, and we want them to be there with their brainpower. The plus is the kids get to know each other. There were twenty-five kids under five at the last meeting.

All our ranch families go to two major meetings a year. Everybody goes. It's six days. We have an appreciation day in the summer, where all of us get together and all of the owners of the stores come to a ranch and we have a good visit. Also, we each spend two days in stores talking with the customers to enlarge in-store customer relations. We make sure the rancher culture reaches our customers—Stetsons and boots are really important.

Doc: We have over a hundred ranches and a hundred and twenty thousand mother cows, and our returns are sustainable. The people who are buying our product are really solid, good folks who want to know where their food comes from and that the land is treated well, and [the cows] haven't had a bunch of artificial additives. Currently, Whole Foods is our biggest partner.

We interview people before we sell them anything. We were on the phone today with a store in southern Oregon that wants our beef. Before we will sell to them, we have a rancher go and make sure that they've got the right customer base. We want to know if they have organic milk and produce and free-range chicken and cage-free eggs. This becomes a package. If they don't have a customer base that is interested in those things, we'll end up with a little display and our meat turns dark. It doesn't help us out any.

We're certified also with the Food Alliance. They demand environmentally friendly land management, equitable labor practices, and humane animal handling. We try to ranch as sustainably as possible. We developed graze-well principles, which means that we minimize the amount of time we are in a particular area when plants are growing. Once the cattle leave an area, we keep them off for an extended period of time. We are very careful with our vegetation, watersheds, and wildlife. We say to the environmental and recreational communities, "Tell us the landscape and wildlife mix you want. We'll use our cattle as tools to give it to you. You set the policy; we'll implement and make a living implementing it. We're willing to change if it is integrated with the biological needs of the land."

I mean, we're a group of redneck, conservative, Republican, right wing, touchy-feely Earth muffins! And it is really neat that most of our customers are urban, liberal, secular Democrats. Yet there is no conflict. Those things don't have anything to do with healthy land, healthy families, healthy foods, healthy communities, and healthy animals.

Connie: The fourteen ranches that started Country Natural Beef have roots that go deep into Oregon and into agriculture. All these ranchers have seen their community disappear. Now we have eleven young families that have come back and are ranching again. To me, the fact that all of these young children are on the ranches indicates that what we are doing is working. We're seeing generations of kids staying on the ranch. Most of them say without CNB they don't think they would have come home, not because they didn't want to, because financially they just wouldn't have been able to.

What's really great—and what you can't really see—is that if Doc and I fell off the face of the Earth tomorrow, Country Natural Beef would continue.

Doc: The financial part is important because we can project it, and CNB is stable. We do have an advantage financially, but it is not huge. What makes the difference is the attitude, the idea that we can do anything we want. When we talk with Whole Foods we are an equal power. We have about a hundred and twenty thousand mother cows now on our ranches. If we had a billion dollars to spend on ranches, feedlots, and packinghouses, we couldn't duplicate what we have. It is a quality of life that people like and want to maintain. We can mobilize our assets into something that customers need, and it gives us equal power. For the first time in my life, I've seen a powerful team of collaborative peers. There aren't a lot of teams in business. There's always a boss or somebody who can hire or fire. We consider all our members as equals, with equal voice.

We're very successful. I mean, nobody's getting rich. We're not that successful, but we're not going broke. And the people are in control.

There are a lot of ranchers who are bitter, and I

Doc and Connie Hatfield *211*

pray for them; they're going to have to die away if they can't make the changes.

In the 1960s Doc and Connie Hatfield moved from Enterprise, Oregon, to a small irrigated ranch in Montana's Bitterroot Valley. Doc worked as a large-animal veterinarian and Connie tended a herd of 150 cows. By 1974 steer calves were down to $0.28 a pound, and they began seeking a place where cattle and land could function together in a more profitable and sustainable manner. In 1976 they moved back to Oregon.

Today Doc and Connie are the founders and spiritual leaders of Country Natural Beef, a cooperative of more than ninety ranch members. Their market consists of selected natural food and upscale retailers in San Francisco, the Seattle area, Oregon, and a handful of stores in Alaska. They also supply Whole Foods Market stores in Colorado, New Mexico, Texas, Louisiana, and Kansas.

THE WEST AS SAUDI ARABIA

In the last decade oil and gas drilling has become *the* topic of concern throughout the West. More and more public lands are being taken over by drilling, and the government continues to fast-track the permitting process. But people are fighting back. Community organizer Jill Morrison received the 2004 Leadership for a Changing World Award for helping private citizens confront oil and gas companies and for insisting that government officials hold industry to a high standard. Rancher Tweeti Blancett made headline news with her lawsuit against the Bureau of Land Management (BLM) demanding responsible drilling. But we thought it was important to hear a different side of the oil and gas story as well. Steve Henke, with the BLM, clarified the much misunderstood and often overlooked history of oil and gas leases. His comment that we are all in this together until we develop better alternatives—we are all burning oil—casts an important perspective on the West as Saudi Arabia.

JILL MORRISON
THE LIES MAKE ME SICK IN MY HEART

We spent a sobering day with Jill Morrison traveling the dirt roads outside Sheridan, Wyoming. The land is strewn with compressor stations, well pads, and four-by-six-foot metal boxes that contain wellheads. The wells display Danger signs on them because of potential methane leaks. New power lines spill across beautiful private ranchland, and hundreds of miles of new dirt roads mar the landscape.

The Powder River Basin is the largest coal-bed methane gas development project in the country, with more than seventy active oil and gas companies, twenty thousand recently drilled methane wells, and many more on the way. Jill runs the Powder River Basin Resource Council in Sheridan. She helps people deal with the violations of the oil and gas industry.

It is amazing how much the oil and gas industry has and continues to get away with in a quote unquote democracy. They treat Wyoming almost as a third-world country. We have so many energy resources: coal, gas, oil, and uranium. While the state is making a lot of money, the majority of the money is made by private corporations. They do pay royalties to the state, and, for example, Wyoming has a billion-dollar surplus. The state is applying a lot of that money to schools, but it's not coming back to the communities that are most affected by the development to deal with the impacts.

A lot of the work I do is to help people understand the political process and the governmental regulatory processes and how to participate effectively in those. We help people stand up and articulate their concerns about the land, because if we don't participate, our democracy will be a façade. Unless people are willing to commit the time and energy to get involved, our constitution and our system don't mean anything.

The common theme I hear out on the land as I go around and work with people is that if the oil and gas people's lips are moving, they're lying. They're like used-car salesmen. Not all of them, but the ones striking the deals and pushing forward and bullying people.

There was a fellow in the Sheridan area named Dale. He is an incredible individual who had a military career in the Special Forces. He fought hard for his country, retired here, and bought his eighty-acre dream farm only to have a coal-bed methane development come in and destroy his retirement dream. When he realized what that meant, that he didn't have any property rights, that he had no say in the matter, that they were going to screw up his water and put a compressor station next to his house, he knew that the investment of his life was destroyed.

Dale had a beautiful way of describing the situation. He'd say, "First, they call you up and they're your best friend, and then all of sudden they approach you like they're the mob."

A lot of the people I work with, like Bev and Roland, are such trusting people who did everything on a handshake. The industry people come to your door, and

they have a piece of paper, and they say, "I'm so-and-so, very nice to meet you. I'm with such-and-such company, and I'm their representative land man, and we're going to come in and drill on your land." They hand them a drawn-out map and say, "Here's the agreement. We're going to pay you this much money for every well, and please sign right here."

The lies make me sick in my heart, and very angry how people are taken advantage of. Of course, a lot of people argue that it is up to citizens to know what's going on. But it is very difficult for people to get the correct information.

Bev and Roland lost their water, and it took us a year of publicizing and front-page articles to embarrass the state and industry into getting them a new water well. We're trying to actually pull together a database on exactly how many wells have been lost. Industry tries to blame it on things like the drought.

So much money has been spent on lawyers to negotiate agreements. And people get an agreement negotiated and then have to try to enforce it. Industry doesn't do what they say they're going to do. So what do people do, sue them? The industry now realizes that most of these people have no money.

We want the companies to have respect for the people on the land. There's a lot of lip service given from regulatory agencies about implementing best-management practices. But on the ground it doesn't happen, and it's really up to people and groups like ours to make it happen. We want good reclamation. We know we need bonding to have good reclamation. But how do you reclaim a drainage that has been ruined by this salty water? You cannot reclaim the soil; you have to haul in topsoil because

the interaction of the sodium in the water with clay soils that don't have enough calcium and magnesium destroys the native soil and the native vegetation. A new toxicity test shows that it is harming aquatic life in the streams and killing what the fish feed on. *And* we lose our water resource. How shortsighted is that?

The water can also contain oils and solvents, and much of it ends up in unlined holding ponds where the pollutants seep into the ground, affecting both the soil and private water. Industry doesn't have to treat it as hazardous waste, because it passes as drinkable and people use it for their domestic and livestock needs. Fortunately, we've been able to embarrass some of the companies into lining their pits.

Water loss is an enormous issue. We had an economist do a study on the economic value of the groundwater. The irony is that the water is probably worth $10 billion. It's a very valuable resource here in this high desert, where we get maybe ten to fourteen inches of rain a year, and we're pumping up this water at the rate of about a million and half barrels of water a day. This is an enormous volume of water, and we're dumping it on the ground. We're in a big push with the state right now to get money from the Water Development Commission for a pipeline to reinject the water so that we can save it for future use. That seems so obvious.

The communities where there is intensive energy development are also experiencing huge social impacts. Because of the influx of thousands of workers into these areas and the twenty-four-hour workdays, there is a big drug abuse problem: not just methamphetamines, but alcohol and other drugs, and consequently an enormous demand for emergency services. Sheridan and Campbell

counties have had to build bigger jails to deal with the law enforcement problems since the oil and gas boom.

Additionally, the infrastructure impacts on the county roads are enormous, and the counties can't afford to maintain them, much less improve them, with all the new damage. There is so much big-truck traffic. A county road that used to get five or ten vehicles a day is getting forty and fifty heavy, big trucks, and more pickups.

It's a constant effort to get the Bureau of Land Management to enforce the laws and do good regulation and make it be something more than a paperwork exercise. This isn't about paperwork, this is about the land and the water and the air and people. So you try to strike the best deal you can under the circumstances. Until July 1, 2005, in Wyoming you had no rights. Now you have some because we passed this split estate bill, which requires industry to notify landowners at least thirty days in advance that they are going to come in and drill. They have to show you a plan. They have to attempt good faith negotiations to come to an agreement with the landowner, who is supposed to have a say in the plan. And they have to compensate you for loss of land value and damages. Montana has a split estate bill from years ago, and both Montana and North Dakota are trying to strengthen theirs. Colorado tried to get one passed. It finally passed in 2007. New Mexico also passed a bill addressing landowner rights in 2007.

What keeps me going is the people we work with. Some people get so discouraged because they've seen everything they worked hard for completely ruined. We did get Bev and Roland a new water well. But the injustice and disrespect and abuse of people by industry and government is what really keeps me going. There's something in me that can't accept that and can't believe that we can't change it or reverse it and try and give people the ability to see and understand that they can have a change of influence. The dismaying thing is to see how much damage has to occur before that can happen. And how discouraging and distressing that is to people who have never realized something like this could happen in this country.

The folks I work with are down-to-earth, conservative, hardworking people. They are ranchers who have been out on the land for generations, housewives, teachers, engineers, and state regulators. They realize that this country runs on energy, and they know that we're in the least-populated state in the nation with the largest resource base in the lower forty-eight. Even if we have an obligation to provide energy for the nation, it does not need to be at the loss of everything we have. We're willing to provide energy and resources to keep this country going, but industry and the corporations can't completely wipe us out of all of our water, land, and clean air. It has to be done in a way that is responsible, respectful, and with the effected landowners as partners instead of people who are being exploited. This is about people and places and homes and lives and our children. We have to have humanity in the way we treat each other and our environment, and if we don't, we're not going to be a society where it's worth living.

Jill Morrison joined the Powder River Basin Resource Council as a community organizer in 1990. Since then she has been working with Wyoming landowners and citizens to address energy development impacts and to ensure good stewardship of land, water, and

air while engaging citizens in civic participation. She knows that meaningful, long-term, and positive change will come when individual citizens insist on having a seat at the table when decisions are being made, and when organizations—sometimes unlikely partners—collaboratively hold government and energy companies accountable for their actions. In 2004 she was recognized as one of eighteen individuals across the country who received the Ford Foundation's Leadership for a Changing World Award. Jill and her husband operate a ranching and outfitting business in northeast Wyoming and have two daughters.

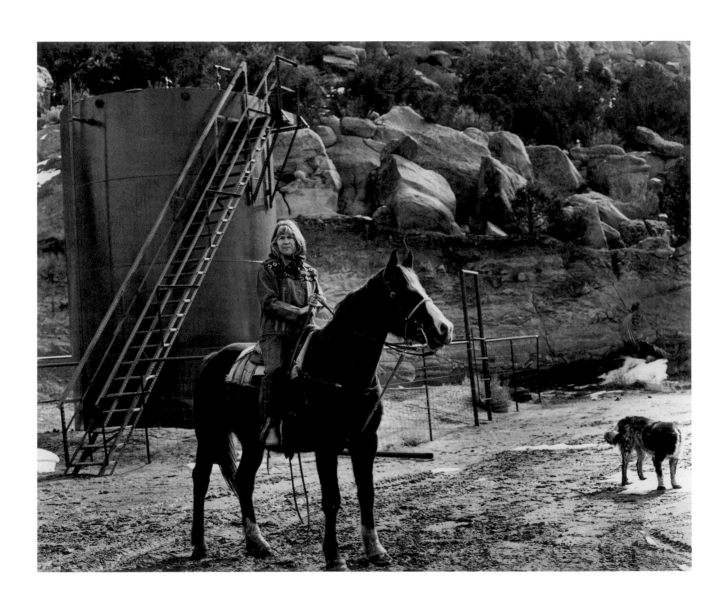

TWEETI BLANCETT
ROSA PARKS IS MY HERO

Tweeti Blancett would like to bring the Republican Party back to the conservation-minded days of Teddy Roosevelt. She is a loud critic of how our public lands are being treated by the oil and gas industry, and she once locked the gate to her ranch to protest the practices of the energy companies that operate there. A local campaign coordinator for George W. Bush in the 2000 presidential election, she became an outspoken opponent of the Bush administration's energy policies.

In alliance with conservationists, farmers, hunters, fishermen, liberals, and conservatives, she is suing the Bureau of Land Management (BLM) for their failure to uphold regulations around drilling. She says this is not just a personal fight she is engaged in, it is a fight to preserve what is beautiful in the Rocky Mountain West. Tweeti owns the Step Back Inn in Aztec, New Mexico. She put us up for the night, and the following day we walked her ranch, which is strewn with oil wells.

———

My husband, Linn, and I run a ranch in beautiful piñon and juniper mesas with prime commercial cattle. If cows can be pretty, they're as pretty as they get. But what do you do with high-dollar cattle, cattle that sell at the top of the market, when they are raised on a ranch where we know that the water and the ground are polluted?

Our ranch is no longer a viable ranch. You can't have as many wells, pipelines, roads, noxious weeds, erosion, water sedimentation, and overall toxicity as we have and maintain a healthy ranch. If we turned cows out now they would die.

There has been drilling on this ranch for fifty years, but since 1990, when coal-bed methane drilling began, we've seen the most destruction. The oil and gas companies put in wells all over the place because extracting methane is not efficient. With each well comes a road, a pipeline, a compressor, a pump jack, a dehydrator to separate gas from water, and a holding tank for polluted water.

We have worked with the oil and gas companies for many, many years in a very cooperative, neighborly fashion, but there are seventeen different gas producers on our ranch alone and seventeen thousand acres impacted with pipelines. If something happens and we want to enact a change, it can never be done locally. It always has to go to Houston or Tulsa or wherever. When you call BLM, they say, "Well, call the oil and gas company, it's their responsibility to fix it." But the corporate philosophy to stand up and take the responsibility is not there, either for past actions or to enact change. It doesn't matter which company we call; it isn't their problem.

Talking hasn't worked. Negotiating hasn't worked. Sitting on committees, trying to work on resolutions hasn't worked. So we made the decision to sell our cattle and file a lawsuit against BLM for their nonenforcement of regulations and rules. The oil and gas industry enjoined against us and brought their high-dollar lawyers into play. Now we have not only opposed the largest industry

on the face of the Earth and the most powerful government, we are in court fighting against their millions with our limited funds.

Industry does not have the right to destroy us. Their right to drill their lease is no different than our right to graze cattle. And we don't think they should be able to do this to anybody else, either. Our camp is made up of all sorts of what industry would call "little people" who are trying to make a difference. If we let this become a liberal-conservative, Democratic or Republican issue, we lose. I see the new alliances forming across the West. People who wouldn't even speak to each other, much less sit down at the table and work on issues, are now working together. It's pretty amazing. It is just nonsense for BLM and industry to say that the Blancetts are behind all this. All of us together are trying to make a change in how this industry treats private, state, and federal lands.

We want responsible drilling. We want the oil and gas companies to take responsibility for their actions. We're arguing for BLM to step up to the plate and enforce its own regulations. There are thirty-five thousand existing wells in the San Juan Basin. How in God's green Earth could anyone police that mess? The logistics of it are unbelievable. Linn and I spent two and a half days GPSing just the lower six sections of our ranch. We have 111 GPS locations where there are well sites, roads, or pipelines. Can you imagine any employee trying to get to all the wells or even find the problems? The BLM Farmington Field Office director, Steve Henke, got lost, and he had oil and gas employees that work on the ranch in the same vehicle. There is no way that BLM can enforce the existing regulations and bring the companies into compliance the way they are operating right now.

We've gathered the science to show what's happened on the land. We're working with current and retired scientists out of Los Alamos and environmentalists that are looking at each well for compliance and for stipulation violations. I'm concerned about the water that puddles from the rains and from the snows on the well locations that have contaminants in them that both livestock and wildlife end up drinking. We've got contamination spills everywhere from unsecured holding ponds that have leaked and poisoned our cows. We understand that there are going to be accidents. What we won't accept is that oil and gas won't step up to the plate and fix the problems.

We have eight hundred miles of road just on our ranch. There's very little of that about which I can say, "I'm happy with this road. This road is in compliance, and it's well maintained, and it's taken care of." Maybe four or five miles out of the eight hundred miles! Most of the BLM roads that run through our property are rutted and impassable when wet. We have trees that are dying from salt contamination. The forage grass is dying too, and that has spread noxious weeds.

San Juan County, New Mexico, contributed $8 billion in oil, gas, and coal money in 2005 alone. Eight billion dollars in one year. The people of New Mexico and the people of the United States got $1 billion of that. Industry walked away with $7 billion. With the wealth that we have in this state, we should have the best highways, the best school systems, the best infrastructure, and the best jobs. And what do we have? We have nothing. We keep shipping it out every year. Have you ever heard of New Mexico being first in anything? Except maybe unwed mothers, rate of illiteracy, or lack of healthcare? We're number one in those things.

Until everybody is sitting down at the same table, playing by the same rules and trying to work on solutions, it is going to stay the same. So it doesn't matter how often I say, "Here are the pictures, here are the issues, here are the problems, here are the wells, here is the science." Change doesn't take place unless it's forced.

I think the bottom line is when you take people like my husband, whose family has been on the land for six generations and [who] truly cares about the land and being a cowboy, it really hits home what the government and industry have done in northwest New Mexico and across the West. Linn and many like him just wanted to just take care of the land, take care of the ranch, and pass it on to their children. When you take the legacy away from landowners and leave them with nothing, that person becomes dangerous, because they have nothing else to lose. We've buried two sons on this ranch. Nothing can compare with that, but this is devastating.

I have a picture of myself with Rosa Parks. I met her in the eighties at a Women and the Constitution gathering in Atlanta. She's my hero. She's a teeny tiny little thing. When she walks into a room, she has a presence and an aura around her. It took a great deal of courage for a young woman to say, "No, I'm not going to sit at the back of the bus anymore. I'm an American. I have the right to have my say. I have the right to say how I feel."

I guess I feel the same way. I'm a little rancher in northwestern New Mexico. We've got federal land and we are charged with stewardship of it. And if I can't say, "No, this isn't right," then we've lost something about who and what we are as Americans. We have the right to stand up, say how we feel, and defend our private property rights.

Editor's Note: On July 1, 2007, the Surface Owners' Protection Act took effect in New Mexico. It is considered the nation's strongest landowner's rights law and requires oil and gas companies to notify landowners thirty days before drilling, propose a written agreement with a surface owner, and pay for the use of and damage to the land surface.

Tweeti Blancett and her husband, Linn, received the second Michael S. Currier Environmental Service Award for their efforts in taking on oil companies for damaging their land. Tweeti is largely responsible for the new and unprecedented collaborations between environmentalists and ranchers in the Southwest. She has testified in Washington, DC, against industry, spoken at environmental meetings, and appeared on the Today *show.*

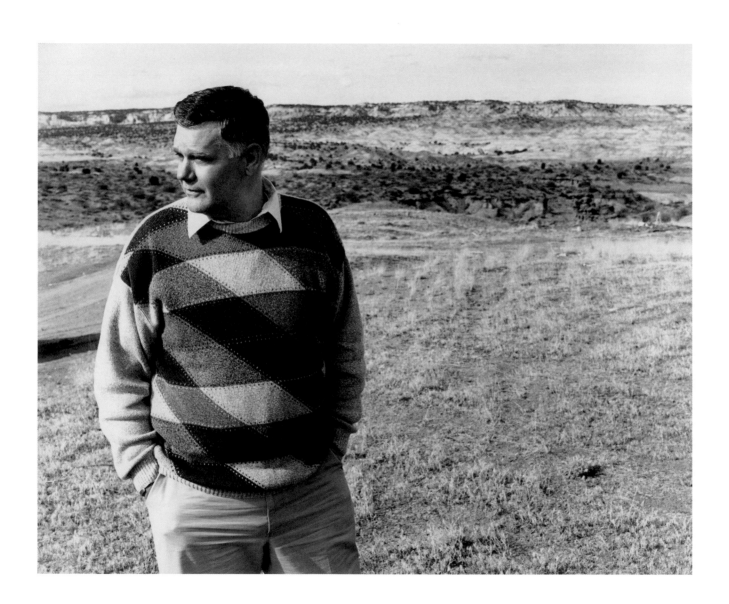

STEVE HENKE
WE'RE ALL CREATING THE DEMAND

Steve Henke is the Bureau of Land Management (BLM) public land manager in Farmington, New Mexico. He is the field director in charge of monitoring oil wells in the San Juan Basin in northern New Mexico, an area rich in natural gas and projected to be one of the largest coal-bed methane producers in the years to come.

Steve's office has been criticized for allowing oil and gas companies to denigrate the basin environment. In 2004 two ranching families, including Tweeti Blancett's, along with a group of environmentalists and Navajo people filed a lawsuit against the BLM for disregarding environmental regulations on wells in their jurisdiction. The case is pending.

We spent an afternoon with Steve at his office in Farmington, where he explained to us the vagaries of land management and why he is caught between a rock and a hard place. After we talked he took us out to a local badlands area, where Meredith photographed him. We joked that he was taking us there to dispose of us, and he retorted that this is where he buries reporters who try to write about him.

I think it is important for you to understand that we are sitting on a world-class gas resource here. The San Juan Basin produces an average of three billion cubic feet of natural gas a day, roughly 8 percent of this nation's natural gas. It fuels our industry, heats our homes, and generates electricity.

If you buy into the fact that this country needs the energy and that we want to get it domestically, if we don't get it out of the San Juan Basin, where are we going to get it? Given the fact that we have eighteen thousand wells and we are 98 percent leased, it is in the public interest to develop that resource to provide energy for this country. The challenge is how do we do that in a manner that minimizes the impact? I'm all about trying to minimize that impact and develop that resource for the good of the country.

BLM land is multiple-use land. The San Juan Basin serves ranchers, recreationalists, off-highway vehicle users, hikers, bikers, hunters, and fishermen. There are designated wilderness areas, a network of ranches, and sites that are culturally and religiously important to Native Americans. There are habitats for endangered species and sensitive riparian areas. Oil and gas leasing and production is just one of the uses that the BLM manages. For a significant portion of our area, oil and gas development is the dominant use. The area of my jurisdiction encompasses approximately 3 million acres of federally owned subsurface mineral estate and 1.3 million surface acres.

I could see it differently if I was starting with a blank canvas, we didn't have any leases, and I didn't have a legacy of fifty years of oil and gas development out there. But under the Mineral Leasing Act of 1920, the federal government leased 98 percent of the federal mineral estate in the San Juan Basin to private individuals

and corporations, granting exclusive rights to develop the oil and gas resources. That very much narrows my say as to whether or not we are going to develop particular parcels of land as a gas resource.

We want to begin addressing these legacy issues. Some of my critics are adamant that everything be brought up to today's standard. I accept the goal, but I have problems with my regulatory authority to do that, because the permits have been in place for so long. We are getting folks to make a substantial investment in rehabbing what I call the legacy roads, pipelines, and well pads. But it is hard to ask somebody with a thirty-year-old well to upgrade it to modern standards.

Obviously, there are some areas that are leased now that were leased fifty years ago, and we look back and say, "You know, oil and gas development is probably not compatible with that environment." It's been so fragmented now, sold and resold and subleased, that it's practically impossible to put the land back together. There is some pretty neat country out there that we'd probably lease with different terms and conditions today.

There absolutely are impacts from oil and gas development, there's no question about it. If you fly over this country, if you drive through it, you can see that we blade roads and well pads and put in pipelines, and those roads are traveled while that well is in production, sometimes thirty or forty years. The analogy I use is, say I have a garden and a three-year-old drove their tractor or tricycle through my garden. A rancher has a garden, and they're trying to grow grass and feed livestock, and we've driven a bulldozer through their pasture and built a road and a well pad. But we can successfully rehabilitate these lands long-term. The problem is that we've been in several years of fairly extreme drought here and have been severely challenged with trying to get vegetation reestablished. We are in the transition zone from the Colorado Plateau, and it's a fairly harsh environment to begin with. And the drought compounds it.

What I struggle with is how do I balance the demand to develop that energy resource with conservation programs related to cultural resources, the ranching community, the open space, water quality, wildlife habitat, and the whole realm of multiple-resource responsibilities I have. I struggle with that.

My big challenge is to try to alert not only my internal staff but our leasehold partners that there are better ways to do business. We can have less impact, a smaller footprint. We can be more sensitive to the ranchers' concerns with hazards to livestock from these oil and gas locations, whether it be fencing of the pits or making sure glycol doesn't drip off the separators that the cattle get into. We can be diligent in our reseeding, and we can look at options like putting a second well bore on an existing location and taking advantage of the existing infrastructure. We can use twinned wells or dual completions and directional drilling to reduce impacts to the surface. The oil and gas companies clean up approximately two hundred wells a year in the basin. Where they drill five hundred, they plug and abandon another two hundred. We make sure they do it right.

We are trying a lot of new things. We don't have the same issues with water disposal as the Powder River Basin. Water produced from coal-bed methane—natural gas—production here is reinjected into deep nonpotable formations. We are experimenting with the potential to use water produced from the drilling process on some of

our road construction and revegetation efforts. There is also a proposal to gather the produced water and pipe it to the electric-generating stations west of town to cool the coal-fired electric-generating stations. We're working to clean up the coal dust that gets on vegetation. People think it's toxic. It's not, it's just unsightly. We also instituted a noise reduction policy for the compressors. The noise from the compressors has been an issue, particularly in the urban interface areas.

We want to find and build a better mousetrap to minimize the impacts. I told my staff that I want to be bold and experimental. We want 100 percent compliance on new construction, whether it's a road, a pipeline, or a right of way.

We are looking at transportation planning. We've got too many roads out there. There's no question, so we want to work with the community and the companies to find out which roads are absolutely needed. We want to maintain and upgrade those, and rehab or put to bed the ones we don't need.

I've tried to work with the leadership of the oil and gas companies to heighten their sensitivity and understanding of the other values, uses, and interests out there. We're working through the traditional-culture property issue with the Navajo Nation; that's been frankly a difficult process. They're concerned about the impact that the oil and gas development might have on traditional properties, be they herb gathering areas, battlegrounds, sacred places, or prayer and ceremonial sites. It's a tough one, because a lot of their information is oral history.

I admit that culturally I come from a different background, and I'm trying to learn to be more sensitive to the Navajo perspective and their way of doing things.

But it's not easy. I'm sure if you talk to them, they'd say it's not easy working with me. But if I agree to do something with the Navajo to allow time to consult on traditional cultural properties, it delays permitting, and there is always a reaction from the oil and gas companies. What makes this job interesting is trying to keep everybody talking and understanding each other.

I've given a lot of thought to the long-term impacts of the new wells. I'm personally offended by allegations that I somehow don't want good water or air quality here. I live here. I plan to live here. I have three children, and I have a personal stake in this as well. But lands heal.

I don't want to be harsh or callous, but it is public policy to lease the public lands for mineral development as well as livestock grazing, and part of multiple use is conflict. Remember, this resource generates federal royalties averaging $600 million annually, half of which go directly to the State of New Mexico. Contrast this with the fact that we're collecting about $100,000 in grazing fees and we're spending about $500,000 to administer that program. I don't say this to denigrate the ranching community.

The oil and gas companies are making voluntary contributions of $1,000 an acre on public lands. We require the mineral lessee to enter into a surface-use agreement with the private landowner, and many of them are compensated directly for a well pad, a road, or a pipeline. That funding is used to enhance the productivity on the acreage that is not devoted to oil and gas. The amount of unreclaimed surface that's taken out for oil and gas is between 4 and 5 percent. Others would have you believe that it is more, but we've actually digitized it on maps and done the calculations, and 4 to 5 percent of the surface is taken out of production. Now again, I ask the question, is that too

high a price to pay for 8 percent of the nation's gas supply?

The controversy is getting a lot of ink, but I have three hundred permitees that have grazing permits, and I have two with their names on that lawsuit. I did start a collaborative group with the ranching industry, the oil and gas industry, and government to address this issue of impact and how can we improve the education and how can we better our practices so we minimize that impact. So, instead of pointing fingers, let's see what we can do to work together to resolve the problems. Tweeti's husband, Linn, is in that group. They identified hazards to livestock from oil and gas activity and made recommendations on fencing and protecting livestock and wildlife from hazardous fluids. We've implemented that across the basin. We've agreed on taking a fresh look at reclamation standards, and we're funding some research from New Mexico State University on a reseeding program. Until 2004 I had twenty inspectors that go out and look at the wells and monitor the production and look at the environmental compliance. We've been criticized for having too few. Now I have over thirty, and we are inspecting each well at least once every three years.

We just completed an EIS [Environmental Impact Statement] for another ten thousand wells over the next twenty years. We will drill about five hundred wells a year on BLM land. Obviously, with that level of activity, we're going to have disappointments, but my assessment is that our track record is improving. Through some of the controversy that's been created—and some of this is to Tweeti's credit—I've been provided additional resources to monitor the development.

I wish the environmentalists were a little more informed. I think they want to have an impact on issues that are important to them, but I'm not sure they're mining in the areas that are going to bear fruit. I don't mind them asking the questions. Are we protecting air quality? Are we doing what we should to protect water quality? All legitimate questions. I get concerned when they call for a different or a revised process or to do a new EIS. Is that going to change the decision?

The fact of the matter is that in this county almost all of us are tied to the oil and gas industry. Whether you're a dentist, a retailer, or a rancher. Many of the ranchers are directly or indirectly employed or receiving some compensation from the oil and gas industry for surface damages on their private land.

In the final analysis, I come back to the question "What is in the public interest?" We can talk about energy conservation and alternative energy sources and so forth, but we're not there yet. We use internal combustion engines to get around, and we're heating our homes with natural gas. So, if you buy in and believe that we need natural gas in this country for the short term, where are we going to get it if we don't get it out of the San Juan Basin? We're all in this together. We're all creating the demand.

—◦•◦—

Steve Henke has a bachelor's degree in range science from New Mexico State University. He has been with the BLM for more than thirty-two years in progressively responsible positions: range conservationist, branch chief, chief of resources area manager, regional coordinator and executive director of the Southwest strategy, field manager, and district manager. He has been married for twenty-five years to his wife, Susan, and they have three children.

ENERGY OUTLOOK

Though the West is being decimated by oil fields, it is also the land of possibility for renewable energy. Randy Udall, as he states in his interview, is obsessed with energy. He takes big energy concerns and finds local solutions. We found that Auden Schendler's entrepreneurship at the Aspen Skiing Company is cutting-edge in greening up business. Mark Sardella believes in the potential of renewable biomass in the Southwest, which seems profoundly sensible. And of course, Amory Lovins is *the* big name in energy in the Rocky Mountain West. We were constantly asked, "Is Amory Lovins in your book?" The answer is yes.

RANDY UDALL
OBSESSED WITH ENERGY

Though Randy dodged our many attempts to include him in the book—he does not like to be in the spotlight—we finally wrangled him into a chair and heard his spin on the current state of energy. Friends from living in Carbondale, we've followed his passion for alternative energy and his progress at the Community Office for Resource Efficiency (CORE), for many years.

Randy's work in alternative energy is a natural extension of the Udall family legacy of conservation and service. He is the son of the late congressman Morris Udall and the nephew of former secretary of the interior Stewart Udall. Until 2007 he directed CORE, a nonprofit organization that promotes energy efficiency and renewable energy in western Colorado. Recently Randy cofounded the Association for the Study of Peak Oil and Gas, a group dedicated to studying the issues surrounding the supply of fossil fuels and other energy challenges.

Energy has been an obsession of mine for a number of years. The English poet William Blake said, "'Energy is eternal delight." We've built a civilization in the West that is based on astounding flows of energy, particularly coming into large cities. I am fascinated by how we are going to adapt to what looks to me to be some enormous energy and environmental challenges coming our way in the next fifty years. How do we adjust for success? It's not going to be easy.

When I go to Phoenix or Tucson, I am struck by how rapidly both these cities have grown. When I was born in 1950, there were forty thousand people in Tucson; there are close to a million now. Phoenix's population has grown from ten thousand in 1900 to close to four million today. These large cities are so artificial they are in effect potted plants. It is not clear to me where either the water or the energy that is needed to sustain them is going to come from in the next century.

When I look closely at the way we're living, it seems like a dream to me. A fantasy. It's a beautiful fantasy, a magical, wonderful way to live, but it's as if we're all operating in a dreamscape. We Americans are the most exotic tribe the planet has ever seen. We are the oil tribe. We are consuming 140 pounds of petroleum products per person per week in the US right now: our body weight, effectively. We are using about one hundred times as much energy each day than westerners did in 1850. Thanks to coal, natural gas, and oil, we are living like gods.

Petroleum is an incredible fluid. It's black magic. It is a geological inheritance, but we're using it up as if there is no tomorrow, in such a hedonist fashion. There is a naive and quaint belief that there is some other fuel or energy resource that we have not discovered or that we can easily develop to replace our use of petroleum. It's not out there. People think water is the lifeblood of the West, but in large cities it is petroleum. Vegas, for example, is built around the fact that people fly in from all over the United States, all over the world, for a weekend.

In the American past there is a tradition of thrift and there is a tradition of conserving natural resources when you need to. But it has almost been lost. I don't see it in my children. I don't see it in the children of my friends. I don't see it in my friends, by and large.

By the time this book is published, we are going to be in the throes of an energy emergency. World oil exports and world oil production will peak by 2015. Due to very steep decline rates in existing wells, half the nation's natural gas now needs to be replaced every three years—and the only place natural gas production is growing is the Rockies. Our region is being cannibalized by America's gargantuan energy appetite, hollowed out like a Thanksgiving pumpkin.

At CORE we work with two local utilities, Holy Cross Energy and Aspen Municipal Electric, to prepare Colorado's Roaring Fork and Crystal River valleys for a cleaner energy future. These two utilities are now national leaders in the amount of wind power they are buying. Renewable energy resources in the West, whether it's solar in the desert or wind power in the Rockies and on the Great Plains, are outstanding, and we're just beginning to tap them. It's a mystery to me why Arizona and New Mexico, which have world-class solar resources, use so little solar energy. And it's a mystery to me in places like Colorado and New Mexico and Wyoming—Wyoming has one of the best wind resources in North America—why we've just begun to tap [wind power]. In 2007 Colorado put $1 billion of wind into the ground. That's a huge source of good news.

The utility companies we work with have come so far. And it's been wonderful to work with utility guys who have a vision and an admirable mission. I think electricity is the greatest bargain in the US right now. In our valley it sells for about $0.08 per kilowatt hour, and that is as much energy as you would produce if you rode a bicycle a hundred miles. It's enough energy to lift a full-sized pickup five hundred feet in the air. But every time you give your local utility company in the West $80 or $90, they're putting two thousand pounds of greenhouse gas into the atmosphere as they make that power, typically burning coal. One-third of those greenhouse gases will still be in the atmosphere a century from now. One-fourth will still be there five hundred years from now. This is why we have a climate change problem.

A typical family in our valley right now is producing about forty-five thousand pounds of greenhouse gases each year, enough to fill two Goodyear blimps, half of it from driving their car, half of it from heating and cooling their homes.

The watchword *efficiency* guides our work at CORE. How can we build buildings better? Buildings are a joke. The kind of houses we build here are million-dollar houses, with no thought of the future. It's not clear to me at all how we are going to be heating these in fifty years. Here in Colorado, a typical house has plenty of sunlight hitting its roof to provide most of its hot water and most of its electricity. A lot of what we've done locally is to change building codes. We started a renewable energy remediation code that's raised $6 million by taxing the construction of homes over five thousand [square] feet. If the owners don't use a renewable energy system, they have to pay a fee. We use that money to install energy-efficient and renewable technologies in local buildings.

We do rebates for solar incentives and energy-efficient appliances. With that money we're buying

wind power from Wyoming and Nebraska, and pieces of Brazilian rain forest. We also retrofit public buildings. Basically we're saying to carpenters, architects, and developers, "You can't build houses anymore that are just parasites on the grid." Right now, all of the buildings we're building go on intensive care the minute they're finished. And they stay that way, presumably for many decades. We want buildings to get off intensive care, and we want them to do more than just shelter their occupants. We want them to produce some electricity, produce some hot water, capture some sunlight, and harvest some rainwater.

We've just finished building two affordable homes—"next generation" houses we call them—here in Carbondale that we sold in the affordable housing program. These houses are designed to use $1.00 a day worth of electricity. And they're beautiful houses. They have incredible air quality, they're going to have very low greenhouse gas emissions, they're warm, and people love living in them.

What we've been trying to do is take broader ideas and concerns and localize solutions to them. How do we change the kind of power you are supplying to your customers? How do we get architects and builders to do things differently when they design and build a new house? How do we get schools to operate their buildings more efficiently? How do we design new schools that are much more energy efficient and are day-lit and have better indoor air quality so that students perform better on tests?

A tsunami of energy realities is going to hit America in the next two decades. Part of what has been hard about this job is that it has thrown me too far into the future. I've looked very closely at world oil production trends, world oil depletion trends. And I've looked very closely at the role the West is going to be asked to play in meeting the nation's energy challenges. We're going to drill one hundred thousand new gas wells in the West in the next ten years. The West is being asked to ride to the rescue of a failed national energy plan. We are rich in natural gas and have a staggering amount of coal, particularly in Wyoming and Montana, but a lot of that coal arguably should stay in the ground and not get burned. Most of the natural gas will get burned, and the nation is going to need it. The nation is turning to the Rocky Mountain West with this beseeching look, saying, "We need your energy." And the impacts in the San Juan Basin, the Piceance Basin, the greater Green River Basin, and the Powder River Basin are already of enormous scale. Pinedale used to be just a charming, godforsaken shit-kicker town in Wyoming that was a wonderful gateway into the Wind Rivers. Now they're taking $30 million worth of natural gas out of wells just west of Pinedale each week. And they're just beginning. Here in the Piceance Basin they're going to put in ten thousand wells in the next twenty-five years. It will be one of the top two gas fields in the United States.

There is a need for local action. We talk about big-picture problems, global problems, and regional problems: they can only be resolved at the local level. It is one thing to agonize over these big problems, but unless you have a mechanism for addressing them at the local level, then it's all just navel-gazing. Why bother if it is just going to be navel-gazing?

I am hopeful about Americans, however, even though we often seem to be brain-dead. When you look back in our history, every so often there is a burst of

seventh-generation thinking. You read the Declaration of Independence. It blows your mind. The Endangered Species Act? We took Noah out of the Bible and put him into law! Who would have thought of such a thing? The Wild and Scenic Rivers Act, and 1872, starting Yellowstone, the world's first national park. Why? Where did it come from? There is a part of us that can see the sacred and not only see the sacred but protect it. So every now and then there are things that happen in our nation's history that embody the best of us, and I am hopeful. I pray that we have another burst of that in the decades ahead.

———•••••———

Randy Udall directed the Community Office for Resource Efficiency (CORE), a nonprofit organization that promotes energy efficiency and renewable energy, from 1994 to 2007. From 1982 until joining CORE, he was a freelance writer specializing in the environment and related scientific topics, including energy efficiency, green buildings, acid rain, groundwater depletion, energy, clean air, global warming, and biodiversity. As a freelancer, Randy has contributed articles to more than a dozen newspapers and magazines, including National Wildlife, Audubon, Outside, Sierra, The Denver Post, *and the* Los Angeles Times. *He recently cofounded the Association for the Study of Peak Oil (ASPO). ASPO is a network of researchers and scientists interested in determining the date and impact of the peak and decline of the world's production of oil and gas, due to resource constraints. Randy and his wife, Leslie, live in Carbondale, Colorado, where they raised their three children.*

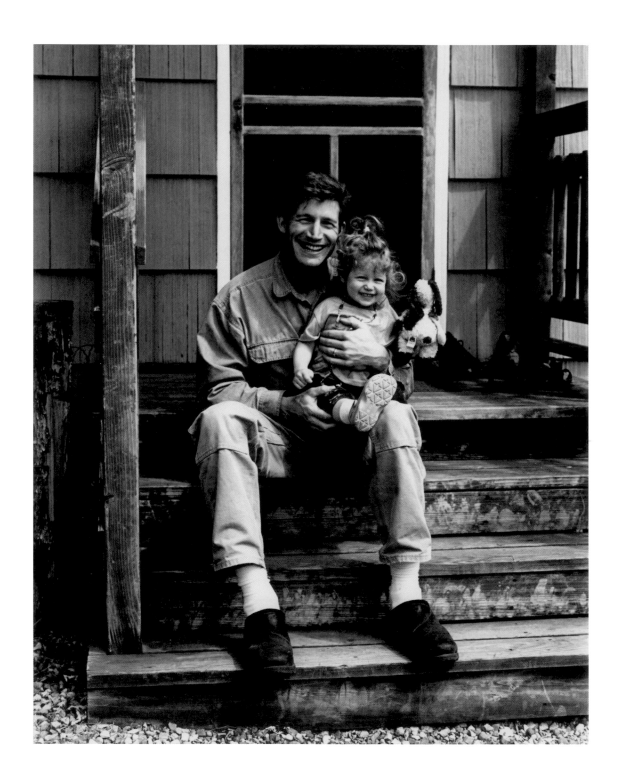

AUDEN SCHENDLER
WE'RE GOING TO HAVE BIGGER PROBLEMS THAN SKIING

When Meredith and I taught with Auden Schendler at Colorado Rocky Mountain School in the 1990s, he thought he'd found his calling as a high school English teacher. Responding to his sizable personality, friends and colleagues there called him "Guy." Today he is known as "the Energy Guy."

Auden began his environmental career in 1993 while crawling underneath mobile homes to nail up insulation. Tiring of that, he went to work at the Rocky Mountain Institute, where he worked as a research associate in corporate sustainability. Now he runs the environmental department at Aspen Skiing Company, which is on the leading edge of mitigating the effects of global warming and of greening up the ski industry. His recently published book, Getting Green Done: Hard Truths from the Front Lines of the Sustainability Revolution, *focuses on how businesses can become more energy efficient.*

We caught up with him at his house in Basalt, where we unfortunately disrupted his daughter, Willa, from her nap. Unsure who was taking her dad's time, she joined us for the interview in an old house that he jokes is one of the least efficient of them all.

When we pull the average skier aside and ask them, "Are you an environmentalist?" They invariably say yes.

I'll ask them, "What does that mean?"

Usually the answer is "I recycle."

People tend to focus on the tangible, the understandable.

I can't tell you how many people call me up and ask me how they can recycle their ski pass. But that action doesn't scale with the challenge of climate change.

When we say, "Climate change," we don't understand it. It's too big. Frankly, I don't think I understand the scope of the problem. So people default: if you can recycle your cup, you can sleep at night. But small, personal measures are a distraction from what's important. They may even be actively bad, because they take your attention off the big policy changes that really matter.

At Aspen Skiing Company [ASC], we've tried to look beyond what people think we should do and instead look at the big impacts of our ski area and the big environmental issues of our time: energy and climate change. We've made that the focus of our environmental program, and we have three ways we are addressing it: advocacy, efficiency, and renewables.

Advocacy is most important because, realistically, it's our biggest lever. Aspen has a big name, it gets covered in the press, and if a ski resort does something, it's a sexy story. In 2006 we filed a brief to the US Supreme Court in support of twelve states and three conservation organizations that were suing the Environmental Protection Agency [EPA] to regulate carbon dioxide as a pollutant. ASC argued that climate change is a direct economic threat to the ski industry. It was the first global warming case to be heard by the Supreme Court, and it is the

most important environmental lawsuit ever to go to the Supreme Court. It was great to be part of the case, but on top of that, we won! It means the EPA has to start regulating CO_2, which is huge progress. To be involved with a Supreme Court case that is of critical importance to the future of the planet is right where we want to be. I'd argue that this is the single most significant action that ASC has taken in its sixty-year history, including opening our slopes for business. (My bosses might demur.)

In March 2007 I was asked to testify before the House Committee on Natural Resources on climate change impacts to public lands. I told them that in the best-case scenario, global warming will increase the cost of doing business for the ski industry and drop profit margins. In the worse-case scenario, if the ski season is one month shorter, say we lose March due to warming, we go out of business. Testifying was one of the greatest experiences of my life. I filed it up there with kayaking the Grand Canyon and climbing Mt. McKinley.

What we do on the ground here, that just gives credibility to the kinds of actions we're taking on policy. Energy impacts on a ski resort come from lifts, snowmaking, buildings, and snowcats. We are working on snowmaking now, but the efficient technology is a huge investment. Lifts and snowcats are harder to make more efficient. So that leaves buildings. And if we're going to solve climate change, we have to fix old buildings and make new ones very, very energy efficient. Our policy: radical energy efficiency in new buildings and a major push to fix old buildings. We built one of the first certified green buildings in the country (we've got three now), and in the interim we've replaced half a dozen old buildings with new, energy-efficient structures.

The ski patrol building at Highlands had the largest solar installation in the ski industry, until we trumped that with 10 kW on some employee housing in Carbondale, then built an actual solar farm with the Colorado Rocky Mountain School at a utility scale: 150 kW. We've done small hydroelectric at Snowmass, and now we're looking at it on all our mountains. What's a ski resort doing developing big-scale renewable energy? It just might be our future.

We hope we've sparked change in the industry, and beyond. Nobody in this business was worried about climate when we started talking about it, but last year the head of the national ski trade association testified to Congress about it. Vail recently committed to a huge green-building program. Mammoth is doing a better job of managing energy than we are.

The question I get all the time is, "What is going to happen with skiing?" In their State of the Rockies report, Colorado College said we are going to see a 3 to 7°C warming, which is 5 to 10°F warming, by 2085. Are you kidding me? The ice ages were caused by a lesser swing in the opposite direction. That's a monumental change. The snowpack in Telluride will have an 83 percent reduction. On April 1 Aspen's will be reduced 43 percent on the average each year. The ski industry may or may not be viable in fifty years.

But bottom line, we are going to have bigger problems than skiing. Global warming is going to affect how we grow food. It is going to affect how disease spreads. It is going to affect how human populations move and live, because coastal areas are going to be underwater. Bangladesh has a hundred and fifty million people, all poor, and all more or less underwater already. When a

population half the size of the US needs a new place to live, a new job…that's going to affect the whole world. The bulk of economic activity in the US happens on the coasts, which are most in danger from sea level rise. So who cares what is going to happen with skiing? At best it's a metaphor.

If climate challenges weren't time-restricted, I'd have no worries. We're moving in the right direction, just too slowly. We've got to engage with relish, and in some ways we have to enjoy this battle, because it's what we've got. We have no choice. It's what's for dinner.

—◦◦◦—

As executive director of sustainability, Auden Schendler oversees Aspen Skiing Company's environmental efforts, which are vast. He serves as director of Aspen Sustainability Associates, a green business–consulting practice. In previous years Auden worked as a residential energy auditor, a high school math and English teacher, an Outward Bound instructor, an emergency medical technician, a planning and zoning commissioner, and an energy efficiency researcher. Auden was named a "Climate Crusader" in Time *magazine's 2006 special issue on climate change. He is also a recipient of the 2007 EPA Climate Protection Award.*

MARK SARDELLA
I CAN'T FIX THIS PROBLEM FOR THE WHOLE WORLD

We first met Mark at the Quivira Coalition annual conference. We knew the timing for this book was perfect when we discovered that ranchers, land managers, and conservationists were talking about the importance of alternative energies.

Mark believes that replacing oil with renewable energy technology is not enough to solve the energy crisis. To this end, he cofounded Local Energy, developing community-based energy projects that promote local ownership and job creation.

He invited us to his house in Tesuque, New Mexico, where he served up an array of wonderful foods and tea. We talked for hours about alternative energy and peak oil and his ideas about how to turn the city of Santa Fe into a biomass mecca.

We returned to Santa Fe a second time for an update on his projects. He and Bill Althouse of Althouse Inc. had just installed his first biomass heating system at the Santa Fe Community College, where Mark teaches courses in community-based energy projects and biomass vocations.

I created Local Energy as a way to help communities become energy self-reliant, to learn to protect themselves against the hardship of rising energy costs. And by the way, I'm a lot less of a lunatic now than when I started this. I know I can't fix this problem for the whole world.

When you study energy in this country, it's mostly a study of money flows. This economy was set up to make certain people very wealthy through the control of energy resources. There is nothing that can produce a concentration of economic wealth the way petroleum does. Almost all the money in our society is petroleum money. The ability to control the production of large amounts of energy *is* control of the economy.

I found out that utility dollars leave New Mexico at a rate of eighty-five cents on every dollar. If you have an investor-owned utility and you pay it a dollar, eighty-five cents of it goes to Wall Street and fifteen cents stays in the community. Santa Fe County alone leaks $85 million a year just in electricity and gas bills. Eighty-five million a year! And the money that leaves doesn't undergo the local multiplier, which is 2.2 for utility dollars, so really, we lose about $190 million in economic activity per year by just paying utility bills.

I look at a community and ask, "What does this community have that it can use to protect itself against what is going on? How can we empower the rural communities?" The reason the biomass industry and biomass technology come to mind is because we have so much biomass fuel and it's really not used much.

By definition, biomass is solar energy stored in organic matter. Everything that grows outdoors, all the plants and trees, are biomass. The neat thing about working with a tree is the only carbon a tree gives off when you burn it is the carbon that it took in during its lifetime. That's all it can give. So while burning a tree

does produce CO_2, it is CO_2 that was taken in during its lifetime. And the next tree actually pulls the carbon back in. So as long as you're harvesting and consuming biomass at a sustainable rate—in other words, no faster than the trees are growing—you're actually reducing carbon in the atmosphere.

Biomass at one time accounted for the biggest component of work done in the economy. Farm labor and going out to cut wood were pretty much what we did, wood for the stove and the wood for cooking. We had a biomass economy, and we gave it up because along came higher value resources. But a biomass economy is not something we have to invent.

In Tres Piedras there's a lumber mill called Kuykendall Lumber. It's the biggest sawmill left in northern New Mexico. The guy cuts around four million board feet a year, and he has an enormous pile of leftover slabs. I estimate, based on the slab piles I looked at, that he's got to have fifty thousand tons of biomass sitting on-site. When we got there, he was setting up a gang saw to try to push fifty thousand tons of slabs, one piece at a time, through the saw. He was going to try to cut it up into eighteen-inch pieces and see if he could get people to come haul it away for firewood. When I pulled in, the fire marshal had just left and told him that he needed to get rid of the piles because he was in danger of burning down all of Tres Piedras. Biomass is a totally unutilized fuel right now. There are probably millions of tons of it nationwide, sitting in piles waiting for people to do something with it.

I saw the finest biomass technology in the world in Austria. You can throw log chips into a biomass boiler and more than 90 percent of the wood's energy ends up as hot water to heat your home or business. Austria is a tiny country, and they have 843 biomass systems similar to the one we're doing at the community college. They have very little land: they're one fourth of the size of New Mexico, and their population is three and half times larger. They have a very dense environment, very little space, and a lot a lot of forest, and they do very intensive forest management.

I received a $1.3 million grant from the US Department of Agriculture to research how to use local biomass to create the maximum amount of economic benefit for a town like Santa Fe. It turns out you don't start in downtown Santa Fe; you start in the rural communities surrounding it. So, Local Energy just did a project at Santa Fe Community College. We put in a very small biomass unit, and we created a biomass vocations training program there. Now the college's goal is to become the premier biomass vocational training outfit in northern New Mexico.

We not only promote learning about biomass vocations, grading the fuel, stoking the furnace, and so on, we're also teaching how one would actually go into business and become a value-added producer. In other words, how would you take a fuel wood producer from the rural community, maybe someone who is currently cutting and selling firewood, and help him become a heat provider? How would you help him own, operate, and maintain a small, low-cost biomass system? How would you help him finance it and then sell heat? We show people how to outfit their systems with utility-grade heat meters so they can do that. I want to help put money directly into rural people's pockets. That's how we create economic development.

The Santa Clara Pueblo and the Taos Pueblo

both figured it out. The Santa Clara Pueblo just asked us to develop and implement a system to heat thirty-five low-income homes on the pueblo with biomass. When I asked them how they were going to get their fuel [and told them] that they were going to need to create a fuel cooperative, they said, "Well, we've got twenty-two guys with pickup trucks and chain saws who drive up into the woods every day. Why don't we just have them load their trucks before they come home?"

People ask me all the time if I get depressed looking at all this information. The answer is no, not anymore. The fact that we're undergoing change is what's important. It may be difficult, but it's a good thing. I think the time between where we are now and when we discover how to live a sustainable lifestyle is going to be loaded with hardship and really, really difficult issues. But ultimately, we are going in the right direction, and that's what really matters.

<hr />

Mark Sardella spent six years designing spaceflight instruments before moving over to the renewable energy field in 1993. (It's not as big a leap as you might think, since satellites are nearly always solar powered.) After several years developing micro-hydroelectric power systems, Mark moved to Santa Fe and opened Sardella Solar Consulting, focusing on the design of photovoltaic power systems and solar water-heating systems. Mark is currently chairman and executive director of Local Energy. Under his direction, Local Energy has carried out more than $2 million in research, education, and demonstration projects designed to better define the relationship between energy and the economy. Mark's twenty-three years of engineering experience includes designing the largest private photovoltaic system in New Mexico, the first grid-connected residential photovoltaic system in New Mexico, and a micro-hydroelectric power system, which was featured on CNN's Earth Matters.

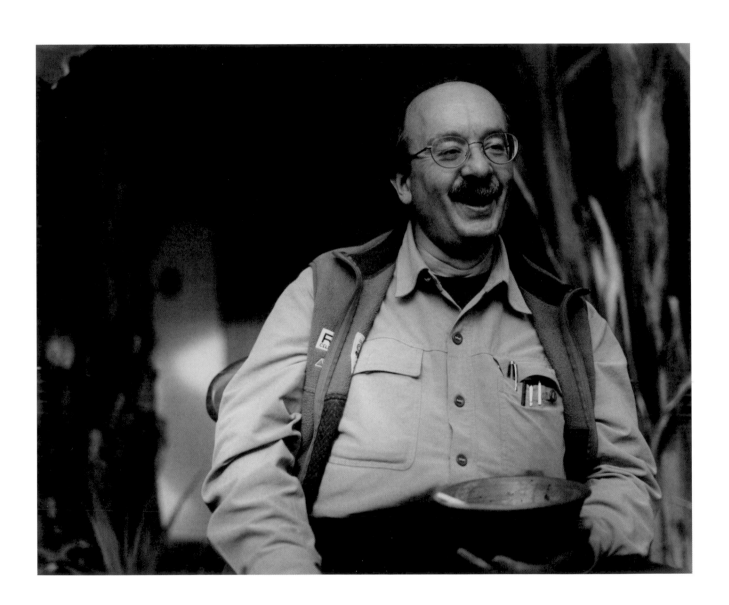

AMORY LOVINS
THE KEY TO A CHEAP HOUSE IS EXPENSIVE WINDOWS

We joined Amory Lovins during his lunch hour at the original headquarters building of Rocky Mountain Institute (RMI), now reverted to his home and office, in Old Snowmass, Colorado. We sat in a glass atrium surrounded by various fruit trees and plants, including his infamous banana grove. Scattered about the building are thirty-six stuffed toy orangutans, which he jokingly blames for late-night banana depredations. Running through the solarium is a small brook that feeds a fishpond stocked with koi. Though undergoing a renovation, RMI headquarters is a serene space. The building is an ongoing experiment in energy efficiency, and RMI has received more than a hundred thousand visitors for scheduled tours.

Amory cofounded RMI as a "think-and-do" tank in 1982, five years after Newsweek called him "one of the Western world's most influential energy thinkers." He has since become the media's energy darling. He's received a "genius award" from the MacArthur Foundation, as well as ten honorary doctorates and many international awards. He advises industries and governments worldwide and maintains that the United States can eliminate its use of oil by the 2040s while reducing its coal and natural gas consumption, all led by for-profit business.

Welcome to the Passive Solar Banana Farm in the middle of Old Snowmass, Colorado. I've harvested twenty-eight banana crops here at 7,100 feet, but have no furnace. I also have mango and avocado trees, papayas and bougainvillea, lemon and coffee plants. What we do here at Rocky Mountain Institute is create abundance by design.

RMI is an independent, entrepreneurial, nonprofit "think-and-do" tank. Formally, our mission is to foster the efficient and restorative use of resources to make the world secure, just, prosperous, and life-sustaining. We therefore help businesses, communities, individuals, and governments become far more efficient while increasing their profits and competitive advantage.

Hunter Lovins and I cofounded RMI. In March 2007 we got a real CEO, Michael Potts, who's a tech entrepreneur, so I was able to move up from CEO to chairman and chief scientist and just do the fun, important stuff while he runs the shop. My main tasks are thought leadership, special projects, strategic influence, mission stewardship, mentoring, rainmaking, fundraising, and memory. I'm the only one who's been here since the inception, and one of the few of our eighty-five people who's been here for a decade or more.

The West, and Colorado in particular, appealed to us as the next American center of innovation in much the way that California did for an earlier generation. I think we are now starting to see that critical mass of people forming. Boulder, for example, has probably the highest concentration of first-rate energy experts per capita of any place on Earth.

There are many good reasons to have established

our nonprofit here and to have incubated it for a quarter-century. The Old Snowmass Valley has more elk than people, and the cleanest monitored air in the state. There are forty-two fourteeners in the backyard. There is wilderness on three sides. I'm an old mountaineer. I used to do a hundred days a year in the mountains when I was younger. Though I grew up in the East, I'm actually a third-generation Coloradan. I find it incomparably inspiring to do work that draws on design lessons from nature. I'd rather look out the window at Mt. Sopris than at the back of somebody's parking lot.

Mostly I learn, think, write, lecture, and consult. I'm spread thinly over about fifty countries, but most of my work is in North America. The rest is mainly in Western Europe, Japan, and China, but I get to a lot of other places as well. In fact, in May, my wife, Judy, and I were in Borneo, hanging out with my orange swinger buddies [orangutans].

One of the biggest things we do is consult with megacorporations, including many Fortune 500 companies. Let's take Walmart, for example. We first worked with them in 1993, helping them design an eco-store in Lawrence, Kansas. For the design I needed a widget that I couldn't find anywhere. So I called the leading widget maker and said, "Hi, I need a widget that does X."

And they said, "Sorry, sir, it's not in the catalog."

I said, "My client is Walmart, and if they like it, they'll buy two truckloads a day forever."

He said, "Yes, sir, when do you want it?"

That's when I learned about Walmart's enormous "demand pull." Now they're an even bigger company, and they're rapidly turning quite green. And it's for real; it's not window dressing. I wanted to engage with them, partly because of their influence on the retail sector, partly to get superefficient products to market in high volume and at low cost, and partly because I surmised that since most of their merchandise is made in China, if we could get them to green their supply chain, that could have a profound effect on Chinese development strategy, which is the future of the world. I think China could well become the world leader in getting us out of the climate mess.

All my hopes for Walmart are coming to pass. The company employs roughly sixty-eight hundred heavy trucks, which annually consume at least a hundred and twenty-five million gallons of diesel fuel. Our analysis led Walmart to announce it will double its heavy trucks' fuel economy by 2015, saving them more than $300 million per year and reducing their carbon dioxide emissions by twenty-six billion pounds between now and 2020. We also helped them retrofit hundreds of stores with more-efficient lighting; heating, ventilating, and air-conditioning (HVAC) systems; and refrigeration. As a company Walmart is quite exciting to work with because they move very quickly. You wouldn't expect that from such a huge company. We're now exploring ways to go much further together.

My biggest project for 2009 is 10xE, Factor 10 Engineering. We are hatching a plot for the nonviolent overthrow of bad engineering. The design results we're achieving in superefficient factories, buildings, and vehicles would not be possible if they had been designed properly in the first place. I'm getting pretty impatient with redesigning things that weren't designed right. The root of the problem is the way engineering is taught, because that creates the way it's practiced. We're hoping to find

funding to write a casebook full of astonishing examples this summer. In it we'll put normally "dis-integrated" design and highly integrated design on facing pages. Reading both, you'll quickly understand why the efficient design saves most—often 90 percent or more—of the energy but costs less to build and works better. We'll probably give the book to engineering schools, because we want to irreversibly rearrange designers' mental furniture so they'll never do it the old way again, at least without wincing.

I'll give you an illustration of the dumb decisions that sometimes occur. A major window maker had an excellent product that insulated eight times as well as a normal sheet of glass. It contained two suspended Heat Mirror films and three cells filled with krypton, which insulates twice as well as air. However, unlike Alpen Glass in Boulder, Colorado, which made our windows, this firm did not include a little breather tube with a balloon on the end that would enable the krypton to equilibrate its pressure if the glass were shipped over the mountains. Therefore, when installed at a different altitude from the altitude where the glazing unit was manufactured, its unrelieved pressure difference and stress could cause the glass to crack. So they had a lot of unhappy customers. Instead of having their engineers solve the problem, they reportedly went to their lawyers, who said, "Well, if you fill it with air instead of krypton, then it's industry standard practice, so nobody can successfully sue you."

This is a stupid answer for several reasons. First, there's a straightforward engineering resolution that Alpen Glass had already proven in the market. Second, air insulates half as well as krypton, so you just lost a lot of insulating value. In fact, you probably lost a whole Alaska's worth of oil and gas energy this way over the life of the next generation of windows. And third, the windows will still crack, and you'll still have unhappy customers. They'll just have no recourse. It is the worst possible solution, but it's what they did.

Now there are testing and labeling standards for superwindows, but with no requirement to use them, except in a few cases. And of course, this is not just for cold climates. There are now flavors of superwindows that are essentially perfect in letting in light without heat, so they can reduce or eliminate air-conditioning in very hot climates. We've done that at 115°F, with better comfort and lower construction cost. Conversely, using 1983 technologies, my house in Old Snowmass saved 99 percent of the space- and water-heating energy and 90 percent of the household electricity with just a ten-month payback on the additional $6,000 cost. The key to a cheap house, cheap to build and cheap to run, is to use expensive windows. But many designers don't understand that. In fact, most houses are not designed by architects anyway. They're designed by builders or owners who may have little technical training and who assume that the best window is the cheapest. Or that you should simply meet code, which is the worst you're allowed to build without going to jail.

We want to change what goes on between the ears of the designer and to inform mindful markets so that those products will actually be offered, demanded, and bought.

— —

RMI has eleven spin-off companies. Rising Sun Enterprises in Basalt is one of the top two places for beautiful

and extremely efficient lighting. E Source is a Boulder firm that is the leading technical and strategic information service on electric efficiency and distributed generation.

Fiberforge, in Glenwood Springs, has a novel technology to make ultralight, ultrastrong structures out of carbon-fiber and other advanced composites. They invented a process that can yield aerospace performance, ultimately at automotive cost and speed. It's like finding a Saudi Arabia under Detroit, because it allows you to take half the weight and fuel use out of a car and make it safer, but the car costs the same to mass-produce.

Our latest spin-off, in January 2008, is Bright Automotive in Anderson, Indiana. This is an impressive gang of senior auto-industry refugees who are commercializing 100+ mpg plug-in hybrid vehicles needing no subsidy.

Lately we've done some radically efficient designs for heavy industrial plants. Our retrofits typically save 30 to 60 percent of their energy use and pay back in two to three years, while new facilities typically save 40 to 90 percent and cost less to build. That's largely the work of our Energy and Resources Team, led by Dr. Stephen Doig. Our latest refinery design should use no grid electricity, no natural gas, no outside water, and produce higher yield with greater flexibility, no slops, no wastewater, and lower capital costs. All this through integrative design. Greg Franta, who in my opinion is the top energy architect in the world—he's worked on probably a third of the world's LEED [Leadership in Energy and Environmental Design] Platinum buildings—runs our Built Environment Team, and he and his colleagues have helped design over a thousand superefficient buildings around the world.

We also have a mobility and vehicle efficiency, or MOVE, team that works both inside and outside the auto industry on transformational cars and has also figured out how to do double or triple the efficiency of heavy trucks and airplanes. We make them much lighter, reduce their friction in moving through the air and along the road, and add advanced propulsion systems and highly integrative design.

Integrative design gives multiple benefits from a single expenditure. For example, the arch holding up the greenhouse we're sitting in has twelve different functions, but I only paid for it once. And there's hardly any component of this building that doesn't do at least three jobs. That's the way nature designs things. You never do just one job. Everything is multipurpose.

Take this building as an example. At four thousand square feet, it's a combined office (whose use we donated as RMI's original headquarters), jungle, and my house. The climate at this altitude is quite severe. It can go to -47°F on occasion—perhaps not anymore with what Hunter Lovins calls "global weirding," but it used to. You can get frost any day of the year. We've had frost on the Fourth of July. You can get thirty-nine continuous days of midwinter cloud. But if you come into this jungle we're sitting in out of a snowstorm, you can still pick fresh bananas.

Moreover, there is no heating system. The building is 99 percent passively heated, thanks to two or three times the normal level of insulation and windows that insulate like fourteen sheets of glass—or nineteen, in the case of those in the north loft—but they look like two sheets of glass and cost less than three. Our windows are probably the most efficient on the market.

Ventilation heat recovery gets back about 95-plus percent of the heat in the outgoing air and puts it into the fresh air coming in. In total, we saved $1,100 of construction cost up front by stopping nearly all the heat losses and thus eliminating the heating system. I then invested that $1,100 plus another $6,000—that's $1.50 a square foot—in saving 99 percent of the water-heating energy, half the water, and 90 percent of the household electricity, which if we bought it would cost five bucks a month.

This is still one of the most thermally and electrically efficient buildings in the world, twenty-six years later. However, it was starting to turn into a technology museum, so we've just renovated it with a new design goal: let's see how much fossil fuel we can stop burning, either here or in power plants, so the building has the biggest possible negative carbon footprint.

We expanded and modernized our solar photovoltaic system. It's much more efficient and runs the building entirely in the daytime, and produces a hefty surplus to sell back to our utility. It will do this despite our having eliminated propane use in the house and gone all-electric. We just installed a new type of Swiss electric cooktop that uses about three-fifths less energy than even an induction cooktop. We think it's the most efficient anywhere. We used to have a propane demand heater to do the last 1 percent of the water heat. Now we've eliminated that and use electric backup in order to eliminate the propane carbon footprint. But we're not substituting fossil fuel elsewhere, because our electricity will be 100 percent solar (even more in the daytime) and 100 percent purchased new wind power at night. (It is truly wind power, because our co-op, Holy Cross

Energy, like the Aspen municipal utility, has an independently certified program: signing up for all wind power results in the construction of more wind machines.)

You might ask, "Well, why don't we just store solar electricity in the daytime and use it at night?" The reason is we would then lose some of it putting it into and getting it back out of a battery. And I would rather take that loss and put it into replacing coal at the power plant.

So, we're still all-renewable.

We have made even further efficiency improvements. We hope to eliminate the two woodstoves and turn their flues into light pipes. A light pipe is a tube typically between ten and twelve inches in diameter lined with shiny coatings that add extra light and use no resources. The light bounces down inside the tube and comes into the house. We are also doing our first day-lighting retrofit. We have two big light tubes that we retrofitted into the solar clothes-drying clerestory.

We've added German vacuum-insulated doors that insulate at R60. That is better than most people's roofs, and it's about thirty times as good as a normal door.

We replaced the old heat exchangers with ones that will use about ten or twenty times less electricity and be about 95 percent efficient at peak flow rather than 60-odd. So that means, let's say on a 0°F day, the fresh air coming into the building will be about 67°F instead of about 42°F.

If you look around you'll see a number of funny little aluminum boxes up on the ceiling. Those are the latest state-of-the-art LEDs, which use about a fifth the electricity of normal halogen lightbulbs and are nicely dimmable and get beautiful color—a nice warm light. So this lighting retrofit, our fifth in twenty-five years,

will correct the badly designed lighting we had before. Now it will look beautiful, you'll see better, and we'll use even less lighting energy and require no lighting maintenance. We'll be almost eliminating compact fluorescents this time.

The last big system going in will help us and others to understand how the building is working. Johnson Controls donated a digital data-acquisition system that will record about 156 measurement points—temperatures, flows, humidities, currents, and other parameters in the building plus a weather station on the roof. Visitors looking at a screen in the hallway and anyone looking at a website will be able to see exactly how the building is working, how it has worked over time, and what the implications are. So that makes it kind of an open-source science experiment for everybody.

We've long posted on the Web a detailed visitor's guide to the building and a virtual tour. For people who want to work on their own homes, we have other tools at our website, www.rmi.org, including nine basic data sheets on how to improve an existing house.

I'd like to say a little about what we're up to at RMI in energy and climate. Our major focus strategically is driving the profitable transition from oil and coal to efficiency and renewables. Over two-fifths of fossil carbon emissions in this country come from burning oil, and over two-fifths come from making electricity, mainly from coal. In both cases we think we have solutions that work better and cost less than present arrangements. We did a major study for the Pentagon in 2004 called *Winning the Oil Endgame* [move.rmi.org/oilendgame]. It's a detailed roadmap for getting the US completely off oil by 2050. We're implementing it through what we call "institutional acupuncture": we figure out where the business logic is congested and not flowing properly and we stick needles in it to get it flowing.

We are well along in figuring out how to do the same thing getting off coal and making the electricity system much more reliable, secure, and affordable than now, and running it all on distributed renewable resources.

We've been working on these issues for several decades and think we now have enough ingredients to assemble a grand synthesis of profitable climate solutions. So it's a little like Winston Churchill's remark that you can always count on the Americans to do the right thing after they've exhausted all other alternatives. By now our country has worked its way pretty well down to the bottom of the list.

People often detail me on the many bad things happening in the world and ask how dare I propose solutions: isn't resistance futile? The only response I've found is to ask, as gently as I can, "Does feeling that way make you more effective?"

The most solid foundation we know for feeling better about the future is to improve it: tangibly, durably, reproducibly, and scalably. At RMI we're practitioners, not theorists. We do solutions, not problems. We do transformation, not incrementalism. In a world short of both hope and time, we seek to practice Raymond Williams's truth that "to be truly radical is to make hope possible, not despair convincing."

Amory Lovins is chairman and chief scientist of Rocky Mountain Institute, a MacArthur Fellowship recipient (1993), and has written twenty-nine books on energy,

resources, economy, and security, including Soft Energy Paths, Small Is Profitable, Natural Capitalism, *and* Winning the Oil Endgame.

A consultant to industry and governments worldwide, he has briefed nineteen heads of state and received the Blue Planet, Volvo, Onassis, Nissan, Shingo, and Mitchell prizes, the Benjamin Franklin and Happold medals, foreign membership of the Royal Swedish Academy of Engineering Sciences, and the Heinz, Lindbergh, Right Livelihood, and World Technology awards. The Wall Street Journal named Amory one of thirty-nine people worldwide "most likely to change the course of business in the '90s," and Car magazine ranked him the twenty-second most powerful person in the global automotive industry (partly as inventor of the ultraefficient automobile Hypercar).

VISIONS OF THE FUTURE

Meeting the men and women featured in this book has led us to believe that the West is heading in new and exciting directions. So many modern concerns are paramount in the American West: global climate change, economic stability, education, population expansion, immigration, public and private land use, water, and energy development. The West is being asked to take a leading role in the balance between human desire and the needs of the environment, and that balance demands vision. As one of the Rocky Mountain West's leading contemporary thinkers on community, regionalism, and human society, Daniel Kemmis has that vision. He sees a larger West and has innovative ideas for governing western lands and revitalizing western democracy. Another visionary, Richard Lamm has always been at the forefront of political change and is one of the new breed of policy analysts who has taken bold stances on immigration, healthcare, and population growth. His position on immigration is complicated and unresolved and quite controversial. And finally, ending the book with one of the hottest topics: water. Patricia Mulroy has been called the most powerful and creative person who manages water in the West. What sets Pat apart from myriad other talented water people is that she is faced with the least amount of water resources of any state in the West and has one of the largest demands to fill.

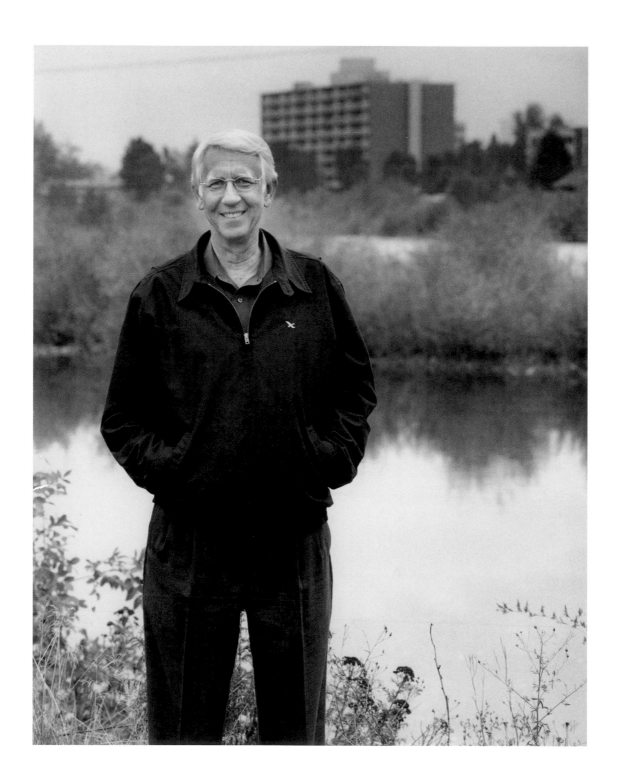

DANIEL KEMMIS
REVITALIZING DEMOCRACY

Daniel Kemmis is helping rebuild the western Democratic Party and believes that a well-functioning democracy might solve some of the West's most potent issues. Dan talked to us in his office at the Center for the Rocky Mountain West (CRMW) in Missoula, Montana, where he served until 2008 as a senior fellow in public policy. We walked with him along the Clark Fork River with the Bitteroot Mountains in the backdrop and discussed the revitalization of downtown Missoula, an effort he was proud to play a part in.

I began asking hard questions about the West when I was in the Montana state legislature. I enjoyed the political gamesmanship—I love politics and being engaged in the kind of politics that the legislature presented. I especially loved it when I got into leadership, first as the minority leader of the House and then as speaker. I also came to recognize that a big part of my job was to make my side look good and make the other side look bad. That can be kind of fun, but it can also be frustrating, particularly for somebody like me who enjoys the life of the mind or the search for truth.

There were very few opportunities for an intellectually honest exchange of views, where people from across the aisle sit down together and try to figure out why each one feels the way they do and then look honestly for acceptable solutions. Our political system doesn't reward that kind of behavior.

When I became mayor of Missoula, I began working with people who have a sense of community and of commonly held values and aspirations. I found that if I worked at it, I could very often get people from different political ideologies to look for common solutions, common ground.

For example, in the nineties, Missoula, like so many Rocky Mountain towns, was facing a large in-migration. Longtime residents were finding it hard to find housing that they could afford. Builders and developers didn't want to serve the affordable housing market, and many people didn't want affordable housing built in their neighborhoods. We were able to create an affordable housing task force where all the interests came together and carefully analyzed the situation. I give almost all of the credit to the people who worked across those ideological and interest barriers to come up with innovative solutions. This is what our communities need more of.

After leaving city hall I joined the Center for the Rocky Mountain West, a regional studies and public policy institute at the University of Montana. We look at the Rocky Mountain West from the perspective of history, economics, and public policy. We focus on growth in all of its manifestations, and on public lands as well as tribal issues on western lands. Because we're at the university, we engage students in the entire western region and help them understand the connectedness of western communities.

I believe we have to find a way to reinhabit the healthy, robust, democratic politics of the West. To me,

some of the elements are creating cities that work, conserving working landscapes, and recognizing the essentially democratic character of collaborative efforts. There are tens of thousands of people in communities across the West who are doing things to make their communities better every day. As a Democrat I wish my political party would pay a lot more attention to these people. The party, which should be the party of democracy, often doesn't see the flourishing democracy in all the western communities. Where you've got real civic energy, where you've got people who are proving their commitment to communities, pay attention to them. Find out what they need to meet their goals.

There are hundreds of examples of the collaborative process now across the West, particularly in public land and natural resource situations. I remember when the US Fish and Wildlife Service wanted to reintroduce grizzly bears into the Northern Rockies. It was a classic case where timber interests and others didn't want to see grizzlies reintroduced because they were afraid it would further reduce access to timber in the national forest. They opposed the idea. There were environmental groups that strongly supported it regardless of the consequences to sawmills or anybody else. Those two sides continued to battle each other. In the meantime, some of the local environmentalists and sawmill owners and timber workers sat down together and came up with a solution: a gradual introduction of bears. The Clinton administration adopted that plan. Unfortunately, the Bush administration overturned it, and it still awaits implementation. Those people could have spent the rest of their lives battling each other, but instead sat down and came up with a creative solution.

I am concerned that all too often the larger decision mechanism overturns the decision people come up with. We saw that with the grizzly bear solution. If that happens too often, people are not going to be willing to put in the hard work that these collaborations require. I'm not sure that the larger decision structure is evolving fast enough to make room for these more innovative approaches.

Right now I believe there is a steady growth in regional consciousness. There are more and more people who are paying attention to what is happening locally and in their neighboring states.

We are beginning to see that regional awareness comes into play in western politics as well. That has been helped along by the West becoming more of a two-party region. As recently as 2000, of the eight states that make up the Rocky Mountain West, none of them had Democratic governors. By 2008, though, five of them had Democratic governors. And while John Kerry won no electoral votes in the region in 2004, Barack Obama carried three of the states, with nineteen electoral votes. Whether you are a Democrat or a Republican, it is heartening to see the West at least becoming bipartisan. Of course, as a Democrat I hope to see it move to more of a Democratic region, and I hope that there will be a new openness among nonwestern Democrats to a more West-friendly approach.

It's a fascinating puzzle to think of what a genuinely western, genuinely Democratic platform would look like. One of the main reasons that Democrats had become the minority party in much of the West was because so many westerners, when they see the D after a candidate's name, have a negative association. They see the D as being beholden to forces outside of the West

that always try to tell the West what to do. Many western Democrats are now working to redefine that *D* in western terms, so that when people see it on a western ballot, they know these are western Democrats who understand the region and actually support the West.

Even though we like to think of the West as rural, the fact is most westerners live in cities. If the West is going to work well, we have to have highly livable cities that provide transportation alternatives to people so that they don't drive so much. We have been very lucky to have two of our leaders, Denver mayor John Hickenlooper and former Salt Lake City mayor Rocky Anderson, who have been very innovative and capable of working with a broad cross section of citizens to improve their cities.

Downtown Denver, for example, was in great trouble by the 1980s. There had been substantial white flight from the central city. Now its downtown is very vibrant. No one person makes that happen. But John Hickenlooper, an entrepreneur whose microbrewery was one of the first businesses to revive downtown, became mayor and brought some of that entrepreneurial energy to bear in city hall.

One of the blessings in my life since leaving the mayor's office is that I am serving on the Missoula redevelopment agency board. I've had an opportunity to be part of making Missoula a better place to live. My office sits on the Clark Fork River, and right across from my office now is a wave that Missoula's kayakers took the lead to build out in the river. It took months and months of concerted effort and a little bit of help from the redevelopment agency. It is so wonderful to watch those boaters out on the river enjoying themselves and watch citizens and tourists up on the riverbank watching the kayakers. To me it is a great example of a community continuing to improve itself.

If you apply too high an expectation to the Rocky Mountain West, you can always find ways in which we are falling short of what we'd like to be doing. There are many things that have happened in Missoula over the last ten or fifteen years that I wish hadn't happened here. There has been a huge wave of big-box stores. We have traffic congestion and all sorts of other problems. Throughout the West we continue to subdivide land at too high a rate. We see urban sprawl in many places while rural communities continue to decline. There are lots of problems, and it would be easy to get discouraged. But I think that we're fortunate that hundreds, in fact thousands, of good citizens continue to look for innovative solutions, whether it is in affordable housing, land and resource management, or downtown revitalization. While you can find examples of decline in political culture, and deeper polarization in some quarters, on another level we see people getting better and better at solving problems together. So I continue to be a Stegnarian optimist. I believe the West is still the "native home of hope," where people come to prosper and grow and where communities get better instead of worse.

Daniel Kemmis is the former mayor of Missoula and former minority leader and speaker of the Montana state House of Representatives. He received the Charles Frankel Prize, awarded to him by President Clinton in 1997 for his outstanding contributions to the humanities. He has written many books and articles, including Community and the Politics of Place, The Good City and the Good Life, *and* This Sovereign Land.

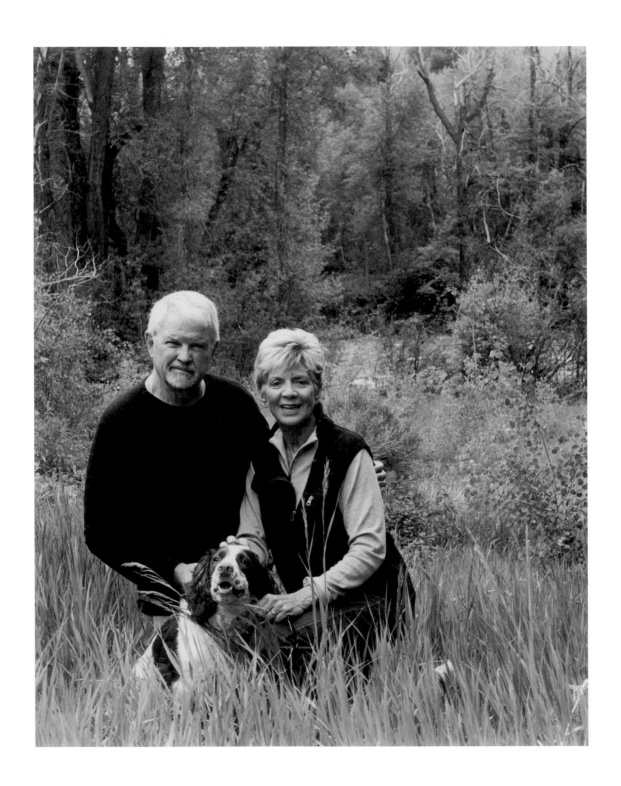

DICK LAMM
IT'S TIME TO TALK ABOUT IMMIGRATION

The first time we visited Dick Lamm he was in the middle of a heated election for the Sierra Club board, which he did not win because of his attempt to involve the Sierra Club in the immigration issue. His speech, "I Have a Plan to Destroy America," in which he questions multi-culturalism, had recently been forwarded as an e-mail to many people. He had been called a racist and felt very misunderstood. Dick served as the governor of Colorado from 1974 to 1987. When he left office he was the longest-serving governor of the state.

We had a soulful visit with Dick. He read us poetry and talked of his love for Colorado's wilderness and open spaces and his fear that democracy is dying. The second time we visited Dick, at the Institute for Public Policy Studies at the University of Denver, he talked to us about his feelings on immigration. He is a supporter of Referendum K, which mandates that the State of Colorado sue the federal government to demand enforcement of existing federal immigration laws.

I think that an old world is dying and that a new world is being born. That old world is a world of growth, and the new world is one of sustainability. I think that we are now in this watershed where it becomes immensely important to recognize that we're living on the upper shoulders of some awesomely exponential curves. No growth curves can continue to grow at the current rate.

The curve that worries me the most is the environment, mainly climate change. Secondly, the population explosion and the implications that will flow from that. The first census in the United States found four million Americans. That means we had four million European Americans. We couldn't count the number of Indians. So the United States had six doublings between 1790 and 1990. It went four, eight, sixteen, thirty-two, sixty-four, one hundred twenty-eight, to two hundred fifty-six million. Now, in 2007, we're at three hundred million people. Two more doublings gives us a billion people in America, which is what we project [for] the end of this century. A billion people in the United States would give us probably twenty million people here in Colorado. I governed this state for twelve years; we do not want twenty million people living in Colorado.

The big issue is immigration. What should be America's demographic destiny? How big of a country do we want to leave to our kids and grandkids? We're taking four times the number of immigrants that we have averaged over our two-hundred-year history. This mass immigration that we're undergoing right now is detrimental to our children, our grandchildren, and our environment.

It is time for an honest discussion about both legal and illegal immigration.

Every generation has accepted newcomers and paid for the water system, the sewer system, and the education system that those new immigrants need. It has always been a good investment. But we now have a whole new reality in illegal immigration. What used to be single males

coming up from Mexico and going home is now entire families coming up here with three, four kids and a grandmother, and they're earning $15,000 to $25,000 a year. Yet it costs the government $10,000 to educate each monolingual Spanish-speaking kid per year. In many families it costs us more to educate the kids in that family than their entire income for the year. The net result of this is an incredible burden on our taxpayers. It's giving us supply-side poverty. We try to improve the healthcare system, the education system, and here comes a new generation of poor people, every year, year after year. Immigration should be legal and in numbers that don't create a burden.

My position on immigration is that we should cut legal immigration in half and we should try our best to stop illegal immigration. We'll never completely stop it, but we should try our best to stop it. It should be illegal to have a job in America without showing that you are legally in the United States. We do have a form of employer sanction, but it is the easiest thing to get around. It's not a realistic employer sanction. I have a green card and a new Social Security card in Bill Clinton's name. I use these to show how easy it is to get fake IDs. These cost me $35. There is a whole marketplace for them. All one has to do is pay $35, and you are treated as an American citizen. I argue that an employer needs to actually check with the government and make sure it is a valid Social Security card, similar to how we process credit cards.

The most important thing to do is to require people to show they are legally in the United States before they get on an airplane, get a job, or open up a bank account. I think it's crazy when there are so many people who want to do us harm not to do it for national security purposes.

In an age of terrorism we should know who is in our country. The polls show that the vast majority of blacks, whites, and Hispanics want to stop illegal immigration.

If we really want to take care of our own poor, I argue for a tight labor market. We need to encourage employers to go into the ghetto and train people to do the jobs. George Bush said that any employer ought to be able to list any job at the wage they want to pay someone to do that job. And if no American takes it, they ought to be able to give it to whoever they want. You tell me, what job is safe under such a plan?

I argue that liberals should love borders. We'll never have any social programs unless we have borders. Do we want a universal healthcare system, a welfare program, food stamps? You can't open them up to the world.

The liberal orthodoxy in general doesn't want to talk about any sensitive issues. I think that the conservatives have two viewpoints on immigration: they have *The Wall Street Journal*, which says we ought to have open borders, and they have Pat Buchanan, who takes a very conservative, almost cultural viewpoint on immigration. The liberals also have two viewpoints. The first are the "we are the world" people who don't believe in borders. The second are the environmentalists, of which I am one, who say, "Look, there is a new issue coming across in America, sustainability and global warming, and the last thing our ecosystem needs is *another* three hundred million consuming Americans!" And that's where we are headed.

The Census Bureau says that we will have one billion Americans at the current immigration rate at the end of the century. Have you been to India? Have you been to China? You should see what a billion people looks like. You can never get away from the stink of

civilization all around you. I think we're going to have to stabilize America's population, consume less, drive cars that get fifty miles to the gallon, insulate our homes a lot better—and that's just a start. I think this is just one of a hell of a lot of things we are going to have to do.

I argue that the West has two different cultures that exist side by side. The first is the culture of growth: our forefathers came out here and they made a garden out of this wilderness by developing dams and new lands and pushing away the limits. It's a great story.

We also have the culture of limits, which holds that we live in a semiarid desert and we have to adapt to a new world of limits. You have to think about droughts, and you can't overgraze your land. I think that those two cultures have been able to exist side by side in Colorado. We dammed the Colorado and built Lake Powell, but I could still kayak the Green and the Yampa rivers.

Well, no longer. Now we have to choose. Are we going to endlessly grow and develop the West, or are we going to say, "Look, folks, we live in a desert. We have thirteen inches of rain out here, and there is a limit to how much development a semiarid climate can handle." This culture challenges the concept of endless growth.

The most sobering day I spent as governor was at the tree-ring laboratory at Colorado State University looking at the kind of drought cycles we've had in the West. That tree-ring laboratory showed that we have had numerous droughts of twenty years or more. We're in a drought cycle now. If it lasts, we are going to have to confront the new world of limits. It will challenge our whole way of life in the West. But why? What's the

greater vision of America? Is it to see how many people we can crowd in, living on hydroponic food? I suggest not. We are going to have to rethink many of our most basic assumptions.

There are six billion people on the planet, and at least half of them want to come to the United States. This is not just Mexico we're talking about. It is all of Central America, it's India, Bangladesh. Immigration should serve *our* needs and *our* purposes, not hurt our own poor people. I believe we have a bigger moral duty to the unemployed person in Pittsburgh than we do to somebody in Bangladesh.

For the future of our kids we have to be able to talk more candidly about some of these issues. We can't be scared just because somebody might call us a racist. Language is a problem because there are racism and discrimination implications, but we cheapen the word when we call anything we disagree with racist. I think that racism and discrimination are real. It is a hurdle, but it isn't a barrier. And it's time now to expand the dialogue.

Dick Lamm is the codirector for the Center for Public Policy and Contemporary Issues at the University of Denver. He was a three-term governor of Colorado between 1975 and 1987. He is the author of several books, including Condition Critical, *a criticism of current US healthcare policies and proposals for reforming them, and* Two Wands, One Nation, *an exploration of race, culture, and community in America. His wife, Dottie, is a social activist and highly respected community leader.*

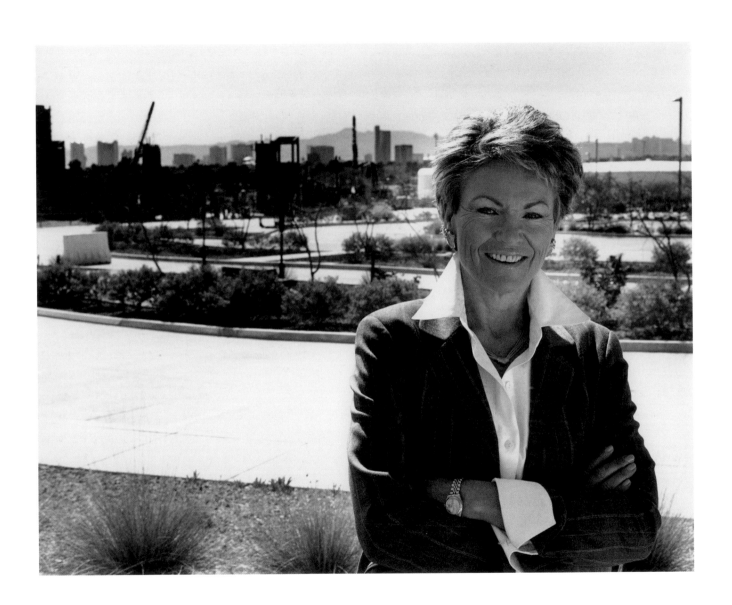

PATRICIA MULROY
NEVER GET BETWEEN A SENIOR CITIZEN AND HIS WEEKLY CAR WASH

Patricia Mulroy oversees the Las Vegas Valley Water District and the Southern Nevada Water Authority (SNWA). She is considered the most influential and out-spoken water manager in the country and has challenged historical water-sharing agreements that until recently seemed set in stone. She has to: the Las Vegas Valley has doubled in population since 1991 to 1.5 million, and gambling resorts now attract close to forty million visitors a year. She can't run out of water.

Meredith and her husband, Chuck, took their first-ever spin to Las Vegas and met Pat for a photograph in the blinding Nevada sun at the new multimillion-dollar water-use demonstration facility. Under construction at the time, the new water center is designed to show Nevadans how to live sustainably in a desert environment. Their formal interview with Pat took place at the very impressive office headquarters of the two water districts.

To me, water is the essential element of life. It is also an economic enabler. Where it runs afoul is when competition and greed overwhelm cooperation. It's too scarce of a resource in the West to be mismanaged.

The future of the Colorado River is going to depend on agricultural-urban cooperation and rural-urban cooperation. The rurals will need the urbans, and the urbans will need the rurals, and it will become a community of interdependence. Until you get rid of

competition and you get rid of winners and losers, you'll never create a trusting relationship with interdependence. You'll never create any kind of partnership based on saying, "Trust me."

There are so many opportunities that open up when you have cooperation.

It's been a long journey. When I became general manager of the Las Vegas Valley Water District in 1989, southern Nevada was going crazy and growth was just exploding. The old, traditional family gaming had been replaced with corporate gaming, and Las Vegas was going through its first metamorphosis. Vegas has an uncanny talent of redefining itself. Steve Wynn had just built the Mirage, and the MGM Grand was being built, and the first mega-resorts were starting to appear. You know, in Nevada the crane is the state bird. If you want to know what growth is doing, just go down to the Strip and count the number of cranes out there.

There are five water providers in southern Nevada, and the Las Vegas Valley Water District is the largest. We serve the city of Las Vegas and all of the unincorporated county. Most people don't realize that the entire Las Vegas Strip is in the unincorporated county; it's not in the city of Las Vegas.

The SNWA, formed from the Las Vegas Valley Water District and the other water district jurisdictions in southern Nevada, came together very differently than

any water board. Instead of competing with each other for water, we needed to work together to conserve and preserve the resource for the entire region; there can't be any winners and losers anymore—those days are over. We came together as the SNWA because we could see that by 1995 we were all going to run out of water. We essentially threw out our priority water rights, gave them up, pooled our resources, and entered in a form of shared-shortage arrangement.

Southern Nevada produces 75 percent of the state's gross product. And when you look at gaming, the Las Vegas Strip uses water in exact inverse fashion from the rest of our customers. Our residential customers use 75 percent of the water outside and 25 percent inside. The hotels use 80 percent inside and 20 percent outside. And they consume only 3 percent of southern Nevada's water. With that 3 percent, they are the largest employer and generate the largest block of gross revenue for the State of Nevada. It would be ridiculous from an economic argument to say that that's a bad investment of 3 percent of your supplies.

Before any of Las Vegas's water features were built, each developer had to submit plans on where the water was coming from. Steve Wynn had to build a wastewater treatment plant in the basement of the parking garage at Treasure Island. He double-plumbed Treasure Island and then used separate groundwater rights that the resort held in the valley to fuel his water features. The Bellagio—once the Dunes Hotel—has an old 1947 water right granted by the state engineer. When he [Wynn] bought the Dunes Hotel, he bought that water right. In truth, that fountain uses a lot less water than the golf course that the Dunes Hotel had in that same spot before. In fact, he had so much excess water he transferred a block of it up to Shadow Creek, where he built a golf course. So those features are supplied entirely by groundwater and treated wastewater, not municipal water supply.

The same holds true for the Venetian. Each one of the Vegas hotels has to develop a plan around what to do with water. You start turning those water features off, and it will have an effect on visitors. You might be able to turn off that pathetic little fire hose in front of New York New York, but you turn around and you dry up the canals in the Venetian, and you watch occupancy drop. How do you discern what's a good water feature from a bad water feature?

In Las Vegas 75 percent of our water is used outside. Everything that is used indoors or that hits the sewer system is 100 percent recycled. We either send it to a regional reuse facility or we send it to a wastewater treatment plant that treats it to tertiary level [and] returns it to Lake Mead, receiving credit for the water returned so that we take an equal amount of water back out again. Our return-flow credit program has increased southern Nevada's water supply by one-third, without diminishing anyone else's.

———

Well, then came 2002 and the drought, and overnight a resource plan that projected enough water until 2040 had nothing. Lake Mead plummeted to a level where there was no surplus to be had, and Arizona needed their reserves for the Central Arizona Project [CAP] and the Salt River Project. So our previous arrangements with Arizona for using their surplus water were no longer available to us.

In January of 2003 we presented the SNWA board with a drought plan. The plan is centered around a diverse and innovative conservation and reuse program. Philosophically, we had approached the drought plan with the notion that this was really an opportunity for us. We had long been talking of and had been active in getting the community to conserve, but just like any voluntary conservation program, not that many people bite; they just don't. People don't like change.

I learned two huge lessons when we created the drought plan. The first was about senior citizens and their car washing habits. Never get between a senior citizen and his weekly car wash. That is not a safe place to be. I never knew that after a certain age, you wash your car every week on the same day, and you live a very routinized schedule. God help the person who interrupts that schedule.

We tried to force the seniors to use car washes that recycle water. Oh my Lord, I thought I was going to be tarred and feathered. So we said, all right, as long as you have a shut-off nozzle on your hose, have at it.

The second lesson was about fountains. We tried to draw a distinction between fountains in shopping centers and business parks and fountains that had a direct economic tie, like on the Strip. Oh my Lord, the business parks went crazy. I woke up one morning to see a psychiatrist on the news saying that his patients needed the sound of a babbling brook in the background to calm their nerves so that he could appropriately have a session with them. I sent him a sound-soother CD.

At the end of the day, the politics got so heated that we came up with a pretty good compromise. In order to have a fountain in southern Nevada, you have to remove enough grass to equal fifty times the amount of water which that fountain uses. So if that fountain is that important to you, then put your money where your mouth is and go out and retrofit turf.

Our drought plan also took on turf very directly. Turf is a big culprit when it comes to water use. New homes are precluded from having turf in the front yard and can only have 50 percent in the backyard. You can't plant it during the hot summer months, because it takes voluminous amounts of water to get it established, especially those cool-weather turfs that people love, the Kentucky bluegrass and the more tropical fescues. The irony to me is just nuts. People move here from snowy regions where they're used to four seasons. But they come here and they want twelve months of spring. We want green, green, green grass, and green, green, green trees. It's nuts. I don't know what happens on the trip in, but it's some kind of reality warp.

The centerpiece of the turf removal program was a financial incentive. Last year we offered our customers $2 per square foot to remove their turf. [Over the years, from its inception in 1999, the amount has moved around between $0.50 and $2 per square foot; it is at $1.50 now for as much as is removed, without limitation.] We spent $110 million taking turf out in this valley. And we've taken out a hundred and ten million square feet. This is enough turf to run a roll of sod halfway around the Earth at the equator.

We save more than six billion gallons of water a year just from this program, and have saved 24.5 billion gallons cumulatively since the program began. Through those measures, in two years we reduced our water use by sixty-five thousand acre-feet, despite the fact that we are growing by eight thousand people a month. It's not whether you grow; it's how you grow. I love high-rises

because to me they say small footprint on the ground and very little landscaping. That is much more sustainable for southern Nevada.

The next part of our plan was to educate the public that "Hey, you don't need to water in July, when it's 120° outside the same as you do in December, when it's 40° outside." We put everyone on a diet. People could only water their landscaping three days a week in the fall and in the spring, and once a week in the winter, and not at all in the summer. And oh my God, the homeowners' associations were going nuts.

I hit the road, as did the board, and our speech was essentially, "Welcome to the Desert Southwest. You have moved to the desert. This is not Kentucky, this is not Florida; you can't pretend you live in the tropics, because you don't. And if you're going to live here, then you have to learn to live with the environment." It seemed as though people who move to Phoenix for some bizarre reason embrace the idea of living in the desert. People who move to Las Vegas defy living in a desert. And we had to turn that around.

That was our first line of defense. The next phase is more complicated and demands a bit of history. Las Vegas's water allotment was decided back in 1928, when water from the Colorado River Basin was divvied up among seven water-starved southwestern states. At that time Nevada had a small population, and even less political clout. Relative to Arizona and California it received a miniscule amount: just 3 or 4 percent of Colorado River water. But that allotment was adequate for about the first sixty years.

We wanted neighboring states to stop fighting in court over the Colorado River and instead work together to resolve our water disputes. To summarize a decade of discussions, we ended up with what was called the Interim Surplus Guidelines—a great collaboration. Nevada and California are able to overuse water out of Lake Mead through 2015, depending on what the lake levels are. We also during that time entered into an arrangement with Arizona to bank their unused Colorado River entitlement in their groundwater basins for our future use.

That agreement was intended to give us supplies that we need through 2020. But the severity and length of the drought changed all that. And we were soon back in negotiations about shortages, not about surpluses. Those negotiations went much faster and yielded a landmark shared-shortage agreement signed by Interior Secretary [Dirk] Kempthorne just last December [2007].

Under this new agreement, the states have agreed, with the SNWA in the lead, to look at any and all possibilities to augment the Colorado River system. In other words, develop non–Colorado River waters, like desalted ocean water or inland-desalted water, and then use those for exchanges to increase the amount of water available for the lower basin. For example, we can bring the water we have rights to on the Virgin River—a tributary of the Colorado—into Lake Mead instead of taking that water and bypassing Lake Mead by piping directly to the Las Vegas Valley. We are also going to be building a storage reservoir on the All-American Canal along the border of California and Mexico to avoid over-deliveries to Mexico. And for any new innovation that increases the flow of water in the Colorado system, Nevada will get the first seventy-five thousand acre-feet of the new water from whatever projects are built. In the longer term, if we can

work with California or Mexico to build an ocean water desalter, we can trade that water for a larger share of the Colorado River for Nevada. We are also digging a deeper intake pipe near the bottom of a shrinking Lake Mead, which should be running by 2012.

We recently filed for unused groundwater in northern Nevada that is not a part of the Colorado River system. In some of these groundwater basins we filed for all of the unused perennial yield, and in some we didn't. We hope to build a 250-mile-long pipeline to tap maybe up to forty billion gallons of rural water a year. With return flows from reuse, that will be enough water to replace or supplement Colorado River water for almost two hundred thousand families.

Well, the outcry after those filings was unbelievable. Owens Valley, California, reared its ugly head, and everybody was screaming that the big urban area is going to dry up rural Nevada, that we were going to be one great big Owens Valley. In the early 1900s Los Angeles tapped—in a rather underhanded way—a large lake in Owens Valley for municipal water supply. LA's actions created immense environmental damage in the area; there were no environmental protection laws, regulation, and no environmental ethic in those days. This situation is continually used as an example of what will happen here if our project comes online, even though the circumstances and the environmental protection requirements are entirely different here. I was pretty naive when we first did it, and I was shocked at the reaction because that was never our intent.

So we're now in the midst of this battle with some rural counties in northern Nevada. Ranchers are upset because they say we're going to dry up their springs and underground aquifers, but the US Geological Survey concluded that there's plenty of water for Las Vegas and the rural valleys.

But I believe we are the first anywhere to convene a citizens' committee and invite the business community, the senior community, the environmentalists, and residents to participate on that committee. We asked them to look at the water futures in southern Nevada. We put in satellite feeds and fed those meetings into the communities up north in Lincoln County and in White Pine County, so that people could go to various central locations and could participate in the meetings from up there. We're trying to create a regional market that gives states, cities, and farmers greater freedom to strike mutually beneficial agreements, but with protections, so that the municipalities work with other regions so that there is no noticeable harm to them in the end.

I think that's the only way we're going to reach solutions. It goes back to that old notion of winners and losers, and haves and have-nots.

We want to get rid of this competition, be it with the northern Nevada counties or the urban centers in the Southwest. The whole Desert Southwest will come to a screeching halt unless we start tackling those issues more harmoniously between the seven Colorado River Basin states. I think every project should be a partnership between us and the other users of this scarce resource. We need to work together on these things.

I was told back in 1990, "Pat, change is going to happen, you can either be an architect of that change or you can be its tenant, that's the only choice you have."

Pat Mulroy oversees the operations of the Southern Nevada Water Authority and the Las Vegas Valley Water District. The water authority treats and delivers water to southern Nevada agencies, which collectively serve more than 1.8 million customers and 40 million annual visitors.

Pat joined the water district more than twenty years ago and began serving as its general manager in 1989. She was a principal architect of the water authority, which has served as a model for other western water agencies since its creation in 1991.

As general manager of one of the country's most progressive water agencies, Pat is exceptionally active in regional and national water issues. She currently serves on the board of directors of the Association of Metropolitan Water Agencies and the National Water Resources Association. She and her husband, Robert, have two children.

EPILOGUE

Voices of the American West is a tribute to all who are working toward a more sustainable West. Its pages are inspired by the increasing number of individuals who believe that they have an obligation to one another and to the natural world to try to solve some of the West's most pressing problems, people who hold faith in the power of action. These stories are part of a larger dialogue in today's West. The time for conversation, for connecting and sharing stories, and for collaborating is now.

When Teddy Roosevelt IV spoke at the one hundredth anniversary of Yellowstone National Park in 2003, he reminded his audience of the importance of "calling upon the wisdom of our ancestors in our present-day struggles." He was speaking to the struggles with land conservation and stewardship, the fracturing of community, and the changing demographics and growth throughout the West. *Voices of the American West* provides unique personal insights with the hope that today's voices will become tomorrow's wisdom.

ACKNOWLEDGMENTS

Our sincere gratitude to the people featured in this book for sharing your lives with us. Each of you has deeply enriched our own experience of the American West.

We'd also like to recognize those we met as we traveled whose hard work and dedication also serves to make the West a better place, especially Dick Pownall, Bob Parker, Maggie Fox, Mark Udall, Teresa Jordan, Jay Fetcher, the late John Fetcher, Stephen Pyne, Mike Phillips, Debbie Tewa, Roger Brown, Bill Maumsee, and the late Sam Caudill.

Our deepest and sincere thanks to Ed Marston, our mentor, critic, and unofficial editor, for his council, insight, critique, and overall guidance. Ed's twenty-plus years of coverage of the issues in the West helped shape the direction of this book.

To our dear friend Adele Hause we offer our heartfelt thanks for your unparalleled wisdom, your gift with words, and the hours you spent thinking about and helping with this project.

To longtime friend Joanne Morgan, thank you for your excellent design ideas, your gift of time, and your endless enthusiasm for our book.

To another dear friend, Darcey Brown, we extend our thanks for your many excellent suggestions. Thanks also to the Brown Family Foundation for your generous support, which helped keep this project alive.

Thank you to Lise Waring for your sharp eye and perfect suggestions.

Thank you to Chuck Ogilby for your council regarding water issues and for traveling with us many times as we crisscrossed the West.

Thank you to the team at Fulcrum Publishing for making the final process of this book so enjoyable: Sam Scinta for your ideas and lengthy conversations; Faith Marcovecchio, our editor, for your excellent questions and suggestions; and Jack Lenzo for your eye for design.

Special thanks to Patti Hartmann at the University of Arizona Press for believing in the book and giving us the gift of reviewers and constructive criticism. And to Claudine Randazzo and Dave Jenney at Northland Publishing for your support and enthusiasm and for helping this book find a home with Fulcrum Publishing.

Thank you to our many friends who were so generous with their support and ideas: John and Laurie McBride, Piper Foster, A. O. Forbes, Molly and Tai Jacober, Kayo Ogilby, Teresa Jordan, Renee Askins, Suzanne Jones, Barbie Christopher, Allen Best, Diane Kenney, Terry Tempest Williams, Auden Schendler, Randy Udall, Art Goodtimes, Matt Lewis, Rhonda Claridge, and Elizabeth Covington.

To the people who read segments of the book, we thank you for suggesting we push further: Darcey Brown, Ed Marston, Alex and Pat Platt, Sara Garton, Mary Eshbaugh Hayes, and Pat Fender.

And to the many people who shared their homes and offered us beds and meals, we are so

grateful: Cami and Doug Lien, Darcey Brown, Mark and Jeannie Clark, Jenny and Charles Lorch, Wendy Vandekamp, Adele Hause, Alex and Jenny Platt, Trevor Campbell, Jennifer and Brian Kriesien, Sid and Cheryl Goodloe, Tweeti Blancett, Wendy and Warner Glenn, and Helen Hopkins.

BIBLIOGRAPHY

Abbey, Edward. *Desert Solitaire*. New York: Pocket Books, 1992.

———. *The Monkey Wrench Gang*. New York: Penguin Classics, 2004.

Askins, Renee. *Shadow Mountain: A Memoir of Wolves, a Woman, and the Wild*. New York: Anchor, 2004.

Brick, Phillip, ed. *Across the Great Divide: Explorations in Collaborative Conservation and The American West*. Washington, DC: Island Press, 2000.

Chouinard, Yvon. *Let My People Go Surfing: The Education of a Reluctant Businessman*. New York: Penguin, 2006.

Collopy, Michael. *Architects of Peace: Visions of Hope in Words and Images*. Novato, CA: New World Library, 2000.

deBuys, William. *Enchantment and Exploitation: The Life and Hard Times of a New Mexico Mountain Range*. Albuquerque: Univ. of New Mexico Press, 1985.

———. *The Walk*. San Antonio, TX: Trinity Univ. Press, 2007.

deBuys, William, and Alex Harris. *River of Traps: A New Mexico Mountain Life*. San Antonio, TX: Trinity Univ. Press, 2007.

deBuys, William, and Joan Myers. *Salt Dreams: Land and Water in Low-Down California*. Albuquerque: Univ. of New Mexico Press, 2001.

deBuys, William, and Don J. Usner. *Valles Caldera: A Vision for New Mexico's National Preserve*. Santa Fe: Museum of New Mexico Press, 2006.

Duncan, David James. *My Story as Told by Water: Confessions, Druidic Rants, Reflections, Bird-Watchings, Fish-Stalkings, Visions, Songs and Prayers Refracting Light, from Living Rivers, in the Age of the Industrial Dark*. San Francisco: Sierra Club Books, 2002.

Fauntleroy, Gussie. *Roxanne Swentzell: Extra-ordinary People*. Santa Fe: *New Mexico Magazine*, 2002.

Fielder, John. *Mountain Ranges of Colorado*. Boulder, CO: Westcliffe, 2004.

———. *Photographing the Landscape: The Art of Seeing*. Boulder, CO: Westcliffe, 1997.

Fischer, Hank. *Paddling Montana*. Guilford, CT: Globe Pequot Press, 2008.

———. *Wolf Wars: The Remarkable Inside Story of the Restoration of Wolves to Yellowstone*. Missoula, MT: Fischer Outdoor Discoveries, 2003.

Fischer, Hank, and Carol Fischer. *Montana Wildlife Viewing Guide*. Guilford, CT: Globe Pequot Press, 1995.

Foreman, Dave. *Confessions of an Eco-Warrior*. New York: Crown Publishing, 1993.

———. *Rewilding North America: A Vision for Conservation in the 21st Century*. Washington, DC: Island Press, 2004.

Fox, Dottie. *Below the Rim: Footsteps through the Grand Canyon*. Aspen, CO: Who Press, 2000.

Friederici, Peter, and Rose Houk, eds. *A New Plateau: Sustaining the Lands and Peoples of Canyon Country*. Minneapolis: Renewing the Countryside, 2004.

Glenn, Warner. *Eyes of Fire: Encounter with a Borderlands Jaguar*. Tucson, AZ: Treasure Chest Books, 1996.

Guthrie, A. B., Jr., Edward Abbey, and Marnie Gaede. *Images from the Great West*. La Cañada, CA: Chaco Press, 1990.

———. *The Big Sky*. Boston: Mariner Books, 2002.

Hawken, Paul, Amory Lovins, and L. Hunter Lovins. *Natural Capitalism: Creating the Next Industrial Revolution*. New York: Back Bay Books, 2008.

Hess, Karl, Jr., and John A. Baden, eds. *Writers on the Range*. Boulder: Univ. Press of Colorado, 1998.

Jackson, William Henry, John Fielder, and Ed Marston. *Colorado, 1870–2000*. Boulder, CO: Westcliffe, 1999.

Johnston, Michael. *In the Deep Heart's Core*. New York: Grove Press, 2003.

Jordan, Teresa. *Riding the White Horse Home: A Western Family Album*. New York: Vintage Departures, 1994.

Keiter, Robert B., ed. *Reclaiming the Native Home of Hope: Community, Ecology, and the American West*. Salt Lake City: Univ. of Utah Press, 1998.

Kemmis, Daniel. *Community and the Politics of Place*. Norman: Univ. of Oklahoma Press, 1992.

———. *The Good City and the Good Life: Renewing the Sense of Community*. Boston: Houghton Mifflin, 1995.

———. *This Sovereign Land: A New Vision for Governing the West*. Washington, DC: Island Press, 2001.

Kingsolver, Barbara. *Animal, Vegetable, Miracle: A Year of Food Life*. New York: Harper Perennial, 2008.

Kittredge, William. *Hole in the Sky: A Memoir*. New York: Vintage, 1993.

———. *The Next Rodeo: New and Selected Essays*. St. Paul, MN: Graywolf Press, 2008.

———. *Who Owns the West?* San Francisco: Mercury House, 1996.

———. *The Willow Field*. New York: Vintage, 2006.

Lamm, Richard. *The Brave New World of Health Care*. Golden, CO: Fulcrum, 2003.

———. *Condition Critical: A New Moral Vision of Health Care*. Golden, CO: Fulcrum, 2007.

———. *Two Wands, One Nation: An Essay on Race and Community in America*. Golden, CO: Fulcrum, 2006.

Lee, Katie. *All My Rivers Are Gone: A Journey of Discovery through Glen Canyon*. Boulder: Johnson Books, 1998.

———. *Glen Canyon Betrayed*. Flagstaff, AZ: Fretwater Press, 2006.

———. *Ten Thousand Goddam Cattle: A History of the American Cowboy in Song, Story and Verse*. Albuquerque: Univ. of New Mexico Press, 2001.

Leopold, Aldo. *A Sand County Almanac*. New York: Oxford Univ. Press, 1968.

Limerick, Patricia Nelson. *The Legacy of Conquest: The Unbroken Past of the American West*. New York: W. W. Norton, 1987.

———. *Something in the Soil: Legacies and Reckonings in the New West*. New York: W. W. Norton, 2001.

Lopez, Barry. *Of Wolves and Men* New York: Scribner, 2004.

Lovins, Amory B. *Small Is Profitable*. Snowmass, CO: Rocky Mountain Institute, 2002.

Lovins, Amory B., E. Kyle Datta, Odd-Even Bustnes, and Jonathan G. Koomey. *Winning the Oil Endgame*. Snowmass, CO: Rocky Mountain Institute, 2004.

Lovins, Amory B., William McDonough, Alan AtKisson, and Hunter Lovins. *The Natural Advantage of Nations: Business Opportunities, Innovation and Governance in the 21st Century*. London: Earthscan Publications, 2006.

Marston, Ed, Richard L. Knight, and Wendell Gilgert. *Ranching West of the 100th Meridian: Culture, Ecology, and Economics*. Washington, DC: Island Press, 2002.

Martin, Russell. *A Story That Stands Like a Dam*. Salt Lake City: Univ. of Utah Press, 1999.

Modica, Andrea. *Real Indians: Portraits of Contemporary Native Americans and America's Tribal Colleges*. Denver: American Indian College Fund, 2003.

Morris, Gregory L. *Talking Up a Storm: Voices of the New West*. Lincoln: Univ. of Nebraska Press, 1995.

Nabhan, Gary Paul. *Coming Home to Eat: The Pleasures and*

Politics of Local Food. New York: W. W. Norton, 2001.

———. *Cultures of Habitat: On Nature, Culture, and Story.* Berkeley, CA: Counterpoint, 1998.

———. *Renewing Salmon Nation's Food Traditions.* Corvallis: Oregon State Univ. Press, 1996.

———. *Why Some Like It Hot: Food, Genes, and Cultural Diversity.* Washington, DC: Island Press, 2006.

Ogilby, Meredith. *A Life Well Rooted.* Carbondale, CO: Hell Roaring Publishing, 2001.

Peacock, Doug. *The Essential Grizzly: The Mingled Fates of Men and Bears.* Guilford, CT: Lyons Press, 2006.

———. *Grizzly Years: In Search of the American Wilderness.* New York: Holt Paperbacks, 1996.

———. *In the Presence of Grizzlies: The Ancient Bond between Men and Bears.* Guilford, CT: Lyons Press, 2009.

———. *Walking It Off: A Veteran's Chronicle of War And Wilderness.* Spokane: Eastern Washington Univ. Press, 2005.

Porritt, Jonathon, and Amory B. Lovins. *Capitalism as if the World Matters.* London: Earthscan Publications, 2007.

Powell, John Wesley, and William deBuys. *Seeing Things Whole: The Essential John Wesley Powell.* Washington, DC: Island Press, 2004.

Pritchett, Laura, Richard L. Knight, and Jeff Lee, eds. *Home Land: Ranching and a West That Works.* Boulder, CO: Johnson Books, 2007.

Ryan, Kathleen Jo. *Ranching Traditions: Legacy of the American West.* New York: Artabras, 1989.

Schendler, Auden. *Getting Green Done: Hard Truths from the Front Lines of the Sustainability Revolution.* New York: PublicAffairs, 2009.

Smith, Annick. *Homestead.* Minneapolis: Milkweed Editions, 1996.

Stegner, Wallace. *Beyond the Hundredth Meridian: John Wesley Powell and the Second Opening of the West.* New York: Penguin, 1992.

Udall, Stewart. *The Quiet Crisis.* New York: Holt, Rinehart, and Winston, 1963.

Van Cleve, Barbara. *Hard Twist: Western Ranch Women.* Santa Fe: Museum of New Mexico Press, 1995.

Vincentelli, Moira. *Women Potters: Transforming Traditions.* Piscataway, NJ: Rutgers Univ. Press, 2004.

Ward, Chip. *Hope's Horizon: Three Visions for Healing the American Land.* Washington, DC: Island Press, 2004.

White, Courtney. "The Working Wilderness: A Call for a Land Health Movement." In *The Way of Ignorance and Other Essays* by Wendell Berry. Berkeley, CA: Counterpoint, 2006.

———. *Revolution on the Range: The Rise of a New Ranch in the American West.* Washington, DC: Island Press, 2008.

Wilkinson, Charles. *Blood Struggle: The Rise of Modern Indian Nations.* New York: W. W. Norton, 2006.

———. *Crossing the Next Meridian: Land, Water, and the Future of the West.* Washington, DC: Island Press, 1993.

———. *The Eagle Bird: Mapping a New West.* Boulder, CO: Johnson Books, 1999.

Wilkinson, Charles, and Diane Sylvain. *Fire on the Plateau: Conflict and Endurance in the American Southwest.* Washington, DC: Island Press, 1999.

Williams, Terry Tempest. *Finding Beauty in a Broken World.* New York: Pantheon, 2008.

———. *Leap.* New York: Vintage, 2001.

———. *The Open Space of Democracy.* Great Barrington, MA: Orion Society, 2004.

———. *Red: Passion and Patience in the Desert.* New York: Vintage, 2002.

———. *Refuge: An Unnatural History of Family and Place.* New York: Vintage, 1992.

———. *An Unspoken Hunger: Stories from the Field.* New York: Vintage, 1995.

Wuerthner, George, and Mollie Matteson. *Welfare Ranching: The Subsidized Destruction of the American West.* Washington, DC: Island Press, 2002.